A
BLOOM
A DAY

A BLOOM A DAY

A Fortune-Telling
BIRTHDAY BOOK

PHOTOGRAPHS BY RON VAN DONGEN
TEXT BY BILLIE LYTHBERG AND SIAN NORTHFIELD

CHRONICLE BOOKS
SAN FRANCISCO

First published in the United States of America in 2009
by Chronicle Books LLC.

Library of Congress Cataloging-in-Publication Data available.

ISBN 978-0-8118-6821-1

Manufactured in China
Designed by Carolyn Lewis

Produced and originated by PQ Blackwell Limited
116 Symonds Street, Auckland, New Zealand.
www.pqblackwell.com

10 9 8 7 6 5 4 3 2 1

Chronicle Books LLC
680 Second Street
San Francisco, California 94107

www.chroniclebooks.com

Few things say 'I love you,' 'I'm sorry,' 'Happy Birthday' or 'Congratulations' quite as often, or as well, as a luscious bouquet. In fact, many of the flowers we give and receive say much more than their accompanying cards might have us believe. Since medieval times flowers have been given symbolic and moral meanings. In the Victorian era this language of flowers came to be known as floriography, when courting couples carefully selected particular blooms to send hidden messages of love, quarrel, apology and forgiveness.

Welcome to BLOOM A DAY, a modern floriography based on the historical significance of flowers, their colors, seasons, names and shapes. There is a flower here for every day of the year, and a flower fortune for those born on each day. Are you a bold tulip or a passionate red rose? An early riser like the hyacinth or a retiring hibiscus? A classically beautiful camellia or a social chameleon like the capricious hydrangea? BLOOM A DAY will tell you about your birthday flower and your favorite flower, decode those flowers you receive, and might even suggest the perfect flowers to use for your own hidden messages.

Billie Lythberg (a creative Anemone)
Sian Northfield (a passionate Begonia)

Bloom where you are planted.

❁

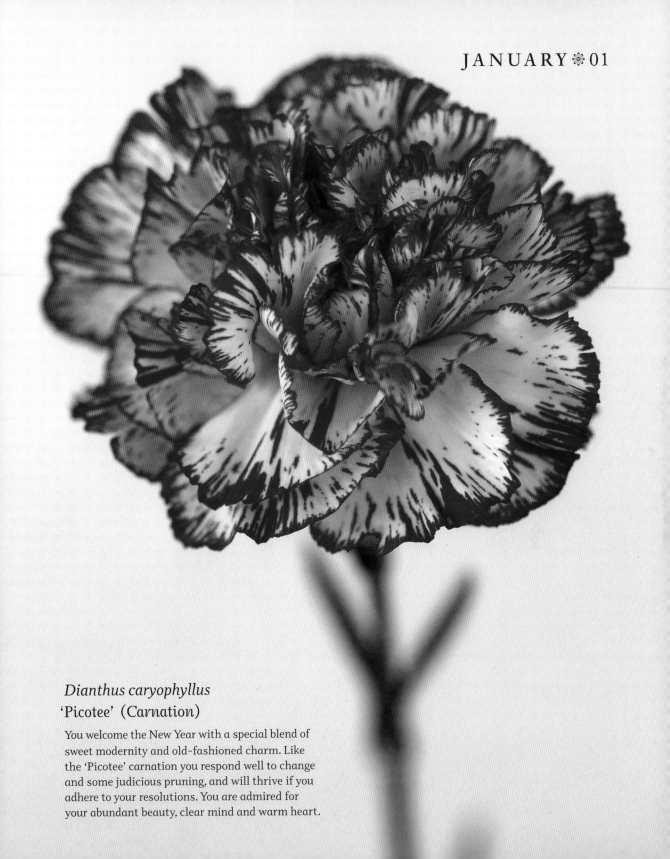

Dianthus caryophyllus
'Picotee' (Carnation)

You welcome the New Year with a special blend of
sweet modernity and old-fashioned charm. Like
the 'Picotee' carnation you respond well to change
and some judicious pruning, and will thrive if you
adhere to your resolutions. You are admired for
your abundant beauty, clear mind and warm heart.

Tulipa 'Christo' (Tulip)

Like this gentle bloom, you possess many layers. Initially you may seem one-dimensional, but as friends and lovers get to know you they see the depth of your spirit and the many facets of your personality. You're romantic, intelligent and able to persevere through trying times.

Narcissus 'Albus Plenus Odoratus' (Daffodil)

Multidimensional, this beautiful daffodil has the added allure of scent—there is more to you than meets the eye. You have a purity of spirit combined with an apparent innocence, which makes you most compelling. Your strong sense of self will guide and protect you through life's challenges.

Pelargonium domesticum 'Carrum Purple' (Martha Washington Geranium)

A symbol of fertility and protection, this flower is strongly associated with parenthood. You are a complex individual with a strong sense of self. Though you can be hard to read, those that persevere are richly rewarded by your warmth and generosity.

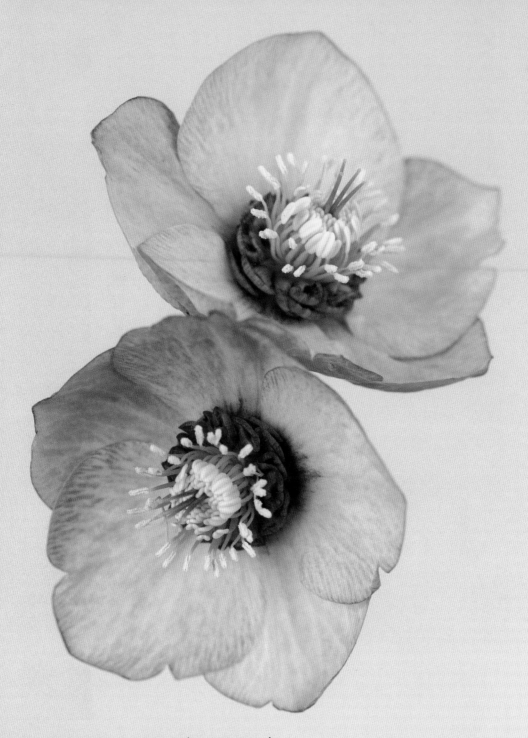

Helleborus hybridus 'Apricot' (Lenten Rose)

Though a member of the humble buttercup family, the lenten rose is a ravishing bloom. You share with this flower an eye for detail and a love of refinement. Your nurturing character brings comfort to those around you and you indulge your love of beauty through your patronage of the fine arts.

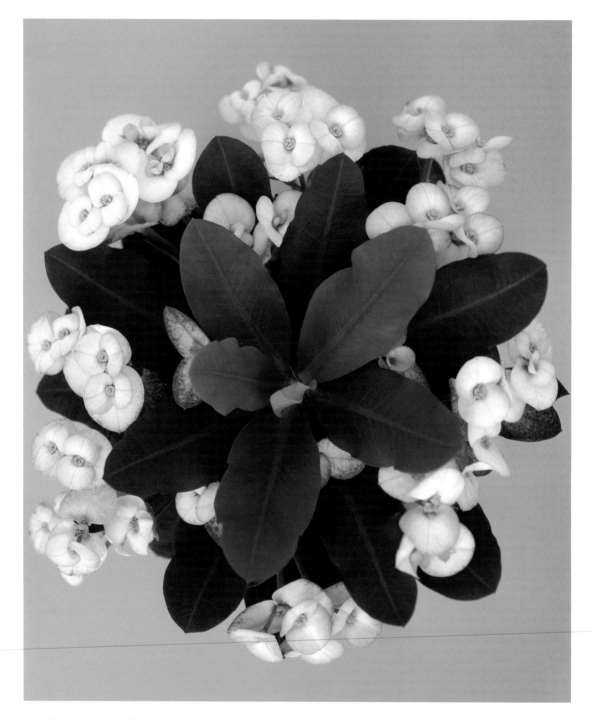

Euphorbia milii (Crown of Thorns)

This architectural plant symbolizes the ability to cleanse and reveal, and to shine anew. You have a refreshing and exuberant personality. You like to introduce people to each other, places and things. The stories you attach to situations help people realize things about themselves, each other or their environment.

Hosta 'Gold Drop' (Hosta)

Grown primarily for its shade-loving foliage, the flower of this hosta is a pleasant surprise. This upright and many-layered flower symbolizes the desire to achieve and a capacity for change. You are a forthright and ambitious team player, with good intentions and creative flair.

Gentiana andrewsii (Bottle Gentian)

The love and power that are symbols of the gentian are manifest in your mental acuity and loyalty. You aspire to greatness and have the faculty to get there. Your organizational skills are unparalleled but your forte is your ability to delegate and have people happily work for you.

Sarracenia alata (Sweet Pitcher Plant)

The pitcher plant symbolizes protection and tenacity. You are potential personified. You find that very little challenges you and that you can get by with minimal effort. Given the right opportunity, you have the potential to stun your peers with your passion and integrity.

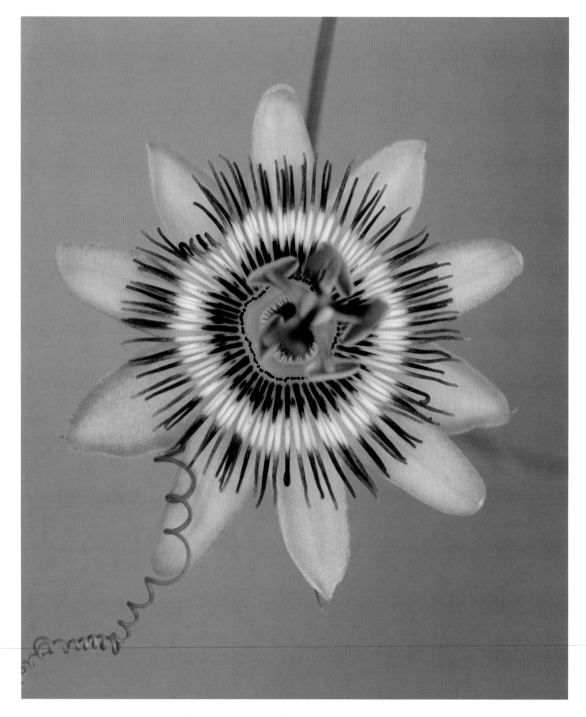

Passiflora 'Blue Crown' (Passion Flower)

The rapid growth and impetuous nature of this flower indicate new beginnings. You are a fast mover who loves the challenge of every day. You exude confidence and sensuality, making you a sought-after lover. Because you understand the fragility of life you exhibit great tenacity.

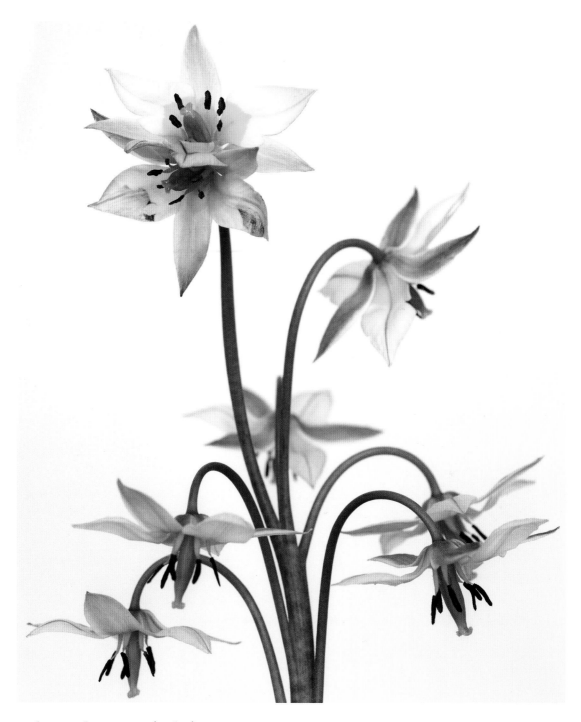

Tulipa turkestanica (Tulip)

The formality of the tulip is challenged by this playful blossom. All tulips share an association with luxury and this bloom is no exception. It blesses you with a strong sense of glamour and style. You are an engaging and effervescent person who likes to take risks and have fun.

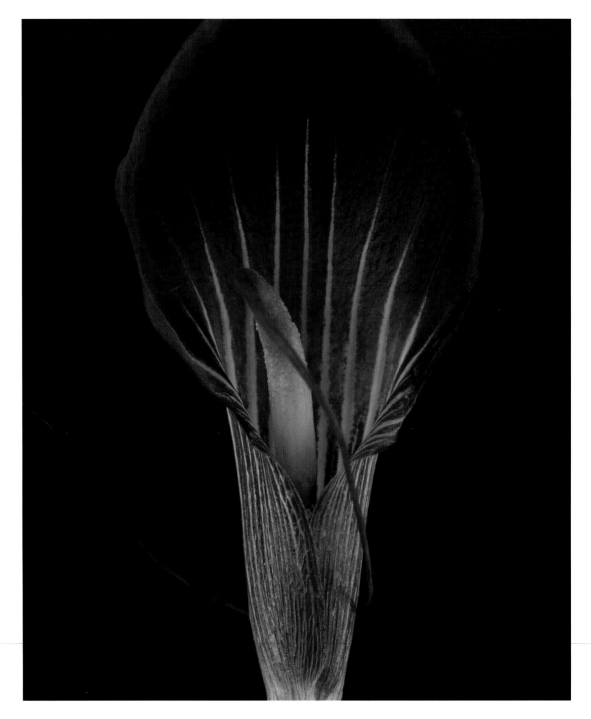

Arisaema speciosum (Cobra Lily)

You like nothing less than to be ignored and may literally pine away if you are not looked after. Fortunately your exotic good looks and sensitive nature inspire others to nurture you. You are imaginative and intuitive and may find the answers to your questions when you learn to trust your dreams.

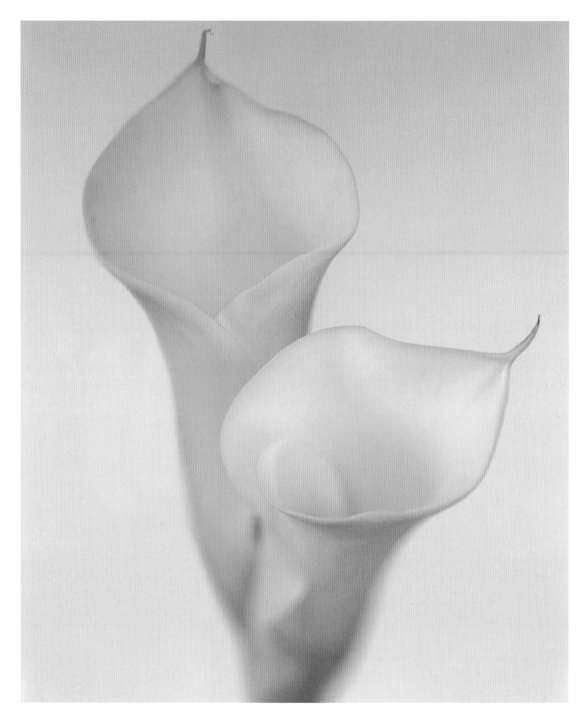

Zantedeschia aethiopica 'Amelie' (Calla Lily)

This lily is a lantern for truth. Just as Amelie glows gold, you too are a beacon for your loved ones. You have a purity and truthfulness about you that others find irresistible. Though you often seem to be dreaming, you are alert and responsive to life's challenges.

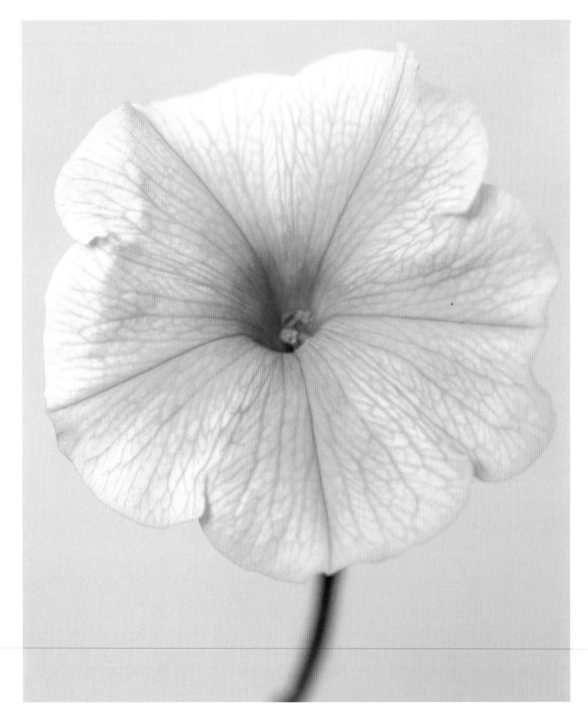

Petunia 'Lemon Zest' (Petunia)

The petunia is ever hopeful and offers sincerity and comfort. You are a refreshing and invigorating individual. With your familiar and assured presence you help those around you to feel at home wherever they are. You have a playful and youthful heart, and a strong sense of faith.

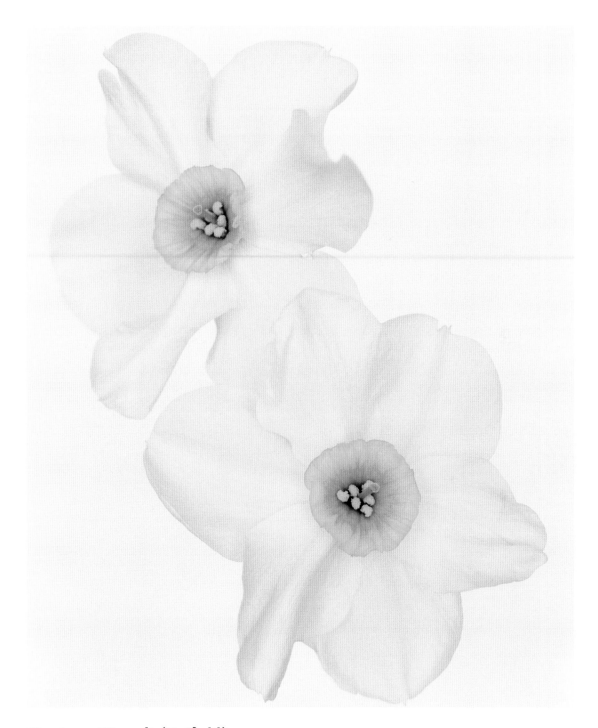

Narcissus 'Sinopel' (Daffodil)

The daffodil glows with the promise of spring and new beginnings. Your positive, cheerful presence brings the same joy to those around you. You have a peaceful approach to life but show great tenacity and will prevail even when faced with trying times.

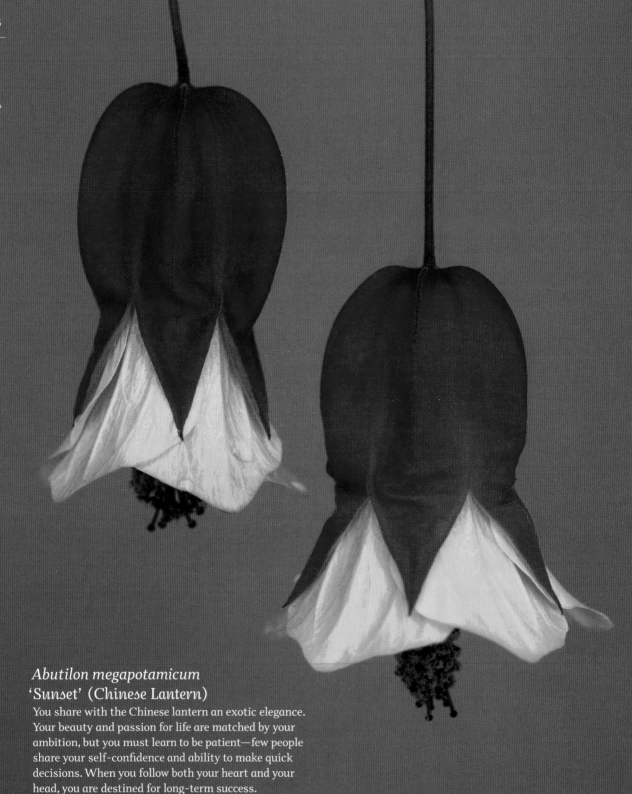

Abutilon megapotamicum
'Sunset' (Chinese Lantern)

You share with the Chinese lantern an exotic elegance.
Your beauty and passion for life are matched by your
ambition, but you must learn to be patient—few people
share your self-confidence and ability to make quick
decisions. When you follow both your heart and your
head, you are destined for long-term success.

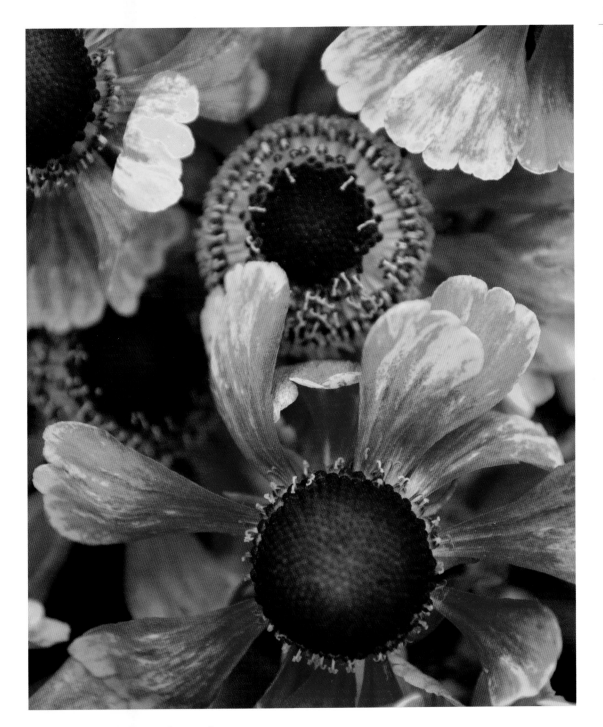

Helenium 'Chelsea' (Daisy)

Few flowers are as cheerful as a daisy. This combination of red and gold lends an air of luxury to an otherwise unassuming bloom. Thus, you represent the union of comforting simplicity and seductive allure. You are a loyal and practical friend, and an adventurous and compelling lover.

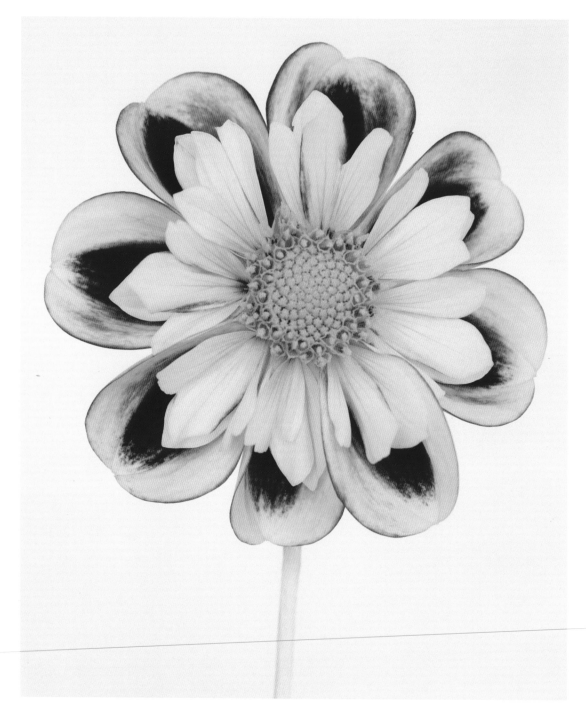

Dahlia 'B.R.' (Dahlia)

Like your flower there is an air of intrigue about you. You are exquisitely pretty with a loveliness that is almost too good to be true. Though you easily attract company you are equally happy when left to your own thoughts. You are wise and understanding and make an excellent partner.

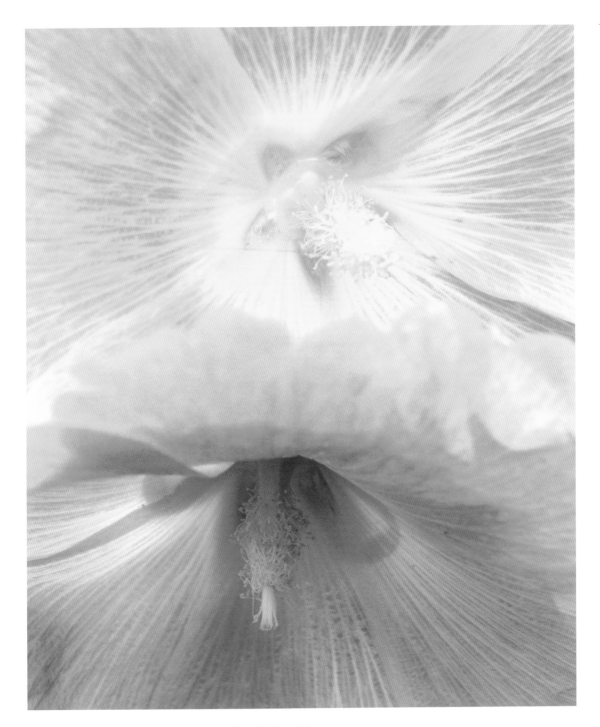

Alcea rosea 'Chater's Salmon' (Hollyhock)

The cheerful, tall hollyhock symbolizes fecundity and inner healing. You are a reassuring friend and lover, capable of calming the greatest tempest with your tranquil presence and thoughtfulness. You have a strong sense of place and exude common sense; tradition and simplicity are your tenets for success.

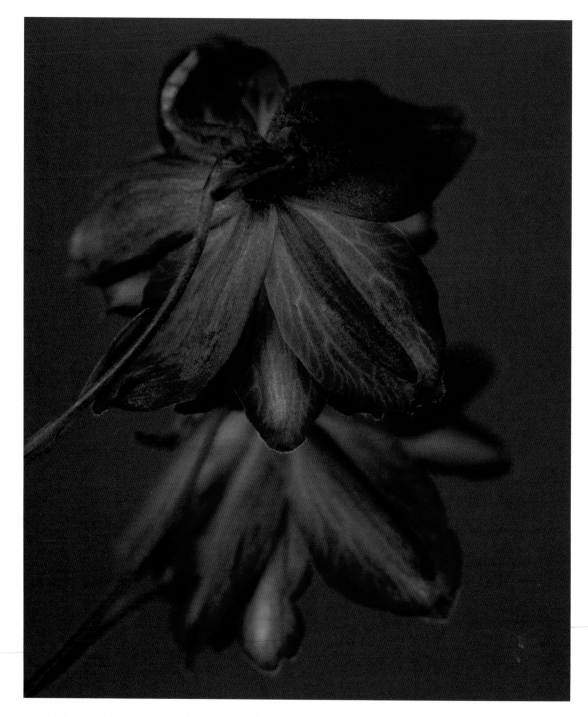

Delphinium elatum 'Black Knight' (Delphinium)

With references in color to the heavens, and in name to the act of communion, this flower reveals lofty principles. You are at once chivalrous and grand. A true believer in your convictions, you are drawn to adventure and perhaps to crusade. You can rely upon your keen intuition to keep you safe.

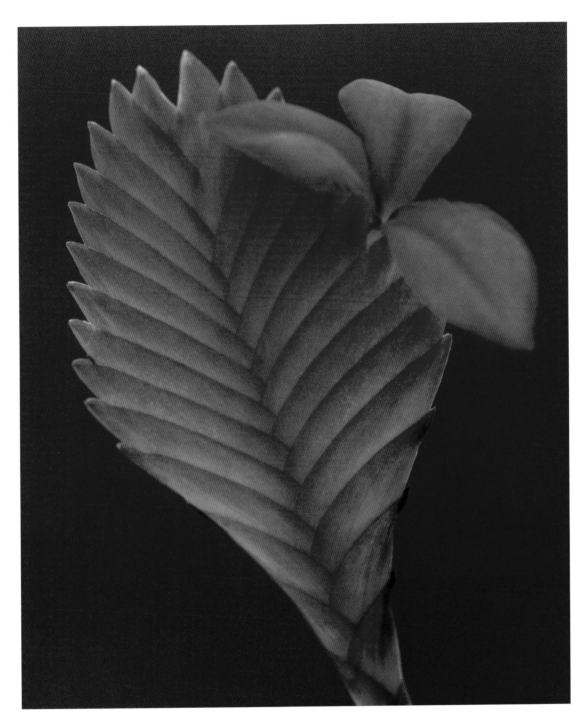

Tillandsia cyanea (Pink Quill)

With its flourish of ravishing cerise and electric violet, the pink quill is truly original. Seldom does such beauty spring from frugal self-sufficiency. Due to your powerful presence and intellectual flair, people may assume you lack resilience, but consistency is yet another of your strengths.

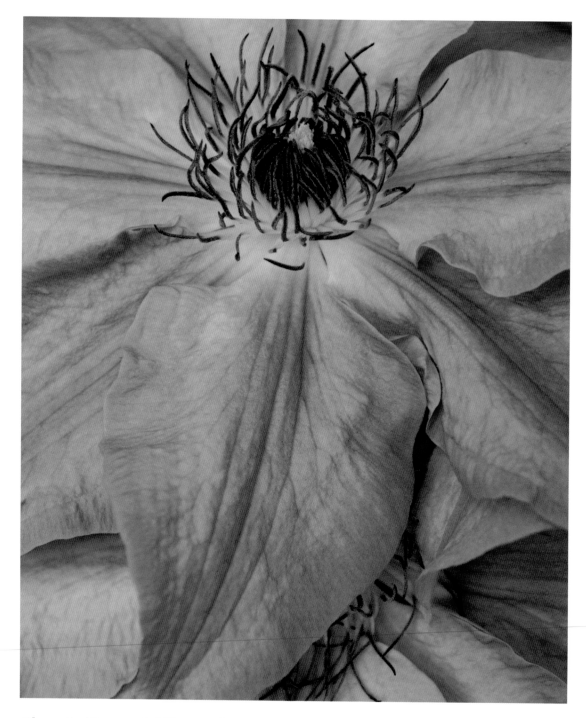

Clematis 'Ramona' (Clematis)

The clematis represents ascension, and symbolizes all-embracing love. You are a generous person with truth and acceptance as your tenets. You can overcome even the most stubborn individuals with your grace and alacrity. Your wisdom is pervasive and your gift for saying the right thing at the right time is famous.

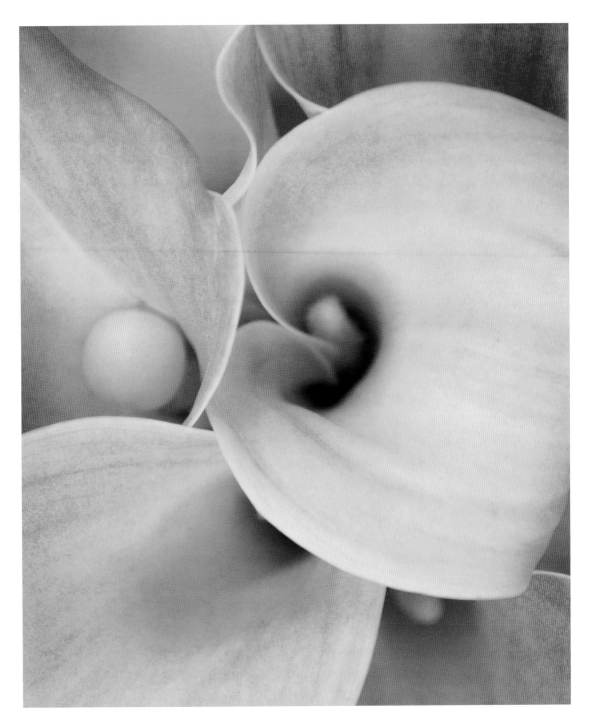

Zantedeschia rehmannii (Calla Lily)

The sweet minimalism of the calla lily speaks of your uncomplicated personality, while the luscious pink hints at your more indulgent tendencies. Though you adore structure and like life to run smoothly, you also enjoy acting on impulse. Fortunately you keep both in balance, making you a fun and reliable mate.

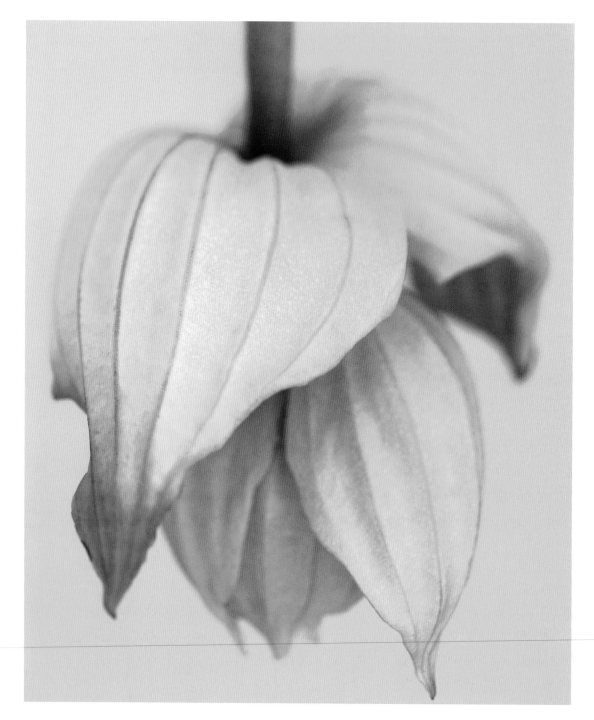

Medinilla magnifica (Rose Grape)

This beautiful flower evokes jungle beats and sensuous mystery. You are a choosy lover for all your overt sexuality. You need the right time and place to be at your best and if not constantly nourished by culture and change you fail to flourish. Friends admire your distinctive style and bold emotions.

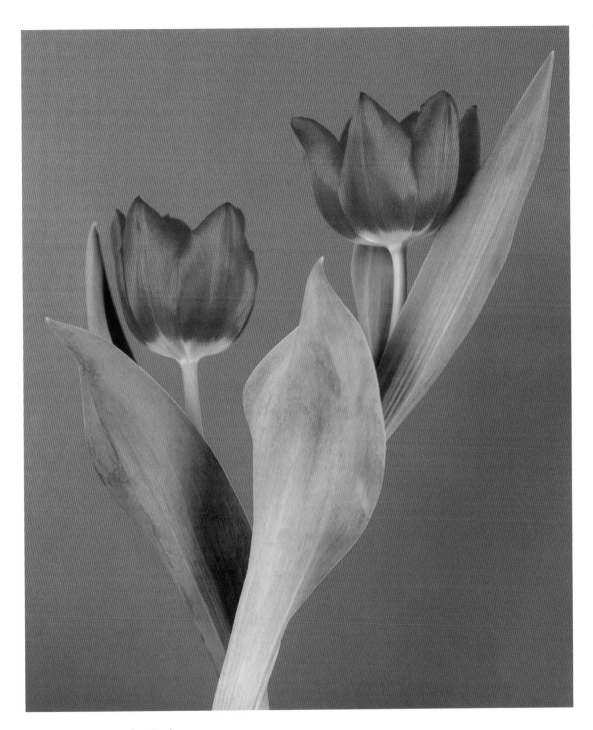

Tulipa 'Rogue' (Tulip)

Sincerity and passion are strongly associated with this tulip and with those born on this day. You know how to have a good time, and have an appreciation for the finer things in life. Your generosity and expansive love cause you to be surrounded by adoring friends.

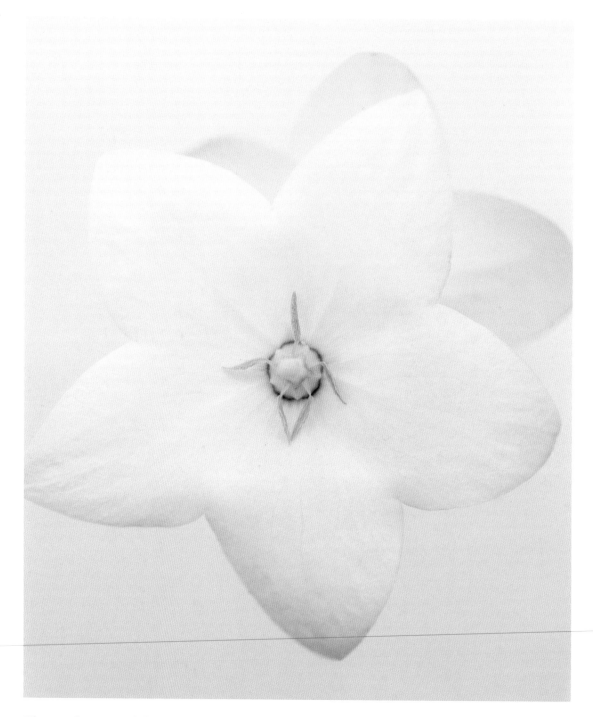

Platycodon grandiflorus 'Alba' (Balloon Flower)

The color white denotes spirituality and the open formation of these petals invokes supplication. With buoyancy and delight you share your generosity and wonder with all. The fullness of this flower as a bud and in full bloom ensures you are always content.

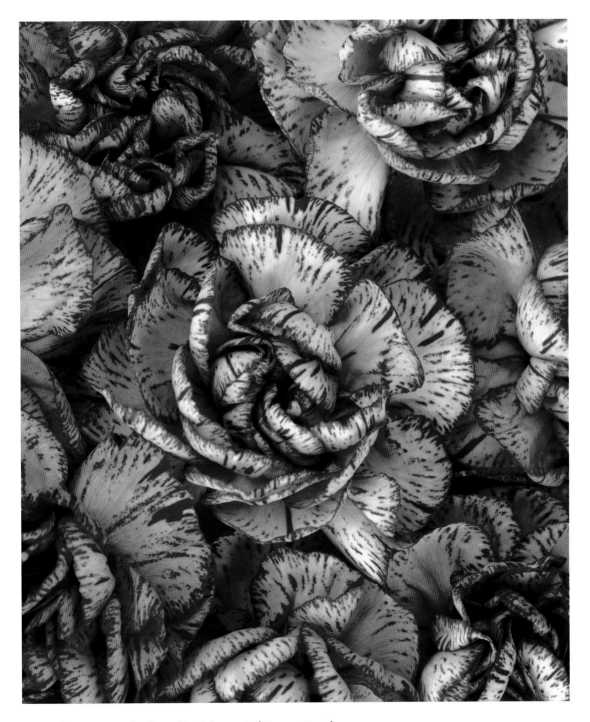

Dianthus caryophyllus 'Raspberry' (Carnation)

The ubiquitous carnation deserves its status as one of the world's best-known flowers. It is pretty and fresh with a delightful scent and a hint of nostalgic whimsy. You delight in doing simple things well. Your home and family are a tribute to your creative energies and calm mind.

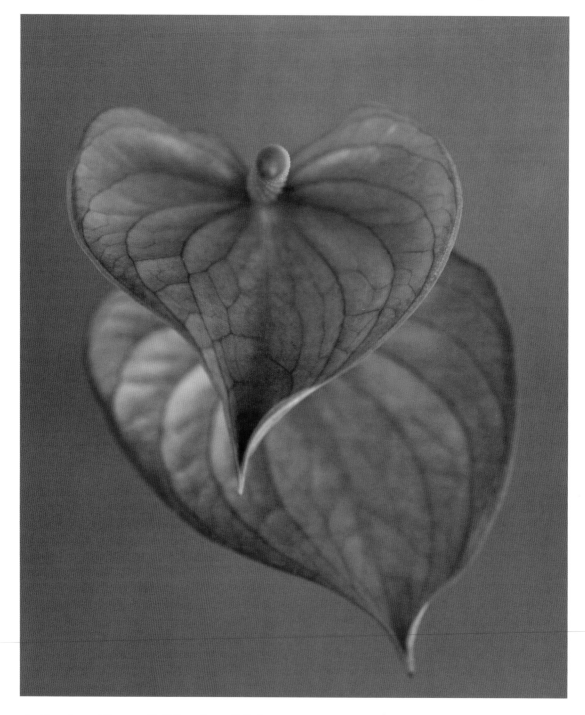

Anthurium 'Samuel' (Flamingo Lily)

Though calm on the surface, your personality contains veins of passion and high emotion. You find delight in outdoor pursuits but are equally drawn to the theatrical world, and will find pleasure when you satisfy these dual interests. You are an attentive, if slightly possessive, lover.

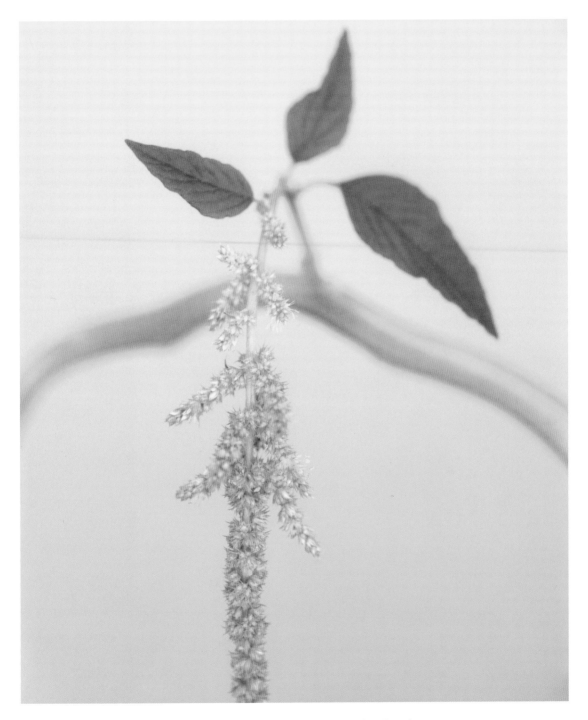

Amaranthus caudatus 'Green Cascade' (Love Lies Bleeding)

The cool hue of 'Green Cascade' makes it a graceful and calm addition to the garden. You are elegant and reserved and a reliable performer. With an interest in natural remedies, you like to live as close to nature as possible, and are frequently found straying from the beaten track.

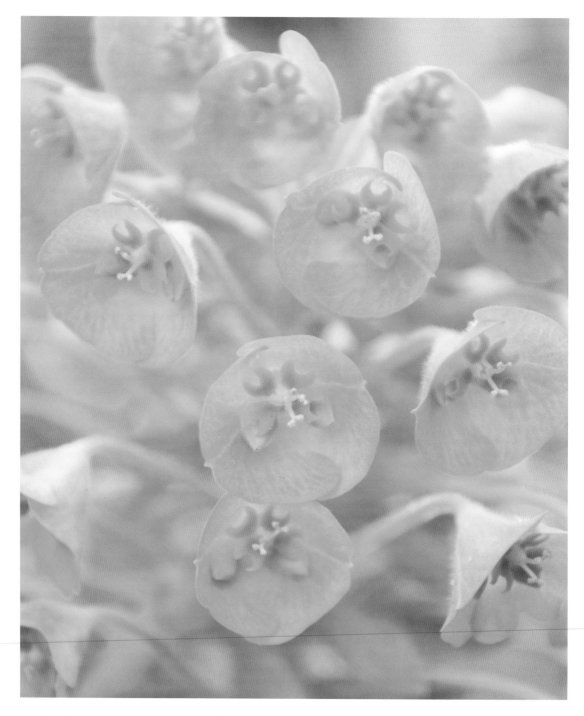

Euphorbia cyparissias (Spurge)

This architectural plant stands out even in the busiest of gardens. Your distinctive looks and adaptable personality make you a popular choice for parties and other team events. You are cheerful and attractive, but also modest, and are often unaware of the true extent of your charms.

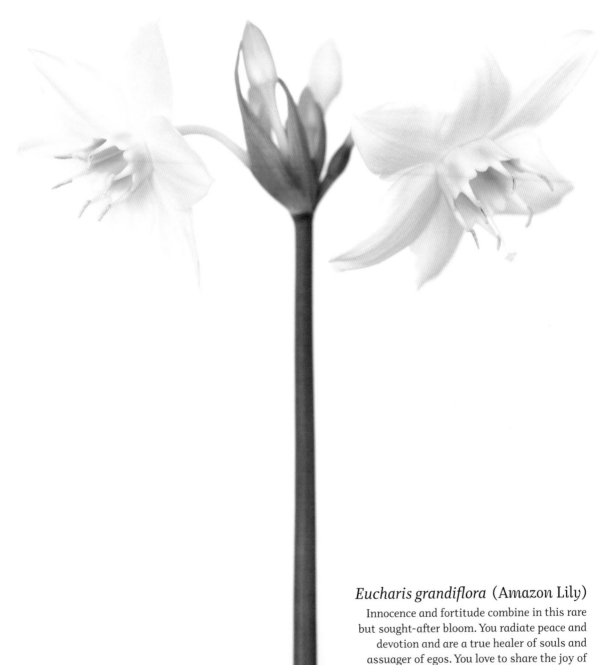

Eucharis grandiflora (Amazon Lily)

Innocence and fortitude combine in this rare but sought-after bloom. You radiate peace and devotion and are a true healer of souls and assuager of egos. You love to share the joy of the beauty of creation with those around you, especially in exotic and secluded locations.

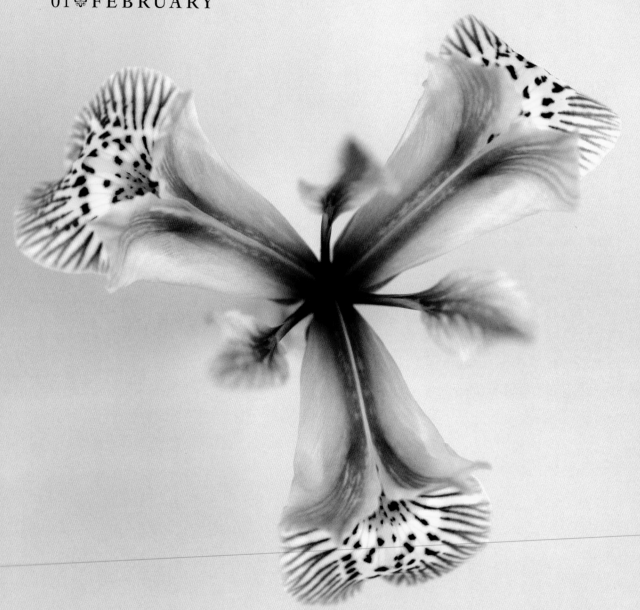

Iris histrioides 'Angel's Tears' (Iris)

Beauty and truth, loyalty and spirit: the symbols of the iris also represent those born on this day. Well-loved by all you meet, you are generous and kind. You make a loyal friend and lover. You yearn for spiritual enlightenment and will find it in unlikely places.

Dahlia 'Maureen Kitchener' (Dahlia)

'Maureen' means the 'star of the sea.' Like the ocean you may present a peaceful countenance but have underlying ebbs and flows. Though you do not always invite close scrutiny, those who truly get to know you will find your inner complexity fascinating.

Ludisia 'Red Velvet' (Jewel Orchid)

Refinement and beauty are the dominant traits of this exotic orchid. But in you there is also a love of the basic and seemingly banal. You can easily glide between worlds of plenty and poverty, each to you rich with experience, beauty and profound connection. Opportunity is your adventure.

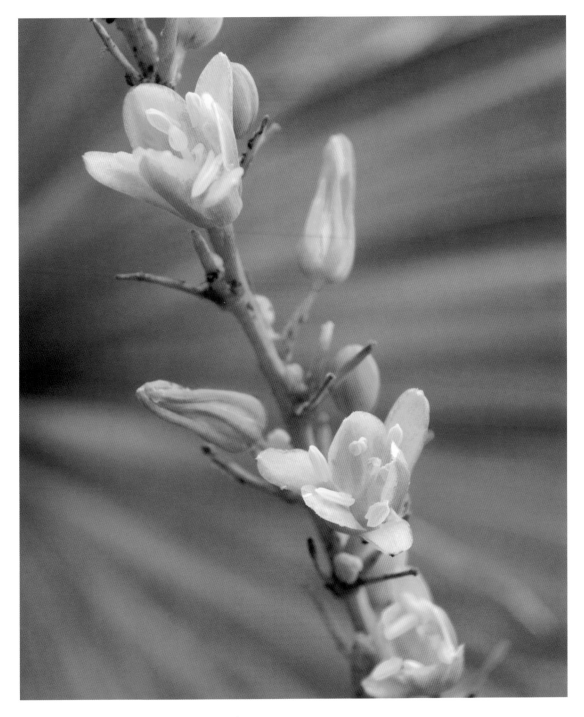

Hesperaloe funifera (Coral Yucca)

The coral yucca does not shout for attention but blooms quietly and sweetly, attracting hummingbirds to its tubular flowers. Likewise, you are an easygoing individual with many admirers but no need for the spotlight. Your ability to soothe emotions and give unselfishly means you are rarely alone.

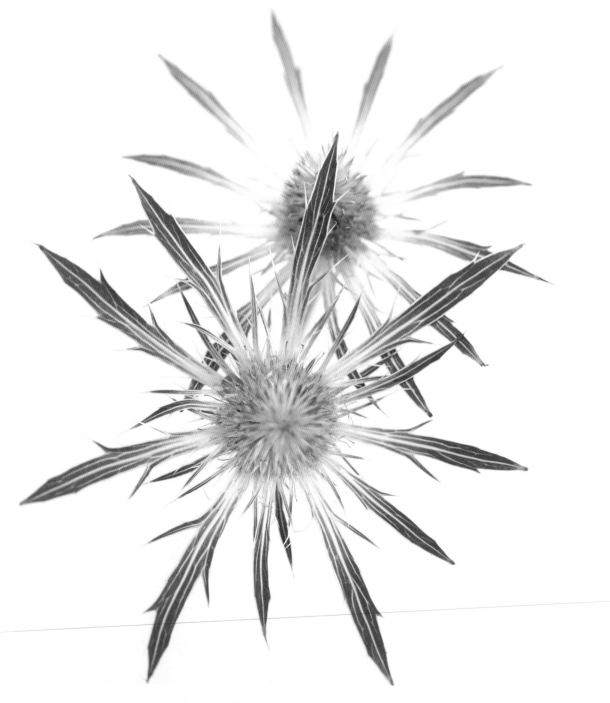

Eryngium amethystinum (Sea Holly)

The impact of this flower comes from its striking form and texture. Those born on this day also know how to get attention. You have a sparkling inner core which infuses your words and deeds with wisdom and truth. Though you are sometimes the target of envy, you know how to protect yourself from negativity and mistrust.

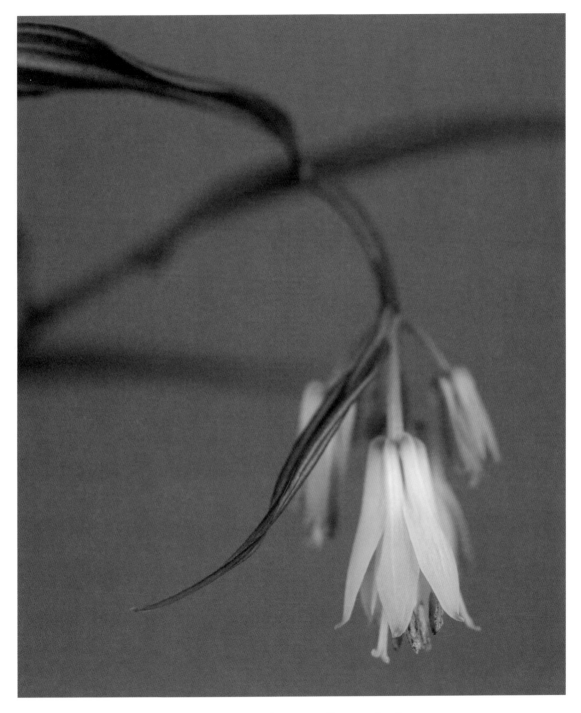

Disporum cantoniense 'Night Heron' (Fairy Bells Bamboo)

Fairy bells are rare and exceptional bamboo flowers. Like their human counterparts they are good-looking and well mannered, and seldom overstep the mark. You are practical and strong willed and have your feet on the ground. But you share with fairy bells a hint of whimsy, and are a loyal and fun companion.

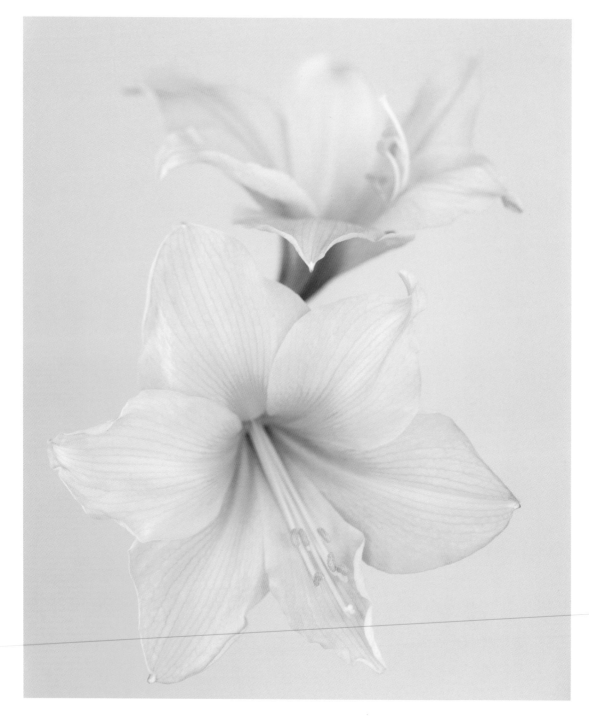

Hippeastrum 'Lemon and Lime' (Amaryllis)

No shy flower, the amaryllis makes its presence felt. You are striking and bold which causes people to flock to you, and friends to adore you. But you are not overbearing. On the contrary, you are sweetly refreshing. You have an analytical mind and a love of nature, and are blessed with a 'green thumb.'

Celosia argentea 'Plumosa' (Plumed Cockscomb)

There is nothing subtle about this flower, blooming bold and bright. You too have a distinctive and eye-catching appearance and may attract many admirers. Your uncompromising approach to life can make it difficult for you to blend into the background, but in one-on-one situations you really shine.

Allium sikkimense
(Ornamental Onion)
Representing love and lust, the salacious
character of this sweet allium is well
tempered by the blue of its flower. With an
edge of sophistication and good sense, you
can be sure that your passionate sexuality
will never rule you. You are alert and intuitive,
and your ability to have prophetic dreams is
much enjoyed by your family.

Anemone 'Vinum' (Poppy Anemone)

The poppy anemone brightens the dark winter with its cheeky face, reminding us that gentle spring is on its way. You offer the world a timely luxury. Though slightly overindulgent, you are bold and mischievous with a big heart, and bring warmth and love to all around you.

Petunia hybrida (Petunia)

Like the flower of perpetual hope, petunia people are never despairing. Like the sun at the center of the universe, you bring warmth to those in your orbit. People gravitate to you because of your optimism and generosity. You have the unique ability to sustain people both physically and emotionally.

Anigozanthus 'Kanga Yellow' (Kangaroo Paw)

The kangaroo paw is an evocative flower that much resembles its animal namesake. You are an eternal optimist with a spring in your step. Your sunny nature and good humor make you extremely popular, but can sometimes belie your sharp mind. Your wisdom and intellect are not to be underestimated.

Dianthus caryophyllus 'Belle Epoque' (Carnation)

Though its name recalls the 'beautiful era' of the late 1800s, this carnation is nevertheless disarmingly modern with its sculptural frivolity and striking coloration. You are serenity personified—though your edges may seem ruffled you are seldom troubled. You have a strong sense of the past to guide you through life.

Kalanchoe uniflora
'Lovebells' (Trailing Kalanchoe)
With a graceful curtsy to show their
acquiescence to love, these delicate blooms
represent the contained and cherished
union of true intimacy. You are a refined
individual with particular tastes and
mores. Your passion for romance may see
you looking to the past for inspiration.

Saintpaulia ionantha (African Violet)

Trustworthy and faithful, these true blue beauties are sentimental yet exotic. You have a profound effect on those you meet, often encouraging openness and always offering sage advice without judgment. Your even temperament and loyalty make you a perfect partner.

Tulipa 'Segwun' (Tulip)

With its red center the 'Segwun' tulip has an underlying majesty. You are outwardly optimistic with a truly romantic heart. People are attracted to your trusting nature and your beautiful eyes. Though prone to self-indulgence, you generously and enthusiastically share your appetite for luxury.

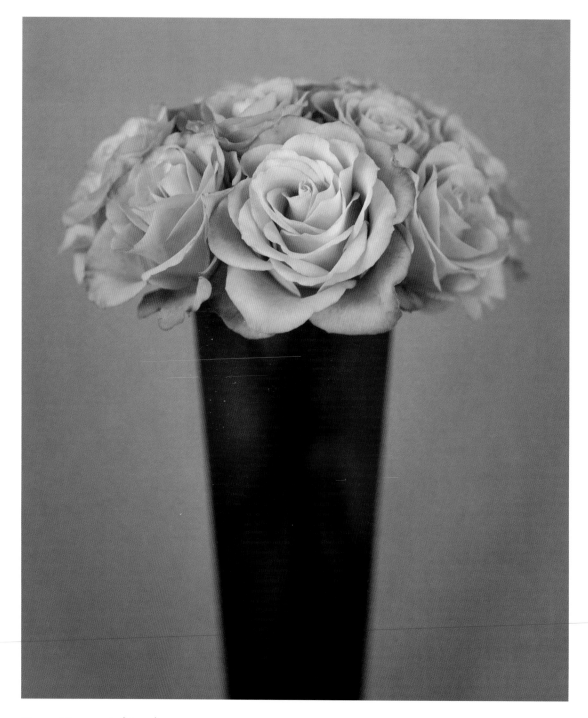

Rosa 'Doreen' (Rose)

The sunny hue of rose 'Doreen' symbolizes optimism and confidence. You are doubly blessed with joy and self-confidence. You are discerning and analytical with the ability to see different points of view. Your friends admire your self-expression and good judgment.

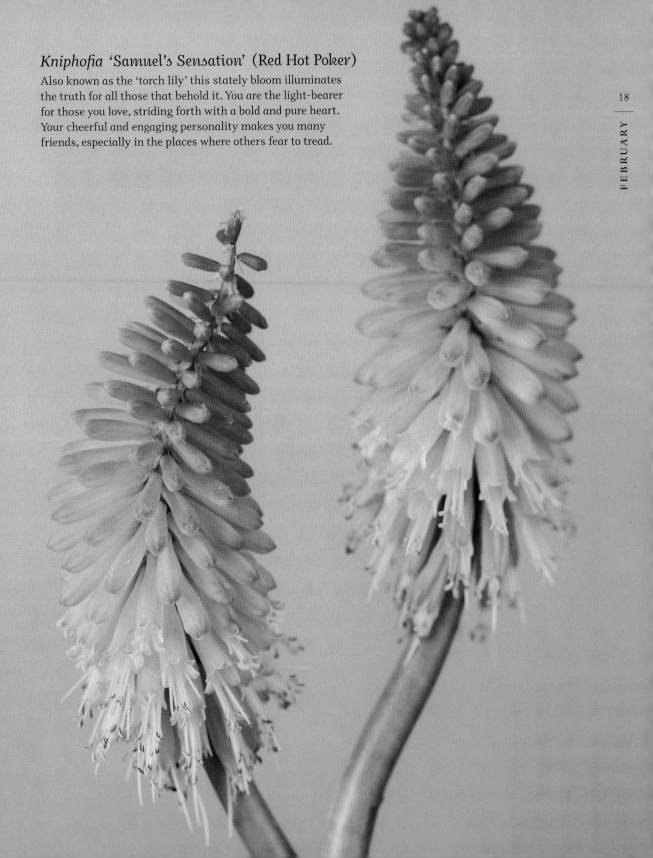

Kniphofia 'Samuel's Sensation' (Red Hot Poker)

Also known as the 'torch lily' this stately bloom illuminates the truth for all those that behold it. You are the light-bearer for those you love, striding forth with a bold and pure heart. Your cheerful and engaging personality makes you many friends, especially in the places where others fear to tread.

Bougainvillea 'Coconut Ice' (*Bougainvillea*)

The bougainvillea suggests tropical heat and siestas. Its simplicity and beauty belie its ability to multitask: you too are a complex performer. You are initially cautious but amenable to new ideas and embrace life's challenges. You have a healthy spirituality and an open heart.

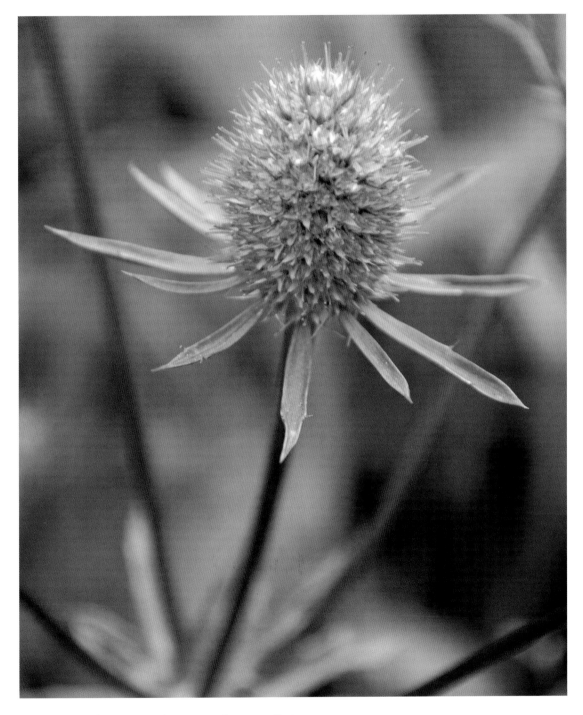

Eryngium planum 'Jade Frost' (Sea Holly)

Blue and silver combine to make 'Jade Frost' a striking and unusual bloom. With an appreciation of architecture and sculpture you are drawn to the more monumental fine arts. You have a fine intuition and gifted imagination, and an aptitude for creative writing.

Allium ampeloprasum (Broadleaf Wild Leek)

Leeks symbolize love and protection. When they discern your layers your friends will be astounded by your complexity. You are loved for your generosity of spirit and your ability to let people be themselves. You have a calm approach to life and when challenged will either think through a situation or simply walk away.

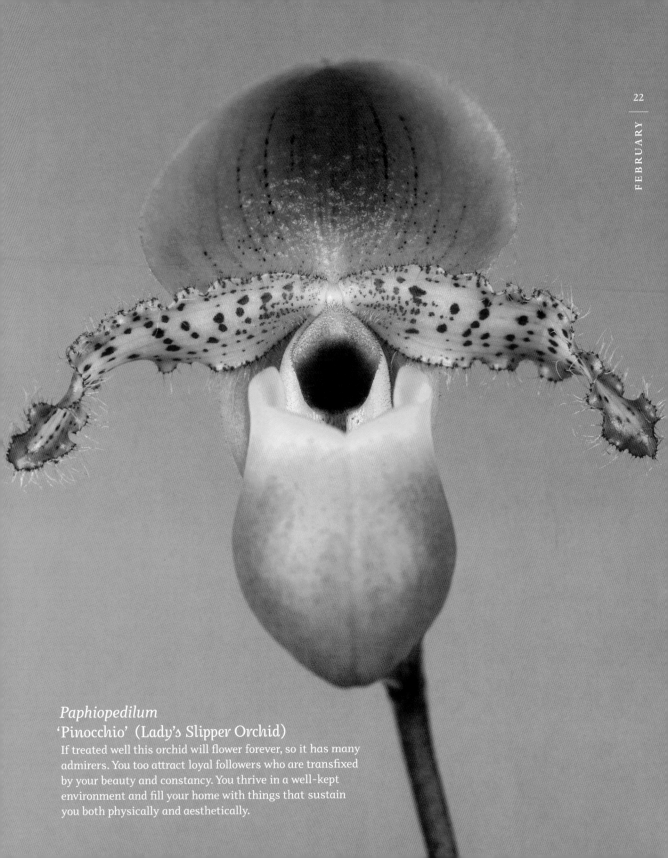

Paphiopedilum
'Pinocchio' (Lady's Slipper Orchid)
If treated well this orchid will flower forever, so it has many
admirers. You too attract loyal followers who are transfixed
by your beauty and constancy. You thrive in a well-kept
environment and fill your home with things that sustain
you both physically and aesthetically.

Hibiscus moscheutos 'Luna Blush' (Rose Mallow)

The pale yellow of 'Luna Blush' symbolizes restrained joy, while its pink tips signify compassion. You have a refined sense of fun and great empathy for others. You draw your greatest pleasure from good books, artistic pursuits and carefully cultivated friendships.

Tulipa 'Fringed Elegance' (Tulip)

With flagrant disregard for its name, this tulip has nothing to hide. Traditionally, those with tulips as their flower have a certain mystery about them. But because you are a positive person you have no need to hide your emotions. This means you are often surrounded by people who like to bask in your glow.

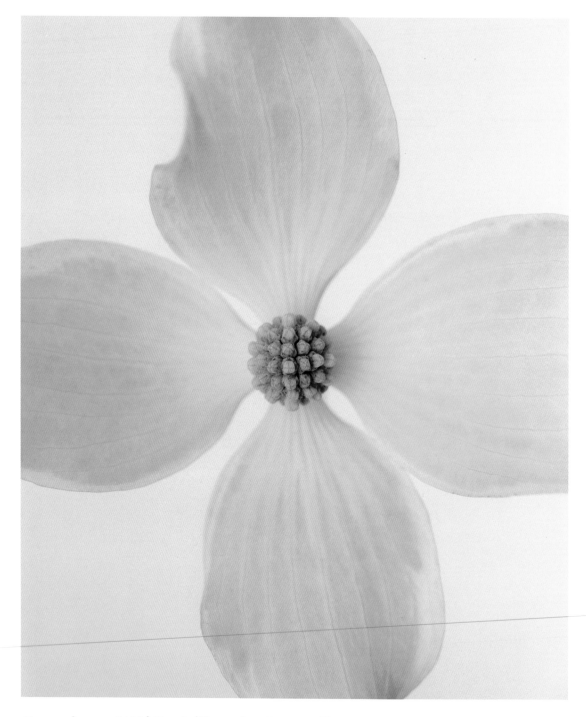

Cornus kousa 'Wolf Eyes' (Flowering Dogwood)

The flowering dogwood is a favorite with artists who appreciate the beauty it displays at every season of its life. With 'Wolf Eyes' as your flower you will enjoy long-lasting loveliness. Your keen insight assists you to thrive in diverse environments, giving you an enviable ability to discern clearly the truth of every situation.

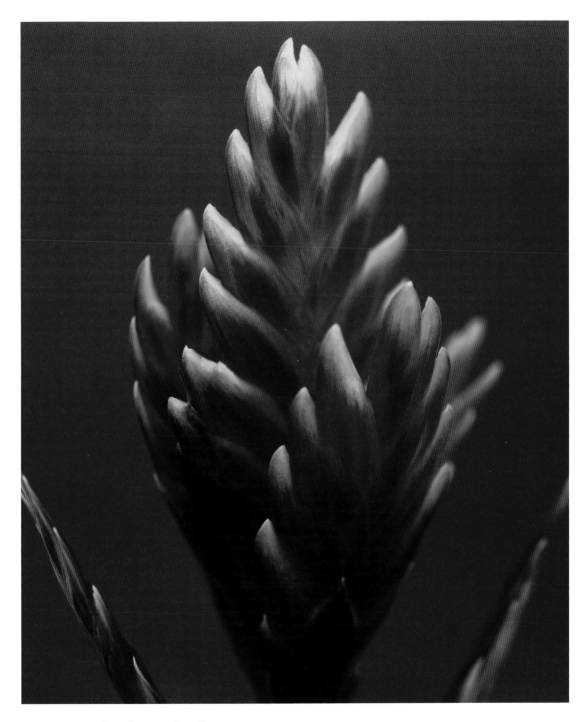

Vriesea 'Carly' (Bromeliad)

Surreal and ethereal, these flowers look like they come from another world. You are an original thinker with a passion for the esoteric and arcane, and an ability to a mix the old with the new. You are creative and energetic with a solid grasp of your own identity.

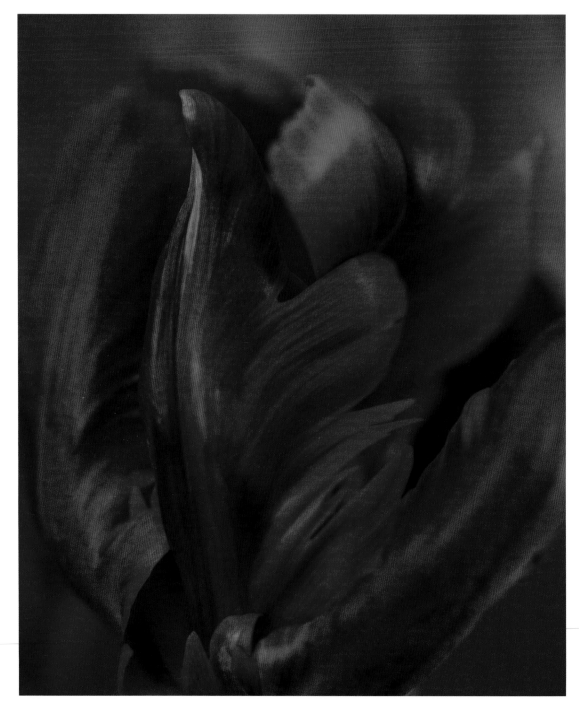

Tulipa 'Rococo' (Tulip)

The layers of the 'Rococo' tulip symbolize hidden talents. You are a deeply passionate person with an appetite for love that is hard to match. You find great joy in the appreciation of art and literature. You have a sense of mystery about you that ensures you will never be short of a companion.

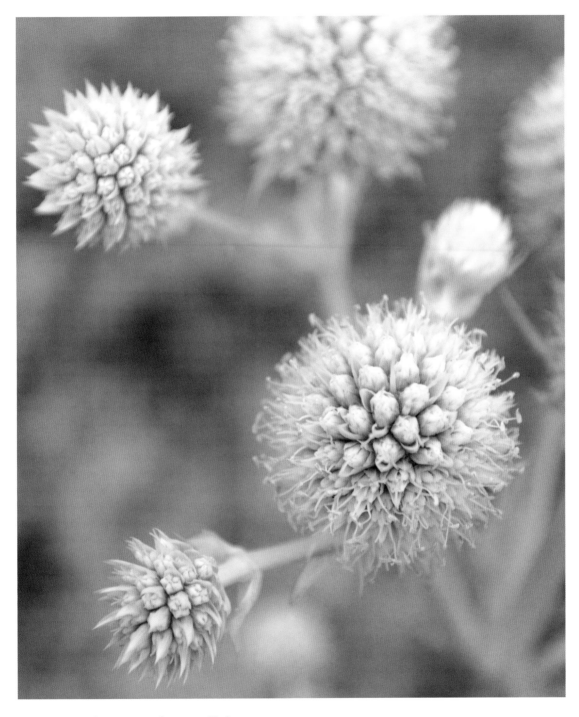

Eryngium eburneum (Sea Holly)

Often described as 'architectural,' sea holly represents fortitude and a strong sense of place. You have an innate ability to make yourself at home wherever you are. You are an independent and forthright individual with many friends. Your hospitality is famous and your grace and ease with life convey your inner peace.

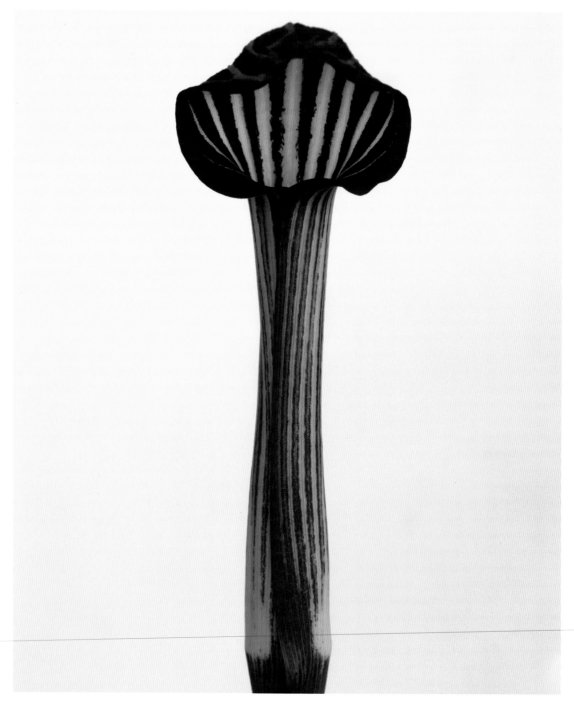

Arisaema concinnum (Cobra Lily)

Self-contained, poised and elegant, there is no denying the charm of this bloom. Nature has blessed you with unusual good looks and steely determination. You are a consistent performer with a robust constitution, upon whom friends rely for honest and constructive advice.

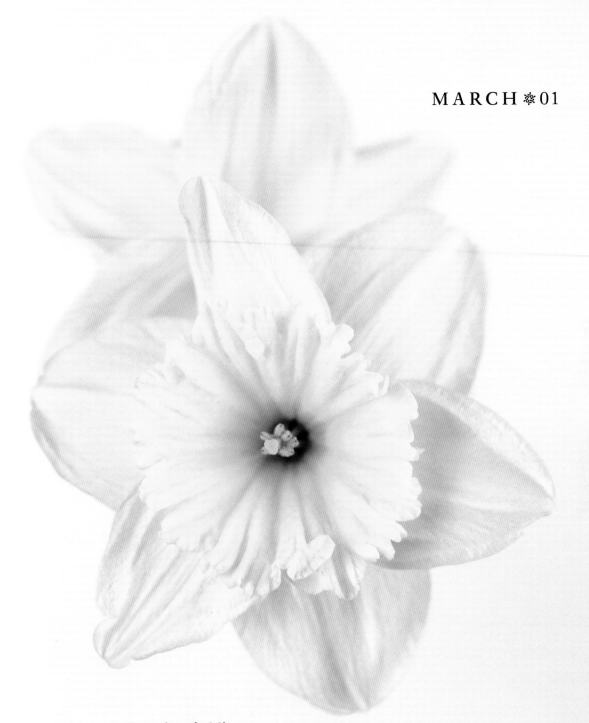

Narcissus 'Ice Follies' (Daffodil)

With a dismissive glance at winter this daffodil is ready for the joys of spring. Like this flower, you are an energetic individual who doesn't need to be told twice to do anything. Your focus and freshness are welcomed by all you meet and you offer a new perspective to difficult situations.

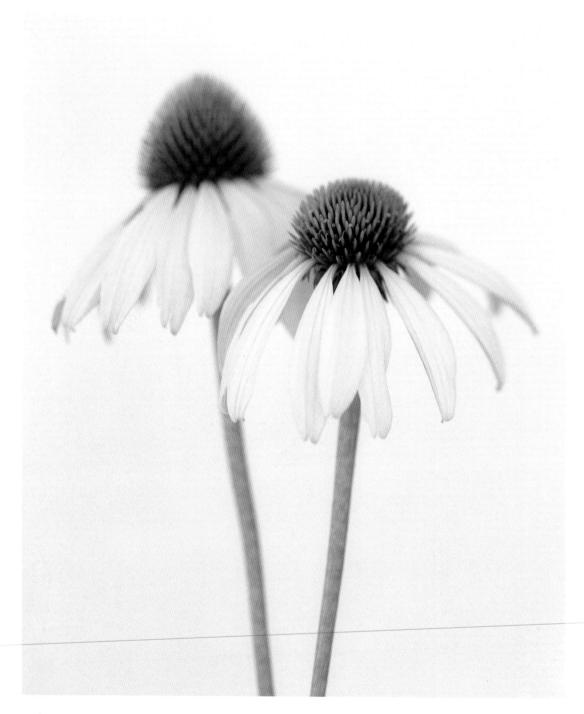

Echinacea purpurea 'White Swan' (White Coneflower)

This endearing wildflower attracts butterflies in abundance. Likewise, you are unpretentious and will attract good fortune. You are self-expressive and seldom hide your feelings. Your friends enjoy your honesty and kindness, and your heart of gold makes you a loyal partner.

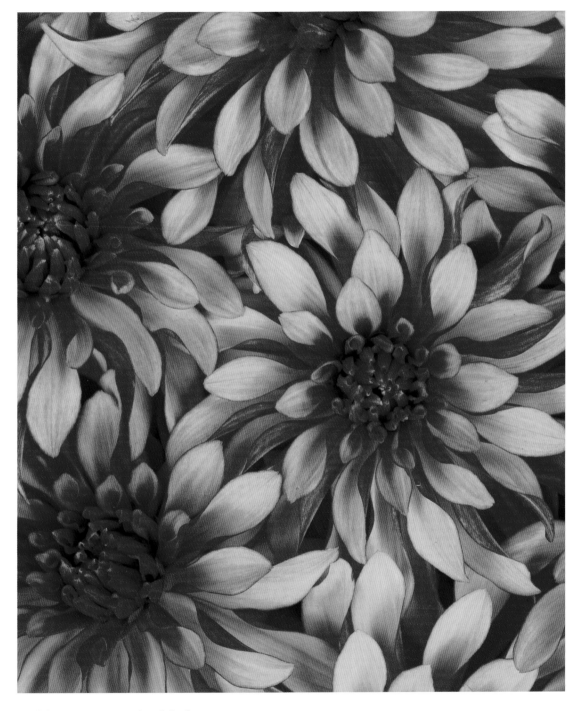

Dahlia 'Magnus' (Dahlia)

The 'Magnus' dahlia is the color of joy and rejuvenation. Your ability to uplift the spirits of your friends earns you a special place in their hearts. Though you sometimes appear ruffled, you have an unwavering belief in yourself and are among the most emotionally resilient of people.

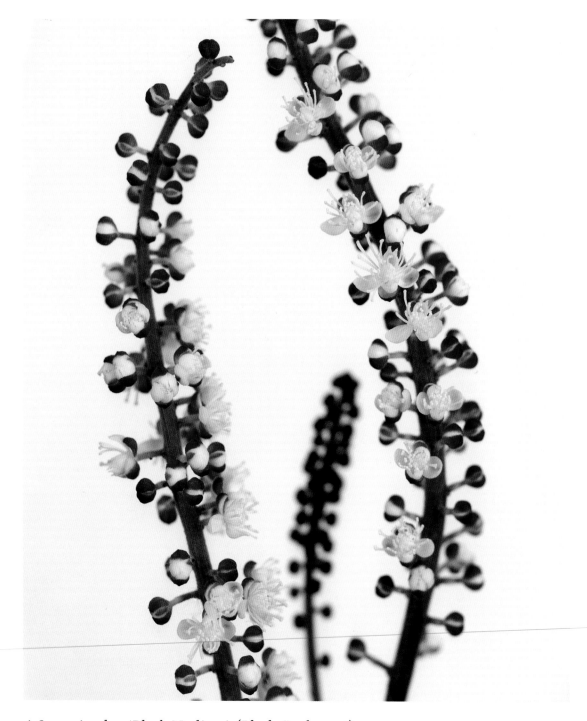

Actaea simplex 'Black Negligee' (Black Snakeroot)

The black snakeroot's dark buds open to reveal sweetly scented white flowers. Like this flower your exterior of veiled mystery disguises a delicate and sincere nature. Though you may at first appear to be sultry and complicated, those who know you best sense your shyness and compassion, and adore your rational and structured approach to life.

Rosa 'Taboo' (Rose)

Lush and opulent, this rose is not for the faint-hearted. It symbolizes deep passion and worldly sophistication with the added enticement of the forbidden. Attention comes easily to you, but you would do well to heed the warning of the 'Taboo' rose: illicit temptations are best avoided and truly rewarding passion can be found close to home.

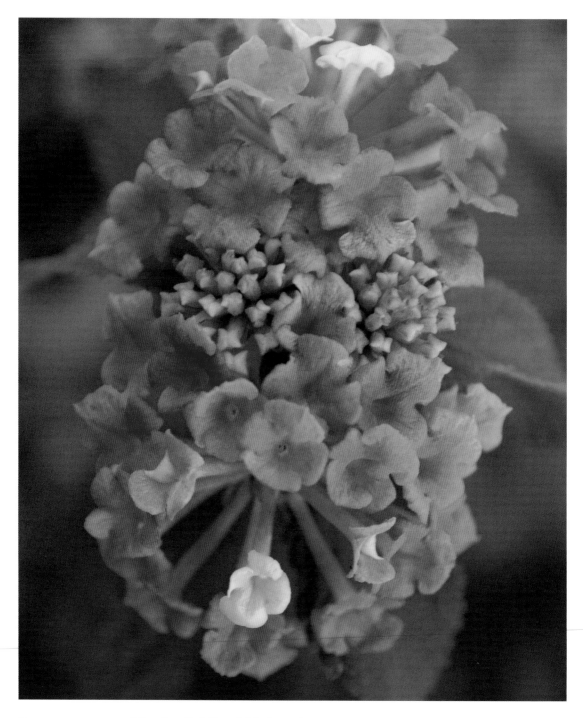

Lantana camara 'Confetti' (Shrub Verbena)

The delightful star-like clusters of 'Confetti' flowers symbolize a dynamic personality. You light up the room wherever you go. You enjoy adapting to situations and are greatly stimulated by the requirements of new surroundings. Your awareness of your own wisdom and strength means that aging holds no fear for you.

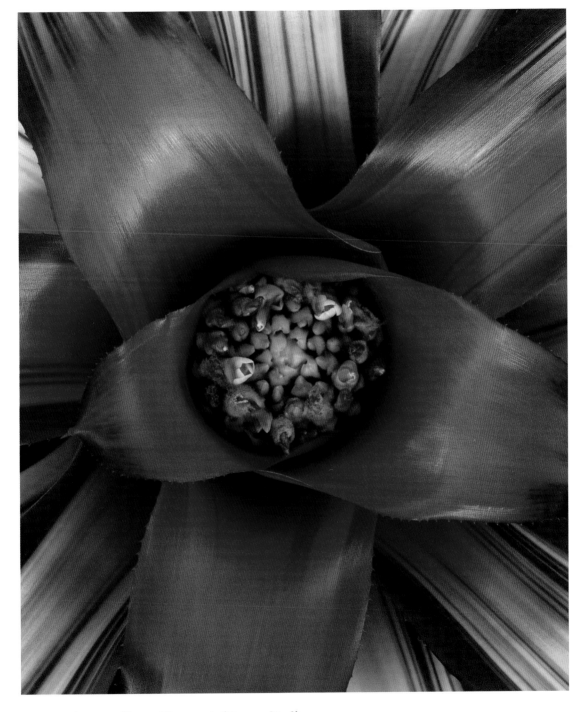

Neoregelia carolinae 'Devroe' (Bromeliad)

The kaleidoscopic glory of this fabulous bromeliad nurtures a pure and true heart. Your extraordinary depth of character is obvious in your exuberant personality and striking personal style. Your trusting nature makes you seem naive, but you are very discerning and those you love are richly rewarded.

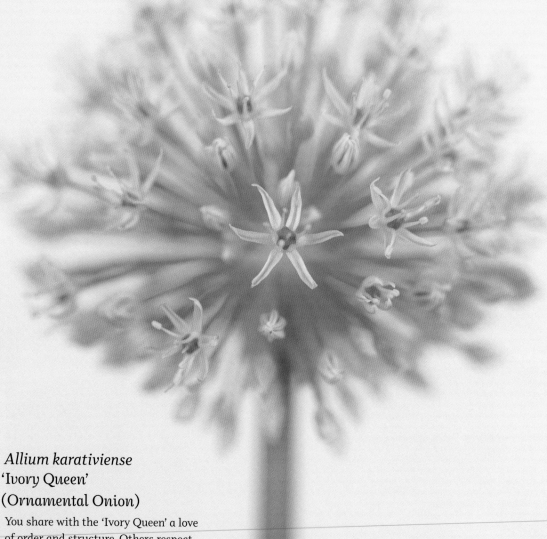

Allium karativiense
'Ivory Queen'
(Ornamental Onion)

You share with the 'Ivory Queen' a love of order and structure. Others respect your clarity of thought and expression, and admire your ability to find a clear path through adversity. When you complement your need for harmony with your natural creativity you will be capable of great things.

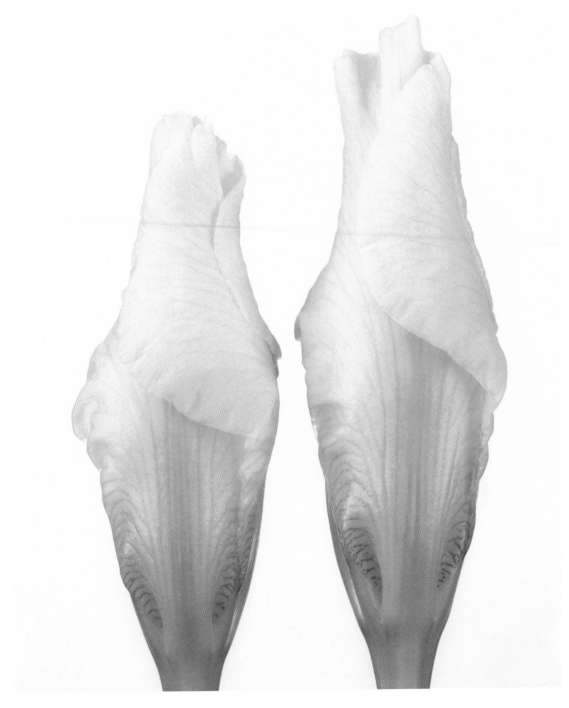

Iris germanica 'Bridal Veil' (Iris)

Kind and sensitive, you are the most delicate of the iris people and require careful nurturing. You do not like to be alone, but you prefer to socialize one on one, rather than party with the crowd. Your thoughtful nature and honest good looks will attract a loyal soulmate, who will urge you toward your full potential.

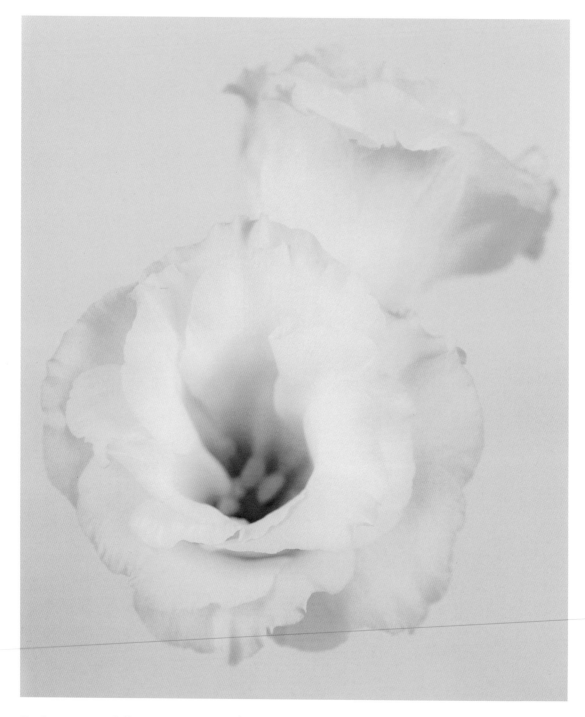

Eustoma grandiflorum 'Jeanette' (Lisianthus)

You embody wholeheartedly the traits of the lisianthus: purity and tenacity. Despite a delicate appearance, you have hidden strengths. Gregarious and forthright, you have a gift for speaking the truth. Your friends benefit from your insight and advice, and are inspired by your energy and personality.

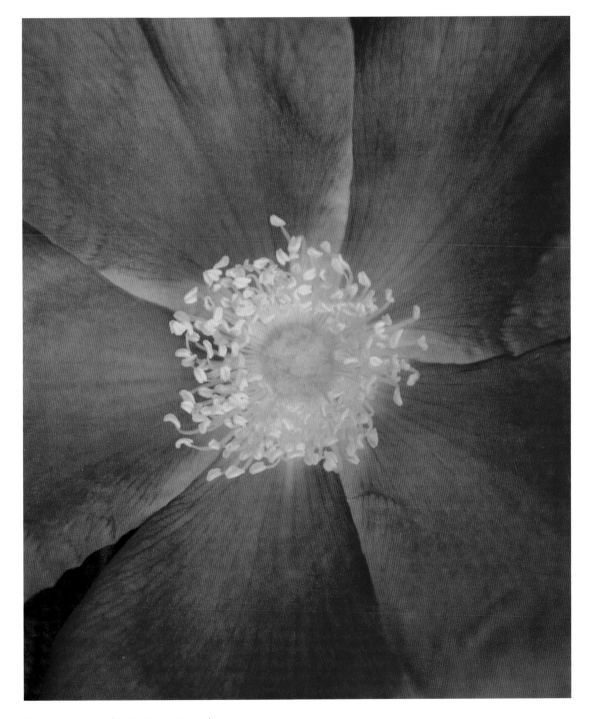

Rosa rugosa (Saltspray Rose)

Robust and fruitful, the saltspray rose thrives where others may perish. You adapt easily to new environments, but a windswept coast is most akin to your inner self. Your robust work ethic makes you a popular team member and you win many friends with your cheerful smile.

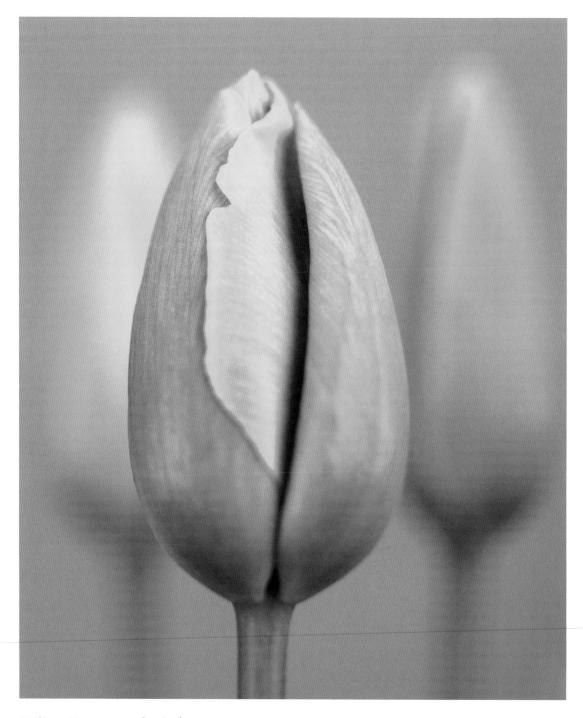

Tulipa 'Sancerre' (Tulip)

Like the 'Sancerre' tulip you know how to get attention. You are a trendsetter and a go-getter. You have lots of energy and a positive attitude. These see you happily busy all the time. The compact formation of this tulip's petals intimate a tendency to over-control—you may need to learn how to relax.

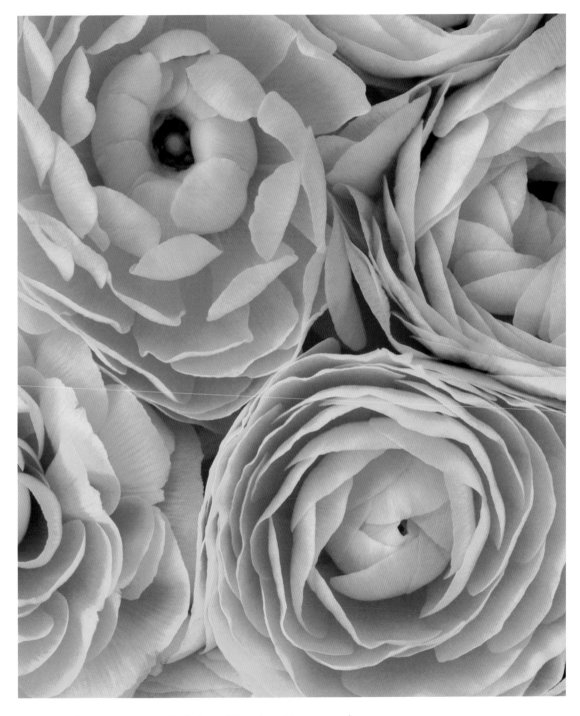

Ranunculus asiaticus 'Heloise' (Persian Buttercup)

This bountiful blossom radiates good cheer. You are an immensely energetic person with a fine sense of personal style. Your positive attitude helps you to alleviate stress wherever you go. You are very adaptable and able to change your mind, and allegiances, very quickly when you need to.

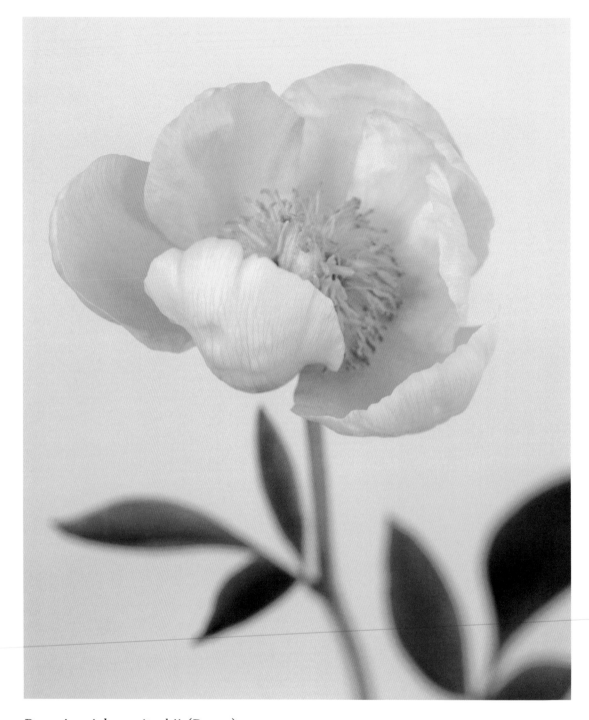

Paeonia miokosewitschii (Peony)

Just as people are drawn to the beauty of the peony, they are drawn to you. Your apparent frailty is misleading and as your layers unfold people are often astounded by your depth. A cheerful demeanor and classical good looks ensure you are never lonely.

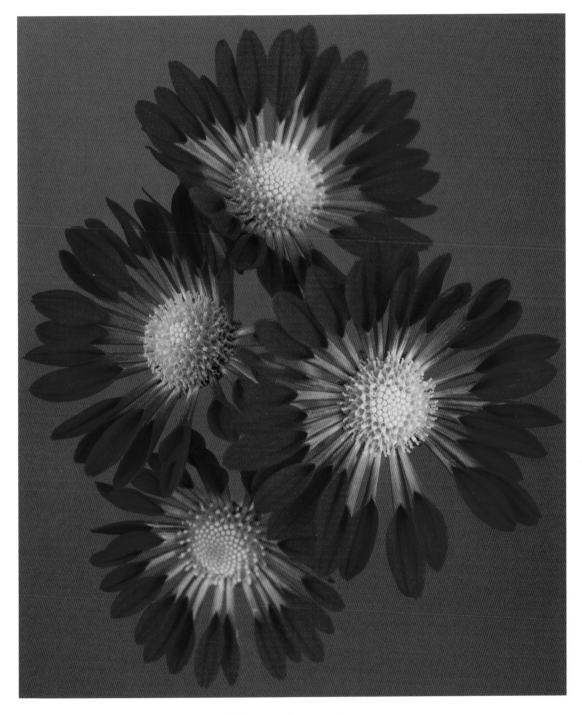

Chrysanthemum 'J.C. Brown' (Chrysanthemum)

Chrysanthemum means 'golden flower,' referring to the original color of the blooms. You are more modern, flirting with passionate red, but you carry stately gold in your heart. This gives you an unrivalled zest for living and a keen eye for antiques.

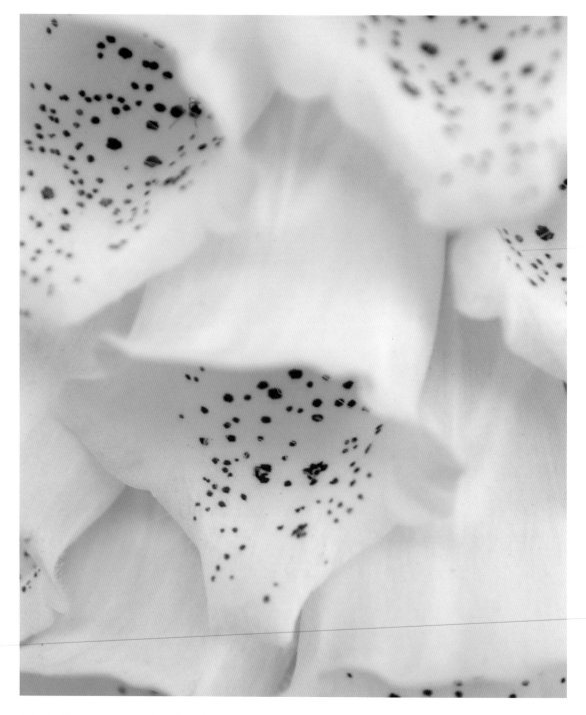

Digitalis purpurea (Foxglove)

The cascade of cups so beautifully displayed by the foxglove symbolizes relationships and birth. You seek change and are devoted to new beginnings, though not those associated with the heart. In romantic relationships you are constantly surprising your lover with your new depths.

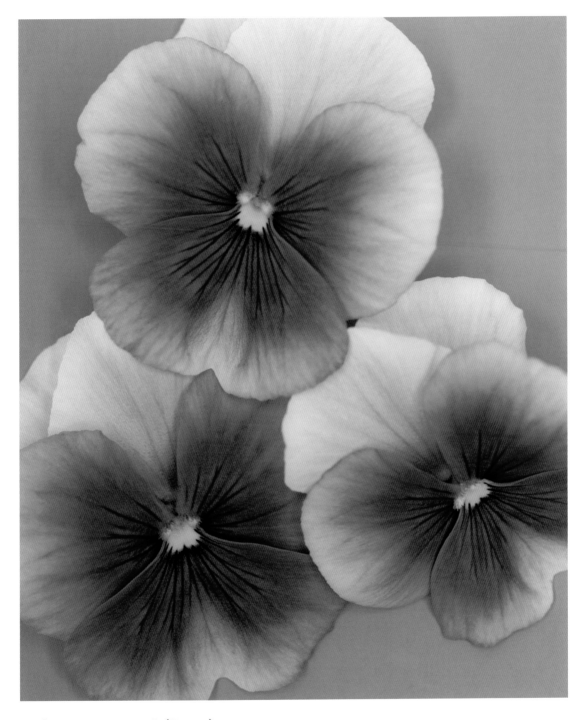

Viola 'Crown Azure' (Pansy)

The voluptuous and generous shape of the pansy seems to contradict its petite stature. You too can appear to be larger than life; you have energy that never seems to run out. The pansy's bright yellow center symbolizes joy, infusing you with optimism and feeding your strong community spirit.

Godetia grandiflora 'Sybil Sherwood' (Farewell to Spring)

Gracious, tender and feminine, you inspire others to look after you and nurture your dreams. You are attracted to like-minded individuals who also enjoy the finer things in life. Though you give generously of your time and energy, you like nothing more than to curl up somewhere quiet with a good book.

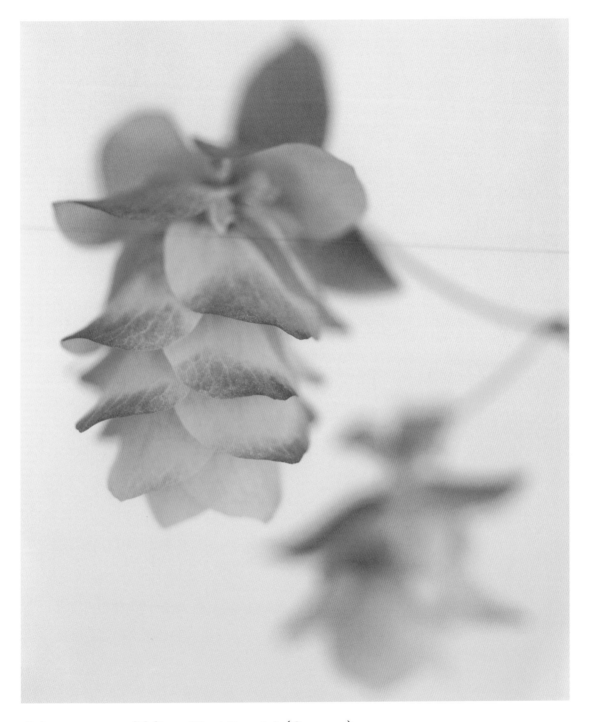

Origanum rotundifolium 'Kent Beauty' (Oregano)

The sweetly blushing oregano symbolizes joy. You are a person of great emotional depth and perception. While you enjoy all company, you prefer to be among your loved ones and family. You radiate warmth and happiness, and intuitively provide what others need.

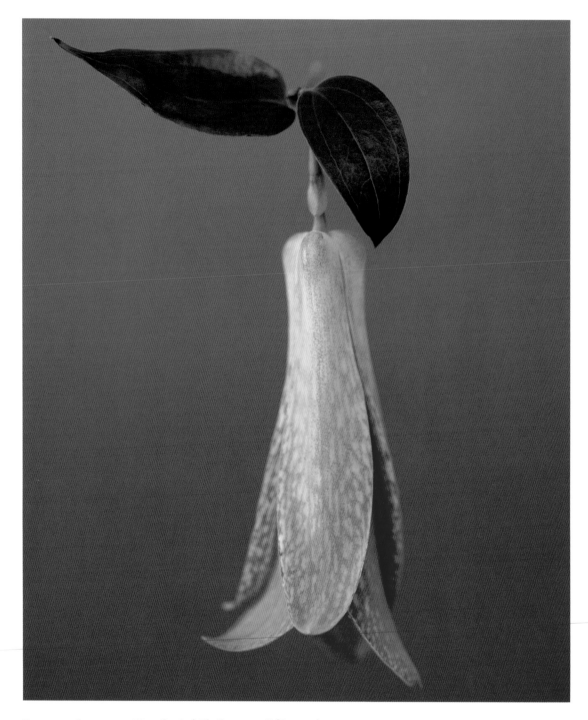

Lapageria rosea 'Yuriko' (Chilean Bellflower)

Naturally pollinated by hummingbirds, the Chilean bellflower knows how to draw a crowd. You are a generous and exceptional person, and many people wish they could have you as a friend. Once you are settled you do not like to move but you keep growing and rewarding those around you.

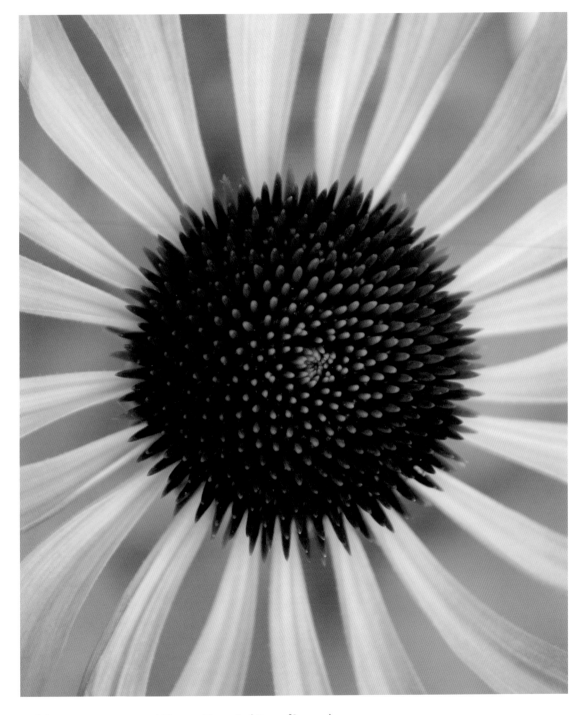

Echinacea purpurea 'Green Envy' (Coneflower)

The tinge of pink at the base of this coneflower's petals represents tenderness and compassion. These endearing characteristics are enhanced by your effervescent energy and healing presence. Envied for your clear mind, you have a complex and nurturing heart. You thrive when given a little room to move.

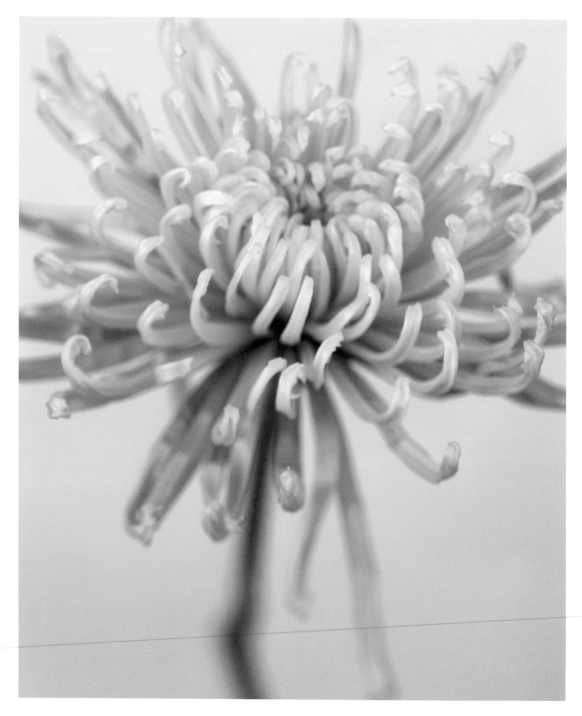

Chrysanthemum morifolium (Chrysanthemum)

With a rich history that spans the globe this bloom truly deserves its venerated status. A symbol of everlasting friendship and national pride, the chrysanthemum is both a private and public flower. You too enjoy the polarities of these realms and can gracefully navigate both. You have a natural ability to make others feel special and loved.

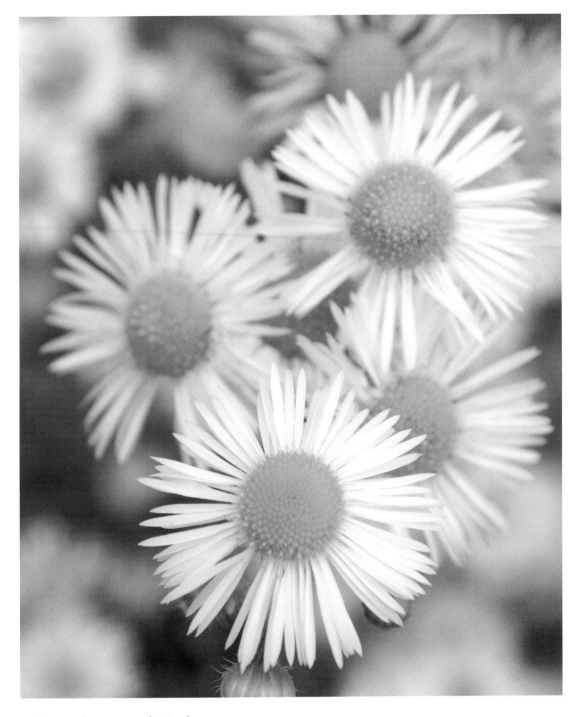

Boltonia decurrens (Aster)

Resembling a star, the delicate aster is surprisingly hardy. Your overwhelming optimism dispels darkness and fills every room you enter with a pure glow. This unfailing positivity makes you a favorite with friends and family. Though you radiate joy unconsciously, you have a deep spiritual belief from which you draw energy.

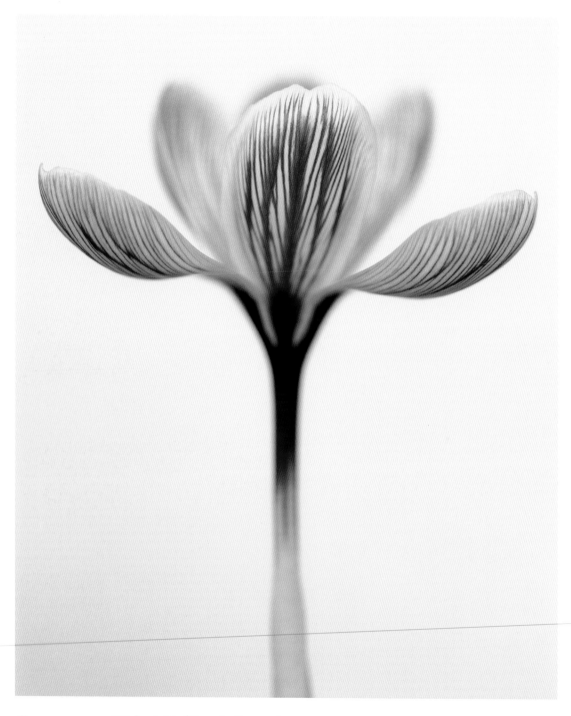

Crocus vernus 'Pickwick' (Dutch Crocus)

The crocus brightens the last days of winter with its delicate yet resilient blooms. They give us a gentle reminder that dark times will pass. Crocus people share this combination of strength and fragility, and will inspire others to look for beauty where they least expect it.

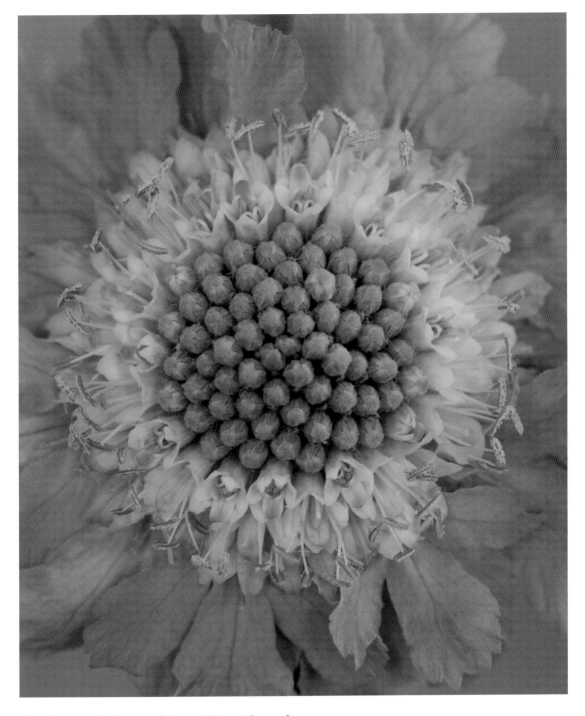

Scabiosa ochroleuca (Pincushion Flower)

Your extraordinary pace and efficiency sometimes make it seem like you have been in two places at one time. You are a very busy person, and are both adaptable and pragmatic. With your intuitive abilities you often preempt situations and what people say, bringing a sense of déjà vu to your day.

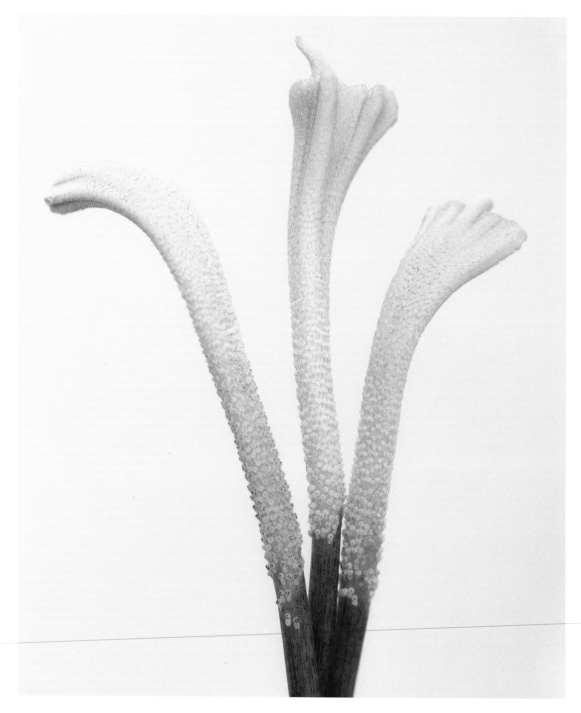

Peperomia 'Lilian' (*Peperomia*)

These flowers have a strong association with protection and nurturing and represent relationships and community. You are especially attuned to the needs of those around you. Your overriding ethos is to work for the greater good and your love and compassion make you a popular friend and family member.

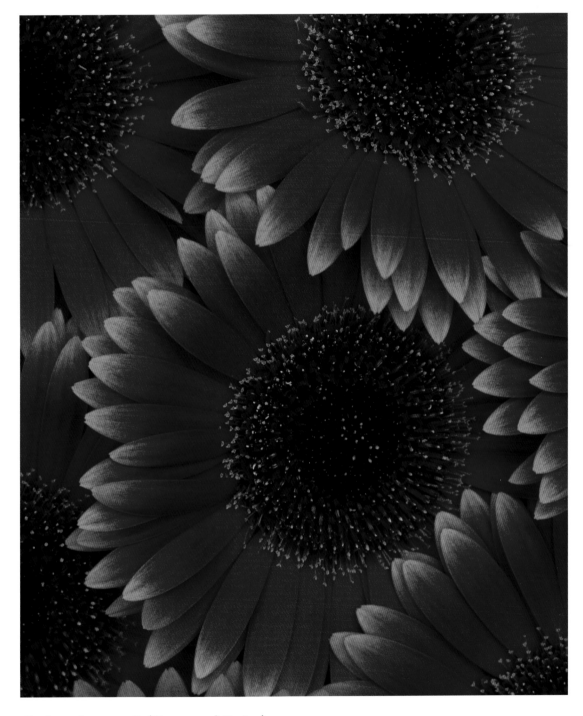

Gerbera jamesonii (Transvaal Daisy)

This exciting flower comes in many hues but this is the original. You are one of the lucky few who are truly good at whatever they do, staying contemporary but accruing wisdom on the way. Your positive outlook sees you warmly embraced by all you meet.

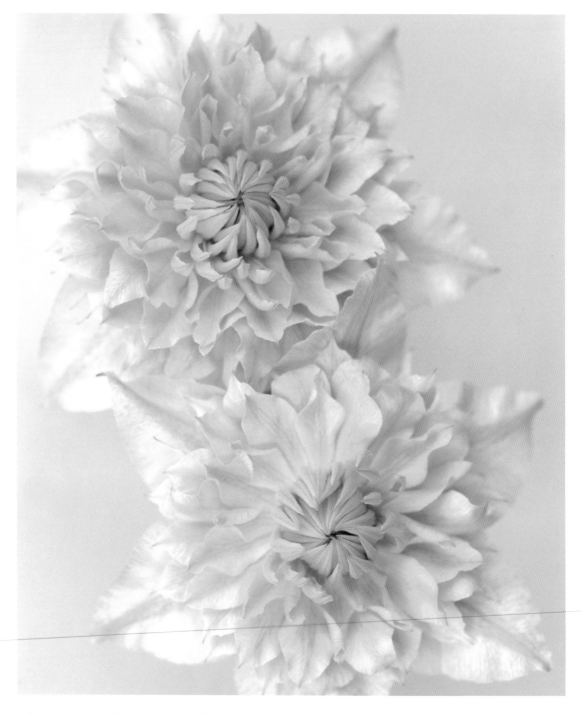

Clematis florida 'Sieboldii' (Passion Flower Clematis)

Climbing towards the heavens, the clematis symbolizes ascension. You have high expectations for which you happily strive. The clarity and singularity of your purpose sees you manifest much admiration from others. Your ideals may be lofty but they are based on truth and love.

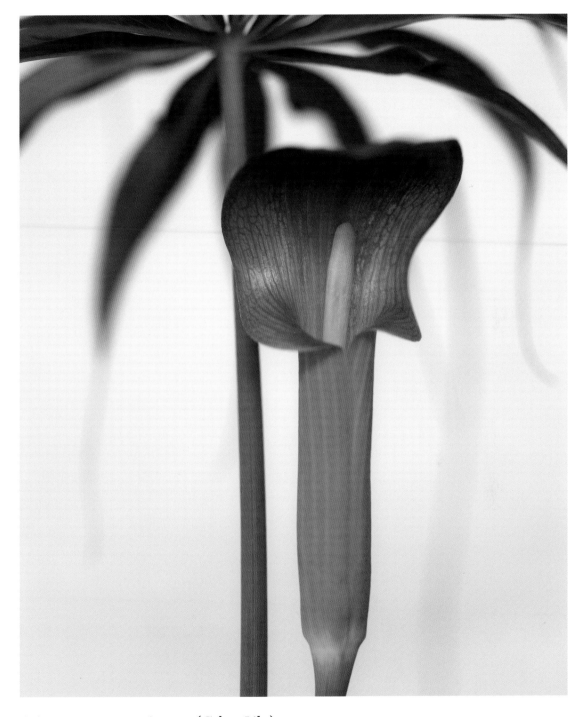

Arisaema consanguineum (Cobra Lily)

Poised and meditative, this bloom represents patience. You have a keen sense of your place in the world, which is strengthened by your interest in genealogy. You are a tranquil individual, an island in the stream, though you strike decisively if necessary. Your strong sense of justice assists you to make good choices.

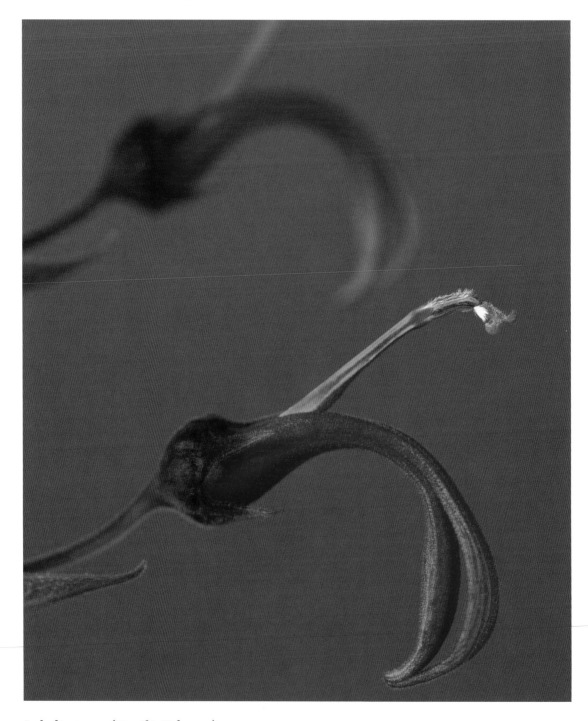

Lobelia tupa (Devil's Tobacco)

This Chilean beauty represents passion and release. You are a breath of fresh air for those you meet, offering warmth and a sense of fun and daring. You have an allure that is nothing short of magnetic and can easily entrance your captives with your wit and wisdom.

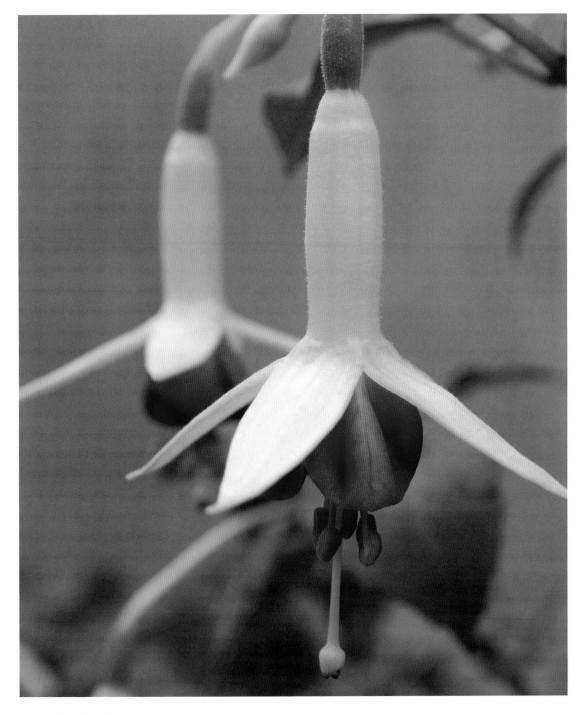

Fuchsia (Fuchsia)

This self-contained and graceful flower is a symbol of good taste. You too have these attributes, enhanced by your unique sense of style and individuality. You have the blessing of being accepted by all you meet, even though you often go against the grain in ways of thinking and being. Your sartorial innovations are much admired.

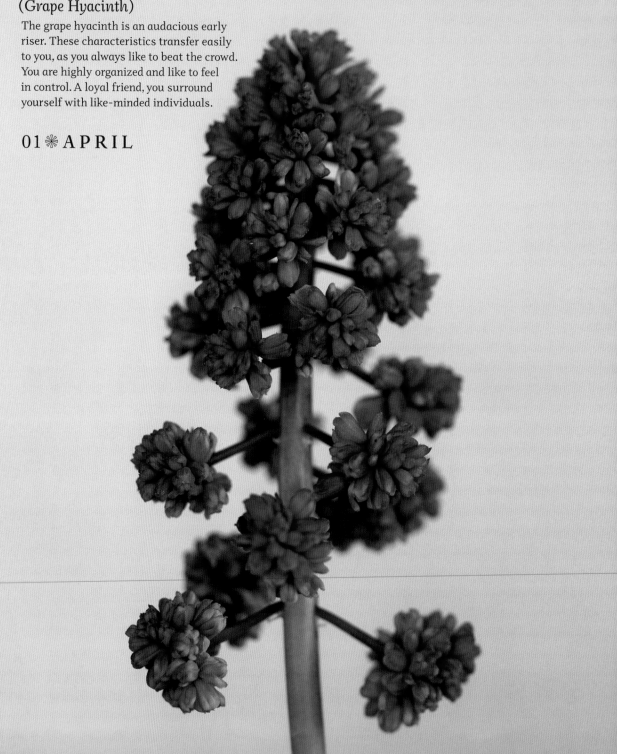

Muscari 'Blue Spike'
(Grape Hyacinth)

The grape hyacinth is an audacious early riser. These characteristics transfer easily to you, as you always like to beat the crowd. You are highly organized and like to feel in control. A loyal friend, you surround yourself with like-minded individuals.

01 ❋ APRIL

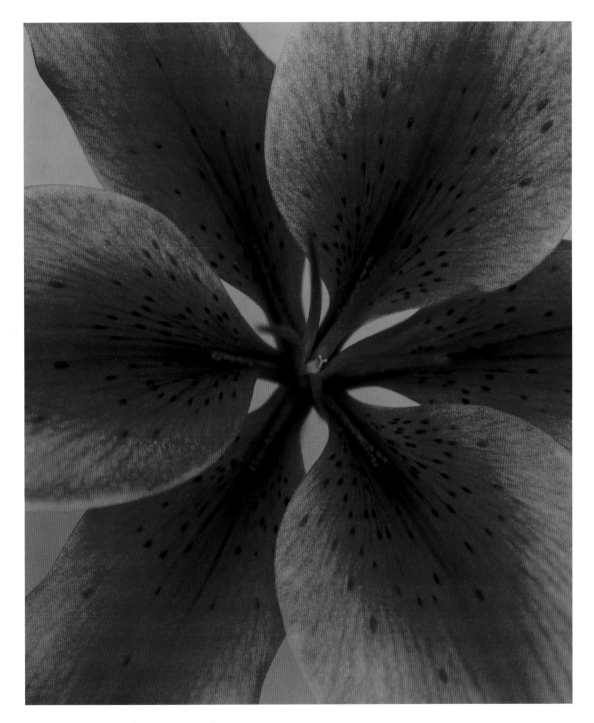

Lilium 'Stones' (Asiatic Lily)

While promising sensuality, the Asiatic lily also brings purity and endurance into play. You are an outwardly vivacious individual who likes to feign modesty and can seem impatient at times. An adventurous person, you will settle well into a profession which involves new experiences and you will be noticed wherever you go.

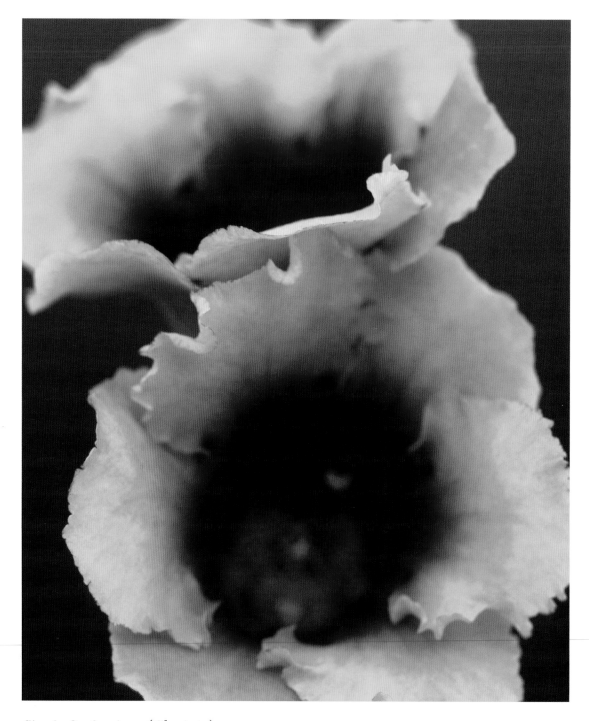

Sinningia speciosa (Gloxinia)

In the Victorian language of flowers gloxinia translates as 'love at first sight.' These delicate petals are misleading, however, as the depth of the flower is obscured by their open embrace. You are happiest in a homey environment and bloom your best when you take time to wind down and relax completely.

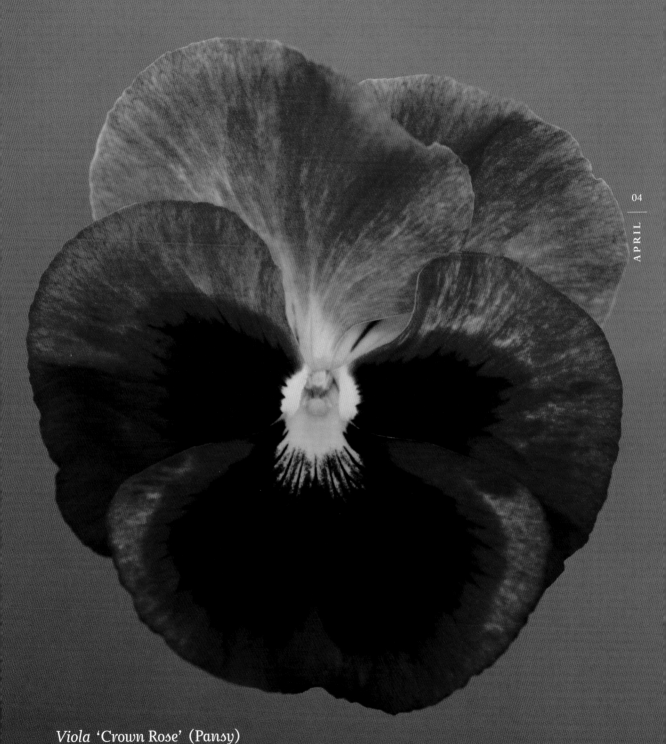

Viola 'Crown Rose' (Pansy)

With its black center and red outer petals this flower symbolizes passion and integrity. Your contagious sense of humor makes you very popular with children. You are a faithful lover with a protective yet trusting heart. You are blessed with an intelligent and uncluttered mind.

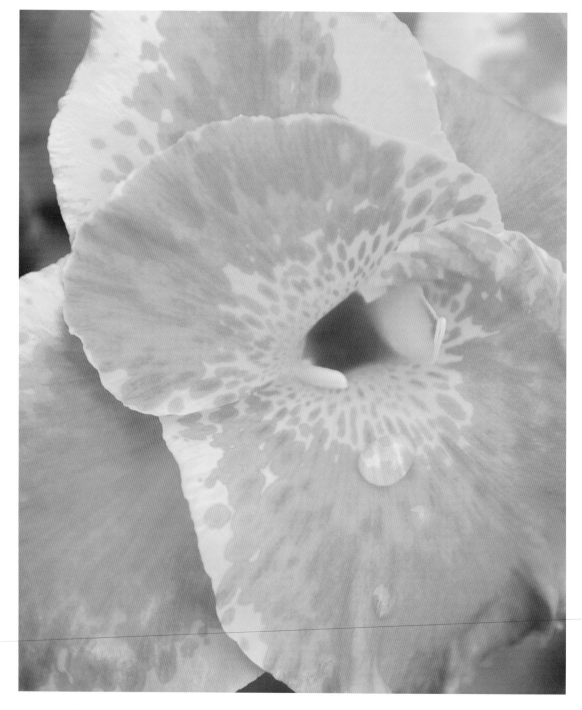

Canna glauca 'Taney' (Orange Longwood Aquatic Canna)

Cannas have bold and upright blooms that nod above their lush foliage. You share their desire for ascension, reaching for lofty goals with the encouragement of your friends and family. Your bold enthusiasm inspires others and you may find yourself pushed into positions of power and leadership.

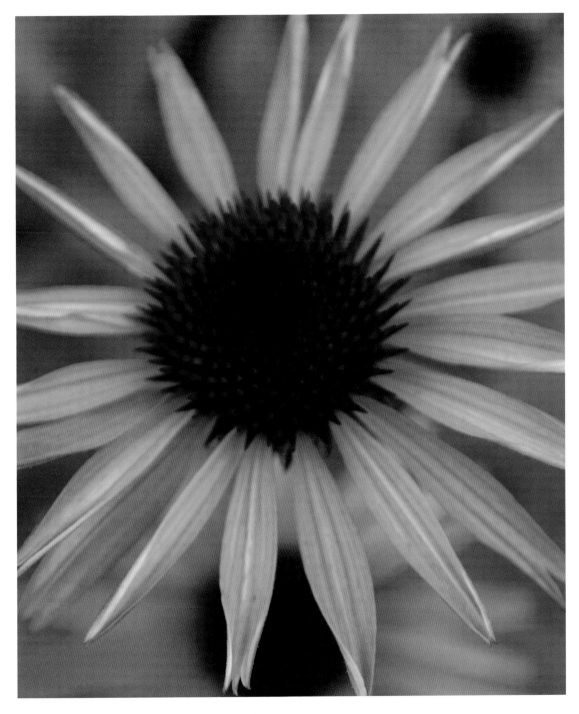

Echinacea 'Evan Saul' (Coneflower)

This powerful flower symbolizes the joy of creation. With 'Evan Saul' as your bloom you are conscious of the influence you yield over people. Whatever the essence of the moment, you have the ability to intensify it. Fortunately, you have only good intentions, so your company and advice are always welcomed.

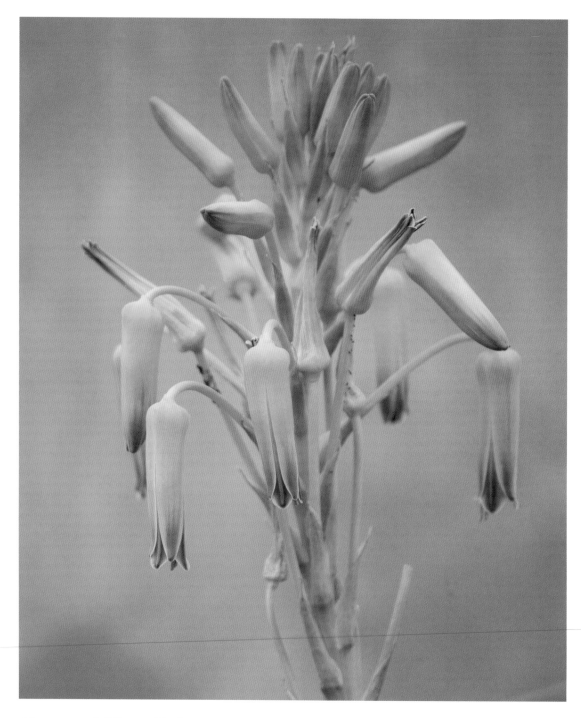

Aloe cooperi (Grass Aloe)

The grass aloe has a connection with childbirth and symbolizes an active and fertile mind. You are a nurturer of people and dreams, with a gift for easing nervous exhaustion. Your affinity with nature makes you a success-ful gardener and you generously share the rewards of your labors.

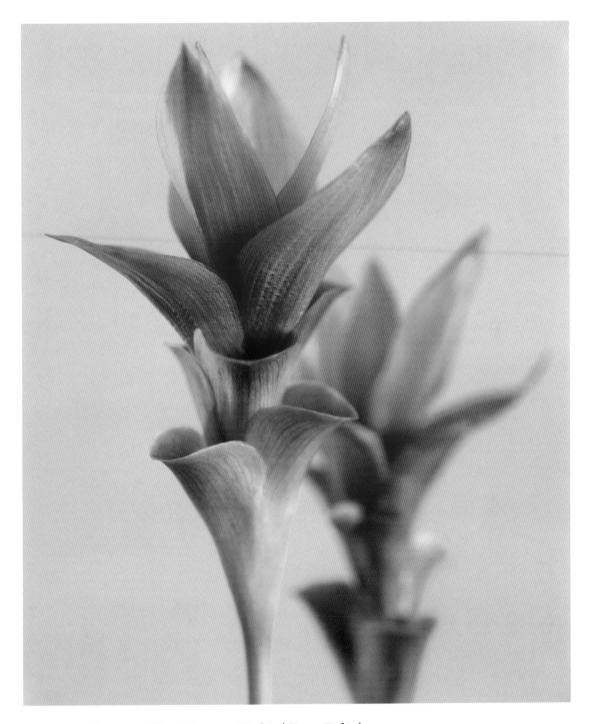

Curcuma alismatifolia 'Kimono Pink' (Siam Tulip)

The love, money, success and power that this flower symbolizes is diffused by its delicate pink coloring. Though still blessed by good fortune, your gentle soul sees you use many of your attributes for the benefit of others. You are expressive and generous but have a grounded and solid integrity.

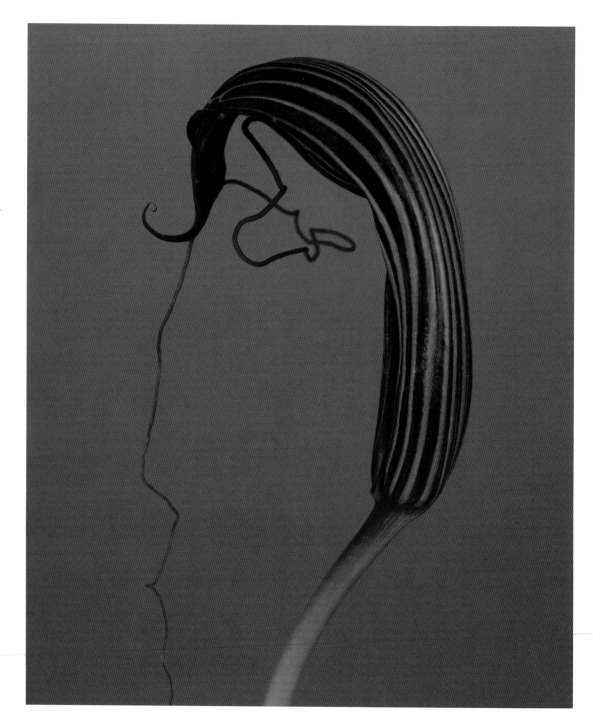

Arisaema costatum (Cobra Lily)

The cobra lily is unashamedly dramatic. You revel in the theatrical and love attention, but your passionate nature is veined with common sense and clear thinking. You are both reliable and consistent. You have high aspirations and enjoy taking in the view from a lofty perch.

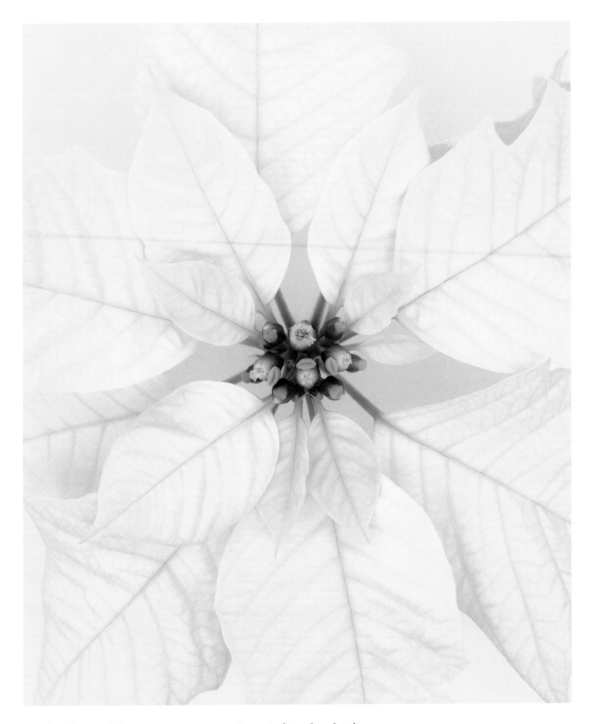

Euphorbia pulcherrima 'Lemon Snow' (Euphorbia)

Statuesque, distinctive and curiously modest, these beautiful flowers know how to keep cool. You are a contained yet expressive person with clear intentions; you know where you are going and how. You have a love of family and strong sense of identity, but also a penchant for spoiling your loved ones.

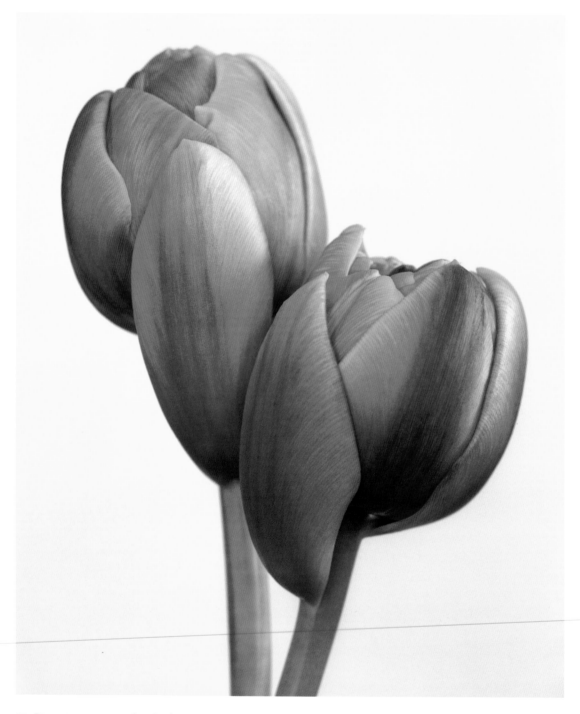

Tulipa 'Bonsoir' (Tulip)

Bidding winter good night and farewell, the 'Bonsoir' tulip reminds us to walk tall. You are outwardly relaxed and harmonious but you have a depth of passion that is rare. You are insightful and generous making you a favorite with your friends, and a sensitive and loyal partner.

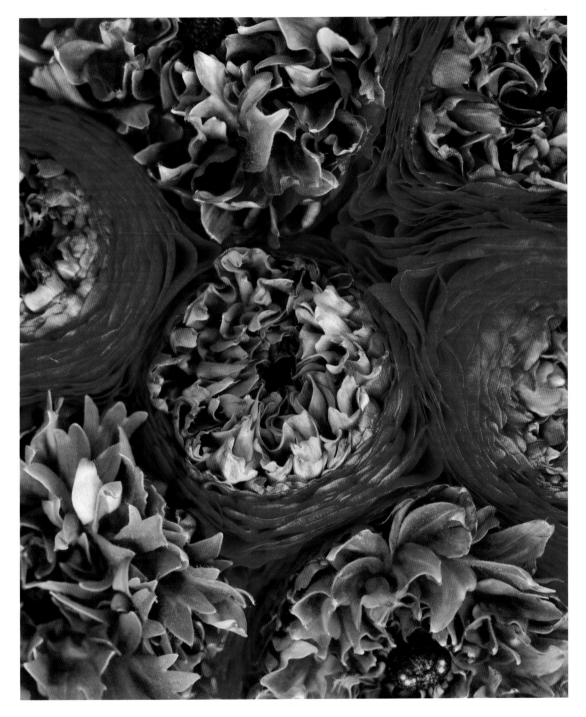

Ranunculus asiaticus (Persian Buttercup)

The charms of the Persian buttercup are far from hidden. You are a powerful person with a strong sense of integrity. You radiate calm and are always grounded, but your sensuality is undeniable. You like to think long and hard before making a decision and your caution usually leads to success.

Astilbe chinensis
'Finale' (Feather Flower)
The feather flower symbolizes
perseverance and modesty. Like this
beautiful flower you are patient and
cautious, and it may take time for you
to reach your true potential. Even when
you feel the moment is right, you are
not one to jump and shout but prefer
to quietly dazzle others with your
grace and innate intelligence.

Crocosmia 'Severn Sunrise' (Falling Stars)

The graceful flowers of falling stars are warm and welcoming. Though you enjoy leaving your life to destiny you also require some semblance of routine and discipline. You like to exercise control over what you perceive to be reasonably within your reach, but the rest you leave up to the powers that be.

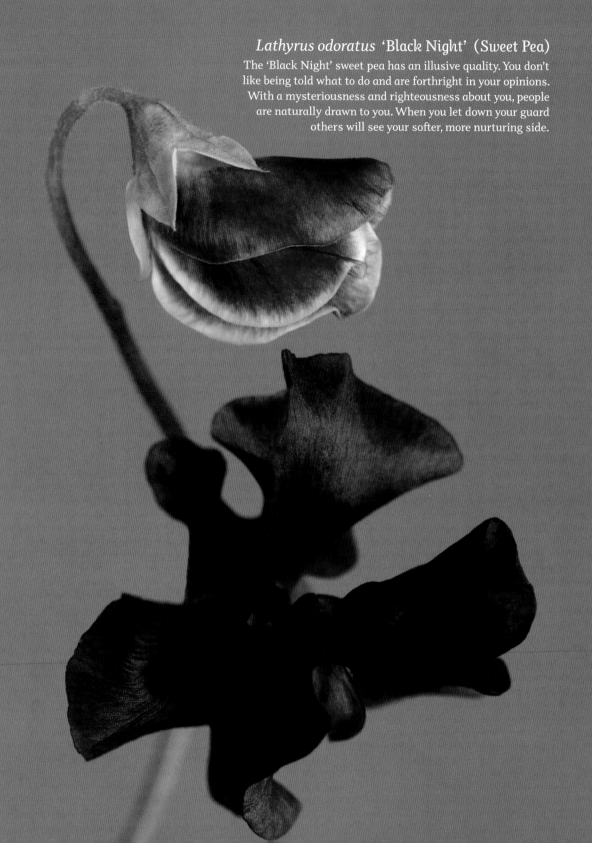

Lathyrus odoratus 'Black Night' (Sweet Pea)

The 'Black Night' sweet pea has an illusive quality. You don't like being told what to do and are forthright in your opinions. With a mysteriousness and righteousness about you, people are naturally drawn to you. When you let down your guard others will see your softer, more nurturing side.

Acanthus mollis (Bear's Breeches)

A statuesque beauty, bear's breeches is associated with the arts. You may fool people with your poker face but this deception thinly veils your well-refined sensibilities. You are an intensely creative person with a love for the ancient and classical. Your crowning glory is your pathos and infectious enthusiasm.

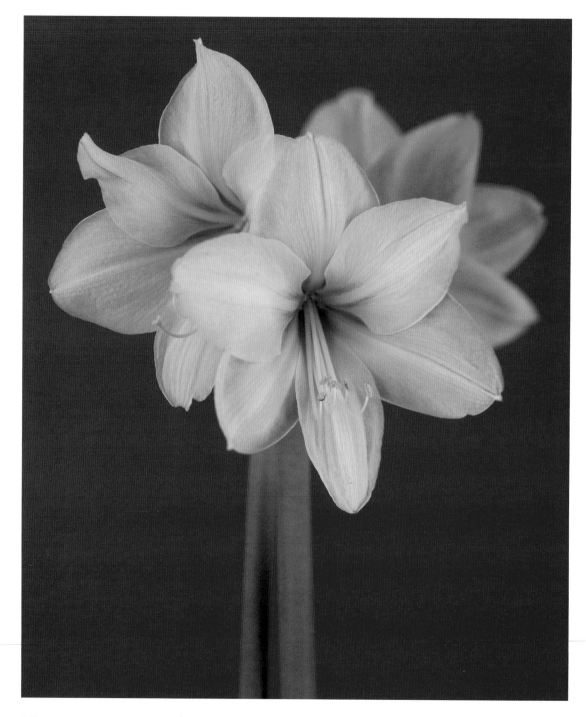

Hippeastrum 'Limona' (Amaryllis)

A soothing beauty, the 'Limona' amaryllis is quiet and understated. You are a carefully groomed individual with a dignified appearance. You like to stand tall and rely upon your honesty and integrity to do so with honor. The friends who get to know you best will enjoy your refreshing outlook on life.

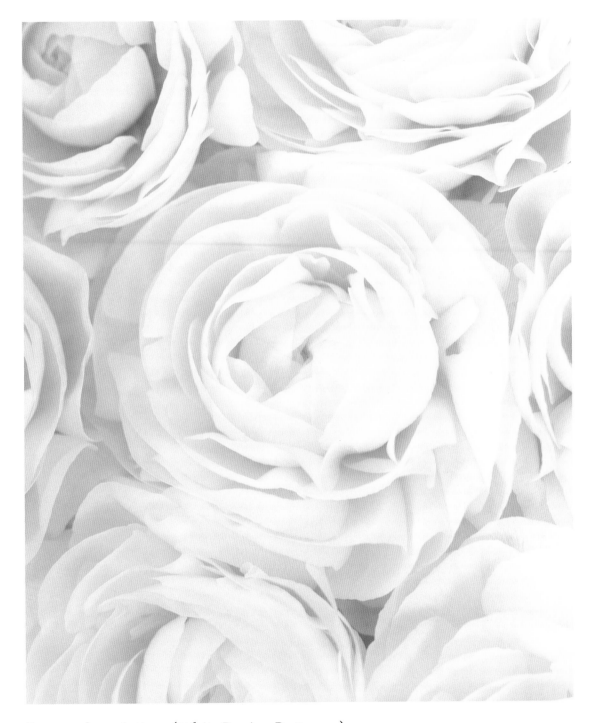

Ranunculus asiaticus (White Persian Buttercup)

The purity of this lovely white Persian buttercup belies the complexity of its accompanying personality. You are a deep thinker who enjoys sharing your knowledge. Your discerning taste and ability to charm allows you great freedom and choice, and may open the door to diverse career paths.

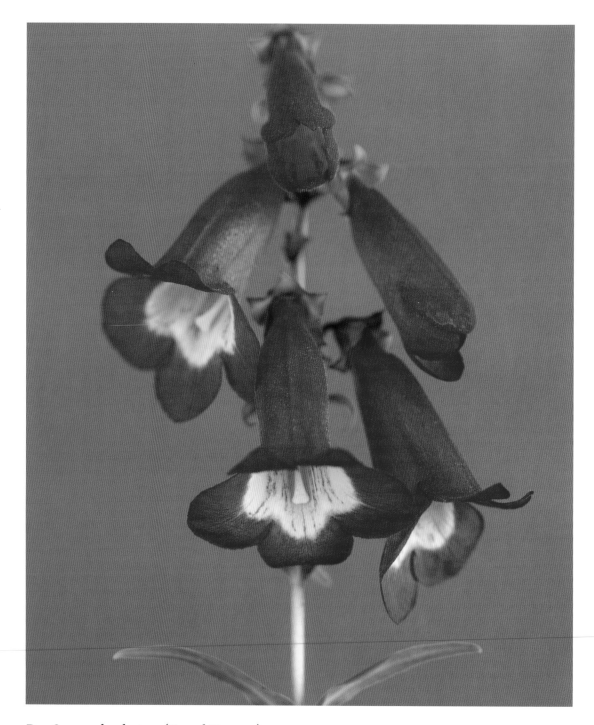

Penstemon barbatus (Beard Tongue)

A cascade of sweet bells feigns modesty for this flower, whose bold ambition is apparent in its bright red petals. You share this effective blend of humility and assertiveness, assisted by a quick and agile mind. A lover of words, you are a born public speaker and gifted linguist.

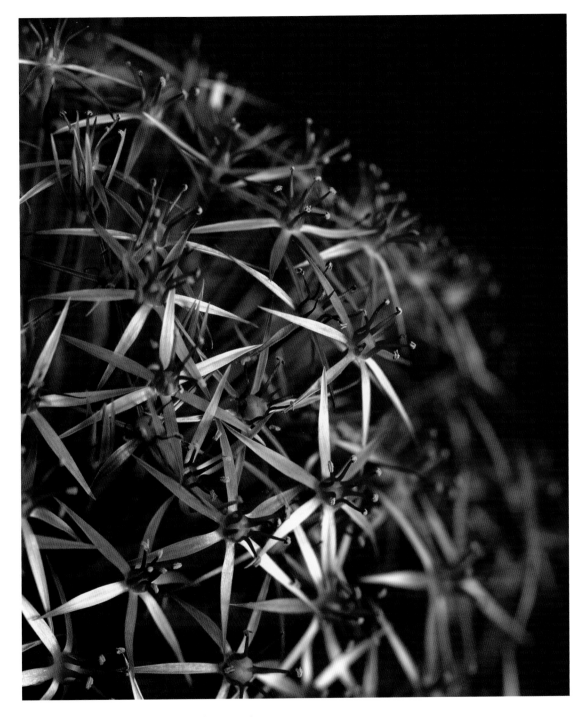

Allium albopilosum (Star of Persia)

Like a crown jewel this outstanding flower represents luxury. You will always be lucky with money, which allows you to be both carefree and generous. Others may at first be overwhelmed by your exotic and complex appearance, but when they get to know you they will find a true and loyal friend.

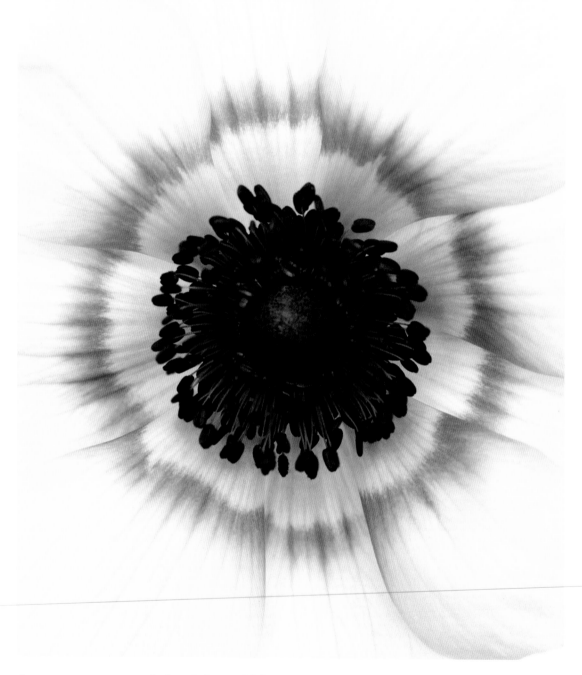

Anemone coronaria (Lily of the Fields)

The lily of the fields is a fragile bloom that brightens the last days of winter. You share with this flower a capacity to bring light and joy to trying times, making you a natural leader. You draw inspiration from your high ideals but must guard against the constraints of being a born perfectionist.

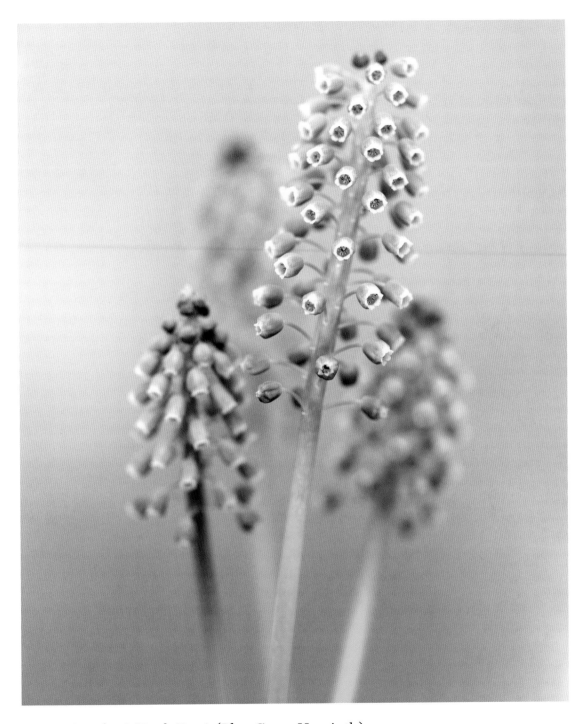

Muscari aucheri 'Dark Eyes' (Blue Grape Hyacinth)

With your 'Dark Eyes' you mesmerize those around you, who understand that your eyes are the window to your compassionate soul. You have a vitality that remains constant throughout your life, giving you the power to nurture and protect others. You bring your loved ones stability and peace.

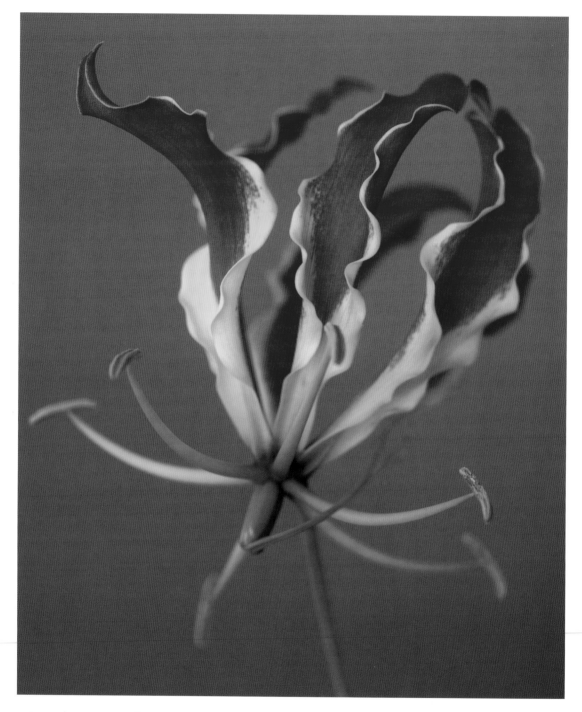

Gloriosa superba (Flame Lily)

If the flame lily is your flower then your beauty is no secret—its Latin name means 'superbly handsome'. Adventurous and ambitious, you also have a delicate constitution. You attract attention but you also crave tenderness and will gravitate towards those who appreciate that your loveliness is more than skin-deep.

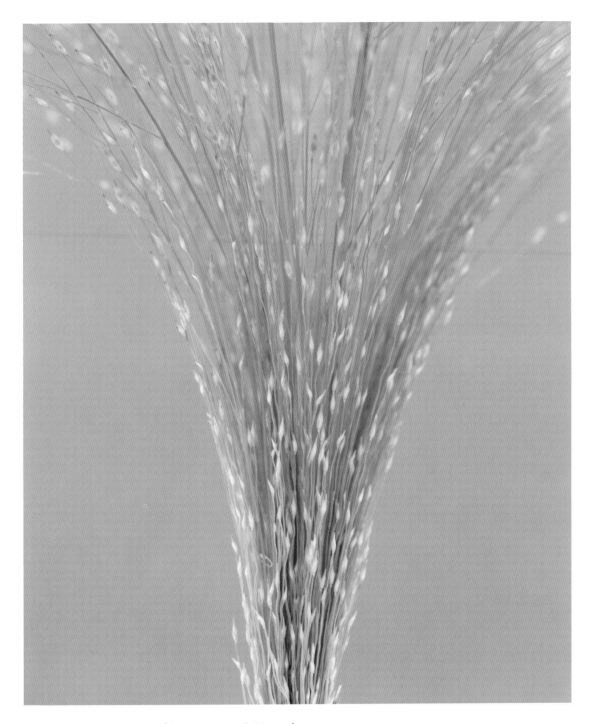

Panicum 'Fountain' (Ornamental Grass)

Bowing to the breeze, this graceful grass symbolizes submission and usefulness. You have a natural tendency to work with others and enjoy the process of creation. Because you can turn your hand to most things, you are a popular helper and are often involved in domestic projects.

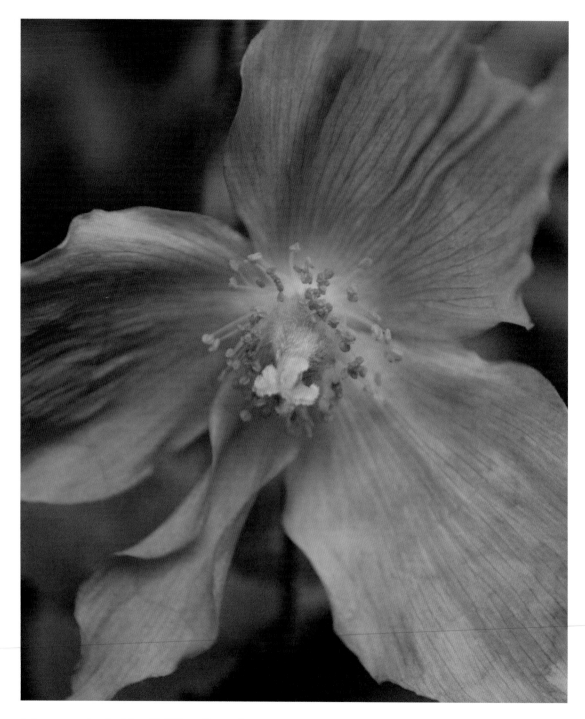

Meconopsis sheldonii (Blue Poppy)

This beautiful blue poppy embraces all the glamour of the other poppies but has the added allure of the fifth element—spirit. You are tranquil within yourself and exude a sense of calm that helps settle those around you. You have an innate understanding of the workings of the world, which others find very reassuring.

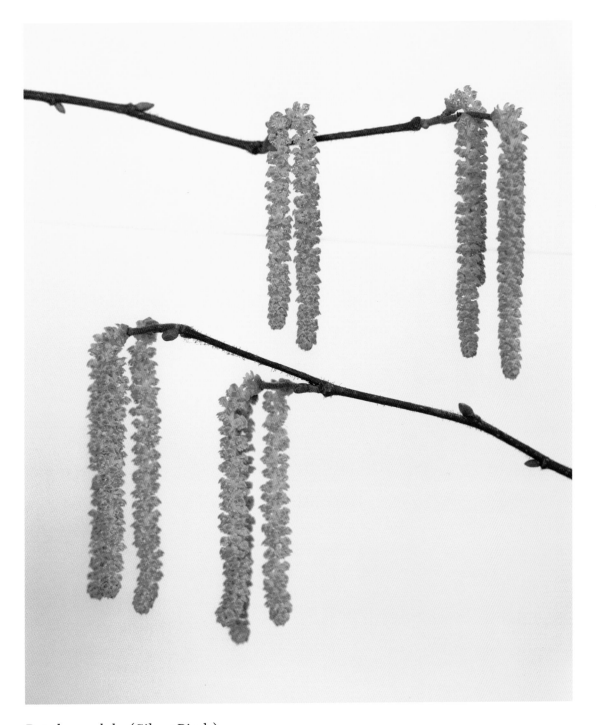

Betula pendula (Silver Birch)

Like strings of jewels, the frothy flowers of the silver birch drip languidly from its boughs. You share its relaxed repose and casual elegance. Quietly optimistic, you bring a sense of sustainable joy to every situation and are renowned for your wise counsel and measured advice.

Euphorbia pulcherrima 'Early Red' (Poinsettia)

Red represents love, confidence and vitality. You have an abundance of all these traits and love to share them around. Generosity and forgiveness characterize your relationships, and you love to be surrounded by family and friends. You are known for your open door and gracious hospitality.

Billbergia 'Thelma Darling Hodge' (Bromeliad)

The tangible beauty of this bromeliad is at once exotic and ancient. You have a daring eroticism about you that often attracts attention. Your ability to shine through all travails makes you both a reliable and relied-upon friend. Though you are an old soul you are young at heart, blending wisdom and grace with a sense of fun.

Rosa 'Cezanne' (Rose)

The 'Cezanne' rose, saturated in pink, symbolizes true romance. You approach your friendships with imagination and depth, and perpetually fascinate and enthrall others. Your warmth and generosity are not exclusive to your personal relationships and are shared with all you meet.

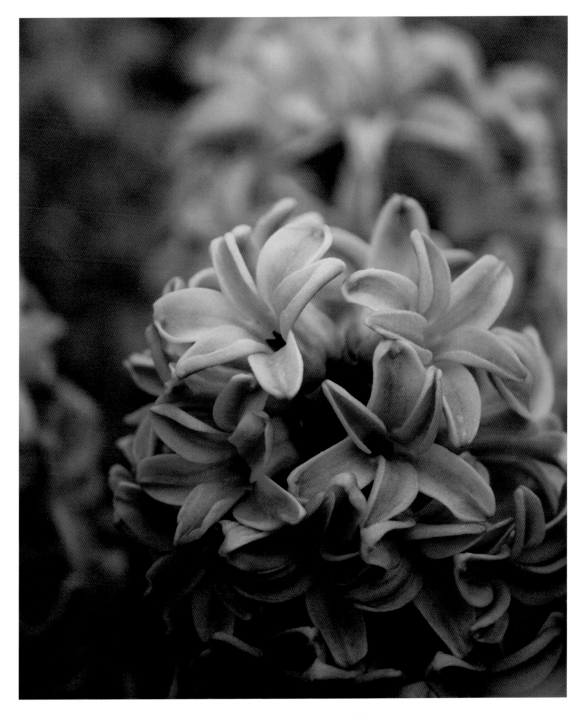

Hyacinthus orientalis 'Splendid Cornelia' (Hyacinth)

Romantic and bright, you are a breath of fresh air to all those around you. You are feminine with a hint of dashing impulsiveness which your friends find beguiling. The violet hue of this hyacinth represents rebirth: you offer your loved ones the potential for positive transformation.

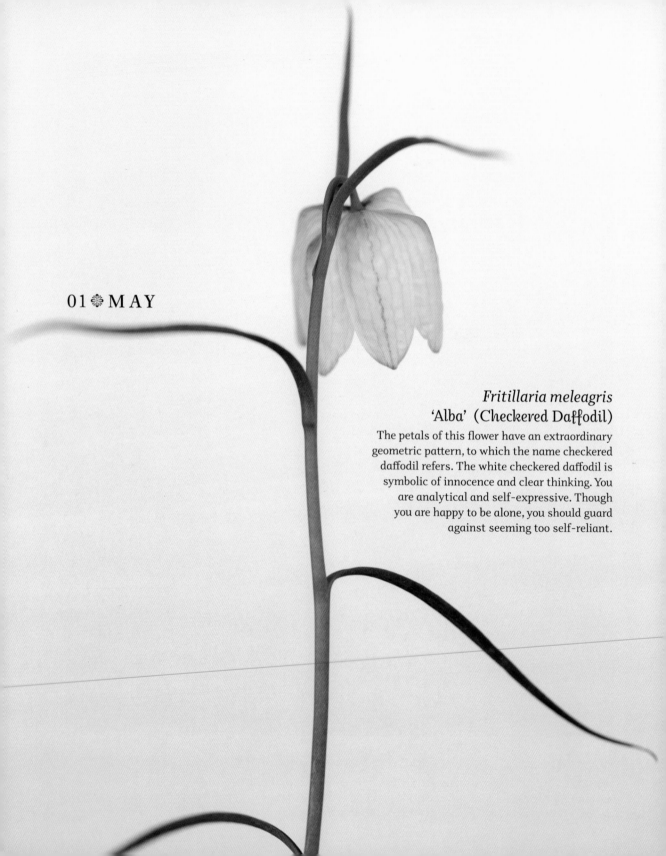

01 ✤ MAY

Fritillaria meleagris
'Alba' (Checkered Daffodil)
The petals of this flower have an extraordinary
geometric pattern, to which the name checkered
daffodil refers. The white checkered daffodil is
symbolic of innocence and clear thinking. You
are analytical and self-expressive. Though
you are happy to be alone, you should guard
against seeming too self-reliant.

Hippeastrum 'Nebula' (Amaryllis)

Like other 'hippies' you attract attention with your showy good looks and bold carriage. You are a warm friend and tender lover, with a taste for the finer things in life. Your capacity to indulge others fortunately extends to yourself—you like to fantasize and daydream, and often have your head in the clouds.

Chionanthus ramiflora (Native Olive)

Like angels falling to earth, the flowers of the olive family symbolize peace and communication. You are aware of your charms but have a noble bearing about you that ensures your privacy. You often know the perfect thing to say and you share your gracious gifts with your friends when they need them the most.

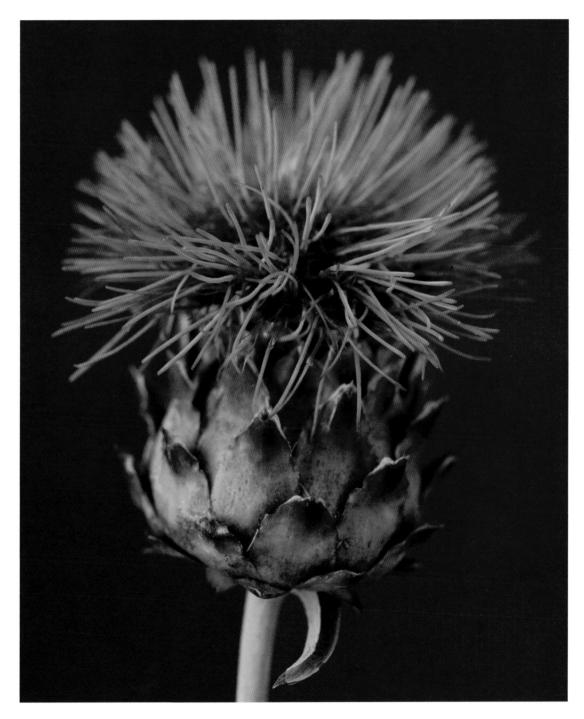

Cynara scolymus (Globe Artichoke)

The globe artichoke represents opportunity and strength. Incredibly resourceful and dynamic, you are famous for your ability to be comfortable anywhere. Nothing is difficult for you. You approach every problem as if it is simply an opportunity, making you a favorite with all your friends.

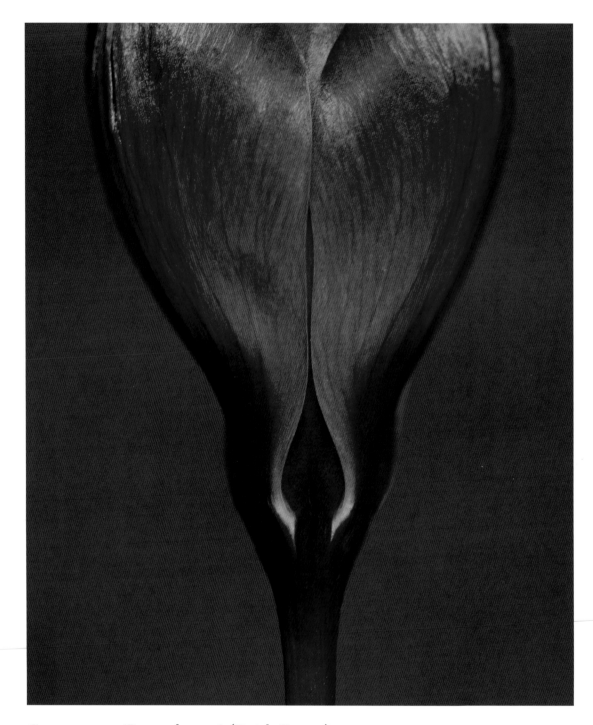

Crocus vernus 'Remembrance' (Dutch Crocus)

You are a trendsetter, like the early blooming Dutch crocus whose delicate flowers herald the beginning of spring. With 'Remembrance' as your flower even your most fleeting appearance makes a lasting impact. Purple is associated with romance and sophistication, making you a source of inspiration for those around you.

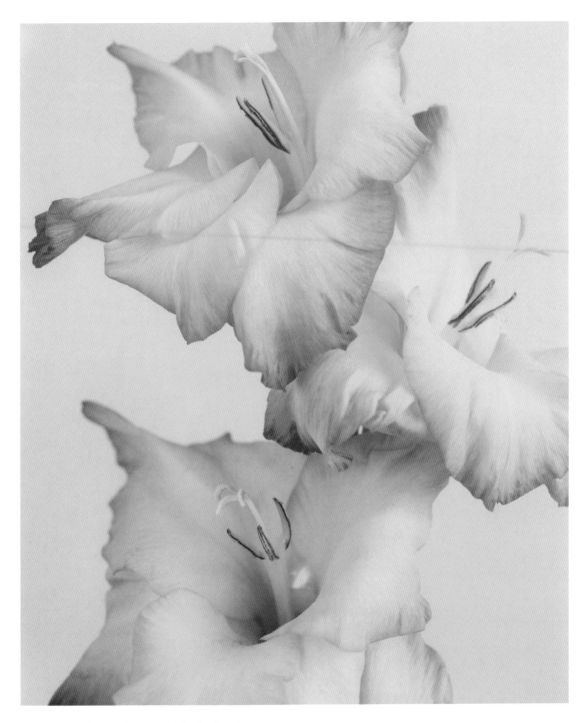

Gladiolus hortulanus (Gladiolus)

Symbolizing strength of character, the gladiolus is welcome in any garden. You are a generous and true lover, and a loyal and colorful friend. Your strength can sometimes come across as combative but essentially you are a peace-loving person. However, with your effusive cheer and optimism you will win everyone over in the end.

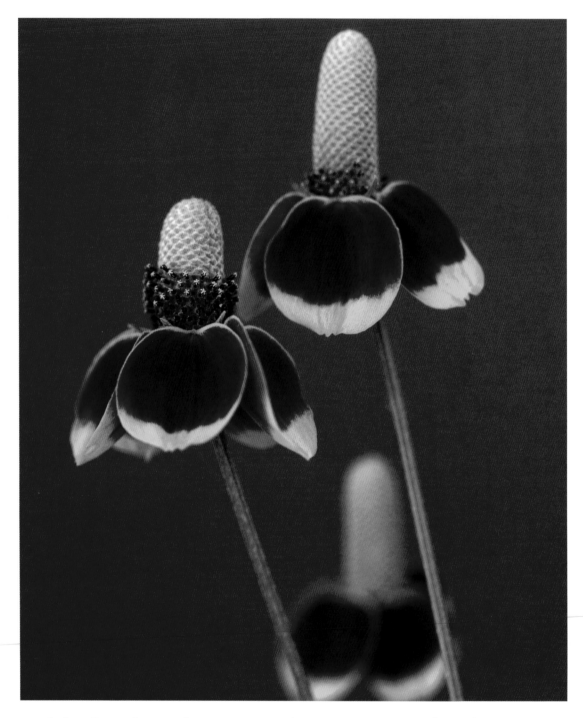

Ratibida columnifera 'Red Mexican Hat' (Upright Prairie Coneflower)

Symbolizing joy, this beautiful bloom reminds us to delight in small things. You love to watch the world go by and your finely tuned observational skills help you with your perceptive readings of people. You are blessed with a keen intellect which you generously share with others—you are a born teacher.

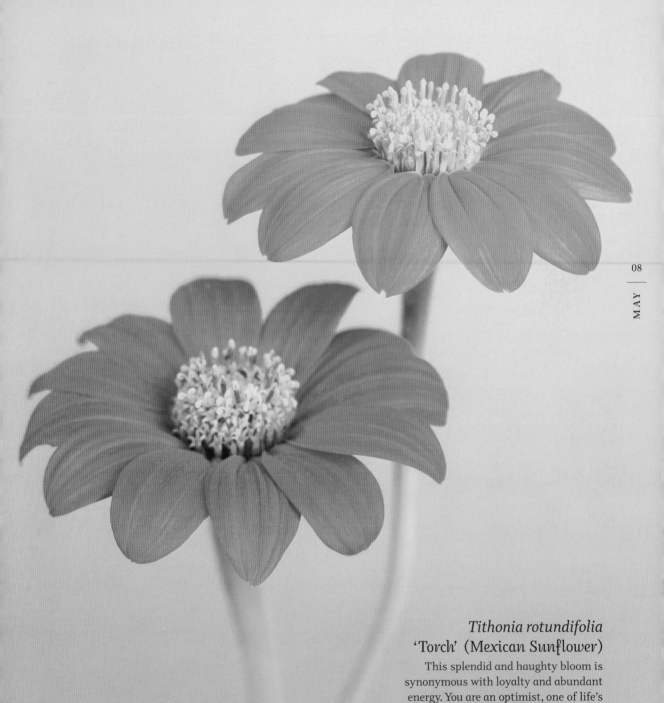

Tithonia rotundifolia
'Torch' (Mexican Sunflower)

This splendid and haughty bloom is
synonymous with loyalty and abundant
energy. You are an optimist, one of life's
true bright sparks. You clear the clouds
and make their silver linings apparent.
With your practical everyday smarts and
your inner glow you make a popular friend.

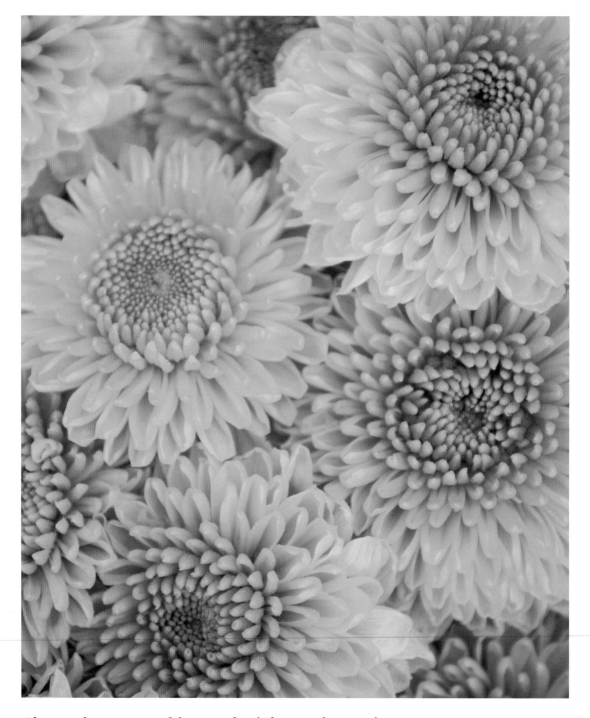

Chrysanthemum morifolium 'Jade' (*Chrysanthemum*)

Loved in antiquity, the chrysanthemum confers to you a mature spirit and strong sense of self-worth. Sunny yellow and acid green indicate optimism and a love of nature. You have boundless energy for outdoor activities, and are most at home when you stray from the beaten track.

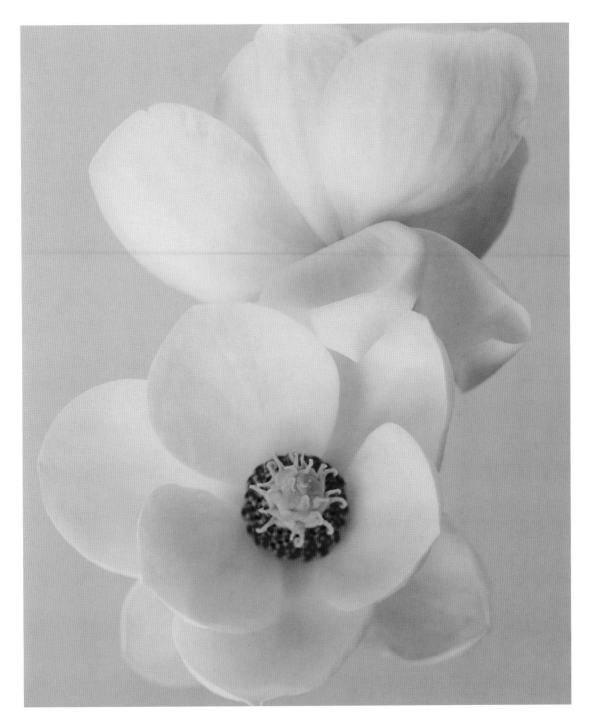

Magnolia sieboldii (Siebold's Magnolia)

Like the subtle grace of Siebold's magnolia, you radiate beauty. You have a love for nature and are happiest when out walking. You prefer the company of people who know what they are doing with their lives, as you too are focused and practical.

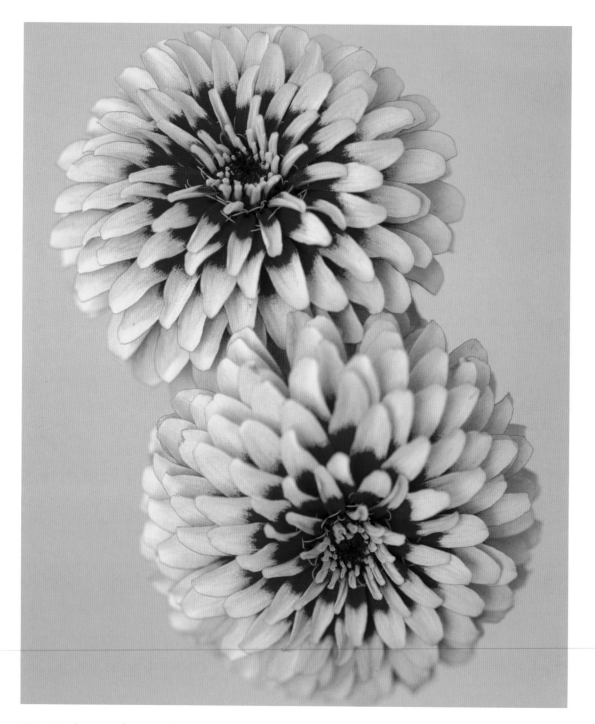

Zinnia elegans (Zinnia)

Easily recognizable, the zinnia is well-loved. You are a loyal and true friend, never missing a birthday or important date. You like to remember and celebrate those who have helped you and those who have gone before. Your positivity and thoughtfulness make you very popular.

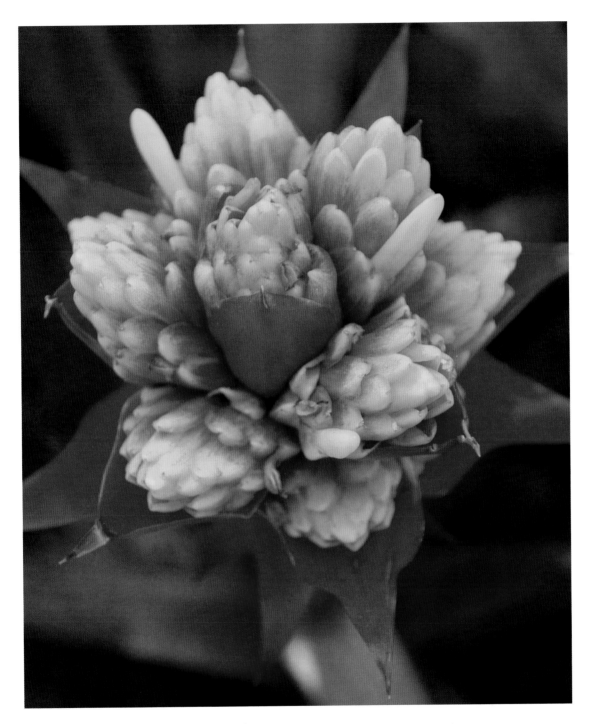

Guzmania 'Limones' (Bromeliad)

Succulent and full of impact, bromeliad flowers always delight and surprise. You are an intrepid person who enjoys extremes. You relish intellectual and cultural stimulation, and feed all your senses with the magic of the world. Though independent and free-spirited, you like to keep your family close.

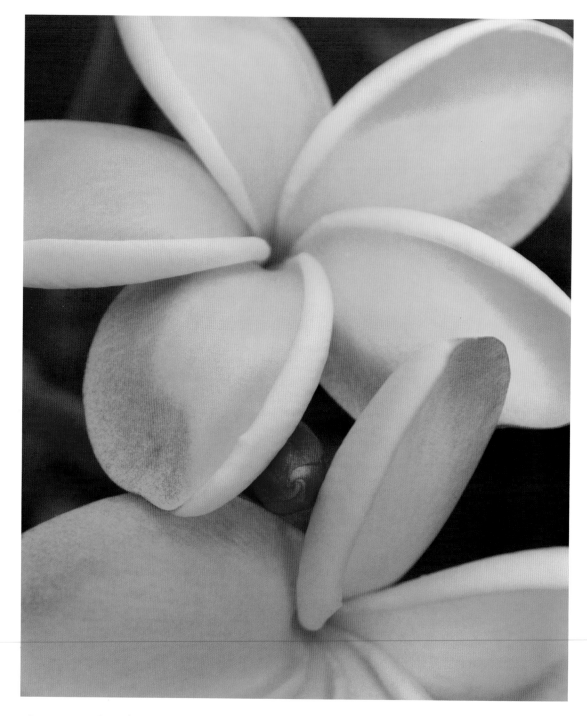

Plumeria rubra (Frangipani)

Sculptural yet uncomplicated, frangipani flowers have a fragrant allure which reaches a peak as dusk falls. You have a love of order and an open-minded approach to life. Though you are likely to appear pretty and sweet during the day, you come into your own at night when your powers of attraction are legendary.

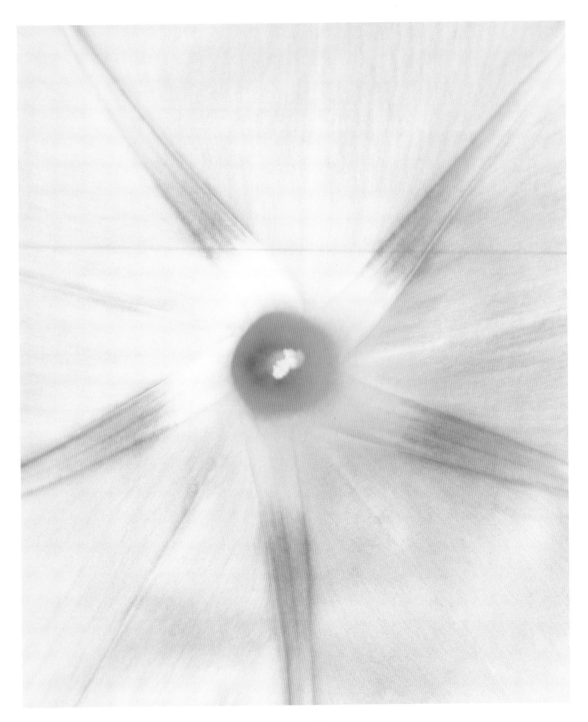

Ipomoea tricolor 'Blue Star' (Morning Glory)

Morning glory embraces each new day with a new flower, symbolizing both enthusiasm and rebirth. You also greet every sunrise with a fresh outlook, and easily shrug off yesterday's woes. Star-like, you have a cool exterior but a warm heart. Your energy is compelling and you may attract secret admirers.

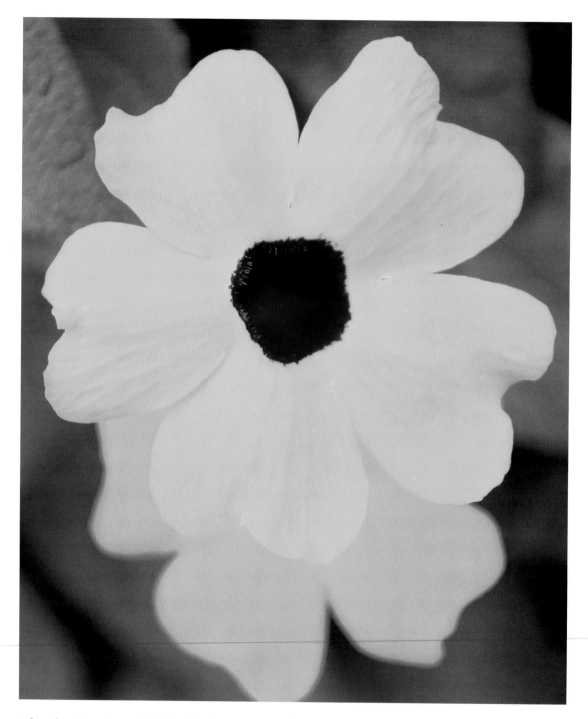

Thunbergia alata (Black-Eyed Susan Vine)

With heart-shaped leaves and petals this long-flowering beauty represents compassion and timelessness. You are an outgoing and friendly person with a tendency to obscure the uglier things in life with your infectious cheer. You have few needs and can make the best of any situation.

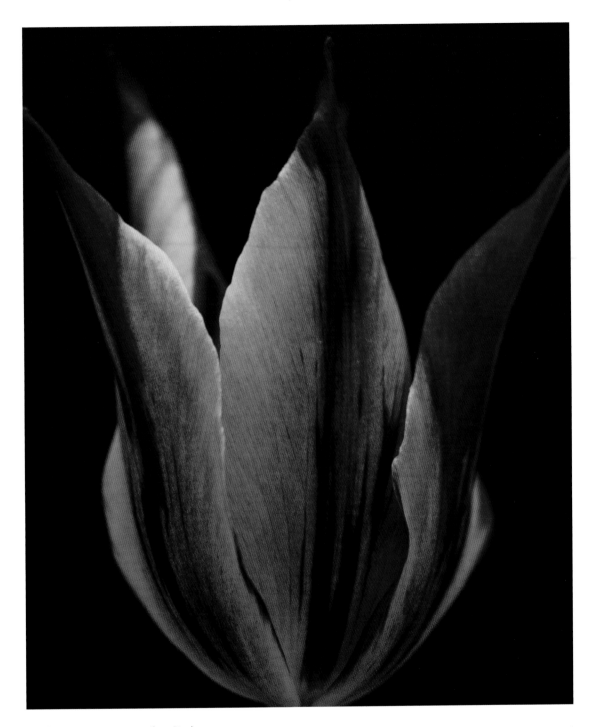

Tulipa 'Maytime' (Tulip)

Tulips are the blooms of luxury and indulgence, and often denote a person prone to self-indulgence. You fly in the face of this convention however, with your sharply focused personality and aesthetic. You are passionate but controlled, with a love of opera and classical music, and a predilection for fine art.

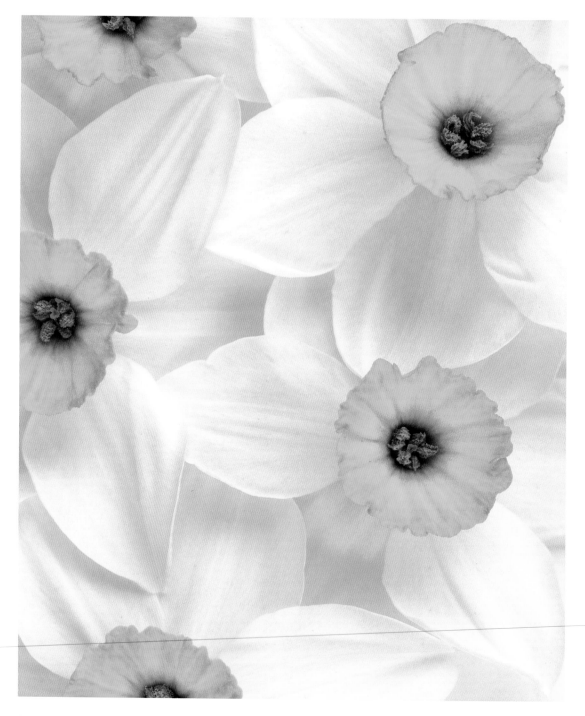

Narcissus 'Jamestown' (Daffodil)

A sublime signal of spring, the appearance of the daffodil is anticipated wherever they grow. You too are well-loved for your positive attitude and your determination to try anything. You are in high demand among your friends and may find yourself over-committed if you accept every invitation.

Amarygia parkeri 'Hathor White' (Belladonna)

The belladonna bursts forth with striking blooms and a heady fragrance, yet it somehow manages to thrive on neglect. This makes you a person of contradictions: beautiful but modest; influential but self-sufficient; with lofty ideals and down-to-earth pragmatism.

Farfugium japonicum 'Crispata' (Crested Leopard Plant)

The yellow petals crowning this flower hint at inner sanguinity. You have a buoyant personality and a disarming sense of humor. Never flashy, you are a steadfast friend. You are drawn to nurture others and capable of producing a feast where others see only famine.

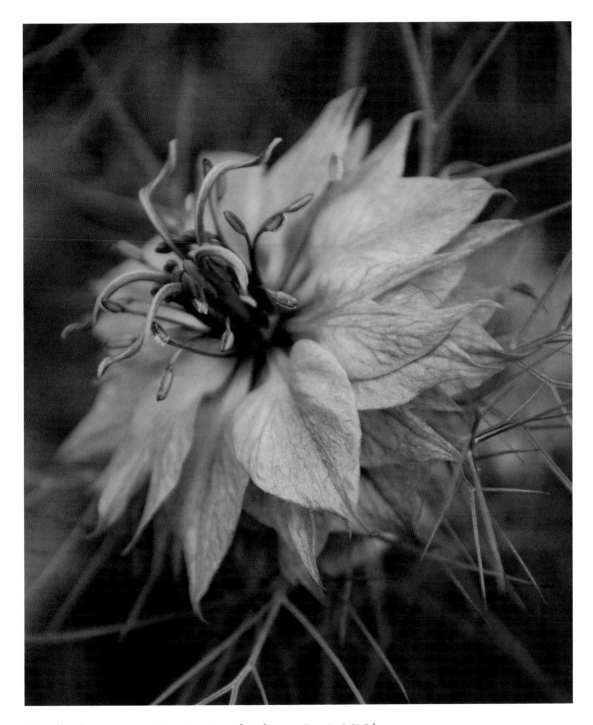

Nigella damascena 'Persian Jewels' (Love-In-A-Mist)

Protected by a crown of chaotically woven leaves the love-in-a-mist flower symbolizes a complex and active mind. You often perplex people, who do not know how to read you. You have a superior air about you that can isolate you but generally those that are intrigued and fascinated by you are the only ones worth hanging on to.

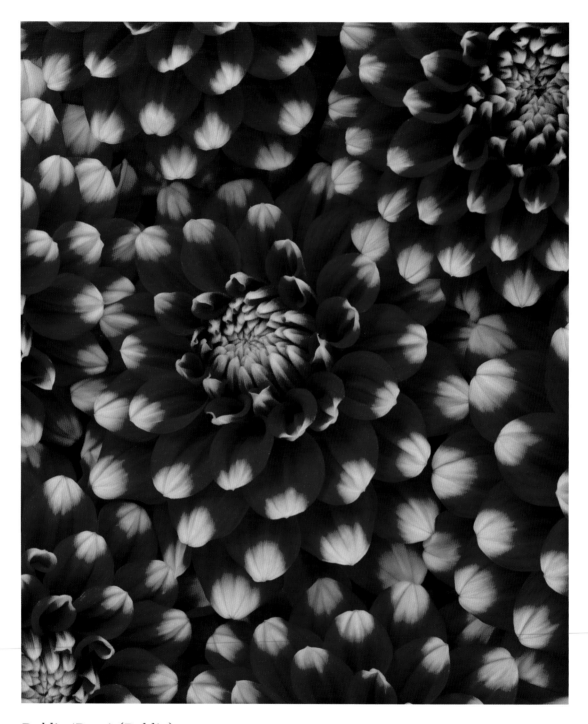

Dahlia 'Duet' (Dahlia)

Like the dahlia 'Duet' you enjoy company and the support of like-minded individuals. Mischievous and fun-loving, you brighten up the room with your sense of spontaneous drama. Friends adore your zest for life, and indulge your tendency to gossip. You are a loyal, if slightly zany, lover.

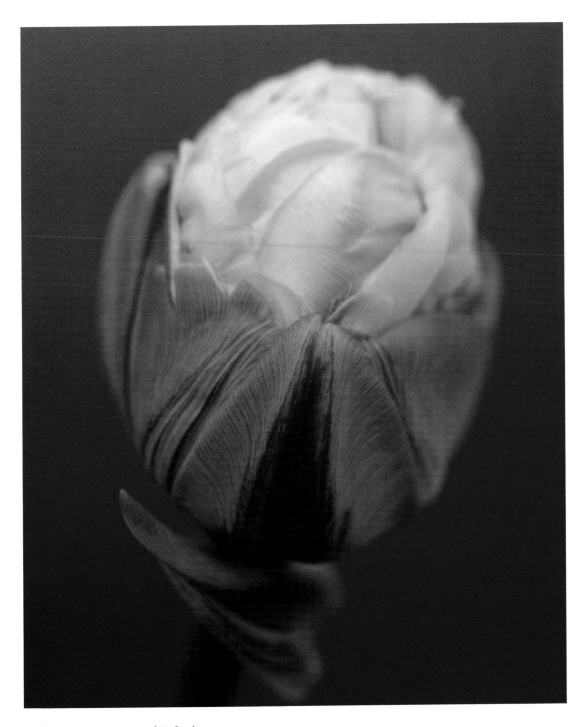

Tulipa 'Ice Cream' (Tulip)

This personality-packed tulip makes those born on this day doubly interesting. Not only do you stand out in a crowd, but you have a caring nature and a keen intellect. You retain a love for nature while being at home in the most culturally rarefied surroundings.

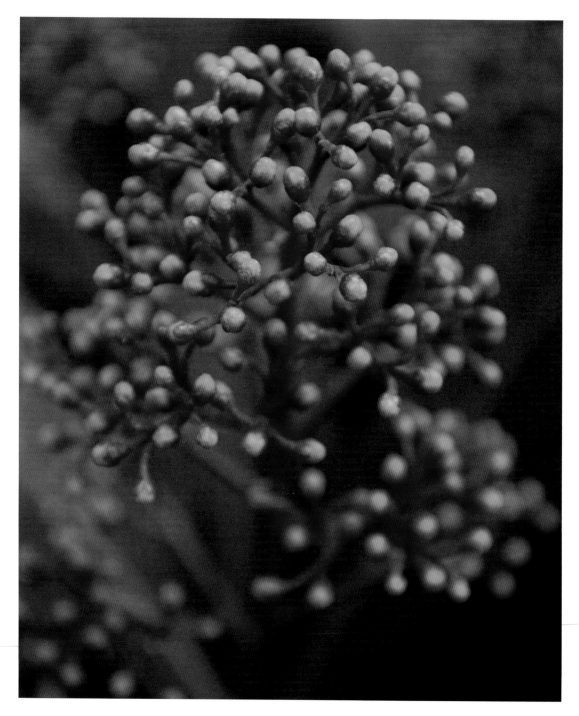

Skimmia japonica (Japanese Skimmia)

As the fragrant white flowers of the skimmia emerge from their glossy red buds its personality shifts from high drama to self-assured calm. Your life may follow the same path, as the unbridled passions of your youth mature to gracious serenity. But you remain capable of extravagance and are an exciting mate.

Camellia japonica 'Lemon Glow' (Japanese Camellia)

The white camellia is synonymous with style. It symbolizes loveliness and an aptitude for patience. You combine these attributes with the powers of discernment and discrimination—the signs of a true fashionista. With 'Lemon Glow' as your flower you are effortlessly chic and disarmingly intellectual.

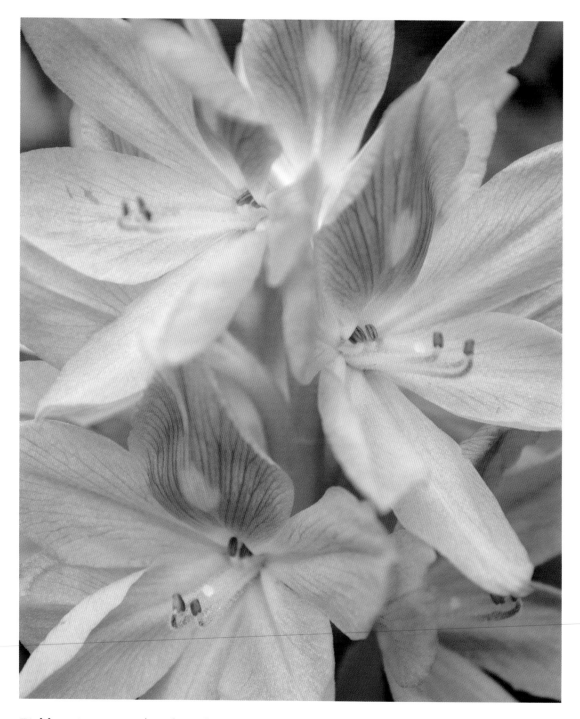

Eichhornia azurea (Anchored Water Hyacinth)

The blousy blooms of this water hyacinth speak of tranquility and mental clarity. You have a calming effect on the people around you and are loved by animals. But the single dot of strong yellow on each bloom highlights your sense of fun, to remind you that no one should be tranquil all the time.

Iochroma cyaneum (Violet Churur)

A favorite with the hummingbird this flower never ceases to bloom. You are happiest when surrounded by your family and friends. You are a herald for new ideas and ways of being, which you enjoy bringing back to your loved ones. You are attractive to many but are actually very choosy about those you let close to you.

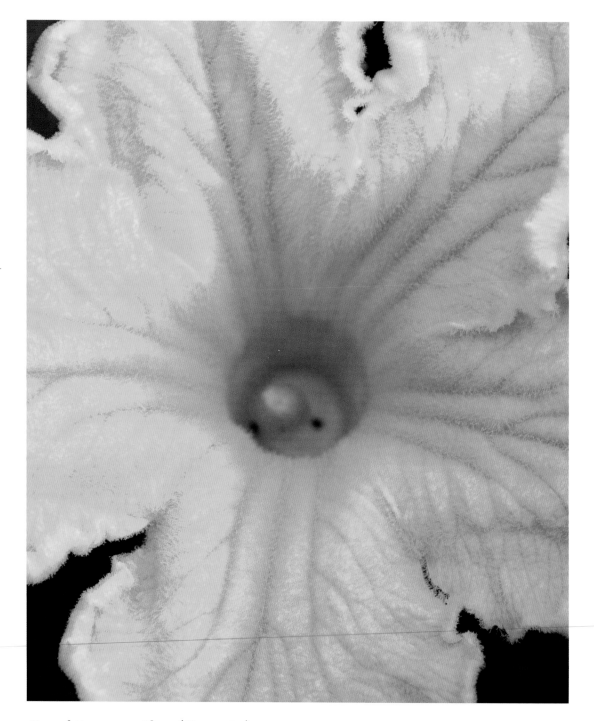

Cucurbita pepo ovifera (Courgette)

The lovely flower of the courgette heralds bounty and sustenance. You offer those you love ultimate protection and nurturing. You never doubt your decisions and believe that all is as it should be. Your common sense and practical approach to life allow you to enjoy the things that really matter.

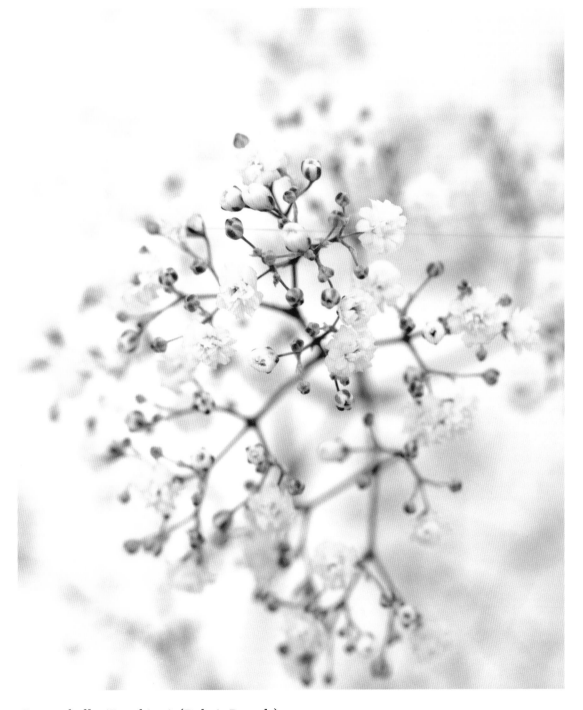

Gypsophylla 'Bambino' (Baby's Breath)

With everlasting love, happiness and a pure heart it is no wonder that you are always a contented member of any community. You love to fit in although you do need your space. If you are left to flourish you will assist and complement those around you.

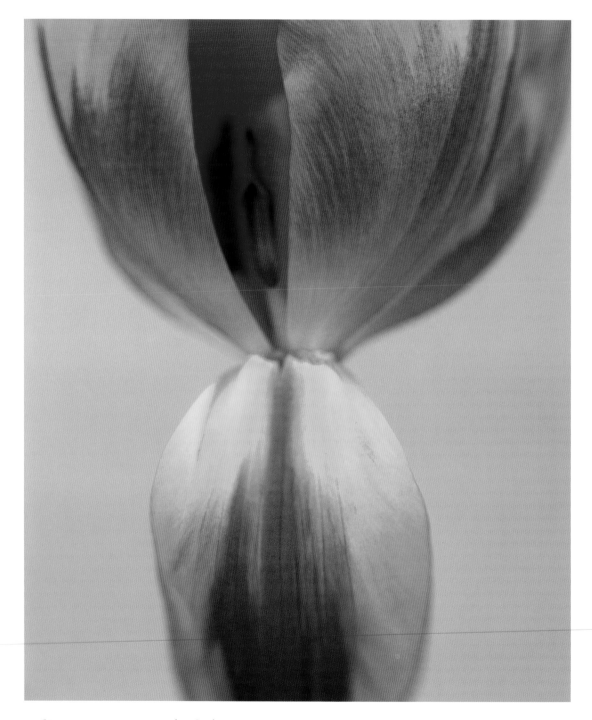

Tulipa 'Prinses Irene' (Tulip)

A true herald of spring, when this tulip blooms it is a magnificent sight. You have a well-developed sense of self-worth which, coupled with your magnetism, makes you irresistible to others. You are prone to self-indulgence, but will learn to exercise a sensible approach to luxury.

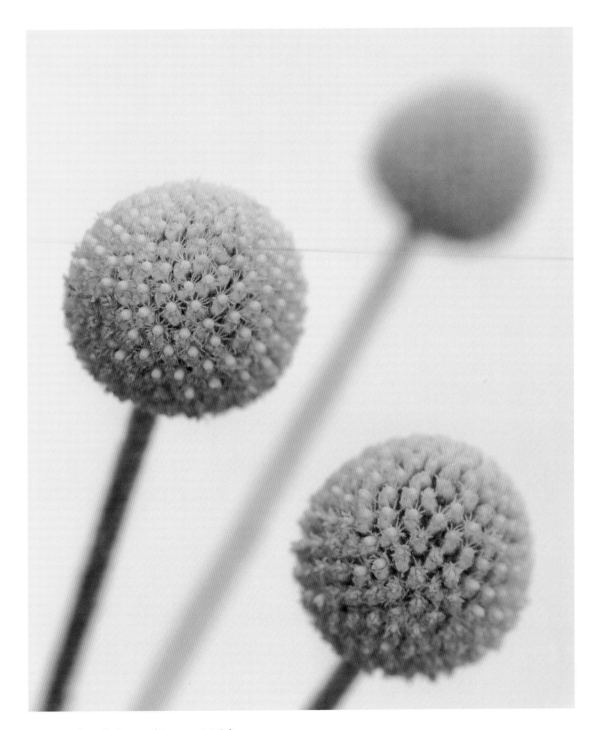

Craspedia globosa (Drumstick)

Just like the sun, people love to be caught in your orbit. You love to share your delight in the simple things and are therefore a natural homemaker. Your sense of playfulness is contagious and you seem to bounce around like a pollen-laden bee from flower to flower.

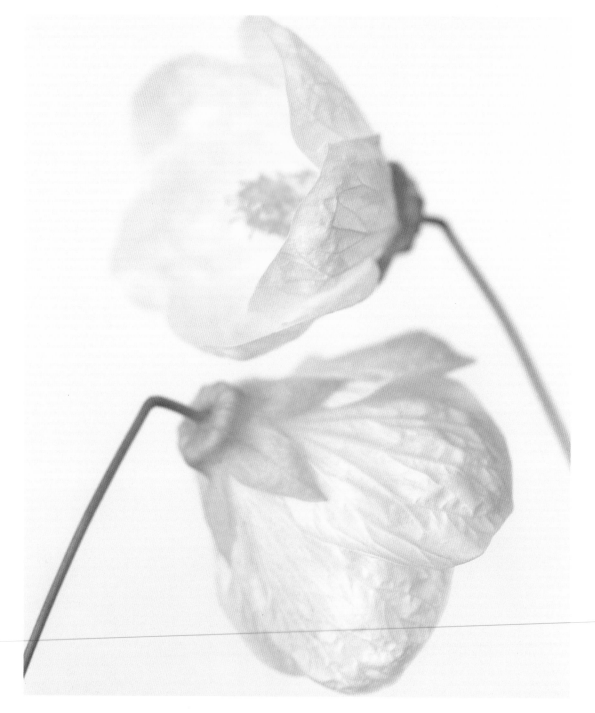

Abutilon 'Blanca' (Chinese Lantern)

The white Chinese lantern is exotic yet demure. Though you appear to be delicate, you have an inner strength and an extremely capable mind. Clarity of thought is your greatest gift, especially when combined with your natural optimism. Friends often seek your wise and uplifting advice.

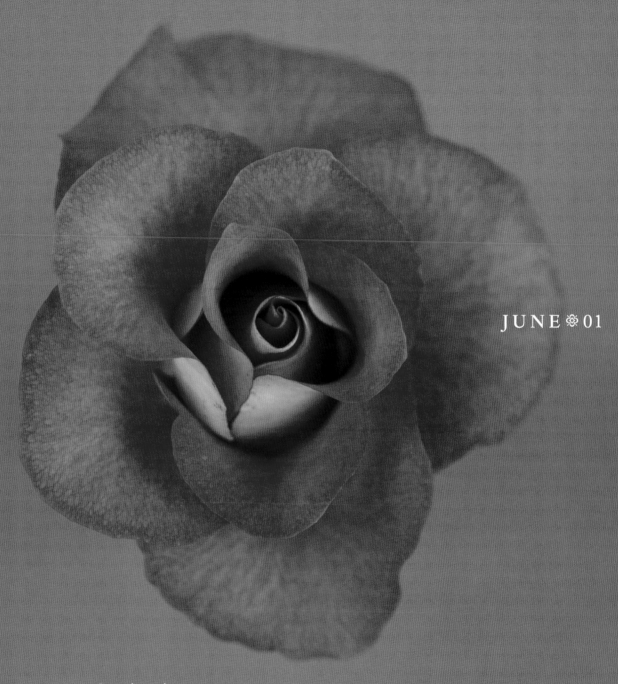

JUNE ❀ 01

Rosa 'Leonidas' (Rose)

As a symbol of both luck and healing the rose is a fortunate companion. With your magnetic charm, you effortlessly collect friends who adore you. Self-contained, you shun interdependence, but you reward others generously with your love. With lion-like confidence, you are unfailing even in times of trial and tribulation.

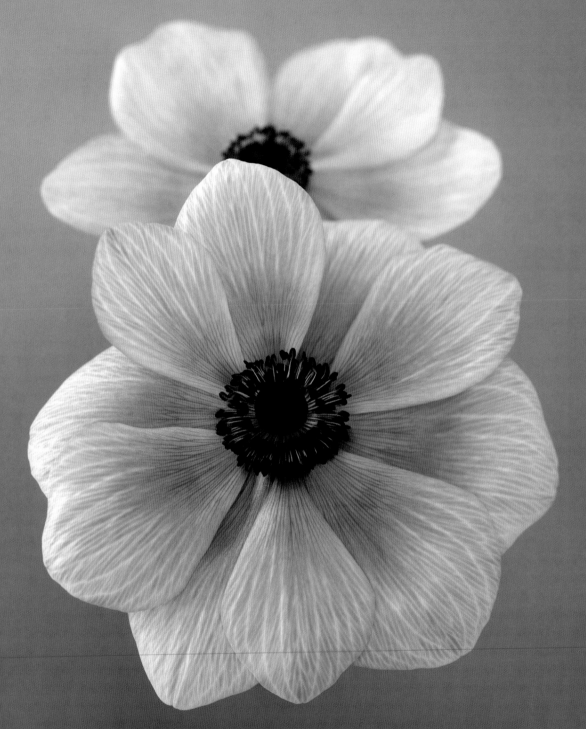

Anemone 'Mona Lisa' (Poppy Anemone)

Like the poppy anemone you are an enigmatic beauty—it is not easy to tell what is on your mind. You are imaginative and inclined to daydream, and sometimes have difficulty separating real life from fantasy. You will find the luxury you desire when you clarify your thoughts and truly connect with those who adore you.

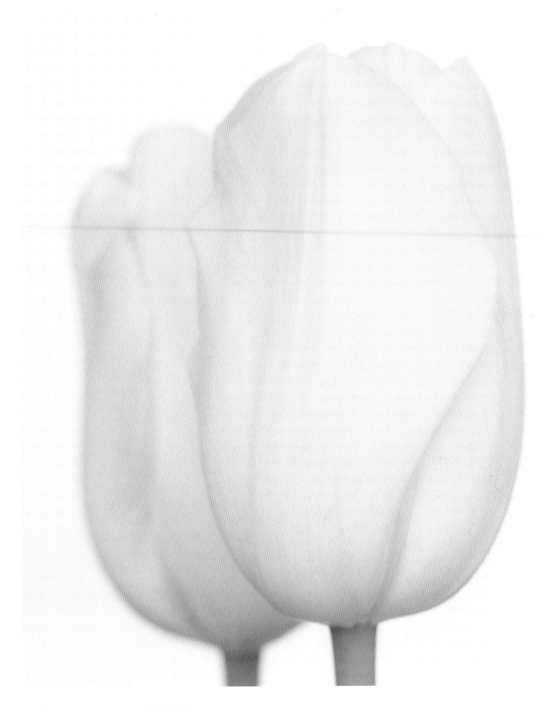

Tulipa 'Maureen' (Tulip)

With its refined shape and purity of color, this tulip exudes tranquility and self-awareness. You are an enlightened individual and, as a result, your opinion is often sought by those around you. You have a love of the arts and are often involved in creative pursuits.

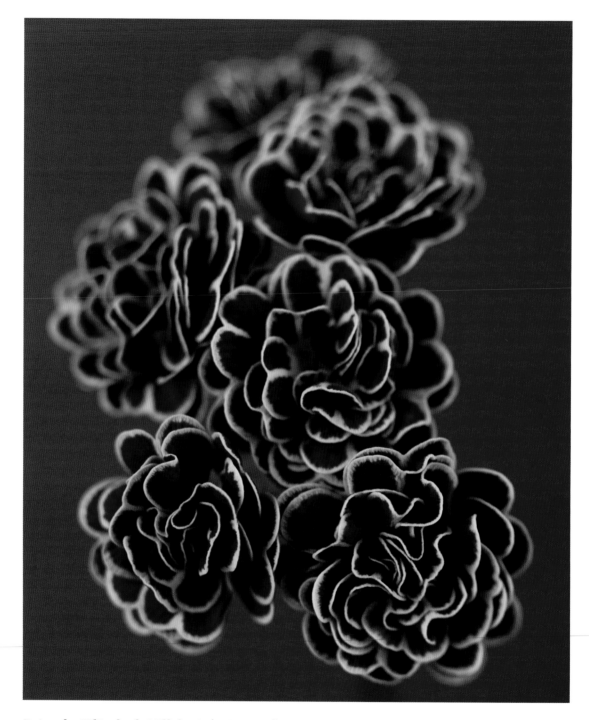

Primula 'Elizabeth Killelay' (Primrose)

One of the first to welcome the spring, the primrose is an anticipated and cheerful sight. You are always on time and looking your best. Your multiple talents and interests keep you very busy, as is your want. You thrive in challenging situations where you have to rely on your experience and plentiful skills.

Ranunculus asiaticus 'Bloomingdale' (Persian Buttercup)

The symbolism of this bloom rests mainly in its prolific petals. You are a complex and generous person. You have much to share and love to give. You thrive on responsibility and those around you rely on you heavily. You are rewarded by the great pleasure you get from your more refined endeavors.

Protea cynaroides (King Protea)

Named for the Greek god Proteus who could change his shape at will, the king protea imbues you with a capricious nature. You enjoy diversity and seek adventure. But you are happiest with the support of a loyal partner, who brings stability and commitment into your life.

Arisaema sikokianum (Japanese Cobra Lily)

The Japanese cobra lily is one of nature's most dramatic plants and you share its exquisite appeal. You are worldly and sophisticated with a passion for art and literature. However your carefully constructed appearance belies your tenderness and your need to be nurtured.

Tulipa 'Insulinde' (Tulip)

The open and variegated petals of the tulip 'Insulinde' reveal that you are more relaxed and less secretive than other tulip people. Your beautiful eyes can see more than most as you have a keen intuition. You are a gentle and loving person, and people often seek your advice.

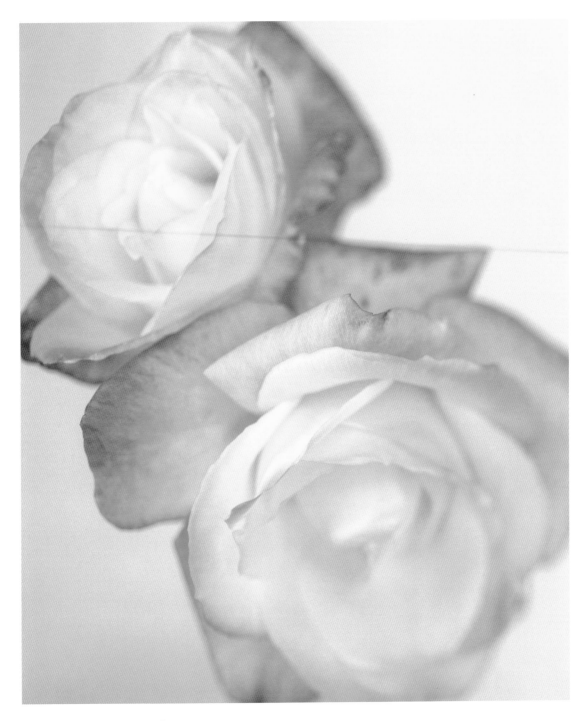

Rosa 'Camille' (Rose)

The 'Camille' rose expresses nurturing and unselfish love. You are warm and generous with a calm and soothing nature. Your quiet strength may be underestimated at times, but you are highly valued by those you love for your extraordinary ability to overcome emotional difficulties. You will find success when you follow your heart.

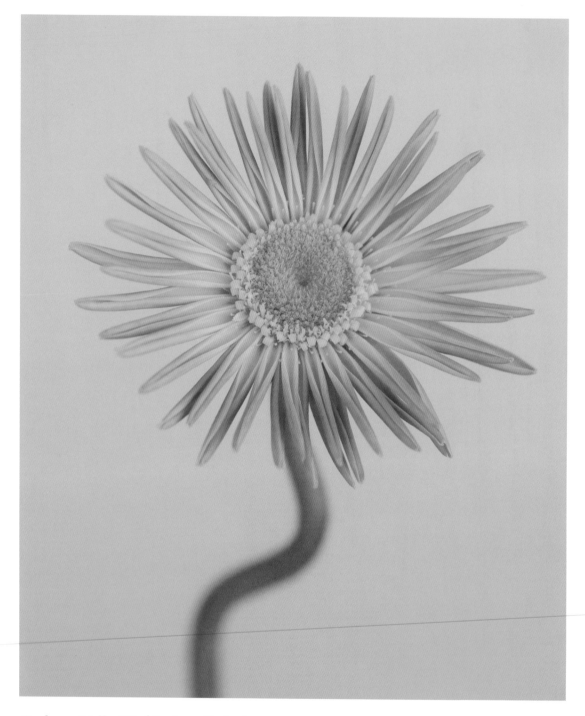

Gerbera 'Kelly N.' (Gerbera Daisy)

Gerberas are modern and exciting flowers. You are a jewel-like individual with many admirers. You are in your element when you are outdoors indulging your love of nature but are equally at home at black-tie events. Versatility and impact, coupled with a sunny disposition, are your key traits.

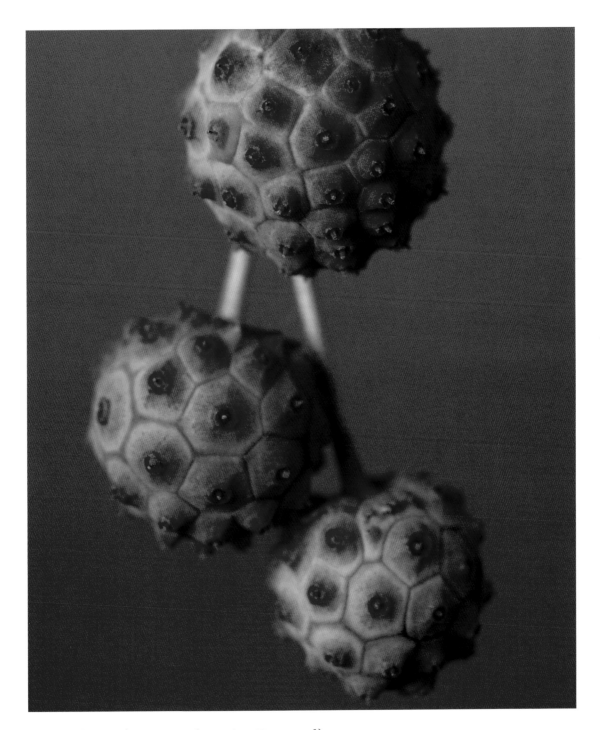

Cornus kousa (Japanese Flowering Dogwood)

The Japanese flowering dogwood is the symbol of tenacious beauty, with its elegant flowers and vibrant fruits. You too are unusually striking and will attract the attention of people with an artistic bent. You are blessed with excellent health and a fertile mind, and will keep your good looks through every season of your life.

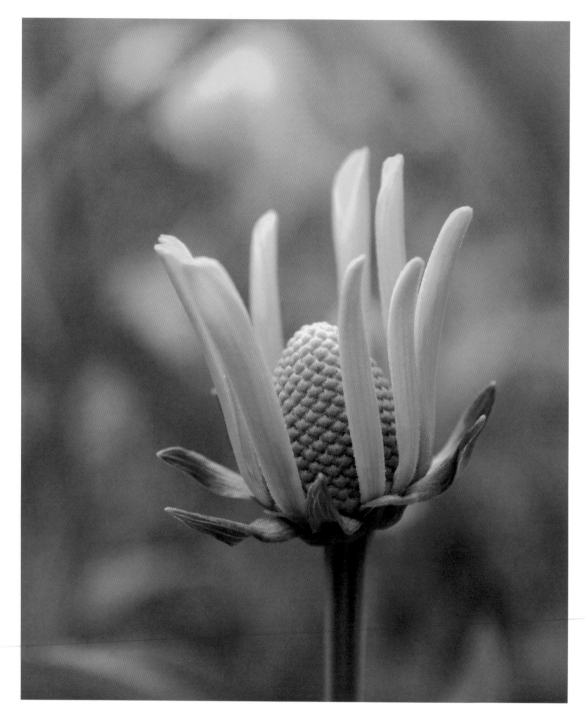

Rudbeckia laciniata 'Herbstsonne' (Cutleaf Coneflower)

Promise and potential are embedded in the symbology of this flower. Most people would feel blessed with just a fraction of your knowledge, skills and physical prowess. You enjoy sharing your gifts and find fulfillment of your talents in these exchanges. With your cheerful disposition, every day is sunny.

Rosa 'Lagowski' (Rose)

The 'Lagowski' rose symbolizes unconscious beauty. Compassionate and kind, you are sometimes unaware of the extent of your loveliness, though it is obvious to those around you. You are a deep thinker with the ability to lift spirits and inspire your friends towards lofty goals.

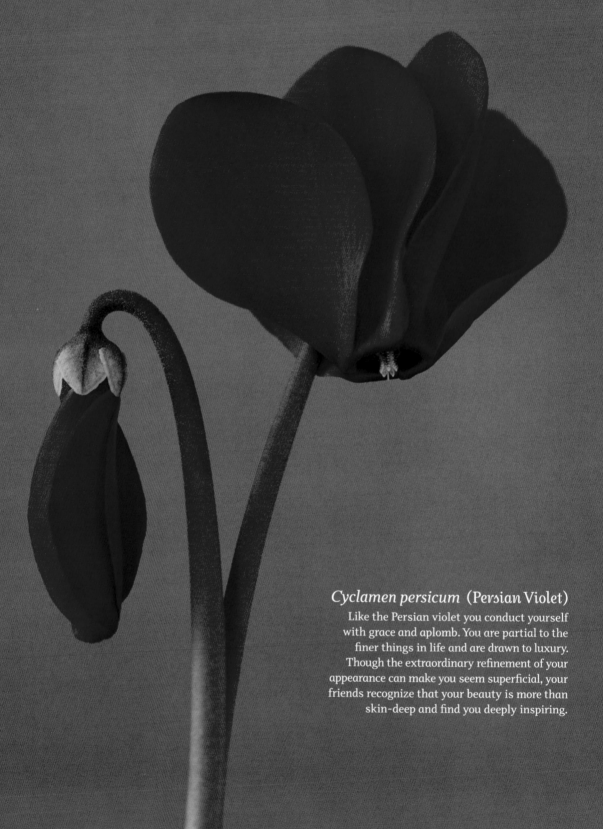

Cyclamen persicum (Persian Violet)

Like the Persian violet you conduct yourself
with grace and aplomb. You are partial to the
finer things in life and are drawn to luxury.
Though the extraordinary refinement of your
appearance can make you seem superficial, your
friends recognize that your beauty is more than
skin-deep and find you deeply inspiring.

Magnolia grandiflora (Southern Magnolia)

There are few flowers that can match the glory of the southern magnolia. You are the pride and joy of those who love you as you are consistently generous and graceful. Your noble bearing means that others will go out of their way to assist you—you are blessed.

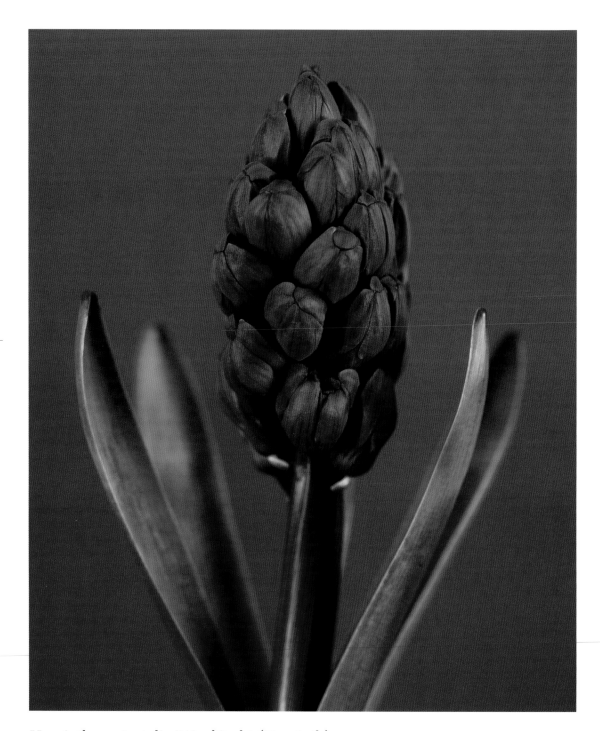

Hyacinthus orientalis 'WoodStock' (Hyacinth)

Like all hyacinth people you are fragrant and cheerful with a refreshing perspective on life. But you keep your natural spontaneity in check and have yet to reach your full potential. When you allow others to see your passionate nature in its full glory you will astonish them.

Tulipa 'Pink Parrot' (Tulip)

The slightly ruffled edges of the 'Pink Parrot' tulip represent your ability to bring calm to heated situations. With your nurturing nature and your unselfish love you make a perfect partner. You have a fascination with the finer things in life, which may need watching in case of overindulgence.

Agapanthus africanus (African Lily)

With its skyward-reaching flower the agapanthus symbolizes generosity and devotion. You are a caring person and your healing touch is often sought by friends in need. You offer your support unselfishly, using your positive qualities for the betterment of all. Your generosity makes you dependable and enduring.

Amarygia 'Marie Louise' (Belladonna)

The belladonna is colloquially called the 'naked lady,' but any thought of impropriety is entirely misleading. Though you stand head and shoulders above the crowd, you are an undemanding and self-contained beauty. You are long-lived and thrive with little attention, preferring to stay out of the spotlight.

Calluna vulgaris (Heather)

Branches of heather were traditionally used to sweep the hearth and confer to you the talents of an earnest and thrifty homemaker. But you are also a free spirit, and take great pleasure from exploring beyond the well-travelled path. This curious blend makes you a wonderful parent and a passionate lover.

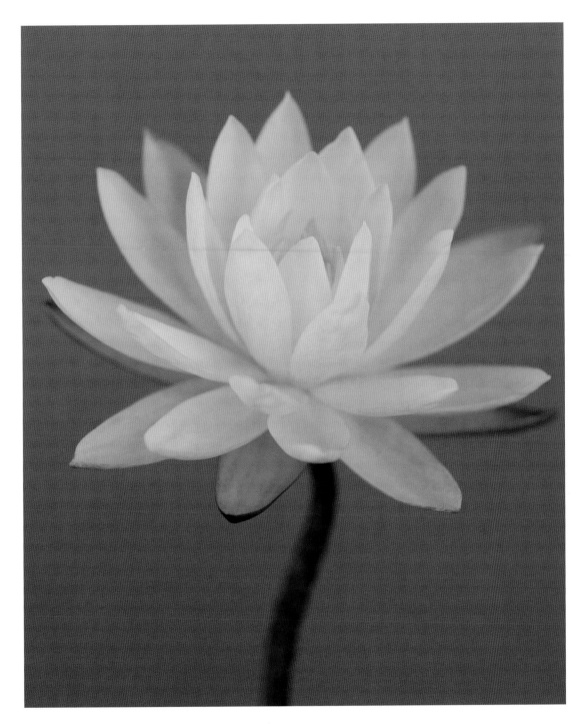

Nymphaea 'Texas Dawn' (Water Lily)

A water lily is like a star fallen from the sky to rest on the water. Here you shine brightly with a pure heart. Reflecting the beauty of those around you, you are never short of friends and admirers. Your truth and optimism ensures you leave an impression.

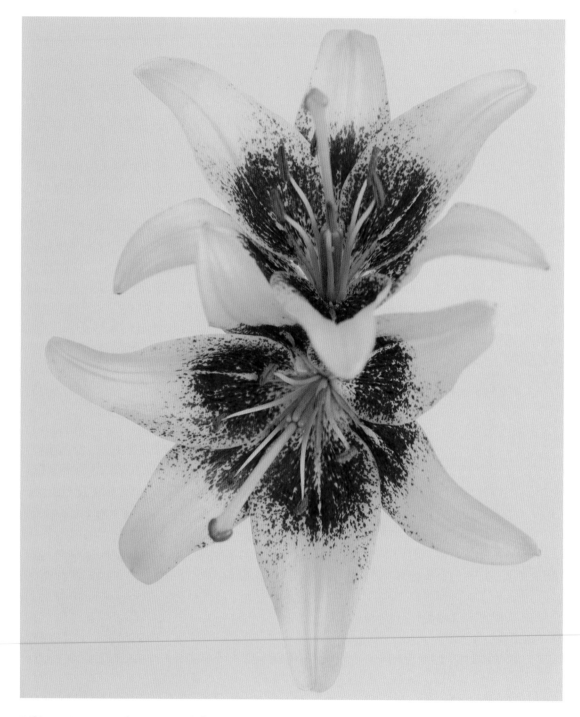

Lilium 'Latvia' (Asiatic Lily)

The powerful presence of this bloom belies a tender heart. You hold the attention of those around you with your unwavering positivity. Just as the Asiatic lily brings joy, you too can light up a room. Those closest to you are privy to your more sensual side.

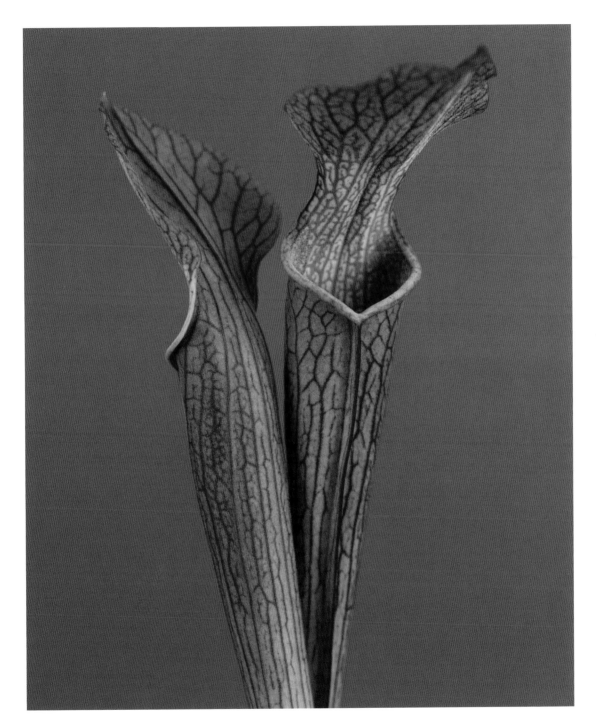

Sarracenia rubra ssp. jonesii (North American Pitcher Plant)

The design and statuesque beauty of this plant disguises its inherent intelligence. You are a focused individual and you know how to get what you want. Your charms and devices are so prolific that if at first you do not succeed, it will be only a matter of time before you do.

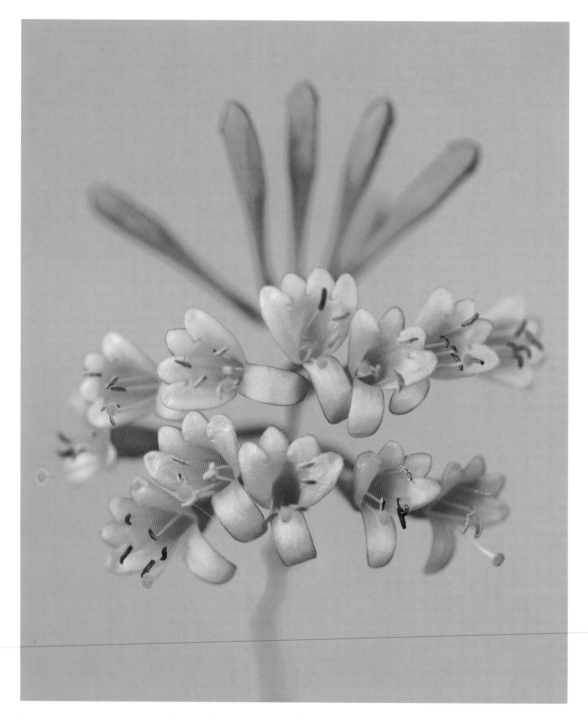

Lonicera sempervirens (Coral Honeysuckle)

Loved by hummingbirds, this merry cluster symbolizes generous and devoted affection. You have a sweet disposition which endears you to many. You are most content surrounded by family and those with whom you have a lot in common. You sweetness is pervasive and you are often thought of as innocent.

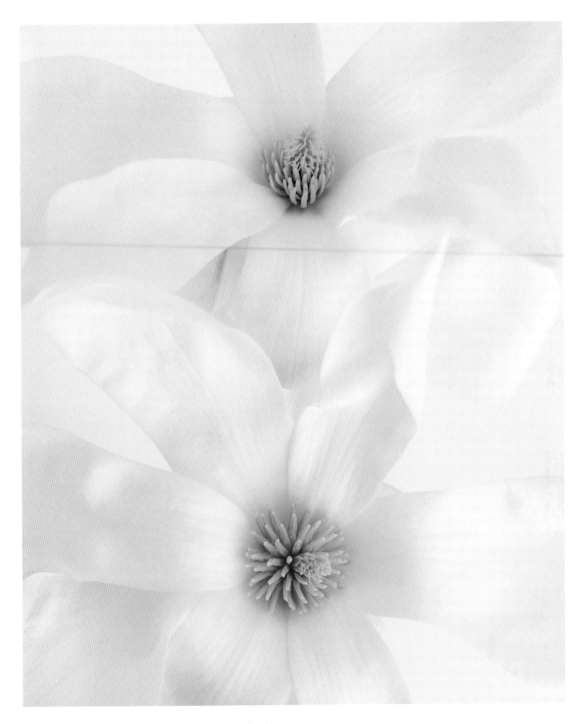

Magnolia denudata (Yulan Magnolia)

The serene majesty of the Yulan magnolia is enhanced by its beautiful white blooms and its subtle perfume. You have a soulful outlook on life which is guarded by your pure spirit. You surprise people as they initially do not notice you, but once they do you are unforgettable because you affect all their senses.

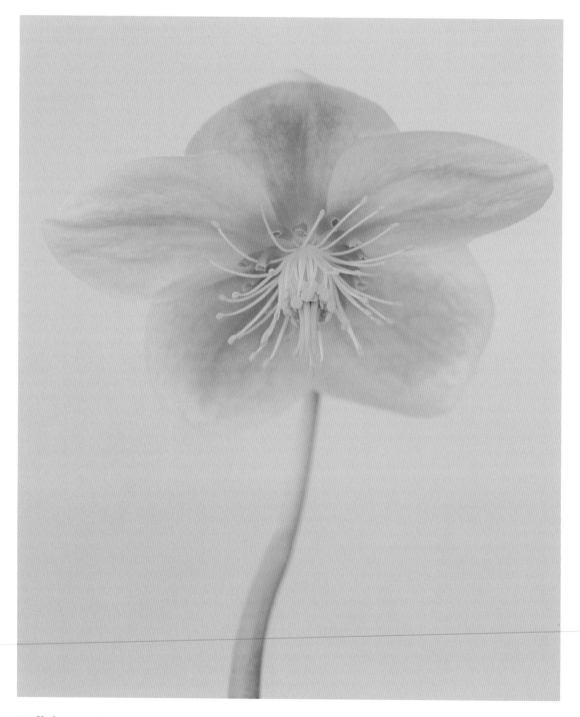

Helleborus nigercors 'White Beauty' (Lenten Rose)

White is the color of purity and insight, honesty and integrity. You have a keen and clear intellect and a disarmingly steady gaze. Though some people find you intimidating, those who choose to flock to you prove worthy of your love and will return it willingly.

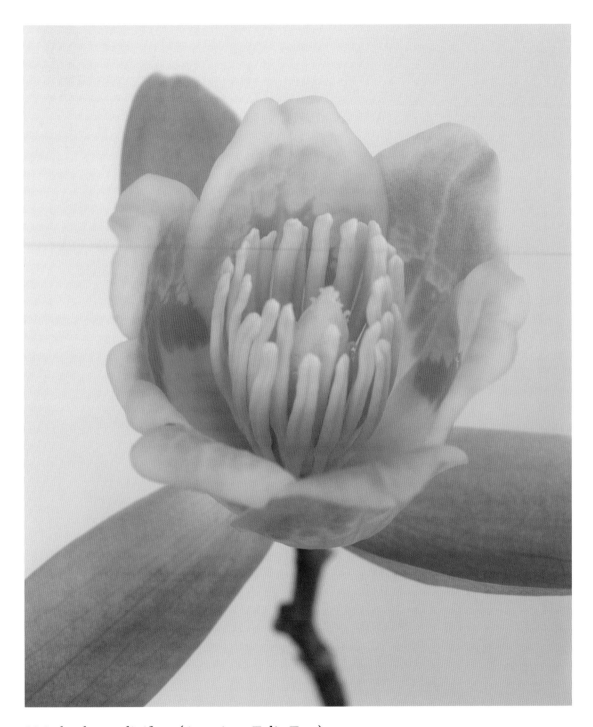

Liriodendron tulipifera (American Tulip Tree)

With its internal strength and conspicuous flower, the liriodendron symbolizes stability and efficiency. You are a person of great integrity with a strong sense of self. You are quick to assess situations and turn them to your advantage. You enjoy people of all ages and are happiest when your home is full of friends and loved ones.

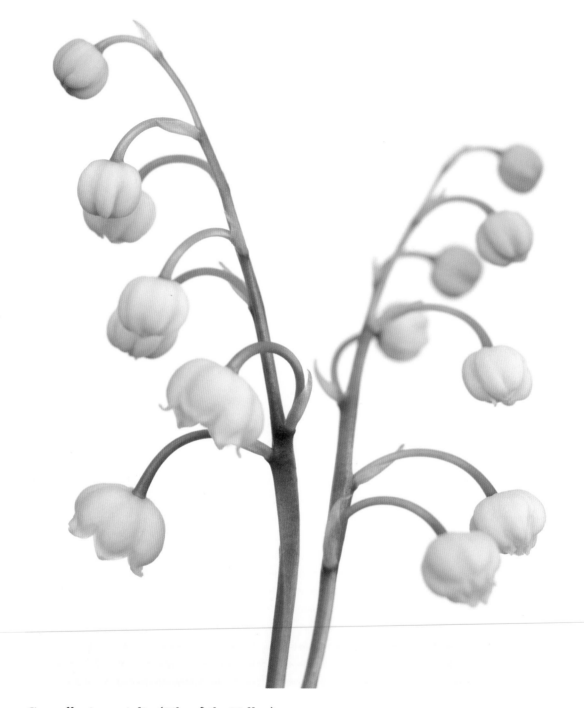

Convallaria majalis (Lily of the Valley)

This beautiful flower evokes innocence and frailty, but these characteristics, though true also in their human counterpart, are coupled with a fast mind capable of great empathy. Like the flower, you are able to thrive with little sustenance—you are self-contained and self-reliant.

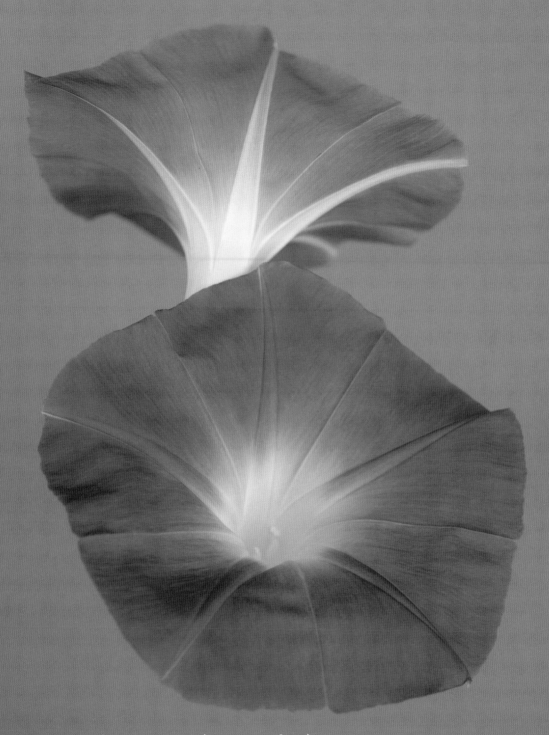

Ipomoea tricolor 'Karen M.' (Morning Glory)

You are keen and energetic and like to throw yourself into every day with unbridled enthusiasm. Your delicate constitution is challenged by the quick pace you set for your life, so you must guard against exhaustion and negativity. Your friends enjoy your passion for life and are always willing to assist you when you need them.

Haemanthus albiflos (Paintbrush Plant)

You are a quiet soul with a talent for the arts. You are well grounded with an intelligent and inquisitive mind. Though you enjoy the companionship of your peers, you also need time alone. You are disinclined to travel and produce your greatest work within the confines of your own home.

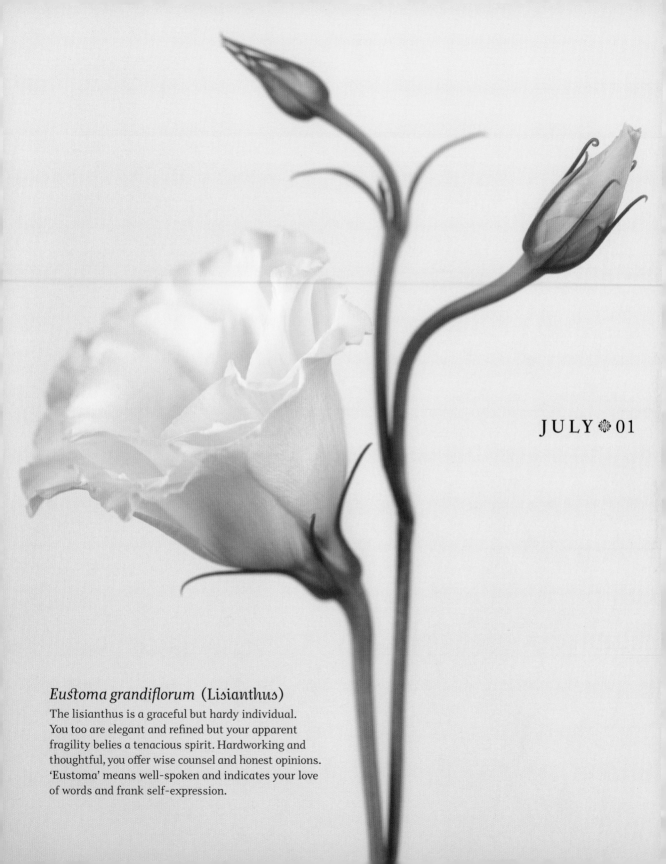

JULY ❋ 01

Eustoma grandiflorum (Lisianthus)

The lisianthus is a graceful but hardy individual.
You too are elegant and refined but your apparent
fragility belies a tenacious spirit. Hardworking and
thoughtful, you offer wise counsel and honest opinions.
'Eustoma' means well-spoken and indicates your love
of words and frank self-expression.

Podophyllum difforme 'Kaleidoscope' (Asian Mayapple)

The mayapple's flowers are often overshadowed by the huge dappled leaves for which it is commonly grown. You are a quiet, observant person but you are also sensual and mysterious making you intiguing and exceptional. You gather those of a like mind close to you and together you relish the more arcane delights of life.

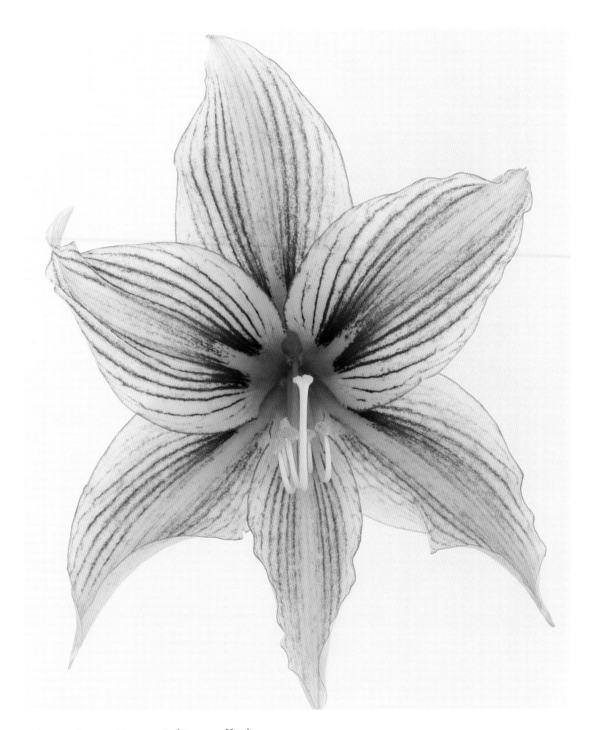

Hippeastrum 'Amare' (Amaryllis)

The very name of this flower means 'to love,' and you have certainly taken this to heart. You combine passion and warmth with happiness and a capacity for clear thinking. This sweet package makes you a popular companion, but you must be sure to protect your need for solitary time and to nurture your love of nature.

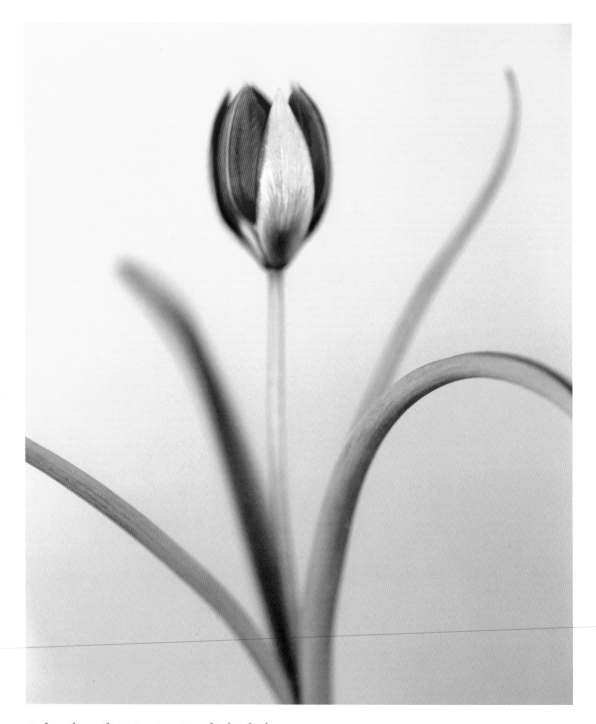

Tulipa humilis 'Persian Pearl' (Tulip)

Like the 'Persian Pearl' you are an original, yet you embody all the classical characteristics of the tulip. You love luxury, you are intelligent and you are passionate. You have an air of mystery about you, yet you are sincere, honest and loyal in love.

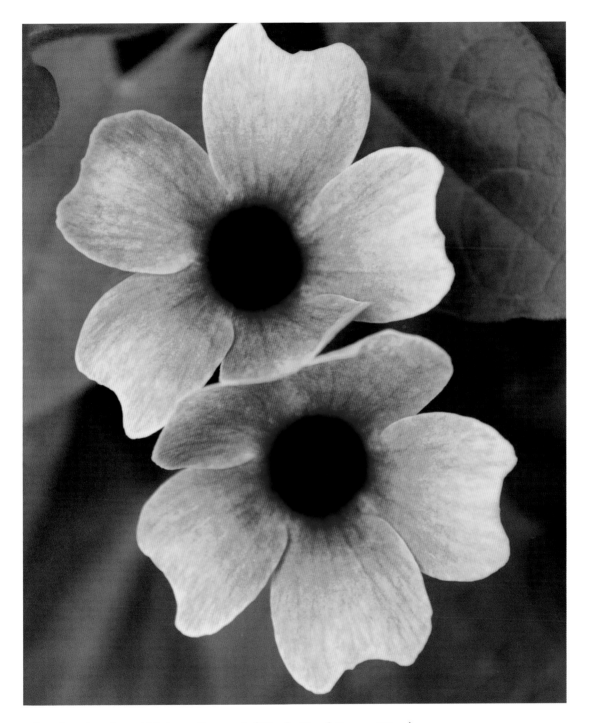

Thunbergia alata 'African Sunset' (Black-Eyed Susan Vine)

The 'African Sunset' is a delicate flower, but will bloom repeatedly if it is protected from the cold. When you too are well nurtured you are capable of grand displays of warmth and generosity. With your depth of wisdom and ability to change your looks to suit the season, you are sure to age gracefully.

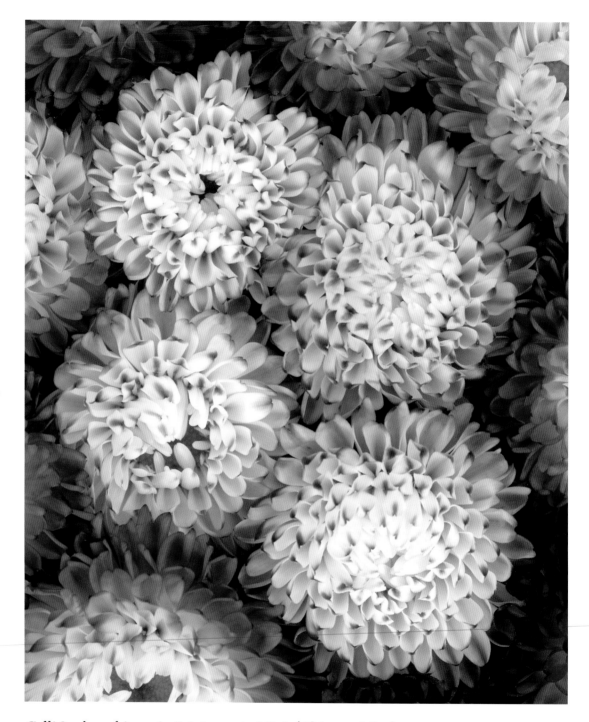

Callistephus chinensis 'Matsumoto Mix' (Chinese Aster)

Though the aster traditionally signifies love and daintiness, you are remarkably enthusiastic and outspoken. There is a complexity to your personality that others find fascinating. Your tendency to drift off into daydreams merely adds to your appeal, giving you an air of mystery and depth.

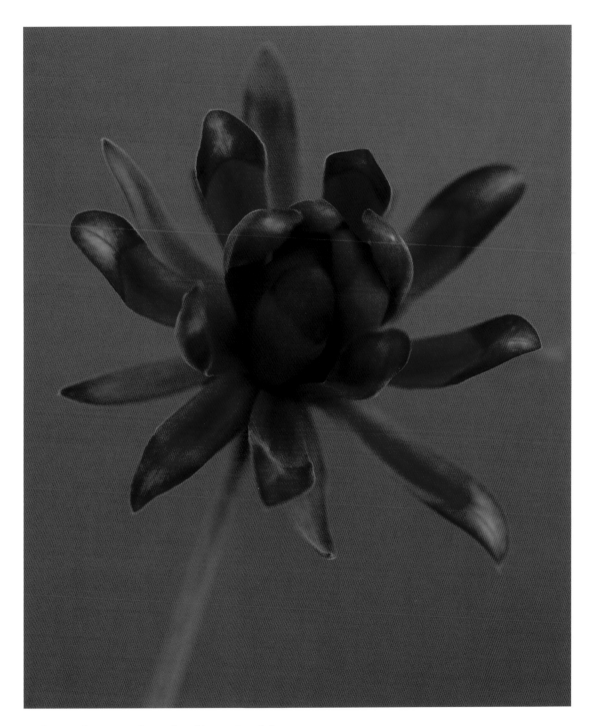

Calycanthus occidentalis (Spice Bush)

With its beauty and a pinch of culinary uses, this enchanting bloom has hidden talents. Representing fiery passion and memory, you definitely leave an impression wherever you go. You have a classical charm that is totally disarming and when you reveal the depths of your individualism people recognize you as a trailblazer.

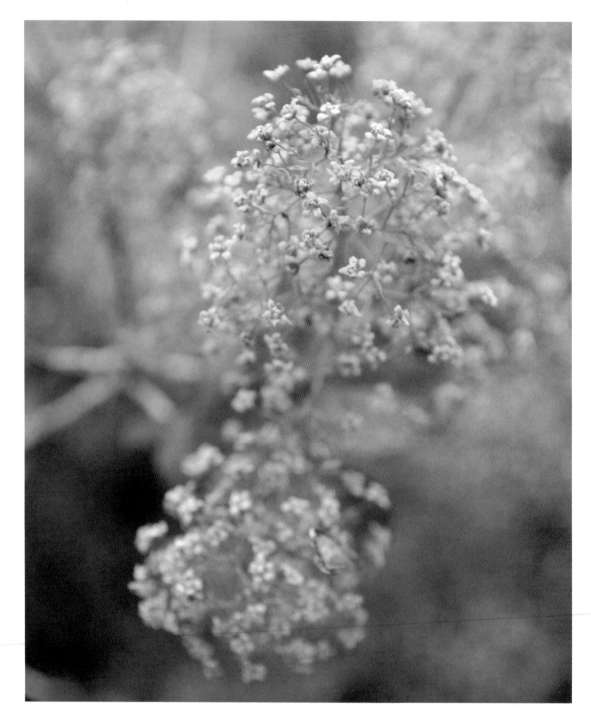

Cotinus coggygria 'Velvet Cloak' (Smoke Tree)

The smoke tree takes its name from its plume-like flowers, which stand out like cotton candy against its dark purple leaves. You share this almost ethereal appeal, bringing the suggestion of frivolity to serious surroundings. You are inspiring and self-contained, thriving on little but offering a loving personality.

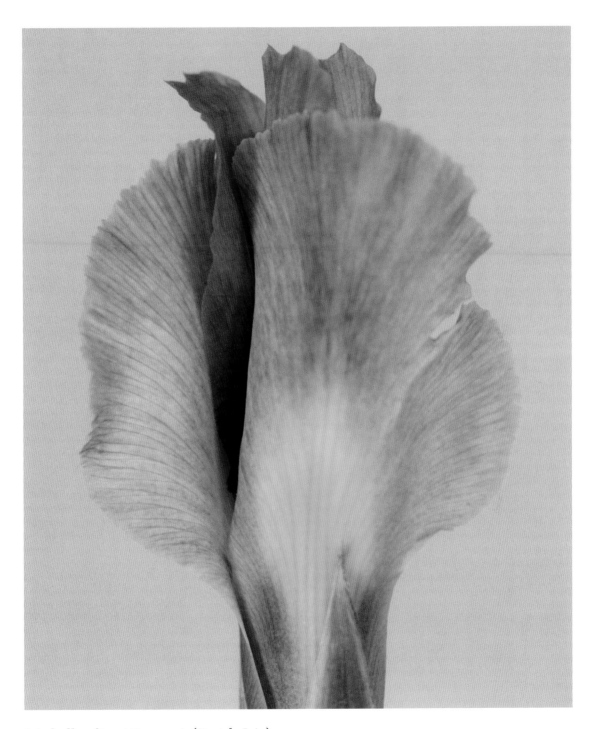

Iris hollandica 'Carmen' (Dutch Iris)

The iris speaks of wisdom and valor: serious qualities for a serious individual. Though you flirt with enthusiasm you tend more often toward quiet contemplation. You are drawn to people who can benefit from your sage advice, and offer steadfast guidance and support to people in need.

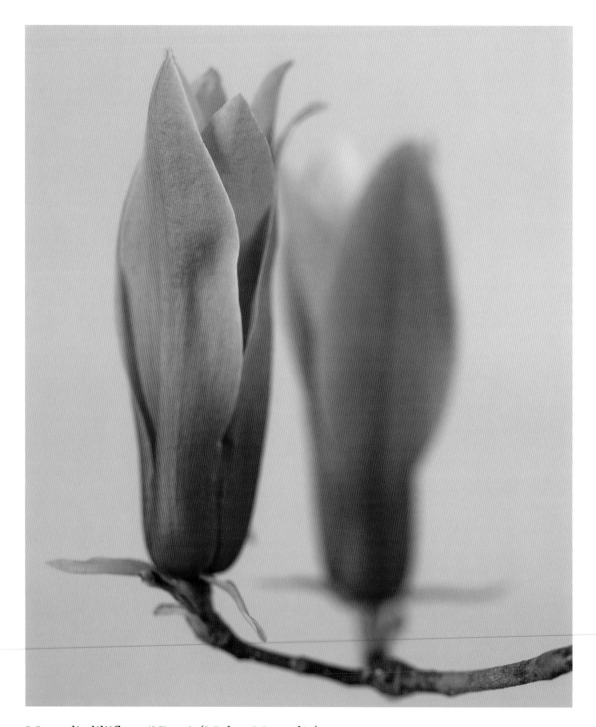

Magnolia liliiflora 'Nigra' (Mulan Magnolia)

The Mulan magnolia bursts forth with glorious flowers every spring. You too like to present yourself well, especially when you know that others are looking. You are attractive and practical and enjoy the simple things in life. You can blend into a crowd but when you want to be noticed you are irresistible.

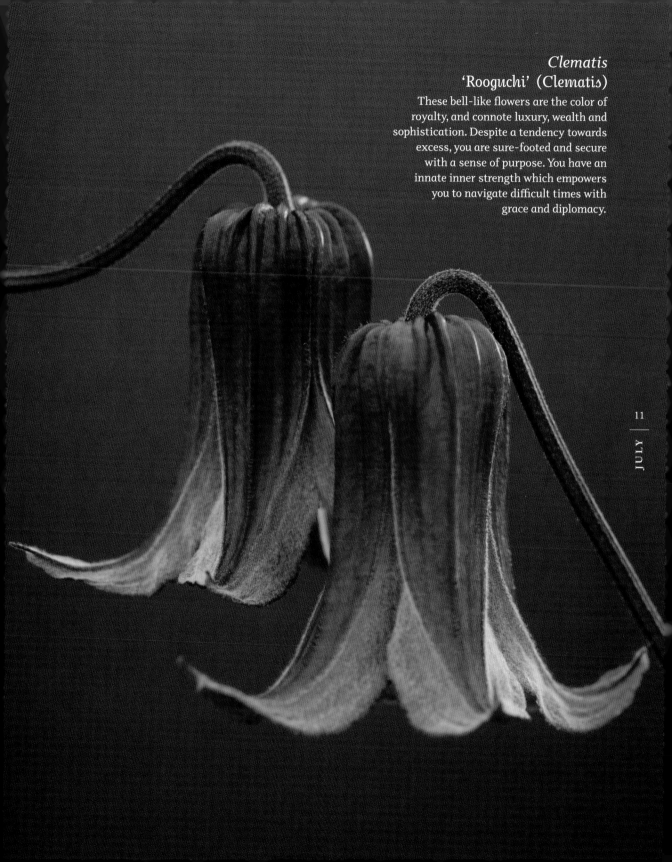

Clematis
'Rooguchi' (Clematis)

These bell-like flowers are the color of royalty, and connote luxury, wealth and sophistication. Despite a tendency towards excess, you are sure-footed and secure with a sense of purpose. You have an innate inner strength which empowers you to navigate difficult times with grace and diplomacy.

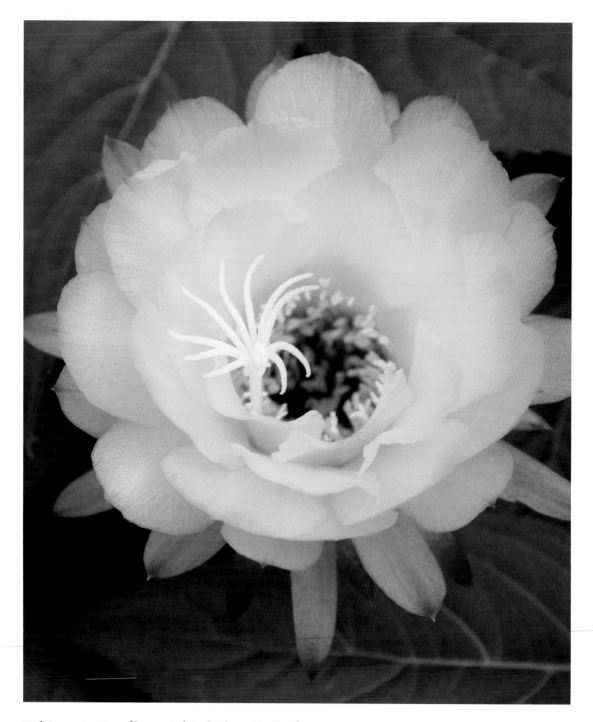

Echinopsis 'Sunflower' (Hedgehog Cactus)

Bright yellow flowers symbolize unbridled joy. Though you sometimes present your prickly side, when you bloom you reveal your true enthusiasm for life. Those who know you best appreciate your ability to transform the mundane into the uplifting and admire your reserves of energy.

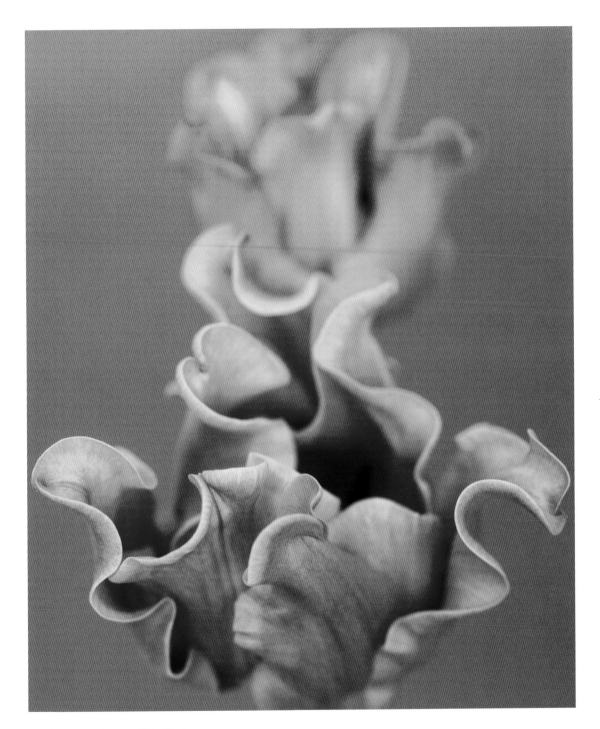

Tulipa 'Picture' (Tulip)

This flamboyant flower embodies the luxury and elegance that tulips are famous for. You have a strong sense of identity which is complemented by a capacity for selfless love. The color pink ensures you will never be lonely, while this tulip's undulating petals belie a tendency towards extravagance.

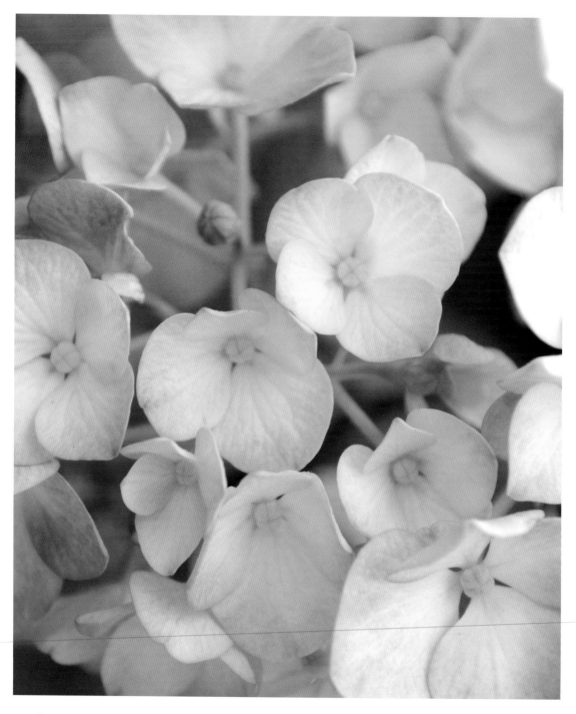

Hydrangea macrophylla 'Endless Summer' (Lacecap Hydrangea)

A symbol of thanks, the hydrangea is a gracious flower. You are often called on for your warmth and wisdom. A true friend, you are appreciated and well-loved by those near you. Like a chameleon you have the ability to change yourself to suit any environment. In this way you reflect the essence of what surrounds you.

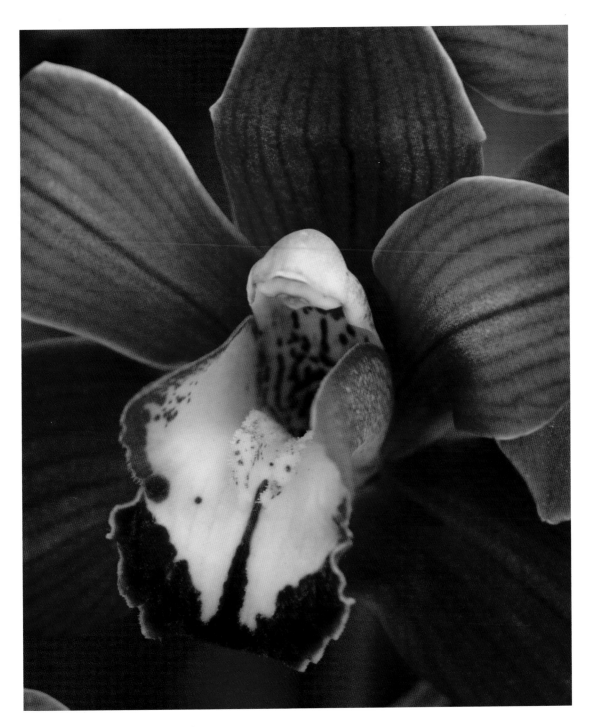

Cymbidium (Boat Orchid)

Ancient yet refreshingly modern, the orchid never fails to charm. With experience comes creative problem solving and judicious decision making, two things at which you excel. You are able to thrive on very little sustenance but this is in no way indicative of your own capacity to give.

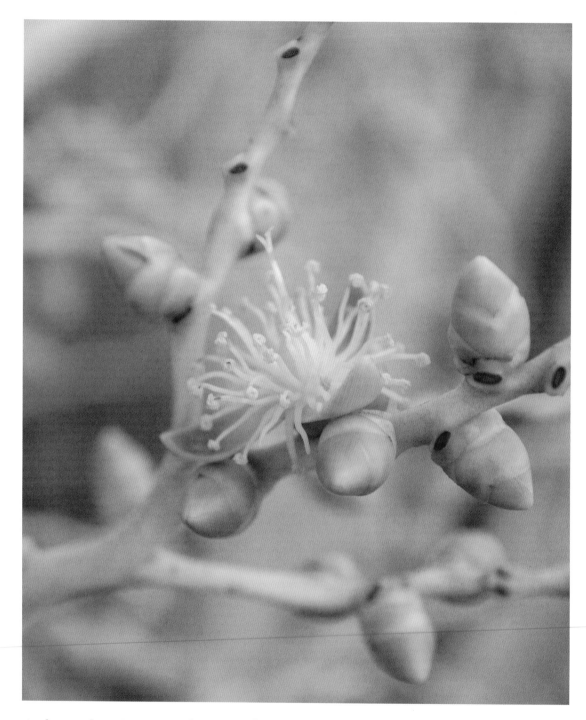

Archontophoenix cunninghamiana (Bangalow Palm)

These delicate flowers crown the lofty heights of the slender Bangalow palm. They endow you with subtle yet exotic looks. You adapt quickly to new environments and are unusually capable of both settling down and being easily uprooted. These qualities make you an excellent traveler and a flexible and inspiring homemaker.

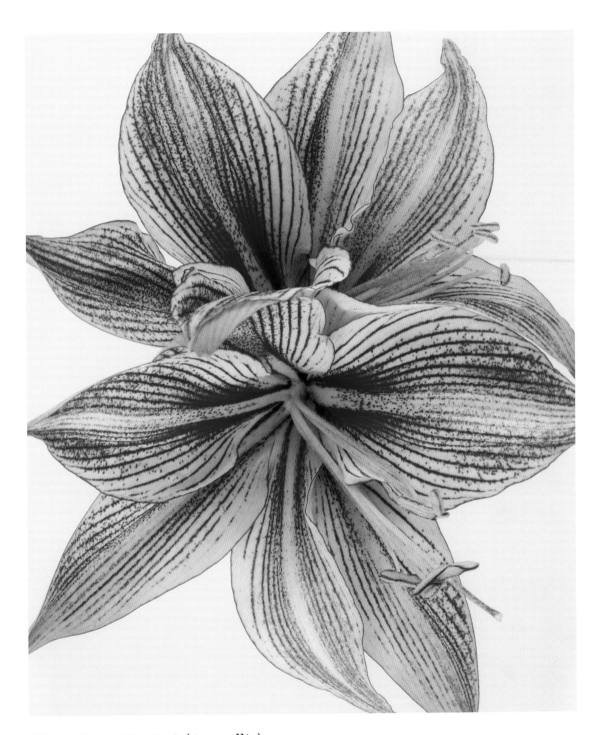

Hippeastrum 'Exotica' (*Amaryllis*)

You are confidence personified. You have strength of character and an ebullient and passionate personality. Though your complex good looks attract many admirers, your truest friends are those who appreciate your moments of great wisdom.

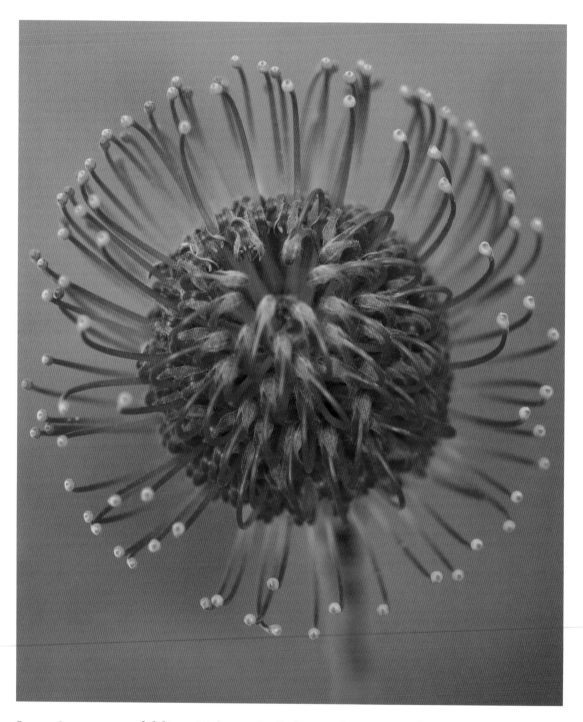

Leucospermum cordifolium 'Salmon Bud' (Pincushion Protea)

Like the phoenix from the flame this glorious bloom will only germinate in the wild after fire has cleansed the earth. Representing simultaneous destruction and rebirth, your energy is intense and confronting. You hold a mirror to the souls of those you meet, challenging them to like what they see.

Pinellia pedatisecta (Green Dragon)

This woodland dweller enjoys the shade, where it exhibits great longevity. You are an adventurous person who likes to see beyond what most have in their range. You strive to always push boundaries and experience new places and people. Your love of nature will also take you to places of incredible beauty and solitude.

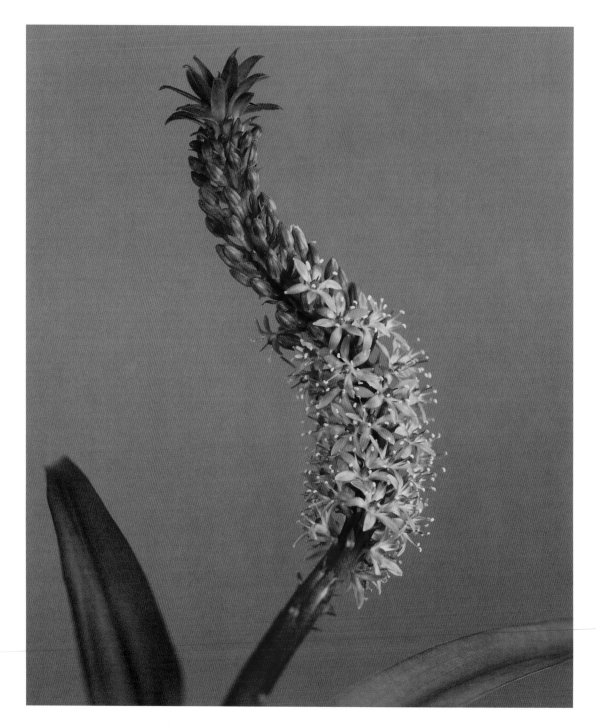

Eucomis autumnalis (Pineapple Lily)

This succulent and exotic-looking flower symbolizes loyalty and satisfaction. You have a clarity of perspective and purpose that is the envy of others. Your luck extends to your relationships, where you find true and long-lasting love. When you understand and utilize your gifts you will gain much contentment.

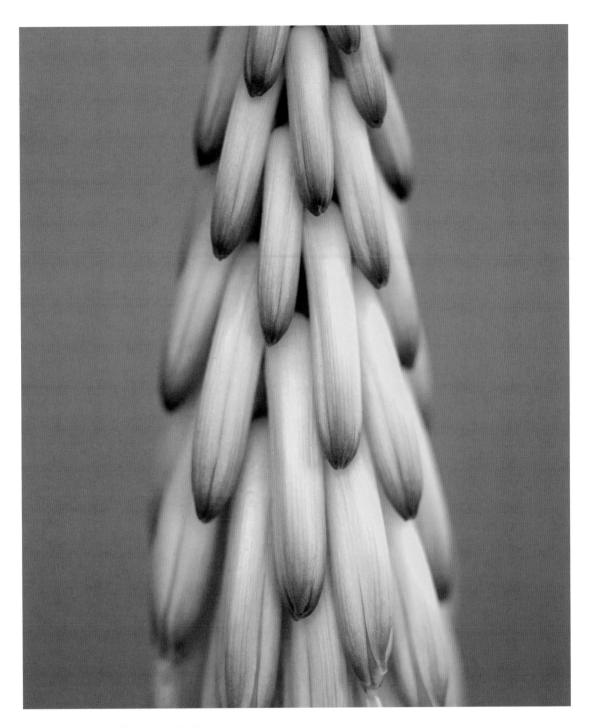

Aloe striatula (Coral Aloe)

Their spiky leaves lead many to assume that aloes are hostile plants. But on the contrary, once you scratch the surface they are like jelly. Aloe people share this trait, with a stern exterior but a gentle heart. The coral aloe's cascading flowers symbolize kindness and optimism and hint at your hidden romanticism and love of nature.

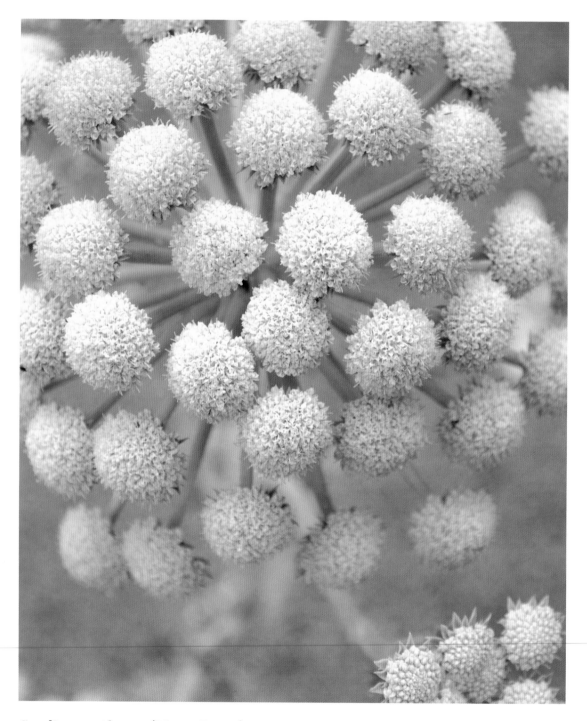

Seseli gummiferum (Moon Carrot)

The cool hue of the moon carrot prevents its firecracker blossoms from seeming totally over the top. This quality of being a tempered extrovert is true also of you. You are flamboyant and zany, but with a cool intellect and capacity for introspection.

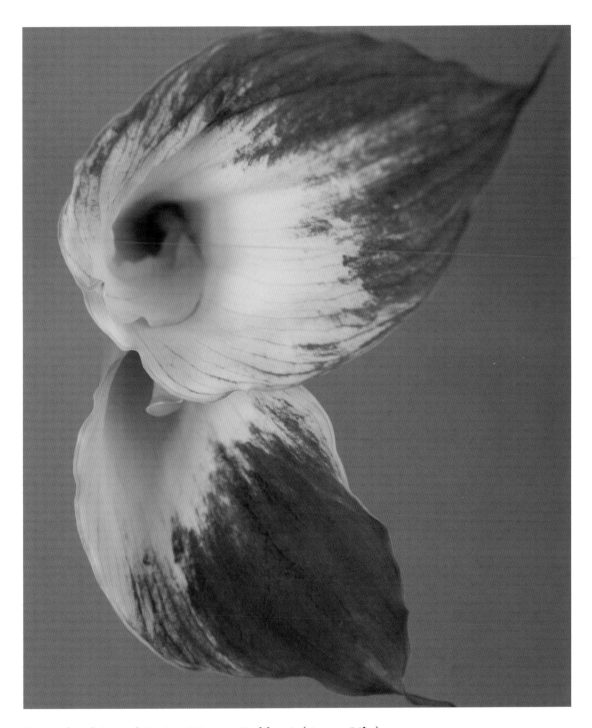

Zantedeschia aethiopica 'Green Goddess' (Arum Lily)

The statuesque appeal of the 'Green Goddess' has made it a favorite of many gardeners. Your creativity and ability to contribute makes you welcome at any social event. With your love of nature and your pursuit of inner peace, you are happiest in quiet contemplation.

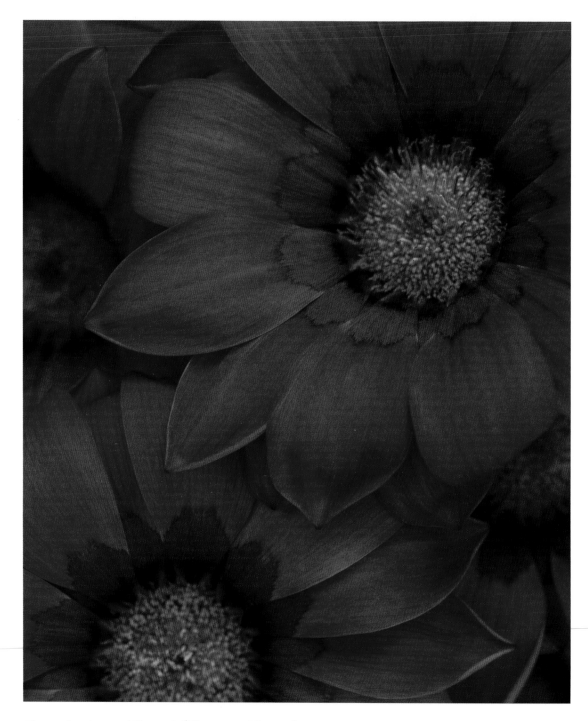

Gazania rigens 'Gazoo' (Treasure Flower)

Fecundity and simplicity are the treasure flower's attributes. Your adaptability and resourcefulness in finding nourishment for your mind, body and soul in diverse situations makes you a born traveler. You enjoy meeting people from all walks of life and your adventurous spirit needs companionship.

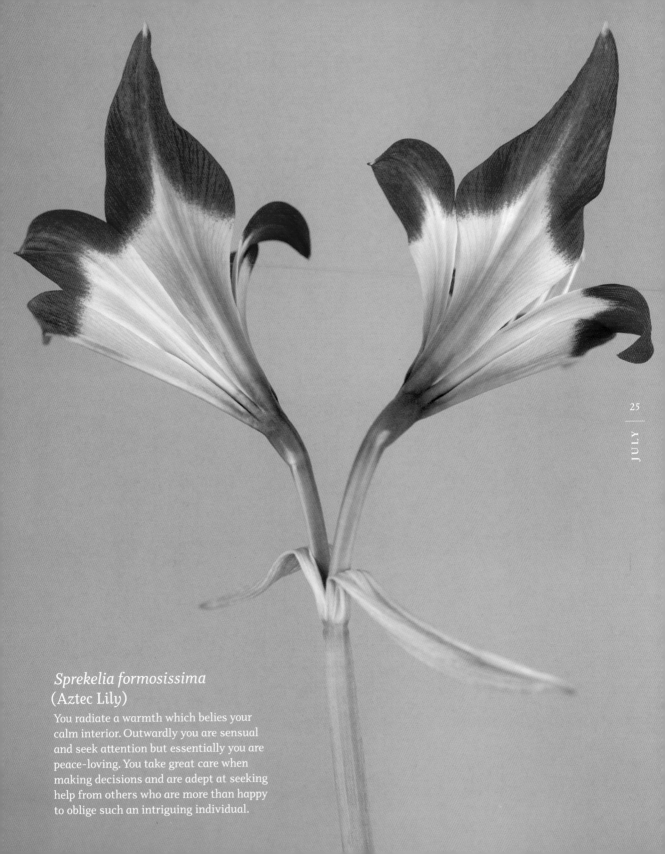

Sprekelia formosissima (Aztec Lily)

You radiate a warmth which belies your calm interior. Outwardly you are sensual and seek attention but essentially you are peace-loving. You take great care when making decisions and are adept at seeking help from others who are more than happy to oblige such an intriguing individual.

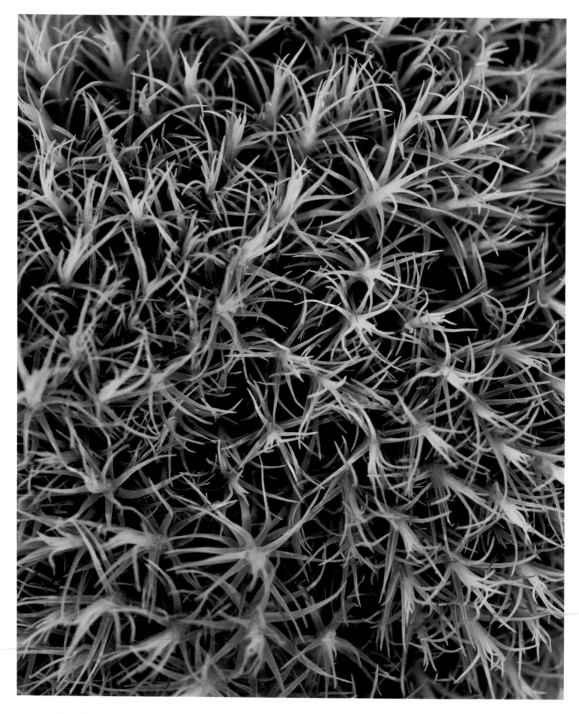

Dianthus barbatus 'Green Trick' (Sweet William)

 With its lyrical undertones, clove-scented sweet william is associated with gallantry and vitality. You have a romantic heart and are prone to promises and whispers. Your integral strength adds to your allure. Subtle yet strong you know how to win over the most stubborn of individuals.

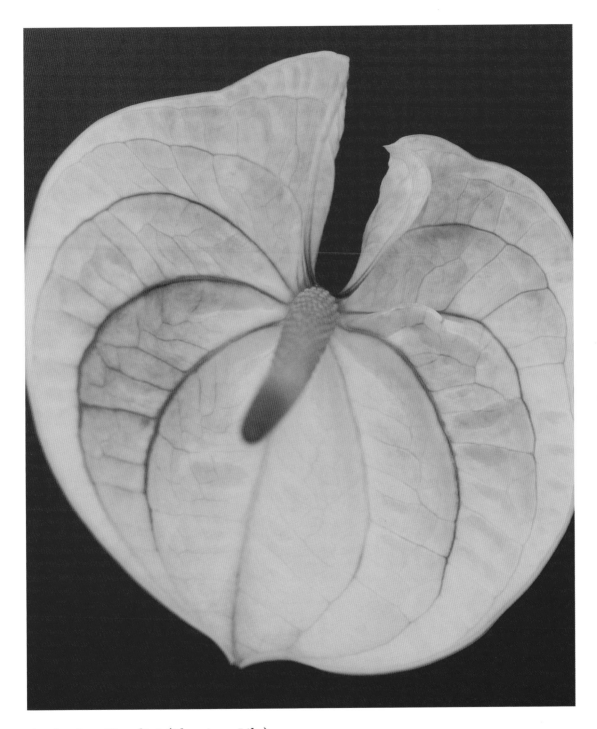

Anthurium 'Rosalie' (Flamingo Lily)

The seemingly artificial appearance of this flower belies a tender but brave heart. You may fool those around you who believe you are easily read—there is more to you than meets the eye. You have a tendency for drama and boundless passion, which make you a dynamic mate.

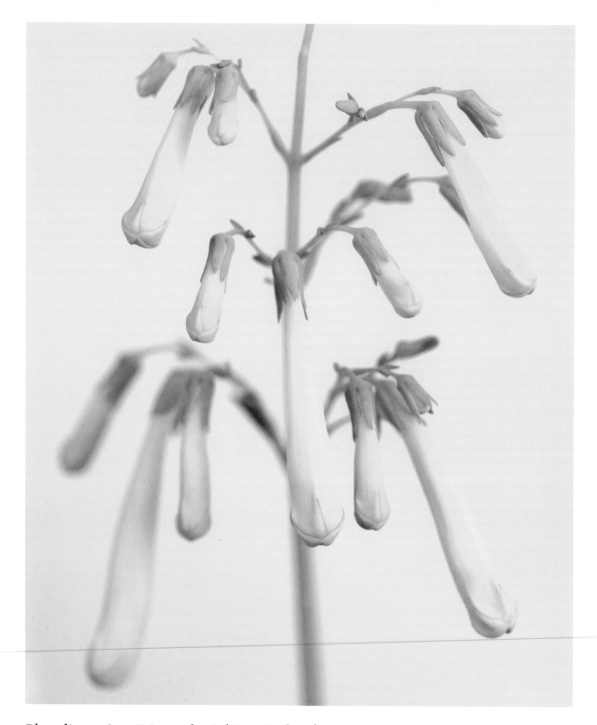

Phygelius rectus 'Moonraker' (Cape Fuchsia)

These graceful flowers bring the color of sunshine to any garden. Despite a fragile appearance you are remark-ably robust and capable of weathering any storm. Longevity, elegance and optimism are your key traits, and you may have an affinity with antiques and rare books.

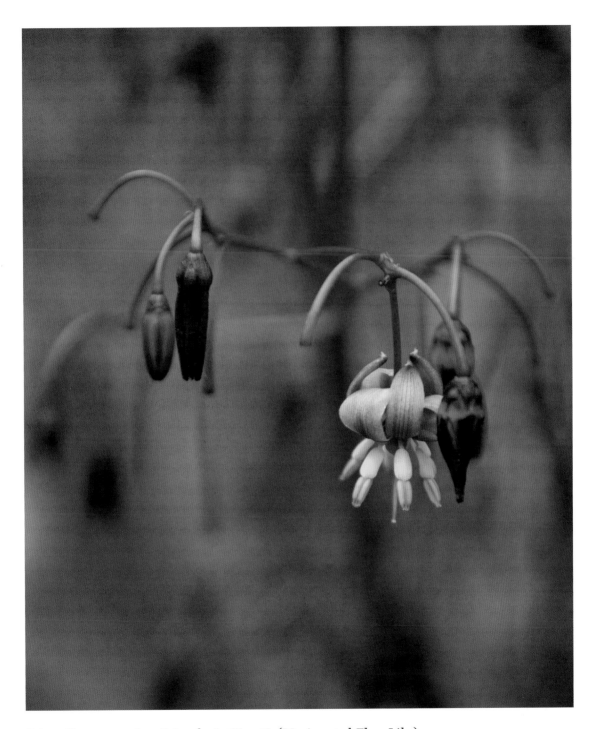

Dianella tasmanica 'Marsha's Giant' (Variegated Flax Lily)

This hardy and tolerant plant symbolizes liberty and determination. You can survive the most extreme conditions, whether they affect your physical, mental or spiritual being. You show your love of freedom by being able to fit in comfortably wherever you go, unhindered by societal and physical constraints.

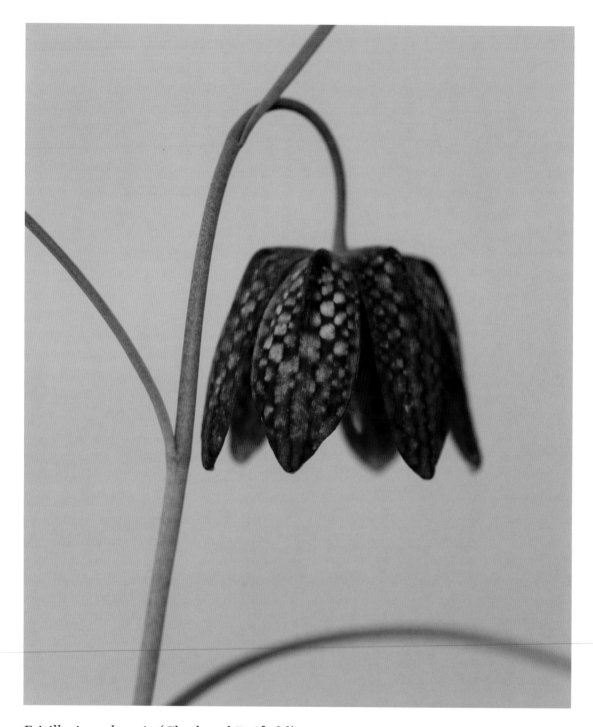

Fritillaria meleagris (Checkered Daffodil)

'Fritillary' means 'dice-box,' referring to the bold geometric pattern on the petals of the checkered daffodil. Its beauty has been celebrated since biblical times. You combine earthy passion with a head for numbers, and are drawn to antiques and curios. Often admired, you attract loyal friends and are an attentive lover.

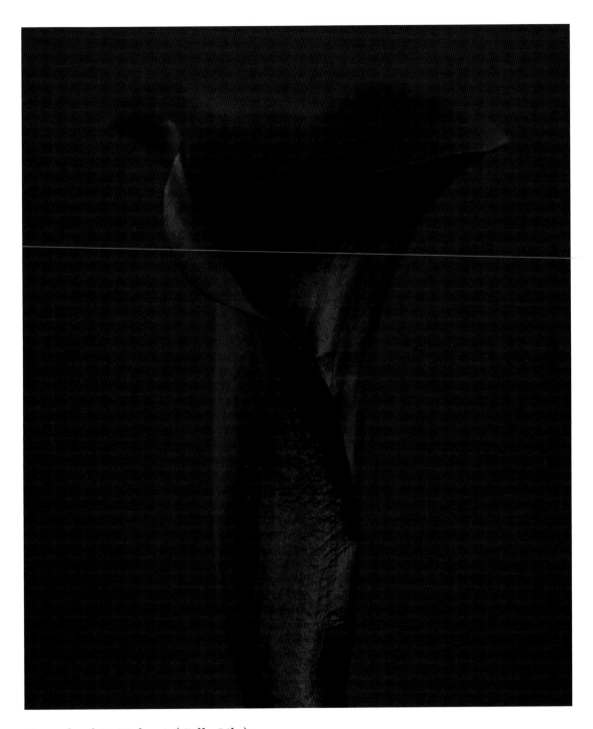

Zantedeschia 'Bolero' (Calla Lily)

As the name 'Bolero' suggests, this flower is all about romanticism and make-believe. Your nature is kind and compassionate. You have a vivid imagination and like to escape this world into the realm of fantasy. Your romantic side is enhanced by your affinity for water.

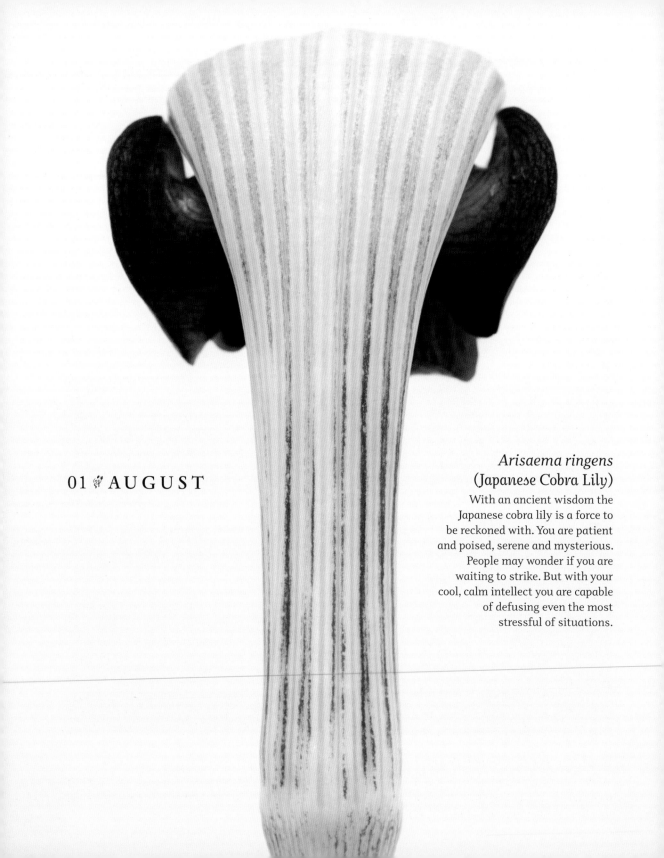

01 AUGUST

Arisaema ringens
(Japanese Cobra Lily)

With an ancient wisdom the Japanese cobra lily is a force to be reckoned with. You are patient and poised, serene and mysterious. People may wonder if you are waiting to strike. But with your cool, calm intellect you are capable of defusing even the most stressful of situations.

Oenothera missouriensis (Missouri Primrose)

With multiple healing properties, this flower is an elegant helpmate. You have a wonderful ability to see opportunity where others do not. When you put your roots down you turn the most unlikely and barren spaces into thriving, inviting and dynamic environments.

Tibouchina urvilleana (Princess Flower)

This vigorous plant with its regal purple flowers symbolizes tenacity and acceptance. You are well liked by your peers and are often thought of as wise and very approachable. You have the ability to work through any crisis and convey an air of calm and confidence.

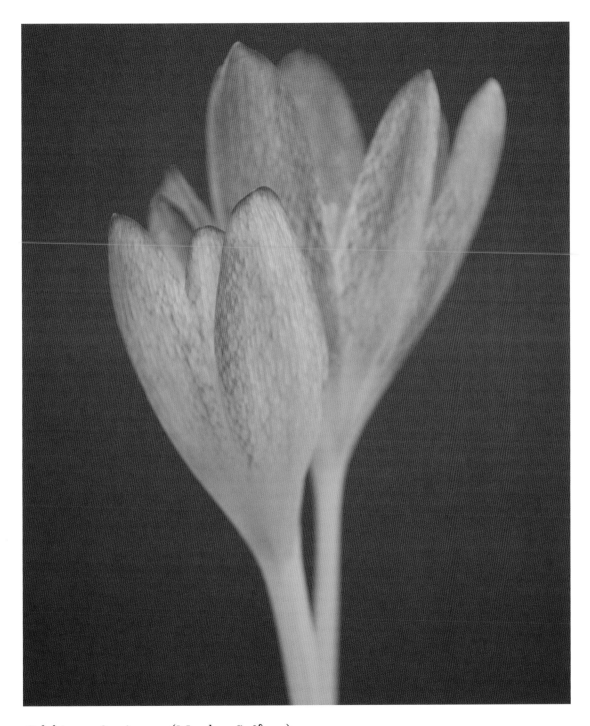

Colchicum speciosum (Meadow Saffron)

Autumn flowers soften the transition to colder days and longer nights. You share this ability to ease life's necessary hardships for those around you. The delicate purple of this bloom indicates a tendency to dream and fantasize, which balances your sensible approach to life.

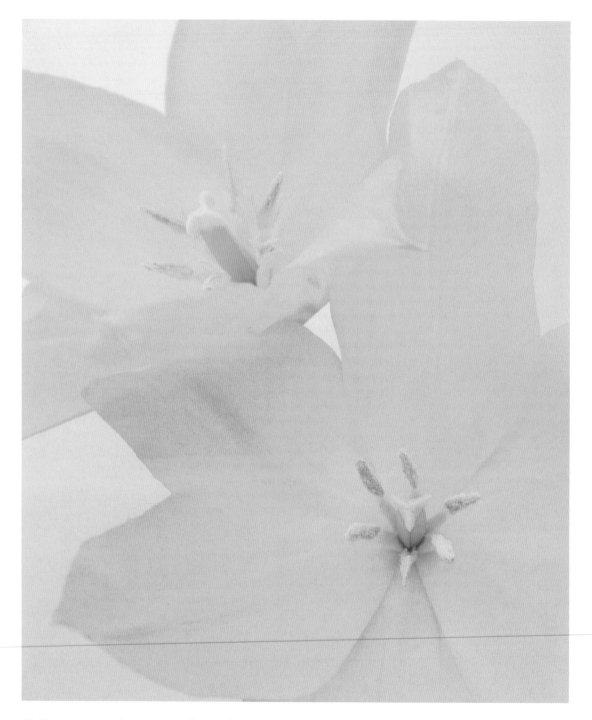

Tulipa 'Prince de Lignac' (Tulip)

Traditionally a symbol of luxury with a hint of mystery thrown in for good measure, the tulip is nonetheless a cheerful flower. With the optimism of brilliant yellow on your side you see the good in every person and situation. You are open to suggestion and new experiences, and have a wicked sense of humor.

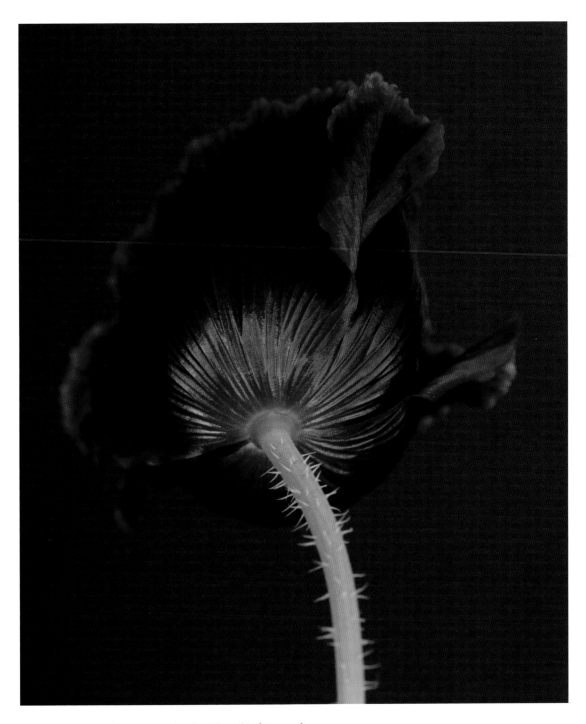

Papaver somniferum 'Black Cloud' (Poppy)

The luscious mystery represented by the color of this poppy reinforces this flower's connection to the realm of fantasy. You have an exceptional capacity to escape this world with the use of your imagination. You are also able with your great communication skills to take those that you love and trust with you.

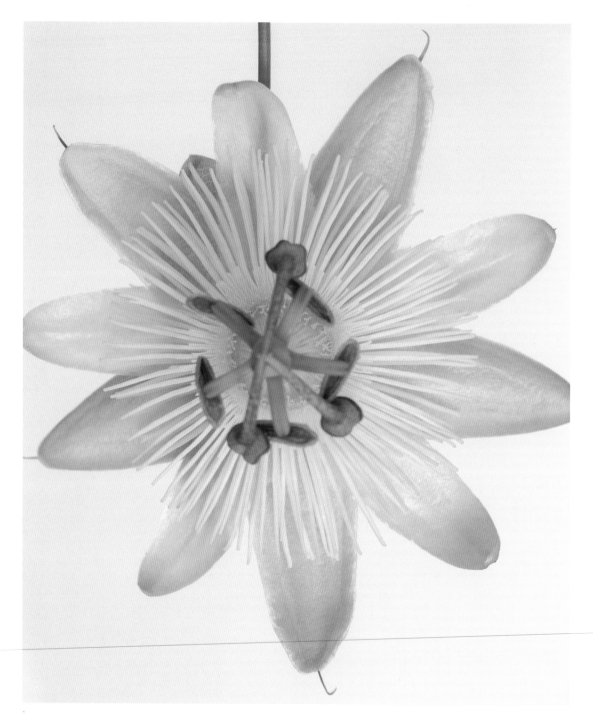

Passiflora 'Constance Elliott' (Passion Flower)

This iconic bloom exudes sensuality but also has a spiritual connection. With grace and perception you manage to defuse tension and have a calming effect on those around you. You have a responsive approach to life and like to achieve as much in a day as possible. You remain grounded whilst thriving in a spiritual environment.

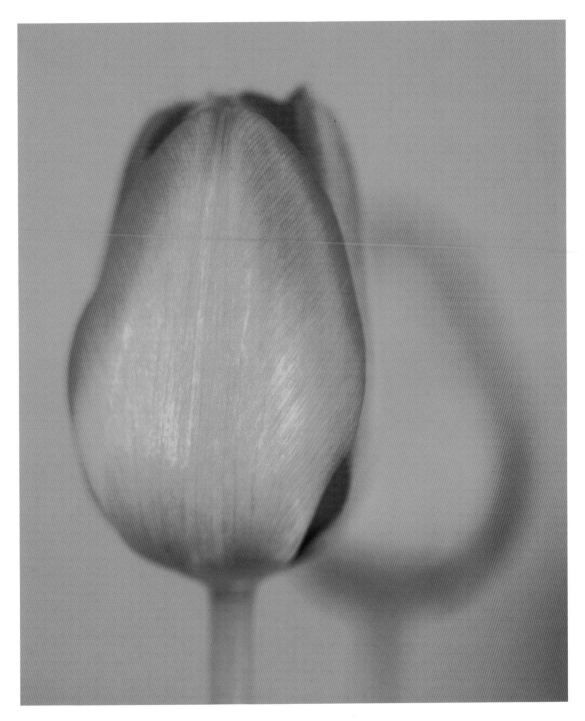

Tulipa 'Flame' (Tulip)

The 'Flame' tulip is at once flamboyant and delicate. You can be hard to read as you are a person of ambiguous and paradoxical behavior. You are exuberant yet contained, passionate yet measured. You have a tendency towards luxury but you seldom spoil yourself.

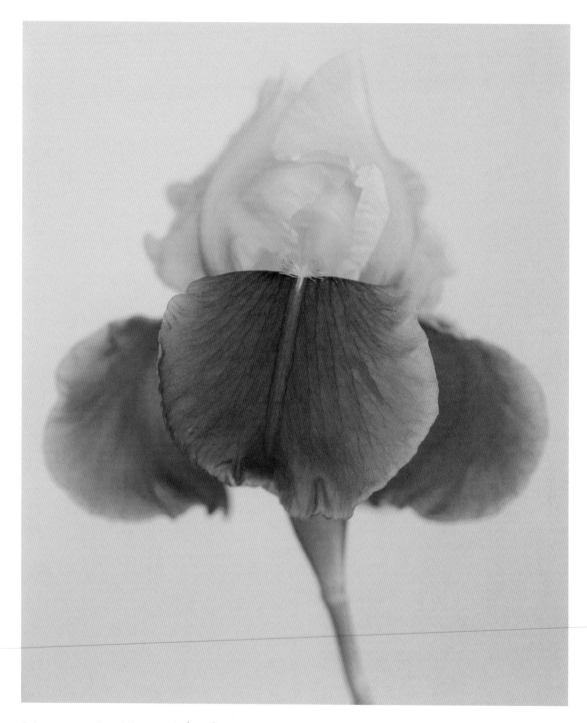

Iris germanica 'Connor' (Iris)

Subtle and sophisticated, the hues of this iris denote a calm and mature mind. Like all iris people you combine beauty with spiritual awareness and are a true and devoted friend. You may tend to look for love in unexpected places but your wisdom means you are likely to be richly rewarded.

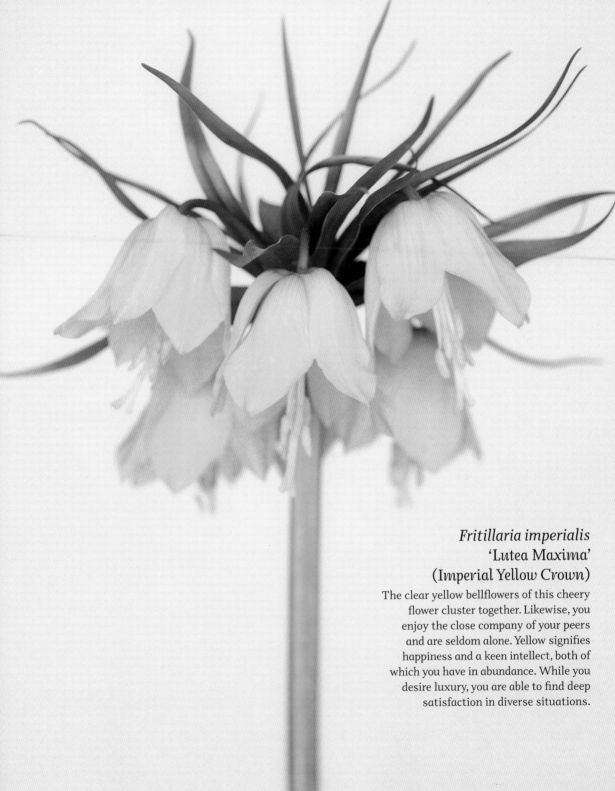

Fritillaria imperialis
'*Lutea Maxima*'
(Imperial Yellow Crown)

The clear yellow bellflowers of this cheery
flower cluster together. Likewise, you
enjoy the close company of your peers
and are seldom alone. Yellow signifies
happiness and a keen intellect, both of
which you have in abundance. While you
desire luxury, you are able to find deep
satisfaction in diverse situations.

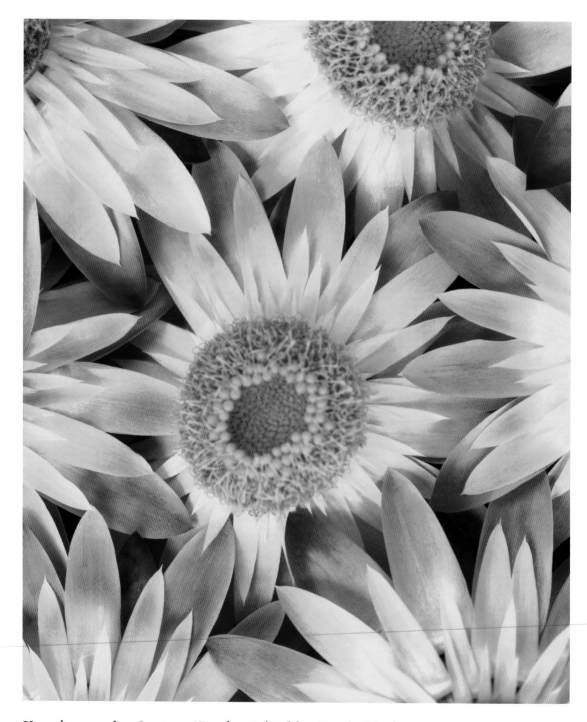

Xerochrysum bracteatum 'Sundaze' (Golden Everlasting)

Many blooms change over time in order to fulfill their destiny. The long lasting 'Sundaze' on the other hand seems to have many lives. With resounding cheer you keep on giving and giving and giving. You have a boundless zest for life and love to bask in the energy-giving properties of the sun.

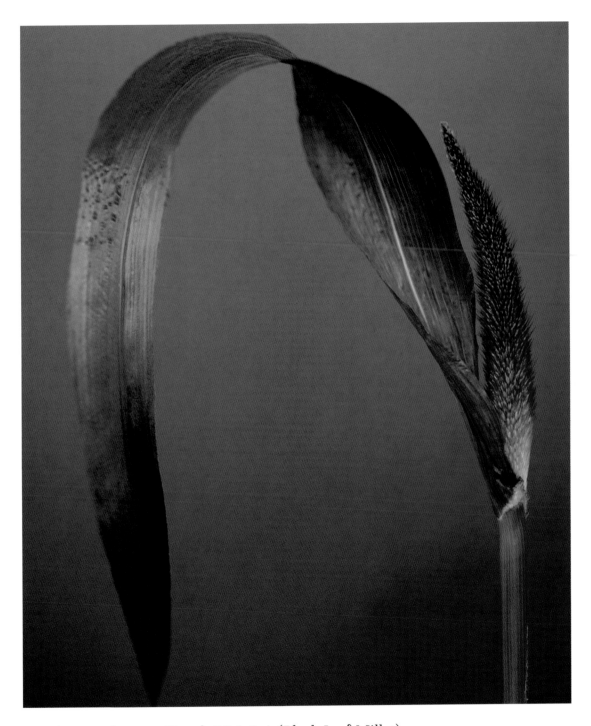

Pennisetum glaucum 'Purple Majesty' (Black Leaf Millet)

With its regal bearing and royal hue, 'Purple Majesty' lives up to its name. This understated yet exquisitely elegant bloom lends you an air of refinement. You have high ideals, emotional maturity and a calm mind. However, you are also prone to fantasizing and yearn for an outlet for your creative energy.

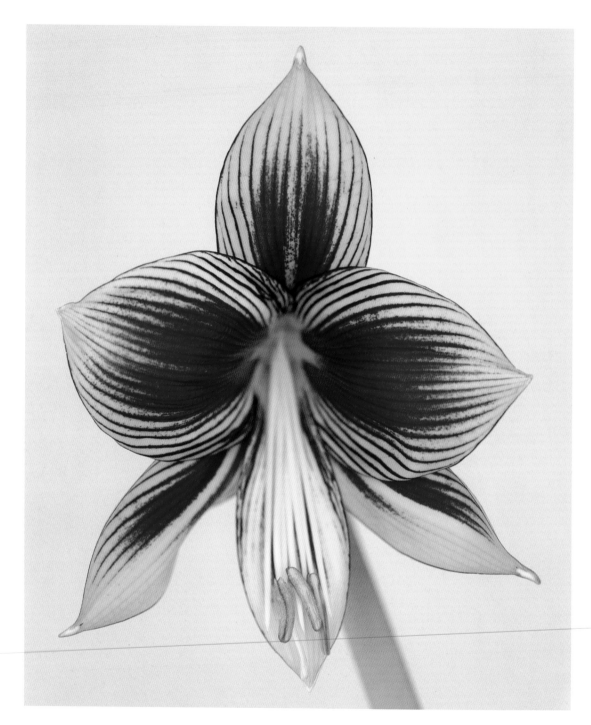

Hippeastrum 'Papillo' (Butterfly Amaryllis)

With powerful good looks and a bold spirit you are a social butterfly. There is a dignity to your bearing that will serve you well at black-tie events, but you also enjoy more casual affairs. Underneath your compelling exterior is a clear and logical mind, with a love of gardening and the outdoors.

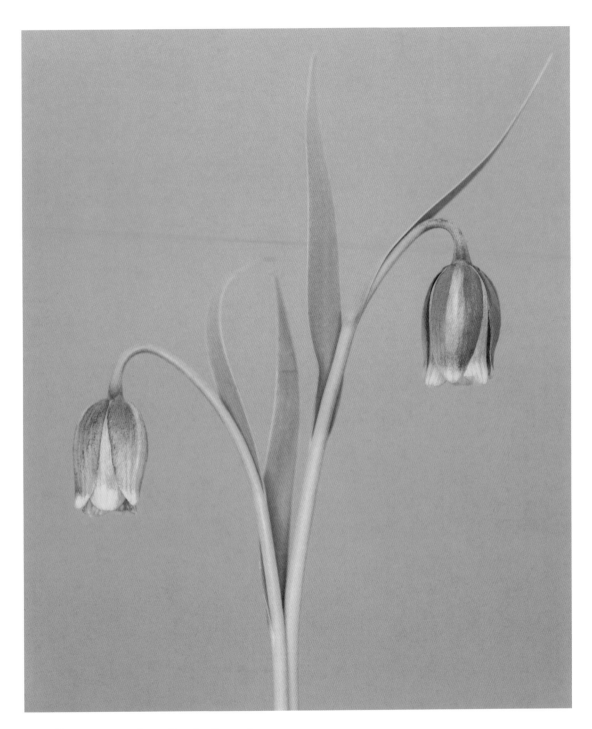

Fritillaria uva-vulpis (Fox's Grape)

The fox's grape is the most resilient member of its bold family. You share with this flower a modest elegance. From the outside you are serene and almost aloof but your friends know you as outgoing and cheerful. You are warmhearted and capable, and always have a project to keep you busy.

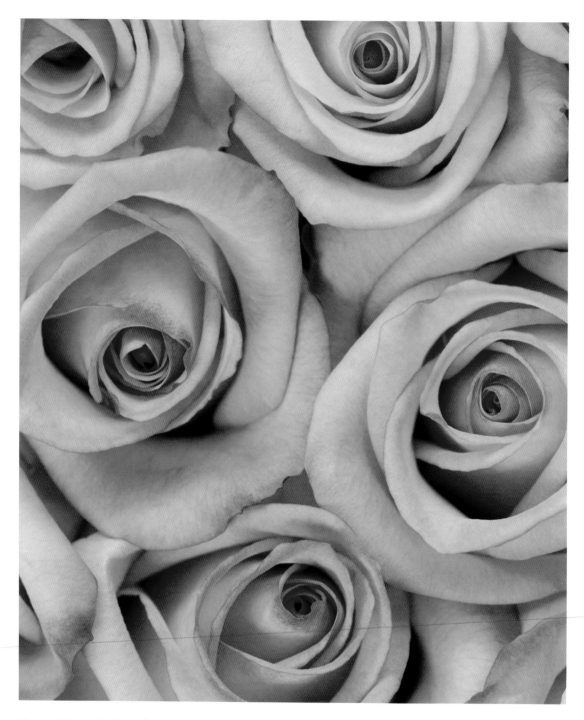

Rosa 'Vogue' (Rose)

Like the 'Vogue' rose you represent perfect happiness and enduring style. Even when you follow fashion trends, you are uniquely chic with a strong sense of self-worth and contentment. Your happiness and capacity for unselfish love add to your beauty. You are youthful and will be untarnished by time.

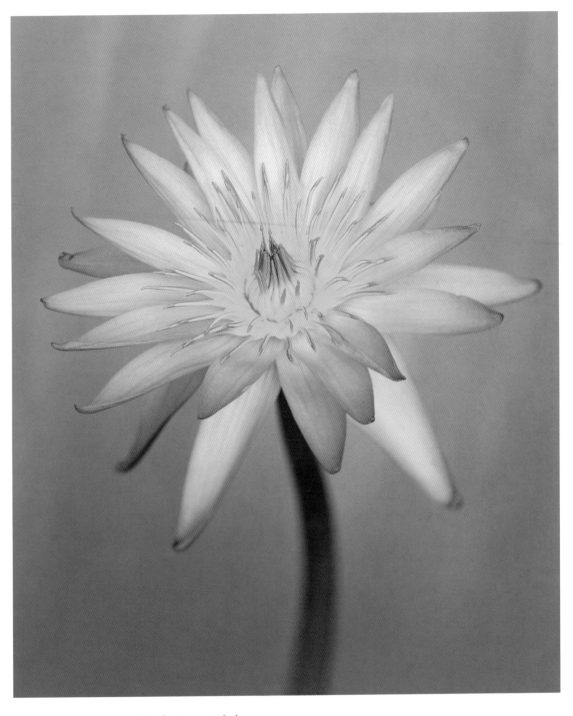

Nymphaea 'Noah G.' (Water Lily)

The symbolism of the water lily is often paradoxical. You are both sensual and pure, mischievous and serene. You have strong family values, and it is among your family that all the aspects of your personality are most appreciated.

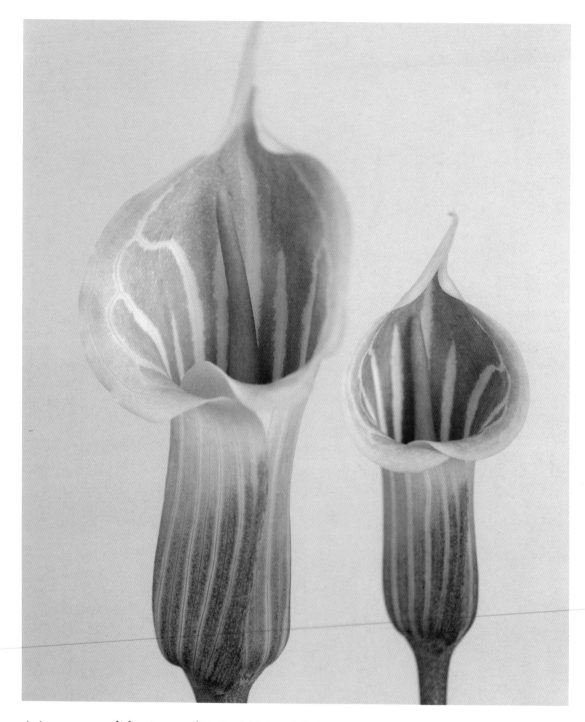

Arisaema candidissimum (Striped Cobra Lily)

Like the striped cobra lily you are poised and graceful, and inspire calm. You appear to be a delicate beauty but you thrive when the heat is on. You may lull others into a false sense of security—your instincts mean you always know when to strike. However, those who gain your trust find you an unselfish friend.

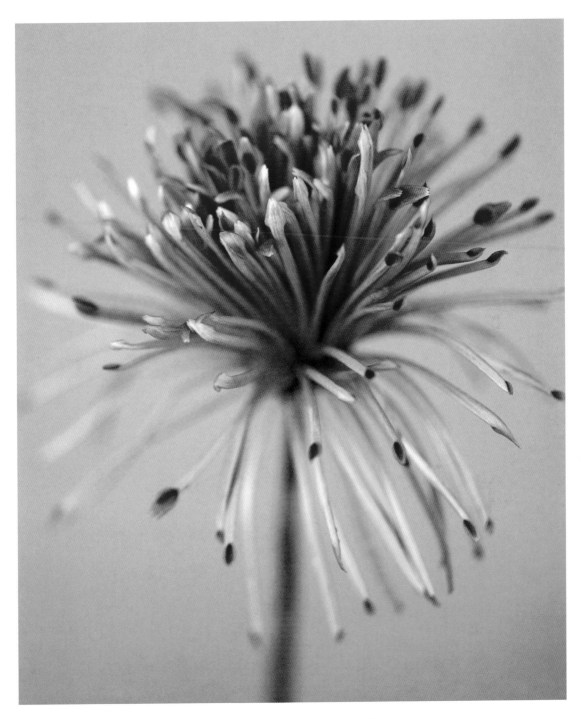

Chrysanthemum 'Carrousel' (Spider Mum Chrysanthemum)

Chrysanthemums are cheerful flowers that symbolize the value of true friendship. Unlike other 'mums,' who follow a traditional path, you embody a zany approach to life and a sense of the fanciful. With your casual demeanor and loving heart you attract friends in abundance, and are a favorite with children.

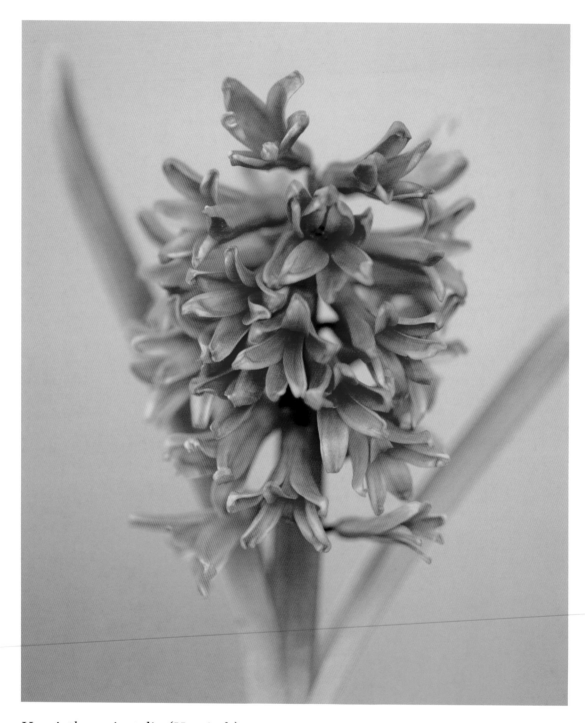

Hyacinthus orientalis (Hyacinth)

The hyacinth symbolizes rebirth, as it chases away the last days of winter with its graceful and fragrant efflorescence. But it is also impatient, a characteristic shared by its human counterparts whose spontaneity and quick wits keep them abreast of the crowd.

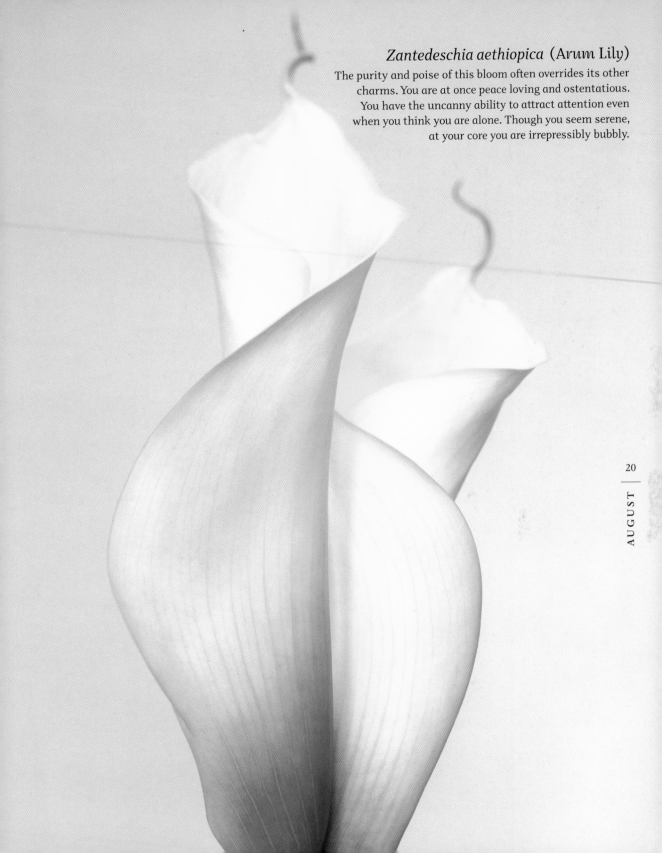

Zantedeschia aethiopica (Arum Lily)

The purity and poise of this bloom often overrides its other charms. You are at once peace loving and ostentatious. You have the uncanny ability to attract attention even when you think you are alone. Though you seem serene, at your core you are irrepressibly bubbly.

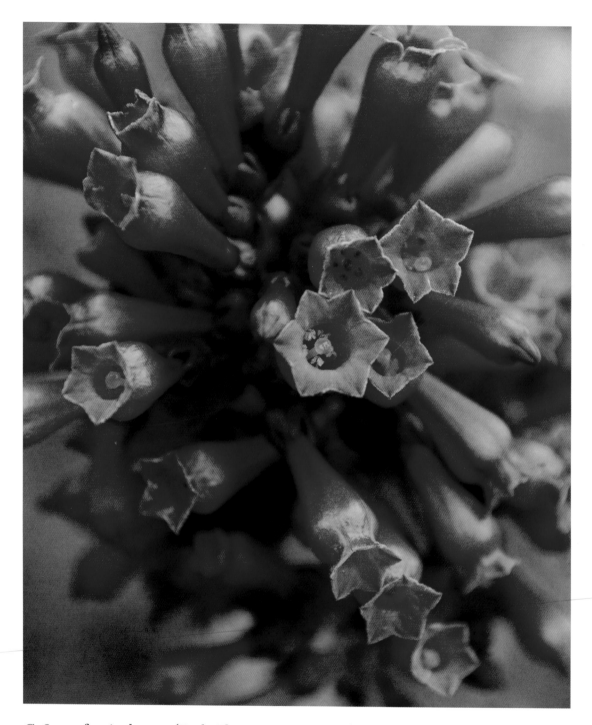

Cestrum fasciculatum (Early Flowering Jessamine)

Red symbolizes passion and the tactile quality of this flower intimates sensuality. With these attributes your reputation as a lover is legendary. But you are also an intensely loyal partner and friend. You are happiest in big crowds and don't like to miss a party.

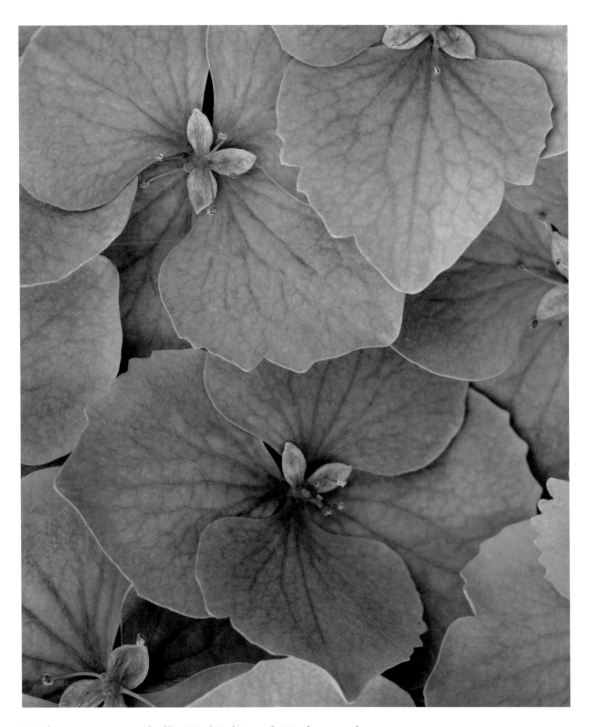

Hydrangea macrophylla 'Todi' (French Hydrangea)

The subtlety of the hydrangea is revealed only through close observation. You too are like a book waiting to be read. Quiet and soulful, you show your delicate complexity only to those who truly deserve your attention. You are blessed with long-lasting good looks and a capricious adaptability to change.

Podophyllum pleianthum (Mayapple)

This medicinally useful and beautiful flower enjoys a woodland setting. You have a caring nature and your mere presence will often relieve discomfort. You enjoy a good view and often find yourself in quiet contemplation when up high. A passionate person, you love to mix and mingle.

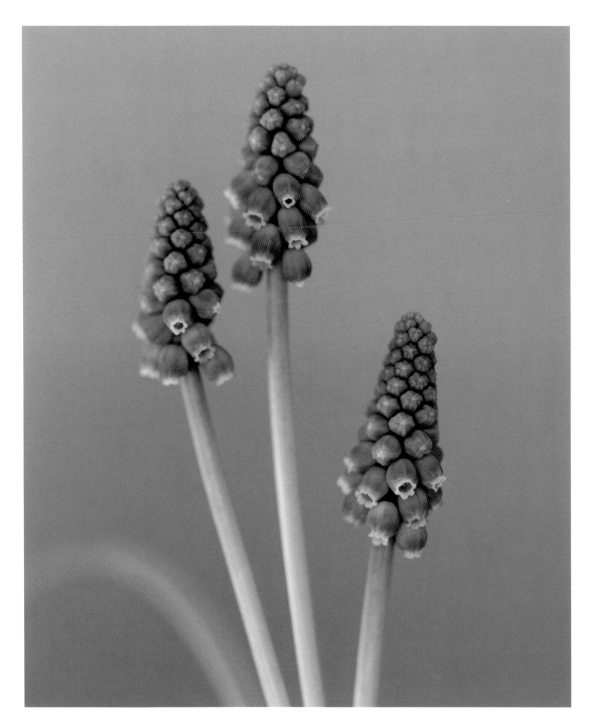

Muscari armeniacum (Grape Hyacinth)

Symbolizing impatience, the hyacinth is quick to see the end of winter and share with us its glorious blooms. You will be familiar with the need to make decisions quickly and to act on them, but luckily you have a keen intellect with which to deal with all this haste. You prevail with panache.

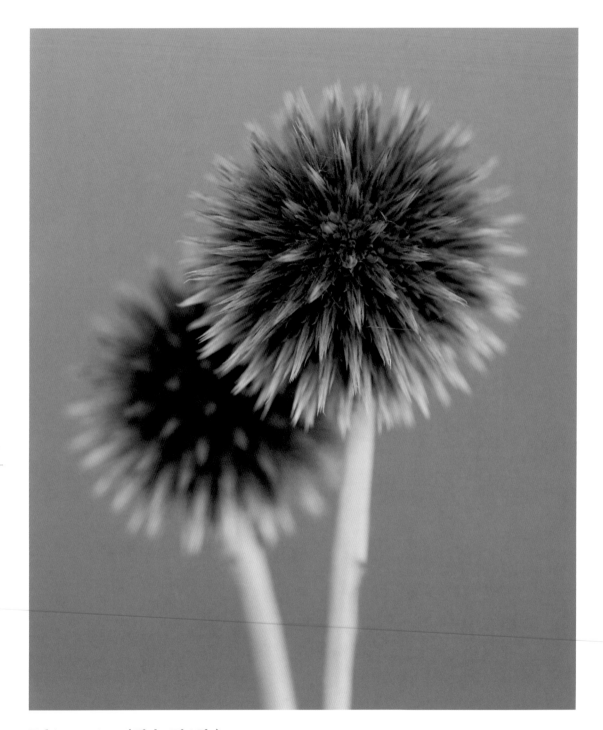

Echinops ritro (Globe Thistle)

The globe thistle is a strikingly architectural plant. You bring something unexpected to your friendships and are a dependable and loyal companion. While friends and lovers are initially attracted to your unusual beauty, it is your uncompromising intelligence and creativity that people really fall for.

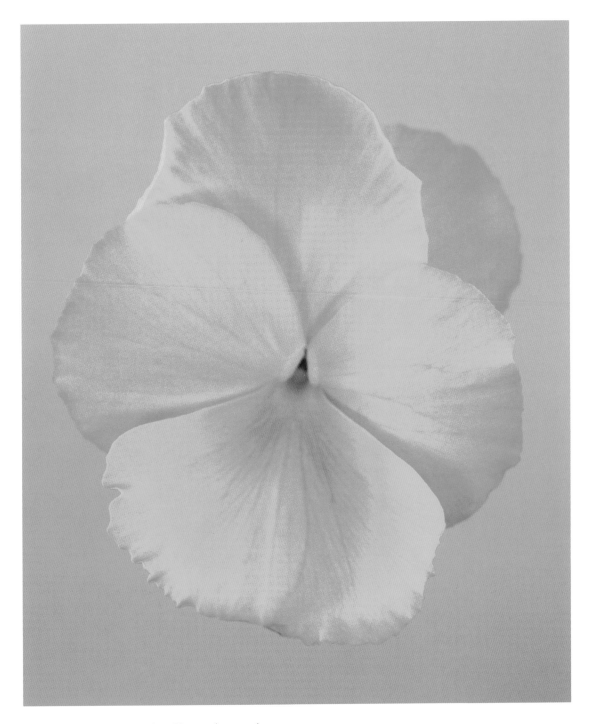

Viola 'Clear Crystal Yellow' (Pansy)

Within your circle of friends you are known as the peacekeeper and often encourage others to seek positive solutions. Clarity and enthusiasm are your key strengths. You are open-minded with great reserves of energy and make an excellent traveler.

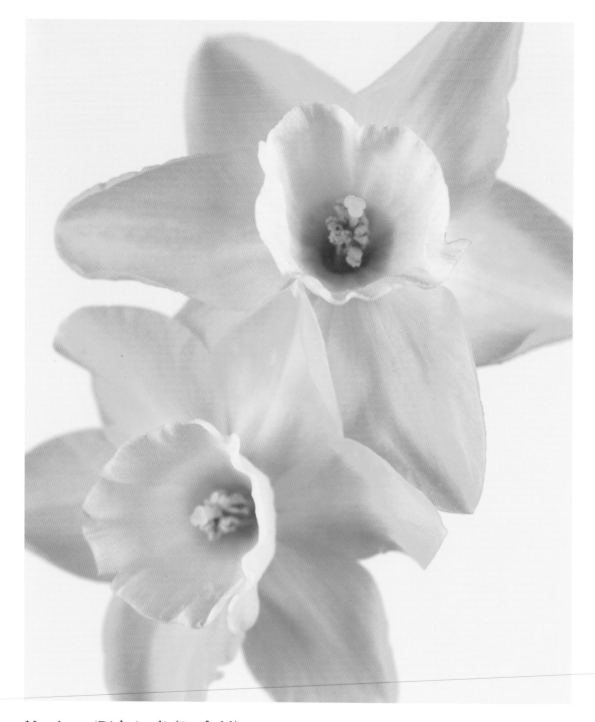

Narcissus 'Dickcissel' (Daffodil)

The daffodil is nature's way of drawing winter to a close with a burst of fresh color and fragrance. You share this flower's ability to inspire positive change and new beginnings. You see the bright side of any situation and offer great encouragement to your friends and family in trying times.

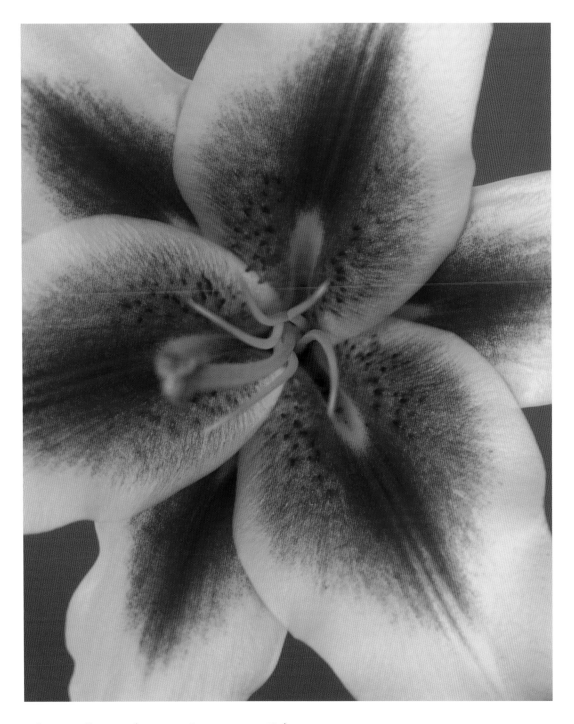

Lilium 'Albany' (Oriental Trumpet Lily)

Hot-blooded and passionate, you like to throw yourself into everything life has to offer. Friends find your energy uplifting and inspiring. You may be especially drawn to the dramatic delights of dance and theater, but you also enjoy the luxurious escapism to be found in a good book.

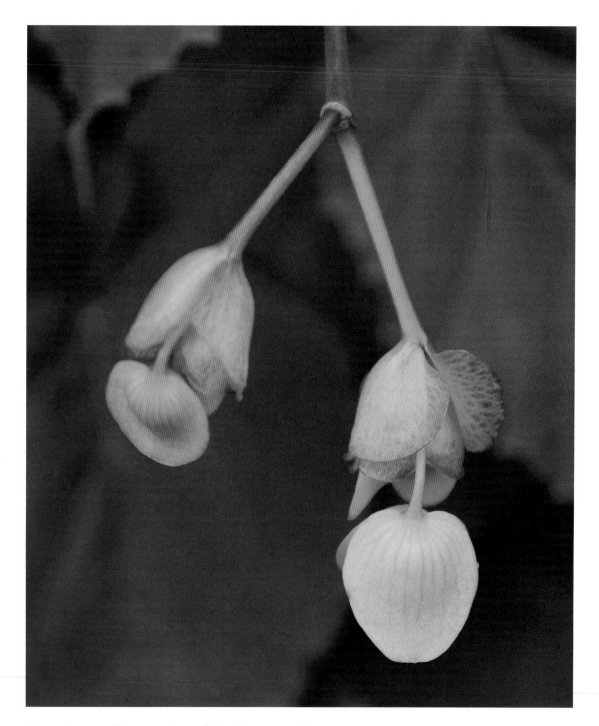

Begonia grandis evansiana (Hardy Begonia)

Fragile pink flowers borne with heart-shaped leaves remind us that love gives strength to even the most delicate beauty. You are well-loved by your friends and family who provide you with tangible support and wise counsel. You are generous and sympathetic to others, and know how to triumph over trying times.

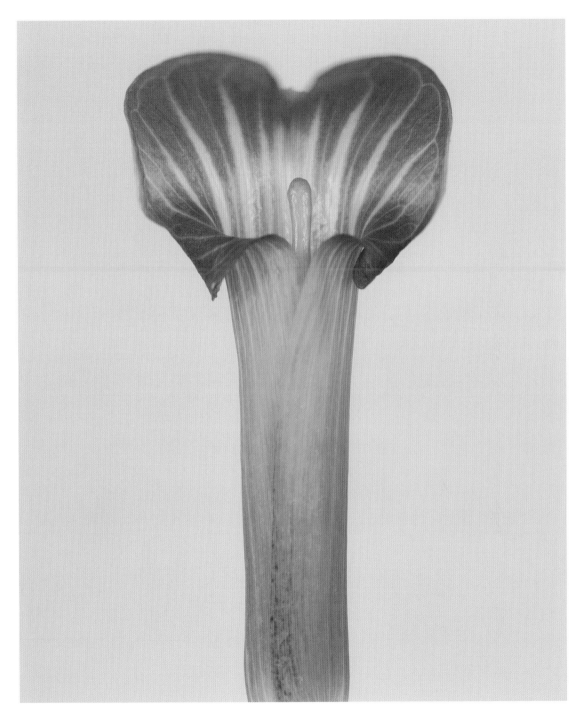

Arisaema serratum (Cobra Lily)

This charming flower symbolizes gallantry. You have an appreciation of the esoteric and an eclectic sense of taste. You are intelligent and forthright with a penchant for mischief and often surprise your loved ones. But you wear your heart on your sleeve and are often revealed as the instigator of pranks.

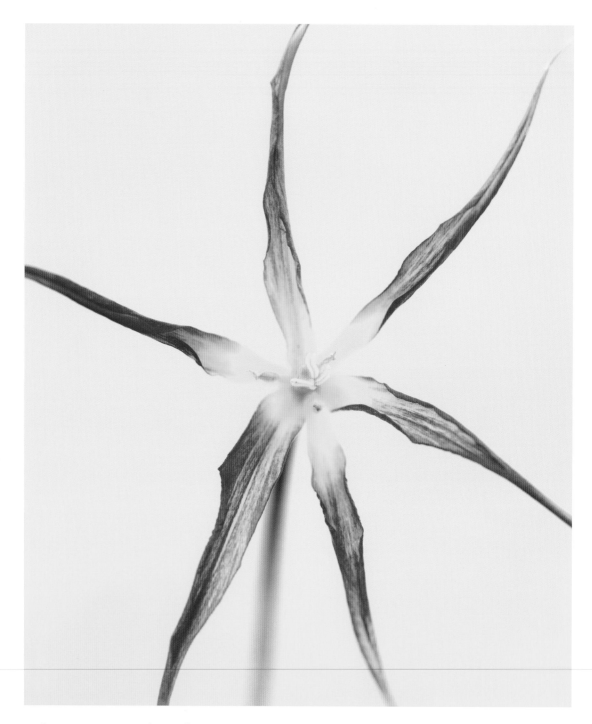

Tulipa acuminata (Tulip)

Unlike any other tulip, this flower symbolizes individuality and difference. You like to make a statement and can be deliberately contentious. You have a playful character which means that instead of people taking you the wrong way they often join you, resulting in much hilarity.

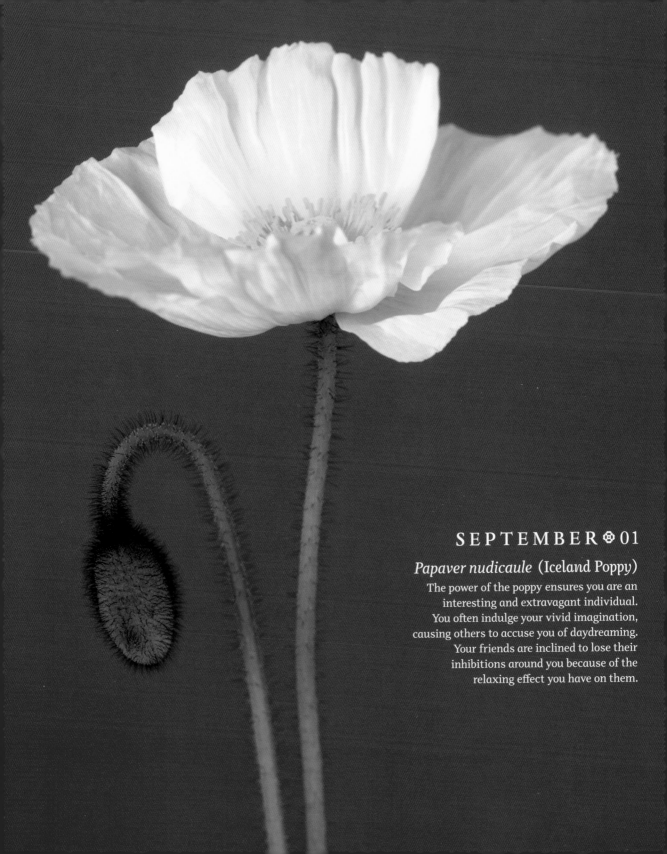

SEPTEMBER ✿ 01

Papaver nudicaule (Iceland Poppy)

The power of the poppy ensures you are an
interesting and extravagant individual.
You often indulge your vivid imagination,
causing others to accuse you of daydreaming.
Your friends are inclined to lose their
inhibitions around you because of the
relaxing effect you have on them.

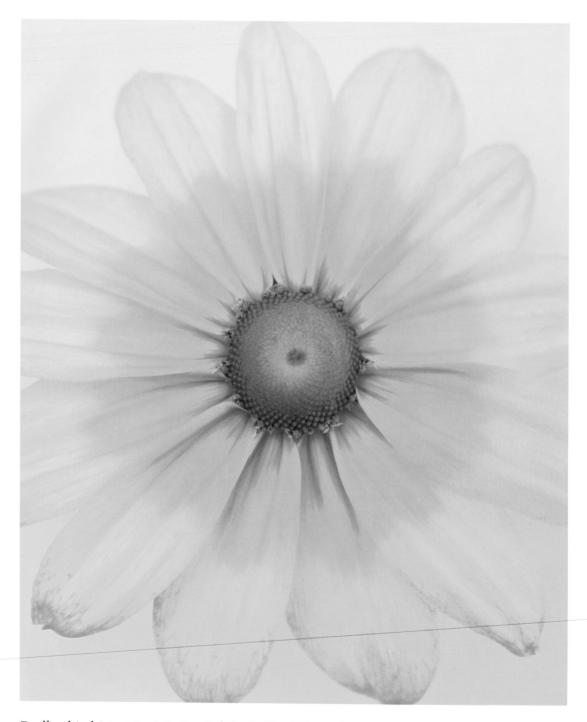

Rudbeckia hirta 'Prairie Sun' (Black-Eyed Susan)

The 'Prairie Sun' is an indicator of good health and a well-loved member of the rangeland. You too have an affinity with well-being and are resourceful and adaptable. You offer encouragement to those around you and inspire them with your own acceptance of life's ebbs and flows.

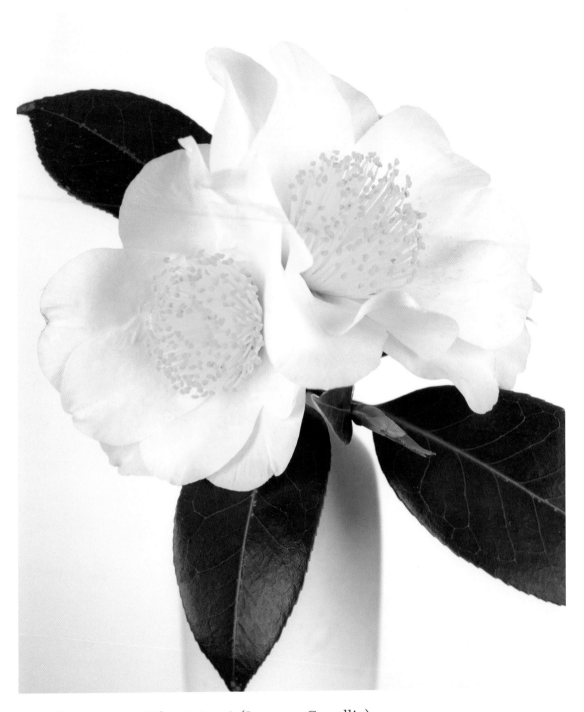

Camellia japonica 'Silver Waves' (Japanese Camellia)

White camellias, the symbol of purity and patience, speak of enduring elegance and flair. With its sunny yellow center, 'Silver Waves' promises you happiness and sunshine. You are appreciated for your timeless style, your warm personality and your eternal optimism.

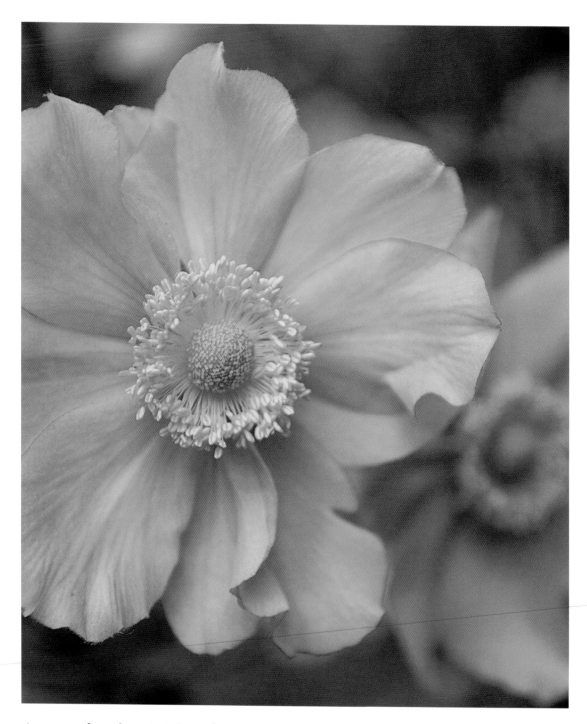

Anemone hupehensis 'Alice' (Japanese Anemone)

A symbol of refinement and delicacy, the anemone is strongly associated with luxury. Many believe you to be aloof and retiring but in your friendships you are enveloping and tenacious. Those that you choose as friends are constantly delighted by the fine wit and intellect for which you are renowned.

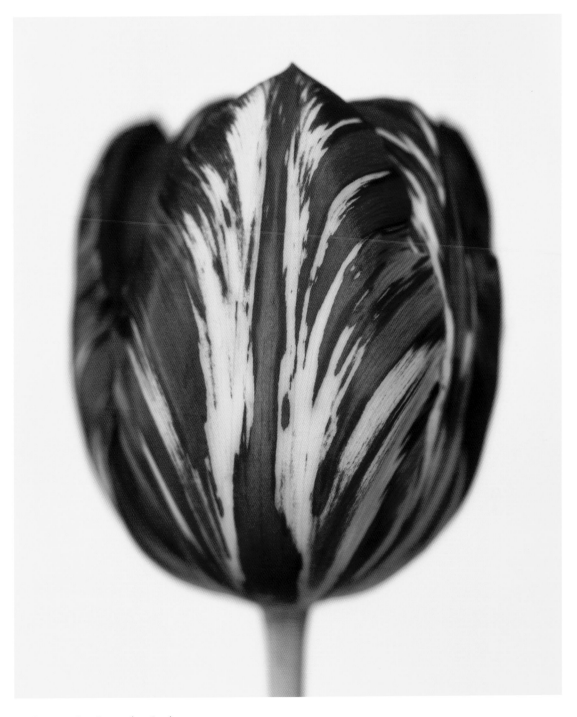

Tulipa 'Absalon' (Tulip)

Bold and bright, like the 'Absalon' tulip you are a strong individual with an insightful and enquiring mind. You have great moral conviction and a true sense of belief. You have an unwavering optimism and passion for life, which is carried in your beautiful trusting eyes.

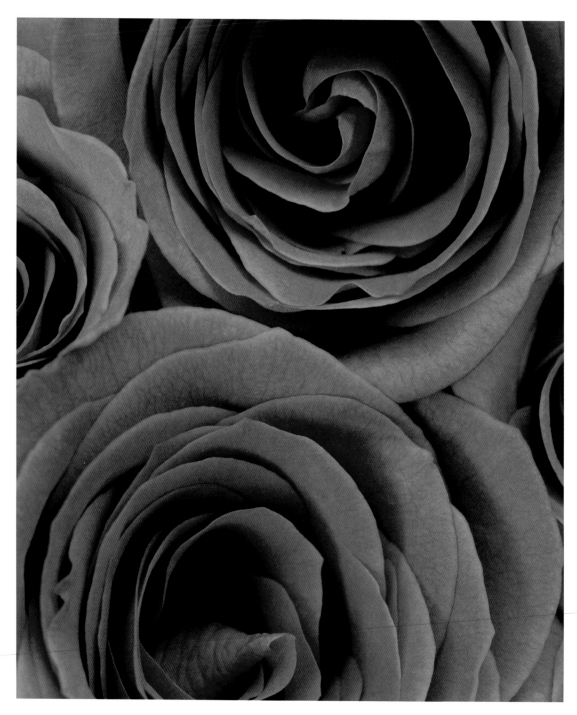

Rosa 'Stella'

Like the 'Stella' rose you are destined to be a star. You are artistic and creative and will find success when you follow your intuition and imagination. However, these same qualities make you prone to daydreaming, but you will achieve even your wildest fantasies when you complement your natural talents with hard work.

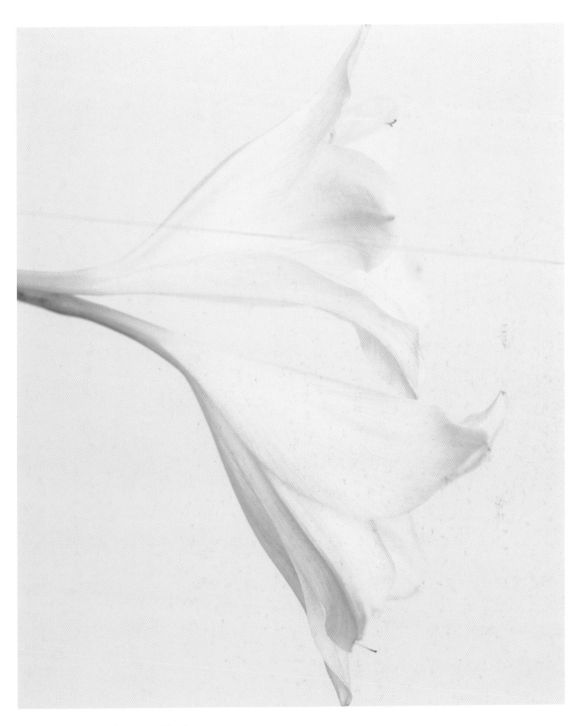

Hippeastrum (Amaryllis)

Compared with other amaryllis people you are decidedly subtle. You have a dignified and delicate beauty, and a refreshingly open approach to life. Though you are attracted to refinement and minimalist design, your generous spirit finds you at the center of friends and family and all the delicious chaos that ensues.

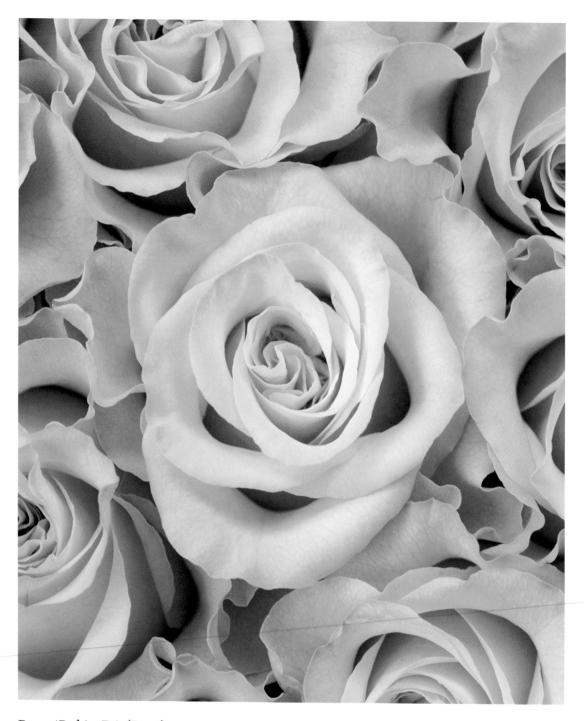

Rosa 'Rubin D.' (Rose)

You share with the 'Rubin D.' rose an exquisite beauty that is many layered. Others will seek you when they are troubled, valuing your sense of balance and ability to assess both sides of any situation. You are capable of great empathy and compassion, and provide wise counsel to friends in need.

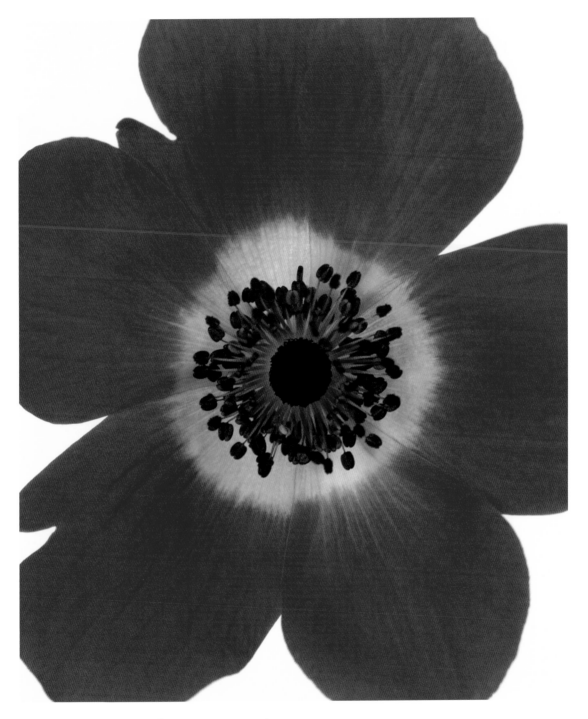

Anemone coronaria (Poppy Anemone)

Like the poppy anemone you are an obvious leader, though you seldom seek power for yourself. Friends and lovers are drawn to your vitality and quick mind, but few see past your love of structure and order to your inner creativity and romanticism. Your apparent fragility is only skin-deep—you are at your strongest when truly challenged.

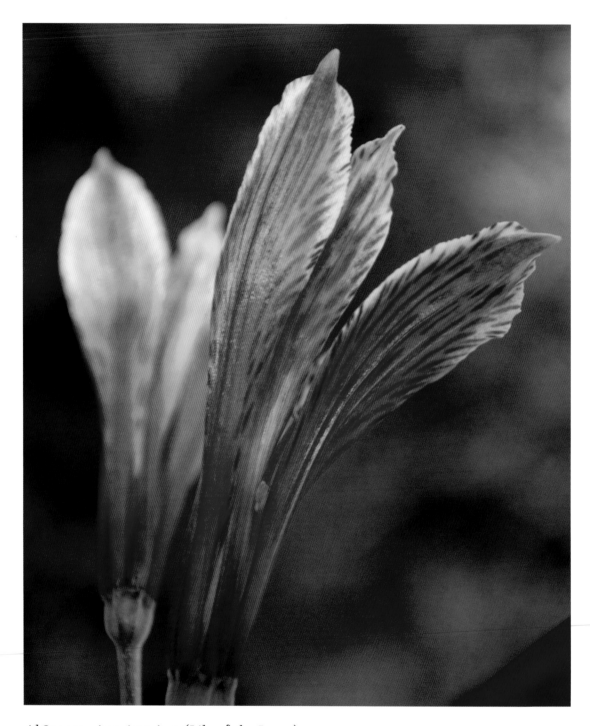

Alstroemeria psittacina (Lily of the Incas)

The exotic appearance of the lily of the Incas conjures the steam and passion of the jungle. You are an enigmatic individual that likes to let loose and be wild occasionally. Fortunately, your seductive personality is well matched by your devotion, making you a loyal lover and valued friend.

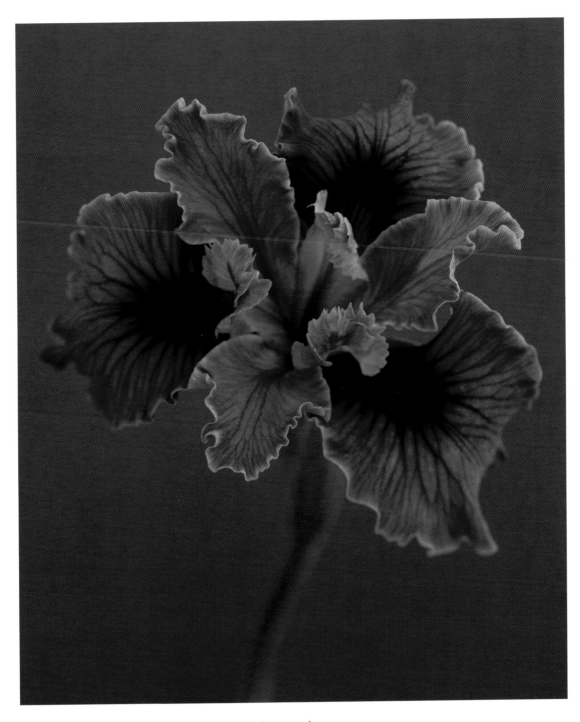

Iris douglasiana 'N. Erickson' (Douglas Iris)

The iris is the symbol of the rainbow, offering multifaceted beauty to the world. None is as spectacular as your birth flower, with its fanciful ruffled edges and rich red hues. Like this iris you are a show-stopper, with bold good looks, a healthy romanticism and a warm heart.

Anthurium 'Green Tulip' (Flamingo Lily)

You have a well-developed sense of the theatrical, which is not to say you are a drama queen—on the contrary you are extremely robust and adapt easily to different environments. Like the flamingo lily you enjoy a life of structure and refinement, and are tuned in to the world around you.

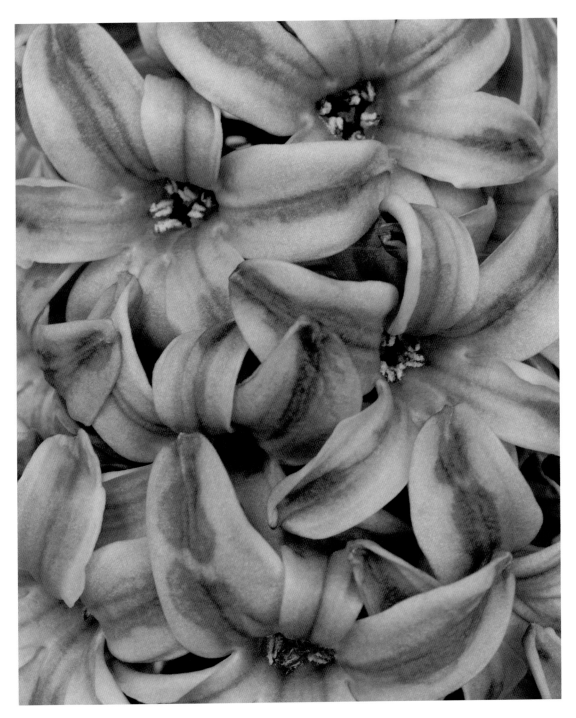

Hyacinthus orientalis 'Blue Pearl' (Hyacinth)

Hyacinths are sculptural spring flowers that offer sweetly scented and stunning blossoms to the last days of winter. Impulsive, cool and charming, you are a compelling early bloomer. You are extremely loyal and as a consequence you are surrounded by devoted friends.

Camellia japonica (Japanese Camellia)

Camellias are the flowers of longevity and faithfulness, and the bold red of your flower symbolizes intrinsic worth. You require constant attention, which your timeless beauty brings to you in abundance, but you compensate by bringing joy and passion to even the coldest days.

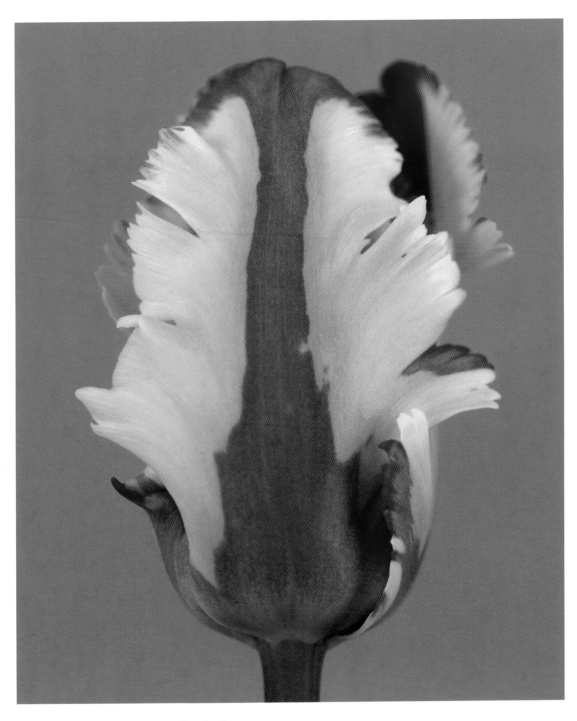

Tulipa 'Flaming Parrot' (Tulip)

Because tulips are associated with luxury and luck, and the 'Flaming Parrot' is so ostentatious, you will have these things in abundance. Though you seem self-contained there is a part of you that loves to let loose occasionally. It goes without saying that you love to talk.

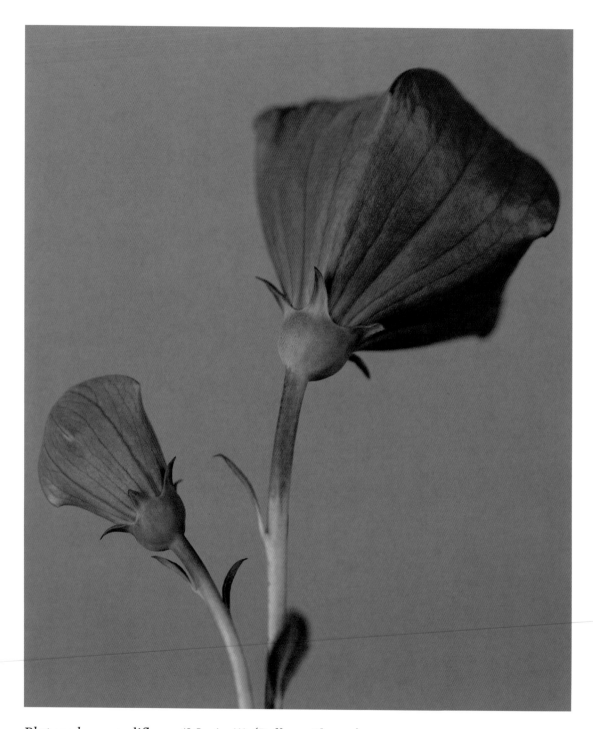

Platycodon grandiflorus 'Mariesii' (Balloon Flower)

In contradiction to its fullness, the balloon flower is a natural anti-inflammatory. With grace and majesty you bring calm to every situation. People trust you easily and often feel elated when in your presence. You have an excellent sense of humor and are known for your rapacious wit.

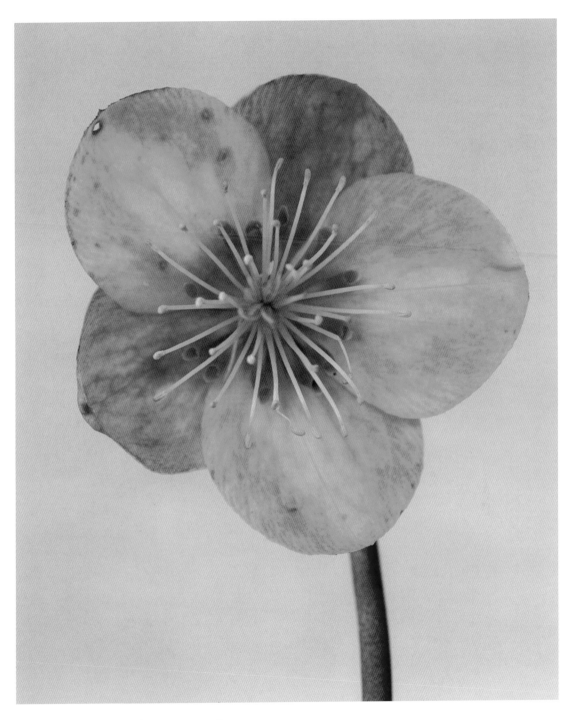

Helleborus sternii (Lenten Rose)

There is an unreal beauty to this lenten rose that can make its birth-sake seem slightly artificial. However, when people really get to know you they will see that you are not perfect, but instead beautifully flawed. Your quirks of nature make you a wonderful friend and maintain the interest of your lover.

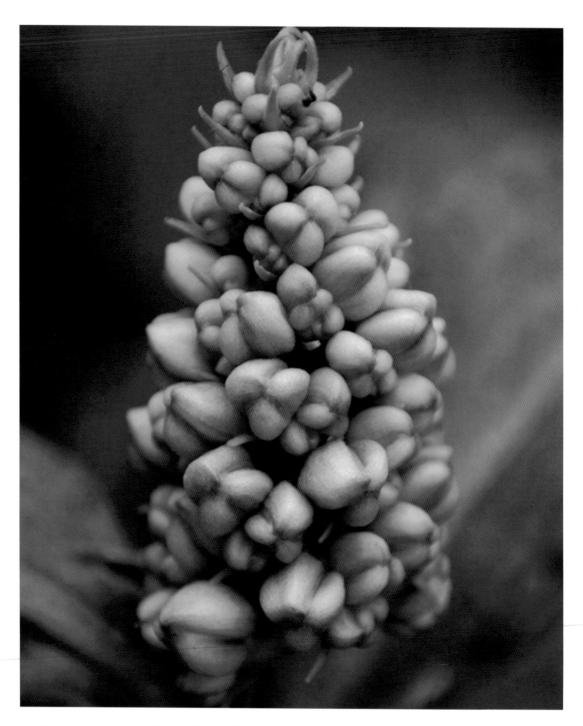

Dichorisandra thyrsiflora (Blue Ginger)

Ginger represents power and success, as does the color blue, making you a force to be reckoned with. Blue is also associated with loyalty and love so it is likely that you will draw power from your relationships with others. Despite all your success and strength you remain modest and relaxed, and an inspiration to your colleagues.

Sedum spectabile (Ice Plant)

Though often overlooked as old-fashioned, when the ice plant flowers everyone notices. You are a dynamic individual with many strings to your bow. You like to tease and take your time to do things, relishing each phase of your journey. When you let go and show your best side you are second to none.

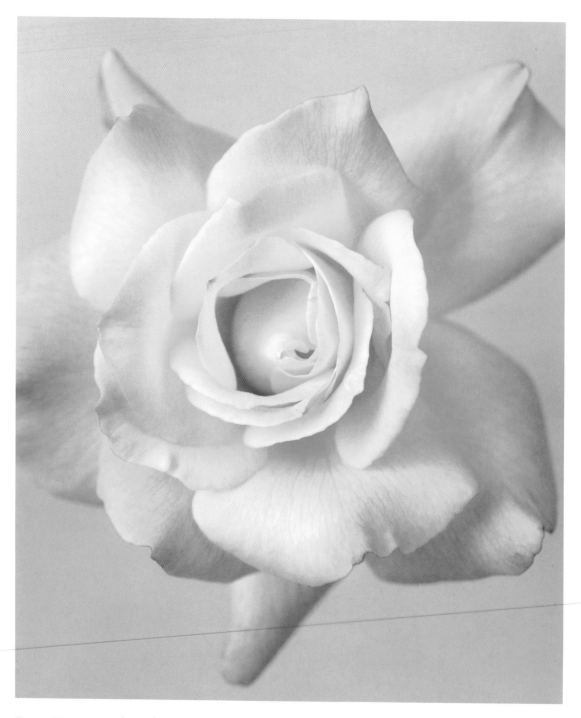

Rosa 'Pristine' (Rose)

Roses symbolize love, and the modest hues of this bloom indicate a gentle heart. Though you do not attract flamboyant displays of affection, you are deeply admired and respected. Compassion is your distinguishing trait, and you have an appreciation for fine art and literature.

Galanthus nivalis (Snowdrop)

The common snowdrop is one of the first bulbs to bloom in spring, and heralds the end of winter. You are hardy and dependable, and have a unique ability to give a great performance under the toughest circumstances. You prefer a simple, almost minimalist life, which affords you clarity of mind and keeps you grounded.

Kalmia latifolia (Mountain Laurel)

Reminiscent of ballerinas, these pretty flowers represent purity and fecundity. The small but significant splashes of red symbolize passion. You are one of those rare but lucky people who combines sexual attractiveness with sensitivity. You have a special glow which makes people look twice.

Magnolia 'Heaven Scent' (Tulip Magnolia)

This proud beauty looks lovingly skyward in thanks. You are happiest when you feel connected to your community. You have a distinctive noble bearing but it is not until people get to know you that they learn of your true beauty: your generosity and compassion.

Euphorbia 'Limewall' (Spurge)

Your bloom blesses you with good health and a robust constitution. You are thrifty and efficient, and with minimal effort you can achieve great things. If you get weary you should take advantage of the great outdoors and its power to clear your mind and refresh your spirit.

Zantedeschia variegata 'Mint' (Arum Lily)

The fluted shape of the arum lily represents protection and the sacred. You are a person of great virtue and your friends know that you always speak the truth. Because you are well balanced in mind, body and soul, your company and opinion are widely sought.

Brugmansia 'Charles Grimaldi' (Angel's Trumpet)

This flower has flair and resounding clarity, and is renowned for its abundant and fragrant blossoms. Seemingly contradictory, you are duality personified. You are at once at ease with both life and death. You have the talent for telling it like it is, and speak a truth almost heaven sent.

Chrysanthemum hybridus (Chrysanthemum)

The chrysanthemum is an ancient flower that has been cultivated for its blooms since the fifteenth century B.C. In your personality, enduring appeal is given a modern interpretation. You are eternally optimistic and extremely passionate, but your potential to be overemotional is kept in check by a clear head.

Osteospermum 'Asti White' (African Daisy)

Opening to the sun and closing to the stars, this lovely flower knows the essence of wakefulness. Ever vigilant and observant, you are adept at reading people and can deliver a swift and accurate appraisal of character. You are by nature trusting and wise, and are surrounded by friends that respect you unreservedly.

Syngonanthus chrysanthus 'Mikado' (Mikado)

The mikado means you know what you want and how to get it. You have been blessed with a sense of purpose that enables you to achieve many of your goals, desires and dreams. You have at your core true optimism and integrity, which help you to surmount any obstacles.

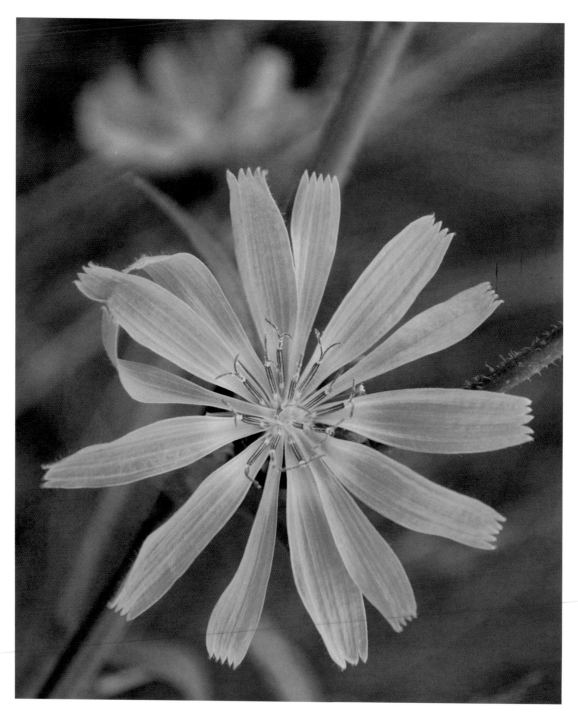

Cichorium intybus (Chicory)

This flower represents clarity and the removal of obstacles. With the felicity of change on your side you are constantly adapting and blossoming anew. You are a natural leader. Your mental acuity and creativity serve you in good stead and encourage you to treat problems as opportunities.

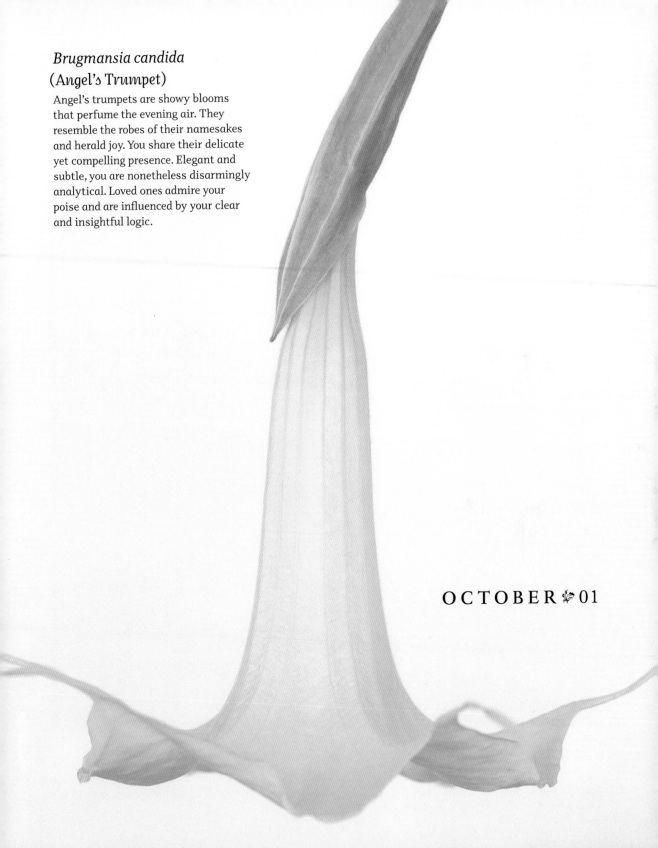

Brugmansia candida
(Angel's Trumpet)

Angel's trumpets are showy blooms
that perfume the evening air. They
resemble the robes of their namesakes
and herald joy. You share their delicate
yet compelling presence. Elegant and
subtle, you are nonetheless disarmingly
analytical. Loved ones admire your
poise and are influenced by your clear
and insightful logic.

OCTOBER ❦ 01

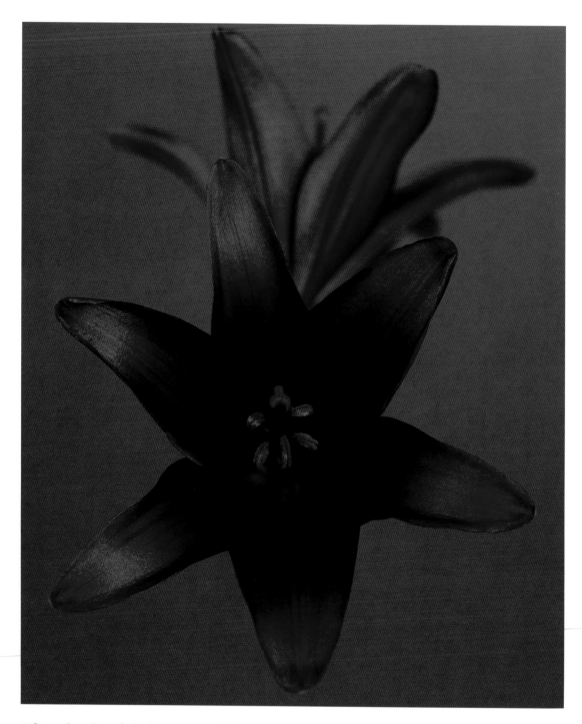

Lilium landini (Black Asiatic Lily)

The deep red color of the black Asiatic lily is associated with vitality and ambition. You will have success in love and share your passion for life with those closest to you. As a protective individual who loves beauty, you will have a powerful aesthetic taste and enjoy collecting.

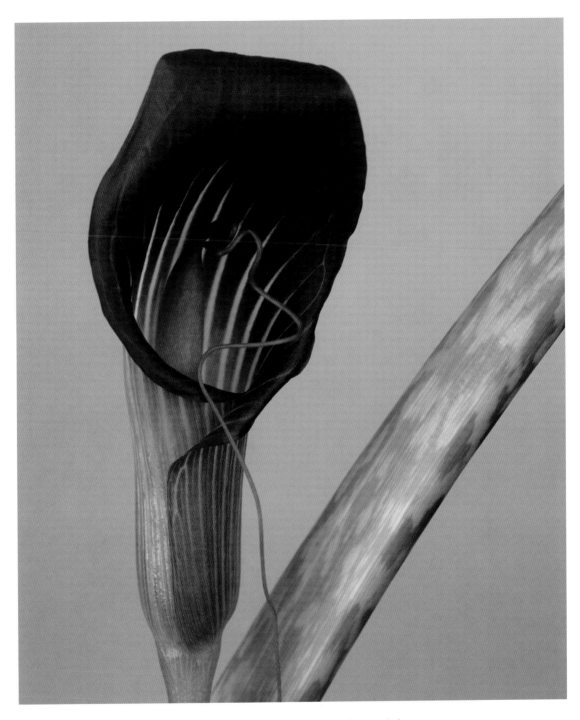

Arisaema speciosum 'Himalaya Giant' (Giant Cobra Lily)

The giant cobra lily of the Himalayas is notoriously difficult to grow away from its home. You have a profound sense of place and like to put down roots. Yet despite your practical approach to life, you are one of nature's creative dreamers.

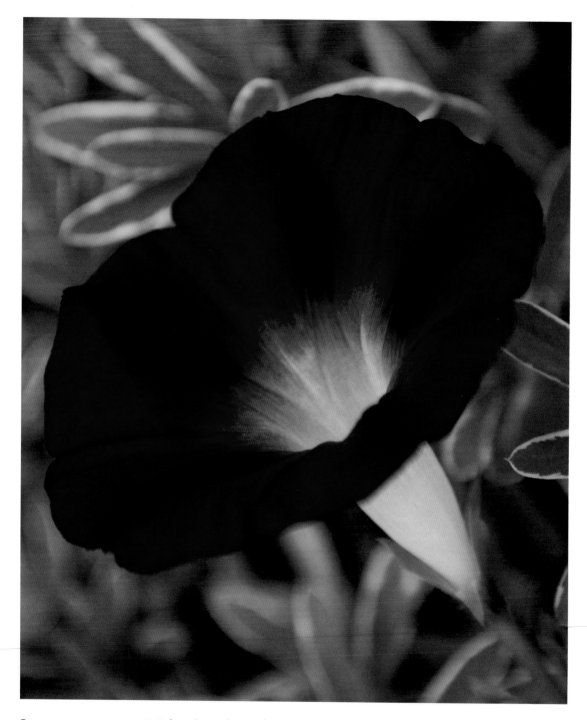

Ipomoea purpurea 'Midnight Velvet' (Tall Morning Glory)

Bringing the darkness into the light, the symbol of the tall morning glory is affection. Your enthusiasm is infectious, you know how to party and are famous for your all-night antics. You love to see the sunrise and are not perturbed by lack of sleep, but when you need to recharge you retreat into a cocoon.

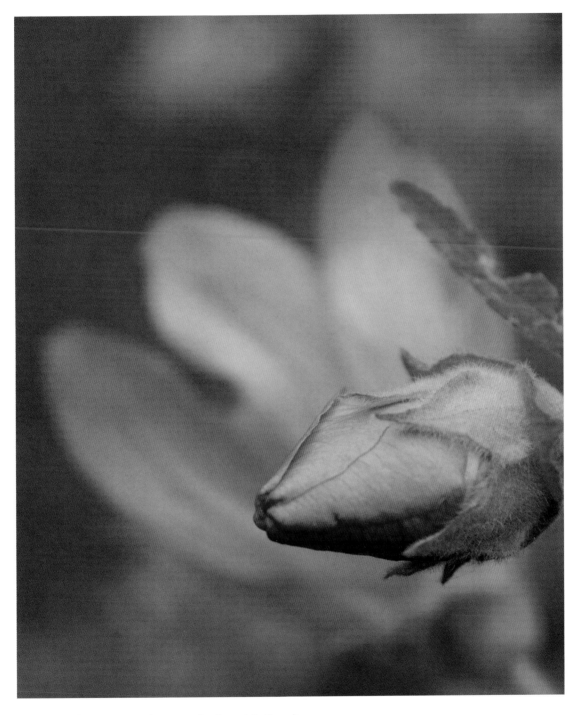

Malva sylvestris 'Zebrina' (Zebra Mallow)

The purple hue of this flower represents spirituality and clarity of thought. You love to travel and are welcomed wherever you go because of your independence and free spirit. You may be drawn to the arts or a career in music. When you follow your natural instincts you will make your mark on the world.

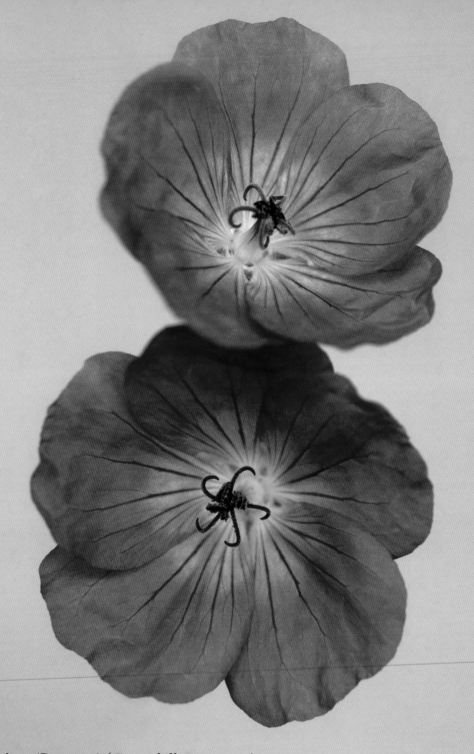

Geranium 'Rozanne' (Cranesbill Geranium)

Vigorous but never invasive, the cranesbill represents tenacity and intuition. You are naturally analytical with a high self-esteem. You are prepared to trust your instincts and will persevere with any task that you truly believe is worthy. These qualities make you a loyal friend and devoted lover, and a highly regarded team player.

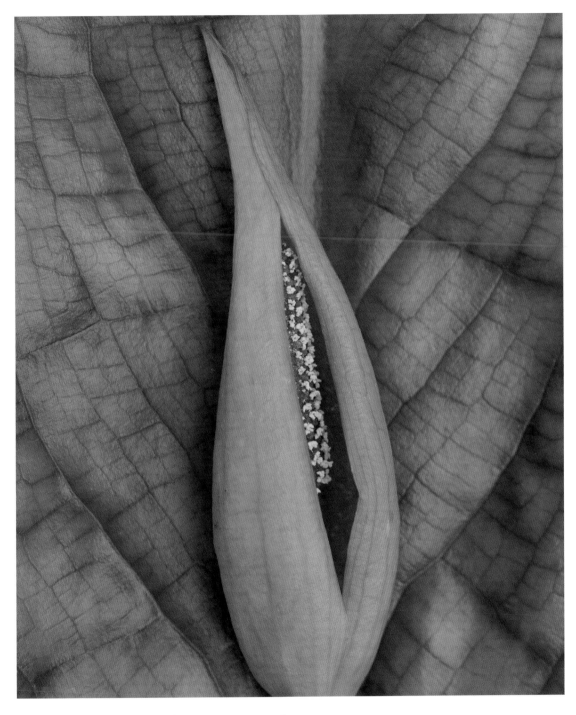

Lysichiton americanus (Swamp Lantern)

You possess an amazing ability to bring light and warmth to the darkest and coldest situations. Even when you feel your most downtrodden you are irresistibly attractive to your suitors and will retain your magnetism into your later years.

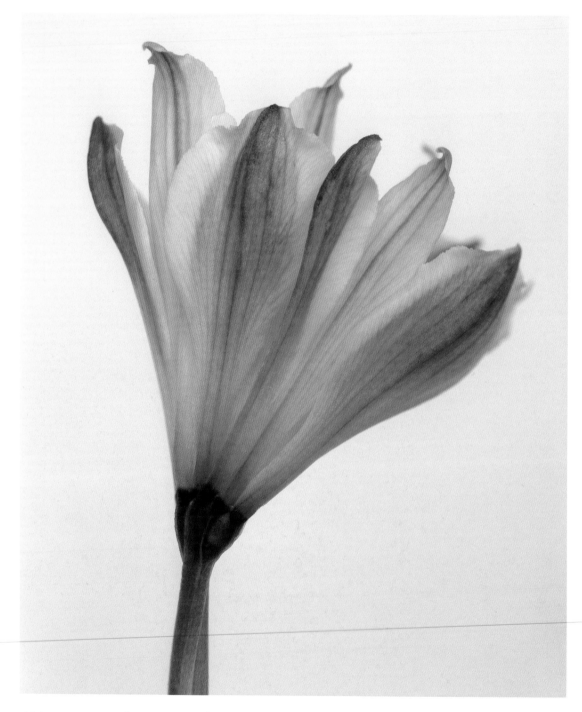

Alstroemeria 'Champagne' (Parrot Lily)

This elegant flower embodies wisdom and sagacity in the delicate hues of its petals. It imbues you with a calm mind, level thinking and quiet disposition. You are surefooted and careful with an innate sense of grace and propriety, and will excel in matters of diplomacy.

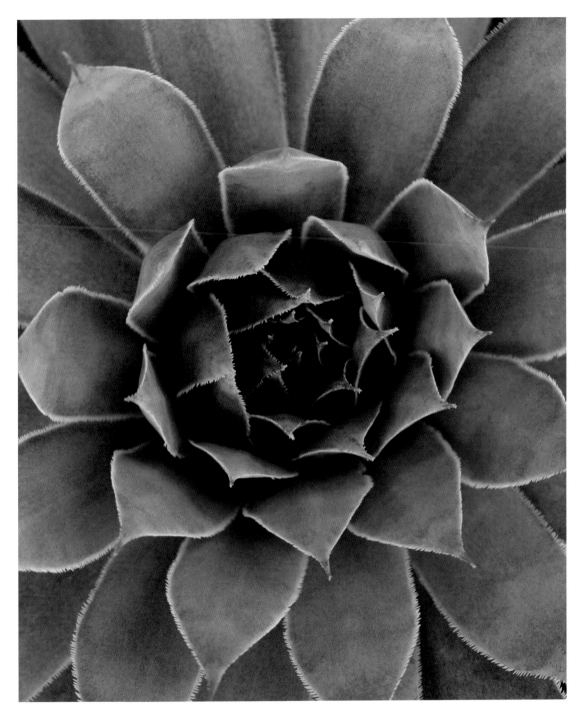

Sempervivum tectorum (Hens and Chickens Plants)

A flush of pink brings this succulent's rosettes to life. Though essentially an earthy and practical person, there is a sweetness to your personality that you may express in your relationships with children. You give generously but ask for little in return, relying on your own extraordinary reserves of energy.

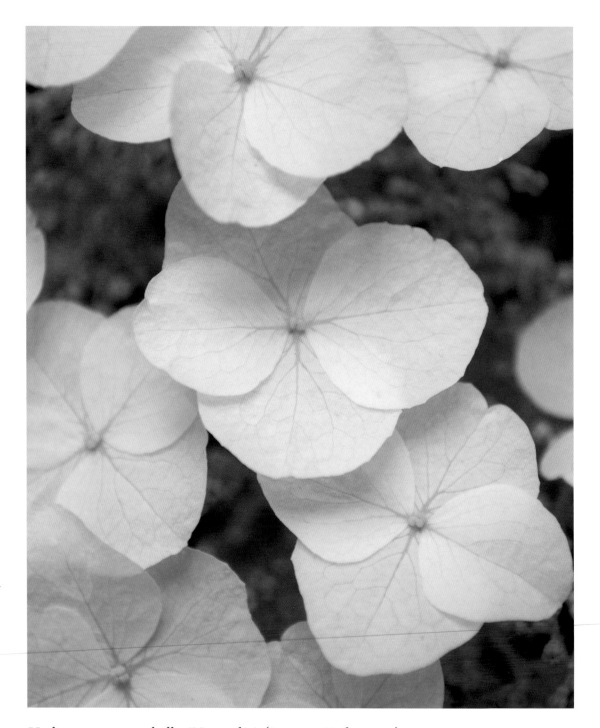

Hydrangea macrophylla 'Normalis' (Lacecap Hydrangea)

A symbol of frivolity and thanks the hydrangea is a capricious flower. Like these changeable blooms you embody a response to your environment and may appear different from place to place. You are intuitive and complex, and may be beguiling, compelling and misleading.

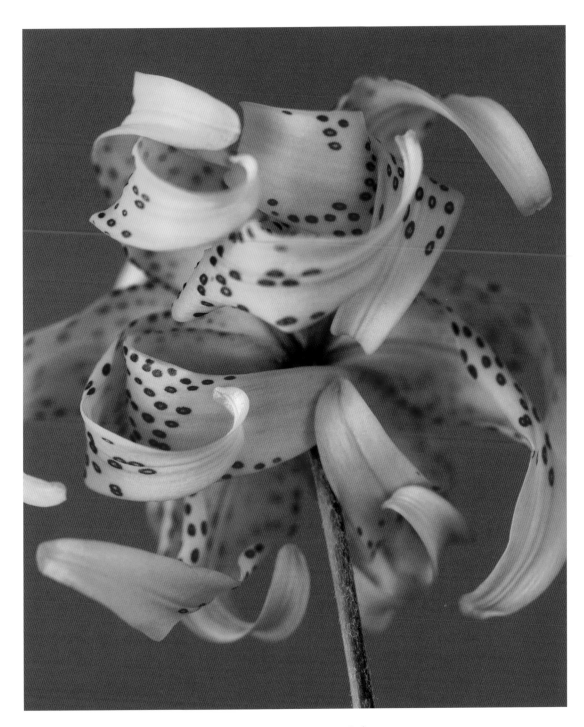

Lilium lanceofolium 'Flore Pleno' (Double Tiger Lily)

This exceptional bloom symbolizes wealth and pride. This combination may well be troublesome in an individual—but not this one. While you are certainly a head-turner, you also know how to radiate delight. You have a profound love for life and attract many friends. These characteristics make you irresistible and a little intoxicating.

Tulipa 'Queen of the Night' (Tulip)

Tulips represent luxury and the 'Queen of the Night' tulip is particularly rich. You are attracted to the delights of luscious silks, precious gems, gourmet food and fine wine. Others are struck by your deep mystery and refined sensuality. You will prosper and enjoy happiness in abundance.

Celosia argentea cristata (Flamingo Feather)

The flamingo feather is robust and exuberant, with an exotic appearance. You share its unusual good looks and bold personality, and are well liked for your willingness to engage with new people and activities. You are passionate and tenacious, making you a formidable opponent, but a devoted and loyal ally.

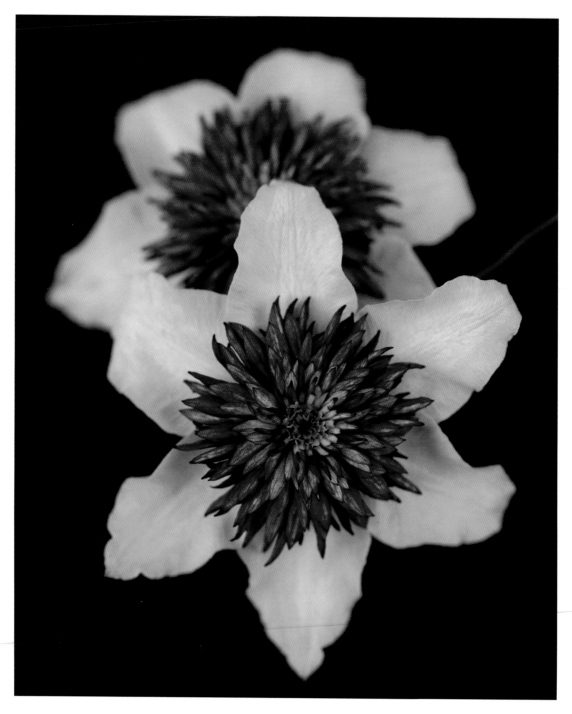

Clematis florida (Passion Flower)

The clematis is an old plant, loved by the ancient Greeks. This variety has a sunny exterior with a heart of pure passion. Optimistic and excitable, you know how to spice up a party. You are a natural social climber but you make a devoted lover and friend.

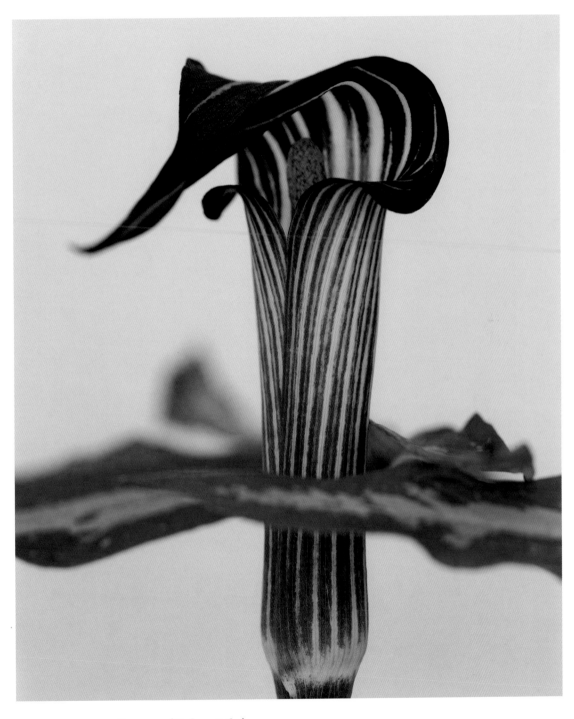

Arisaema angustatum (Cobra Lily)

Like the cobra lily you are seductive and sophisticated. You enjoy luxury and all things artistic, and are likely to be employed in a creative industry. Your friends and lovers enjoy your generosity and though you are prone to exaggeration, you are often the center of attention.

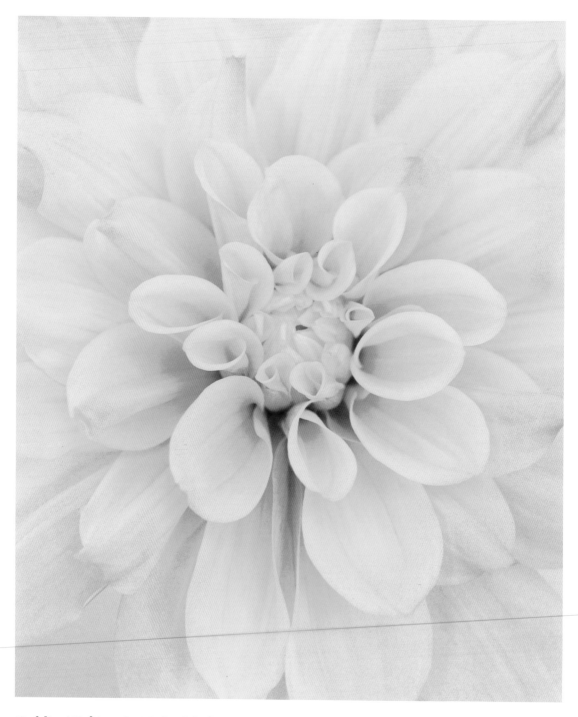

Dahlia 'Café au Lait' (Dahlia)

'Café au Lait' has exquisite petals with a subtlety of color and a precisely sculpted shape. Like this flower you are tasteful and sophisticated. You think carefully before you act, and make time each day to assess your progress through life. Your friends find you uplifting and reassuring.

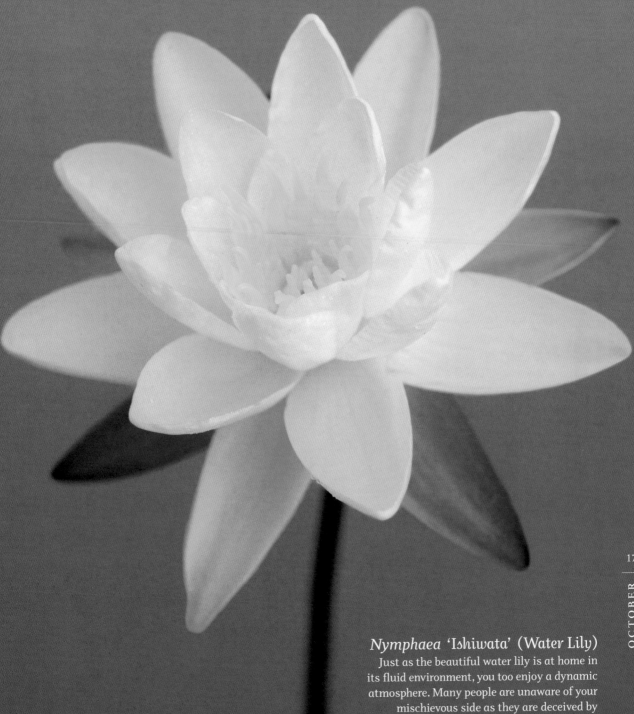

Nymphaea 'Ishiwata' (Water Lily)
Just as the beautiful water lily is at home in
its fluid environment, you too enjoy a dynamic
atmosphere. Many people are unaware of your
mischievous side as they are deceived by
your tranquil outward appearance. You have
a wisdom that many find profound.

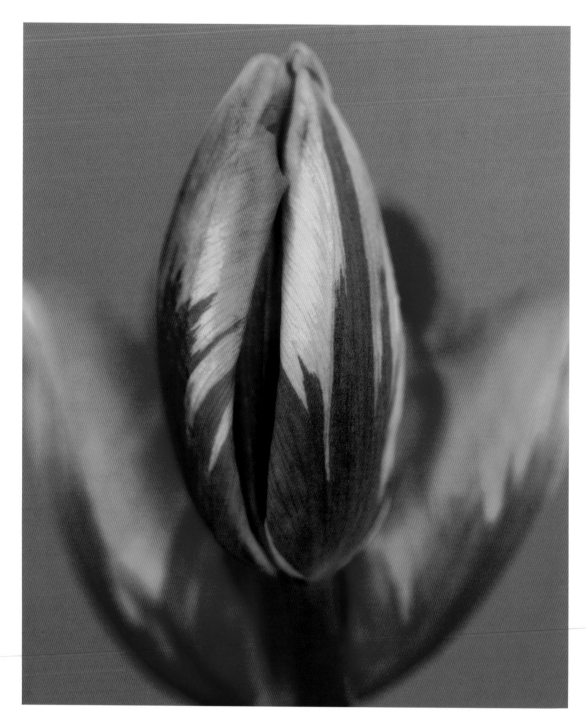

Tulipa 'Fire Queen' (Tulip)

Tulips symbolize luxury and sensuality. Those born on this day enjoy all things rich, gourmet and indulgent. Bold and jewel-like, you stand out in a crowd. You are prone to extravagance and over-generosity. But you are well-loved and the life of the party.

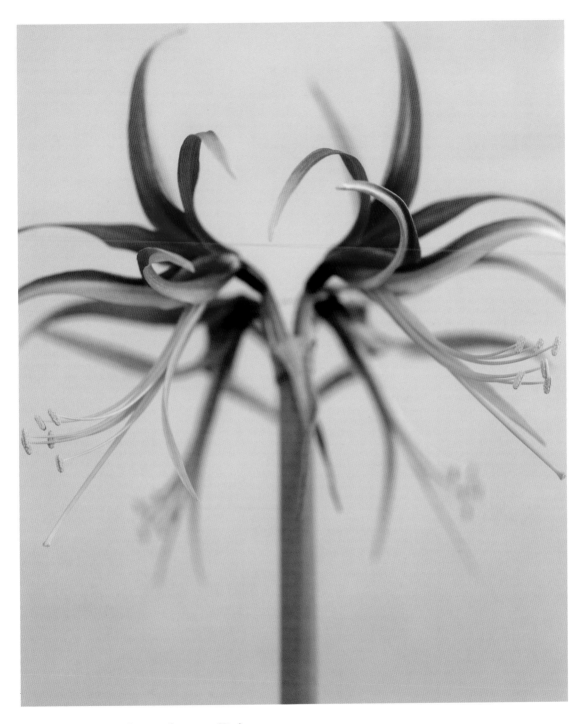

Hippeastrum 'Chico' (*Amaryllis*)

This cheeky flower sits jauntily atop its stem with genuine nonchalance. Likewise, you are casually cool with a mischievous streak. Though your looks are striking, your beauty is natural rather than contrived, and you can sometimes appear to have simply thrown your look together—but this merely adds to your appeal.

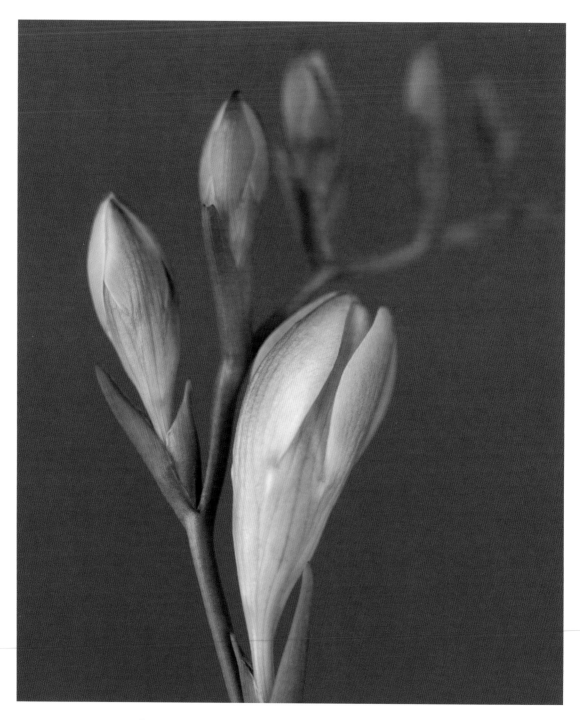

Freesia 'Lavande' (Freesia)

Freesia flowers are the symbol of innocence. They are among the first blooms to appear in spring and are certainly the most fragrant. Like this flower you have an air of old-fashioned sweetness about you balanced by an ability to appear modern and fresh. You are sensitive to beauty and are one of nature's dreamers.

Fuchsia 'Mrs Popple' (Hardy Fuchsia)

Though delicate in appearance, you share with this fuchsia the ability to bounce back spectacularly after a knock. There is an air of expectancy about you, as if at any moment you are about to reveal a hidden truth. Your warm and compassionate personality is richly rewarding for all those around you.

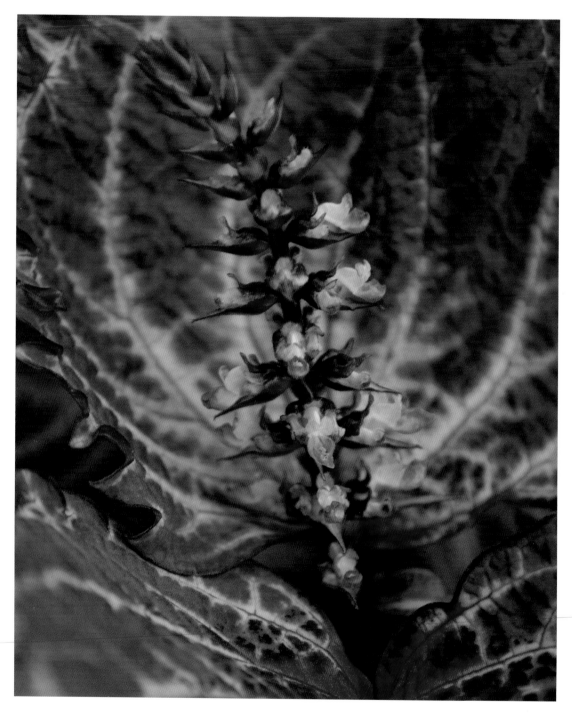

Solenostemon scutellarioides (Coleus)

You have a generous and kind heart that you wear upon your sleeve. This makes you well-loved as your gentleness and all-embracing compassion are the first things that people notice about you. You have a strong faith that feeds your soul and gives you the resilience you need to complete your life's work.

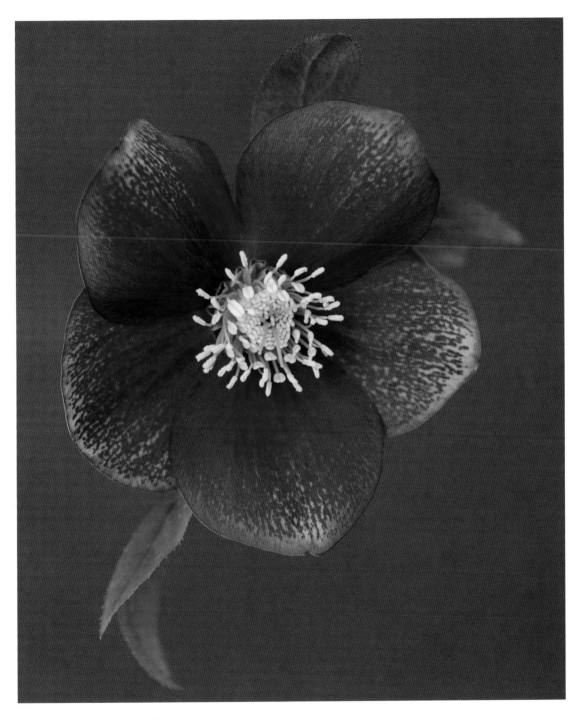

Helleborus 'Haiku' (Lenten Rose)

The 'Haiku' lenten rose is one of nature's most poetic blossoms. With a measured approach to life but a romantic nature, you epitomize controlled passion. You have a gift for language and are best suited to a career that indulges your love of words.

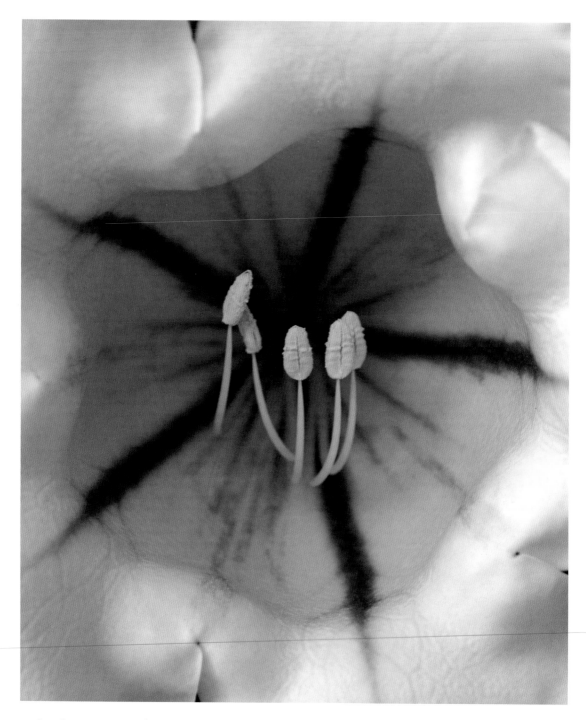

Solandra maxima (Golden Chalice Vine)

The golden chalice vine imbues you with optimism and talent. You are at your best when supported by a hard-working network that loves and nurtures you. Be wary of your tendency to overindulge; you are most effective when you observe moderation. Let your own brilliance shine.

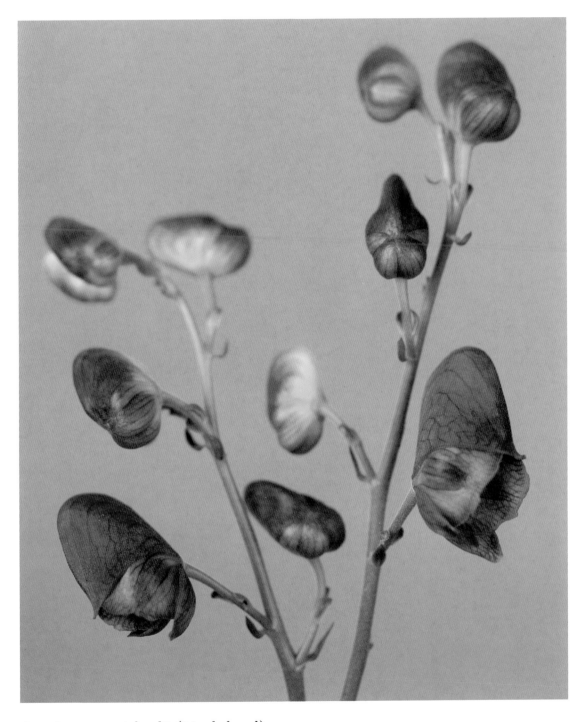

Aconitum carmichaelii (Monkshood)

Chivalry is the key tenet of the monkshood, tempered here by a love of fantasy and dreams. With your surprising mental agility your creative talents are widely appreciated. Your subtlety and good etiquette make you a desirable friend and you are loyal and true to those you love.

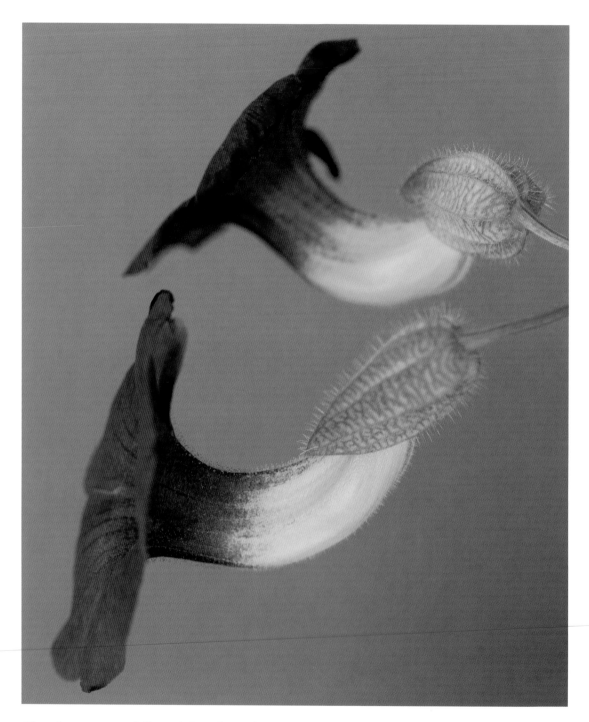

Thunbergia grandiflora (Sky Flower)

A true beauty, the sky flower dazzles with its adaptability and speed of growth. You are a loving and gregarious person who has a positive effect on all you meet. Your reassuring presence and loyalty make you a great friend and lover.

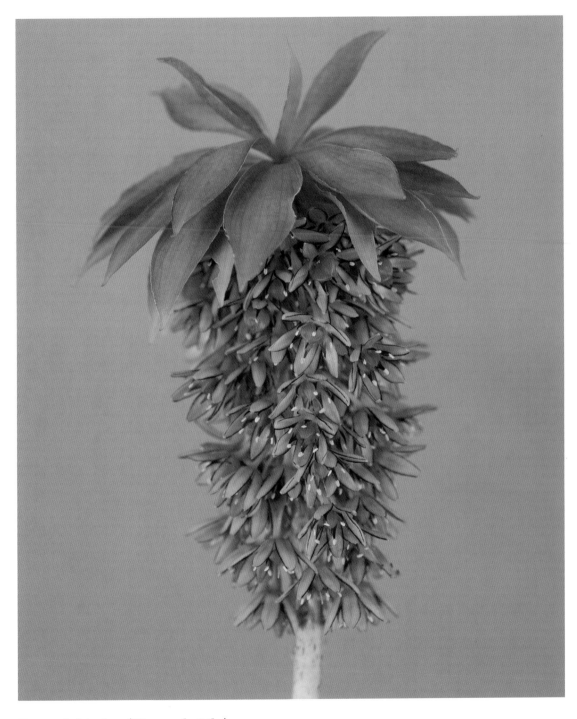

Eucomis bicolor (Pineapple Lily)

The pineapple lily takes its name from its myriad pineapple-like flowers. Like this flower you are sensitive to your environment and like the comforts of your own home, but you bounce back quickly after setbacks. You are blessed with longevity and are likely to be at the center of a large family.

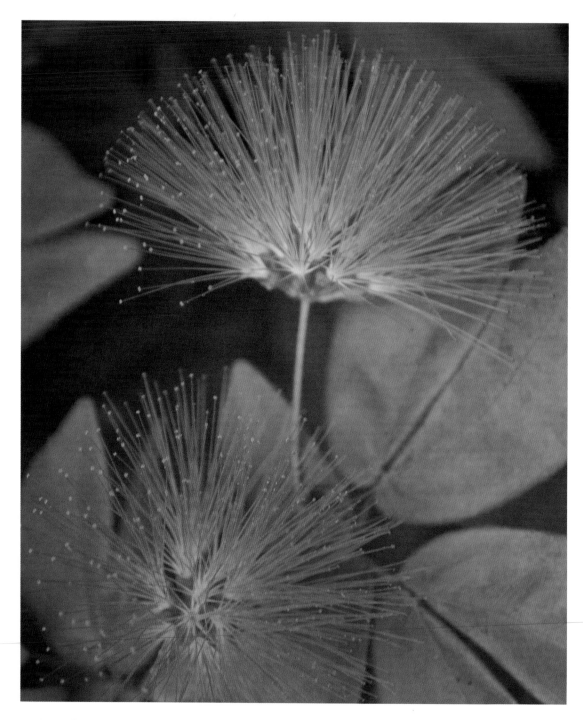

Calliandra haematocephala (Red Powderpuff)

You are hot-blooded and passionate but seldom exert any energy in anger. You prefer to explore your emotions in positive ways and are an expressive lover. Those that know you best will understand that there is something magical and irresistible about your allure.

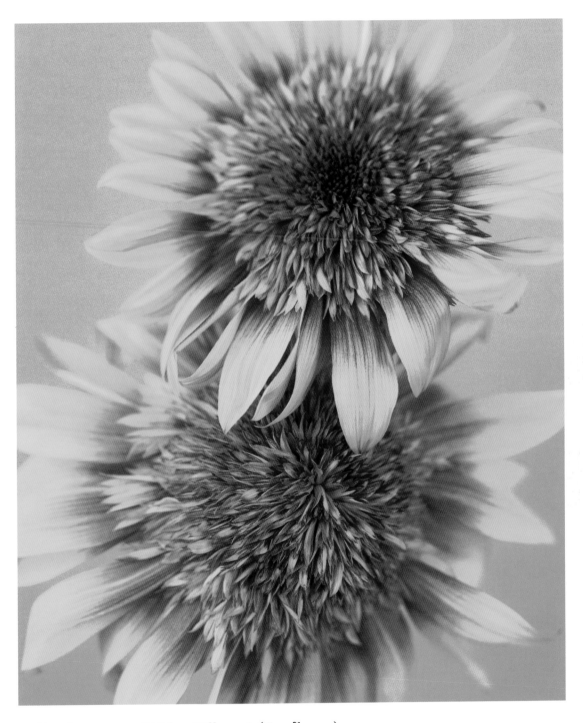

Helianthus annus 'Widow Tillman' (Sunflower)

True joy: the symbol of the sunflower 'Widow Tillman,' is also your greatest blessing. You are free from self-doubt with an extraordinary capacity for fun. You make others feel good and your friends enjoy your stimulating company and zest for life.

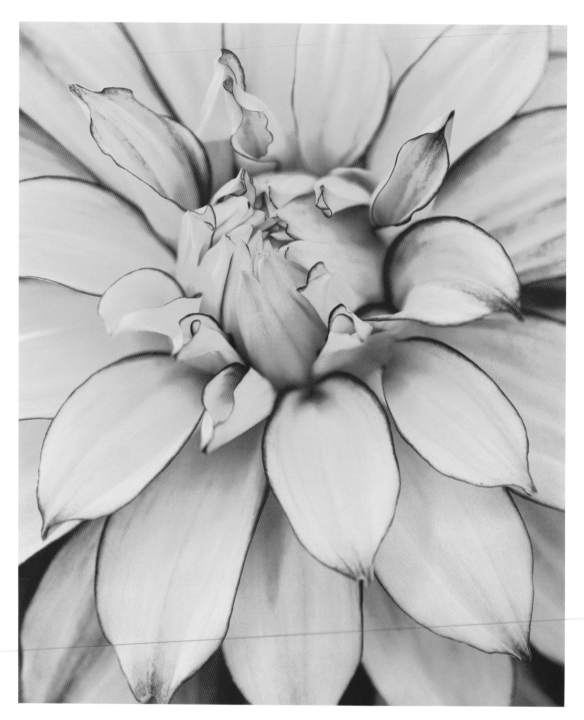

Dahlia 'Lady Darlene' (Dahlia)

You are an exuberant extrovert. The life and soul of the party, you are popular with all you meet. Your sunny nature is tinged with bold passion, making you a desirable partner. You firmly believe that 'what will be will be,' but temper this fatalism with your ability to favorably influence those around you.

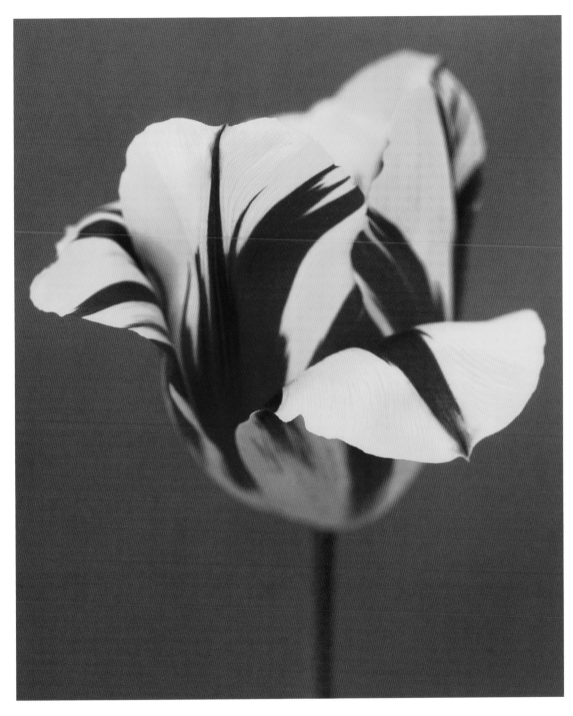

Tulipa 'Helmar' (Tulip)

This beautiful tulip represents passion and integrity. You will therefore have great success in love, not least because of your sunny disposition. You have an ability to use your intuition to assess and defuse situations. Variegation in petal coloring often symbolizes beautiful eyes.

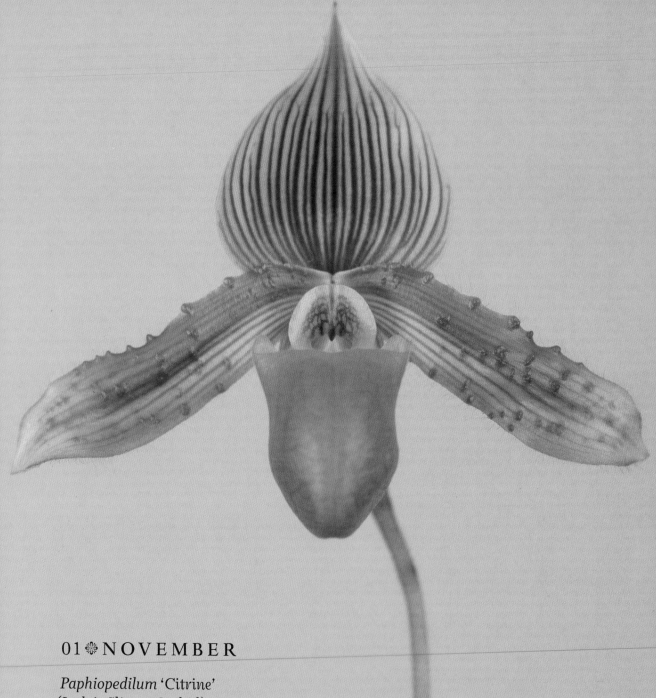

01 ❀ NOVEMBER

Paphiopedilum 'Citrine'
(Lady's Slipper Orchid)

The solitary bloom of this orchid symbolizes attraction
and refinement. You thrive in an environment of excessive
stimulation and love to be surrounded by and supported
by others. You have a keen intellect which guarantees you
inspiration and challenge wherever you are.

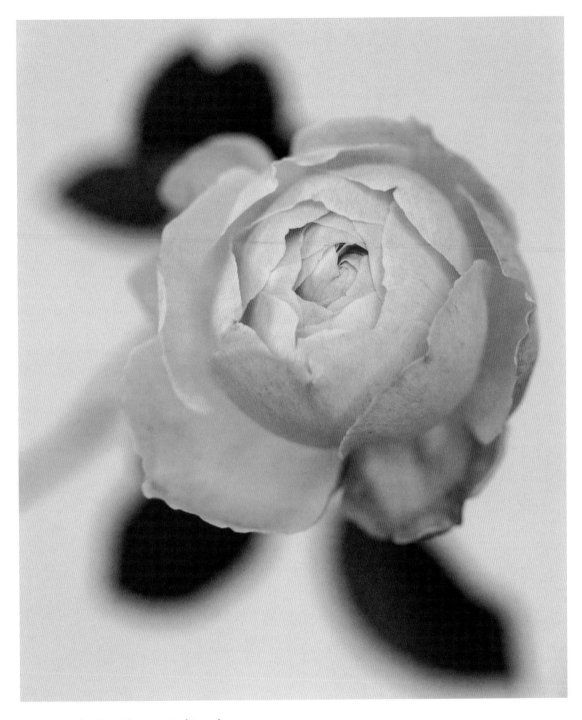

Rosa 'Jude the Obscure' (Rose)

The 'Jude the Obscure' rose symbolizes both the struggle for happiness against the odds, and the praise deserved by those who succeed. You desire a partnership of passion and integrity but you recognize that relationships are complicated. Armed with this knowledge, you will find true love and joy when you simplify your existence.

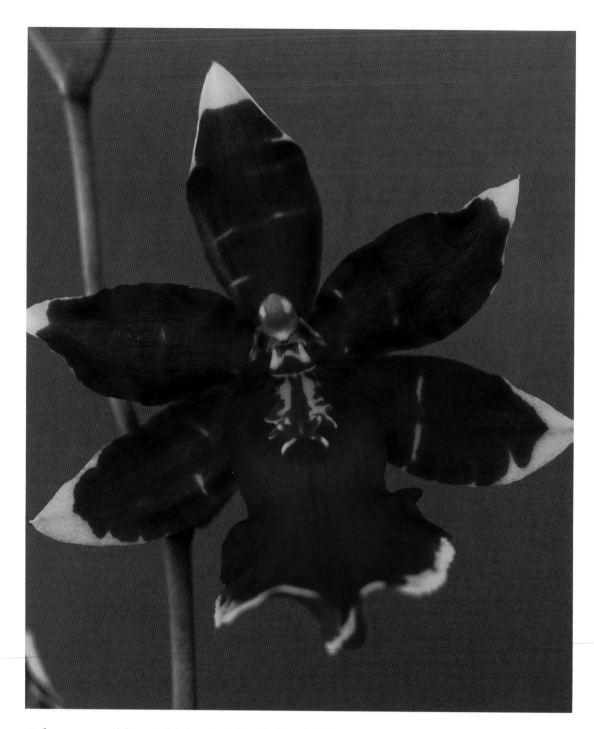

Colmanara wildcat 'Golden Red Star' (Orchid)

With deep red in your heart you may find it hard to resist outbursts of emotion. Fortunately, your passion is tempered by optimism, resulting in extravagant displays of love rather than anger. You aspire to luxury and may have difficulty practicing self-control.

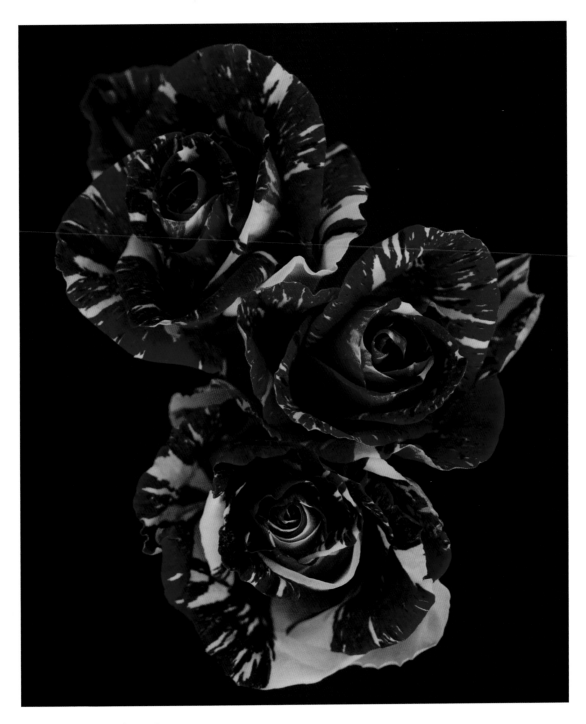

Rosa 'Fibidus' (Rose)

This rose blends vitality and ambition with happiness and clarity of thought. You have a powerful but discerning optimism that allows you to navigate difficulties with skill and grace. Your excellent memory and organizational ability bring career success and your sunny disposition makes you a popular companion.

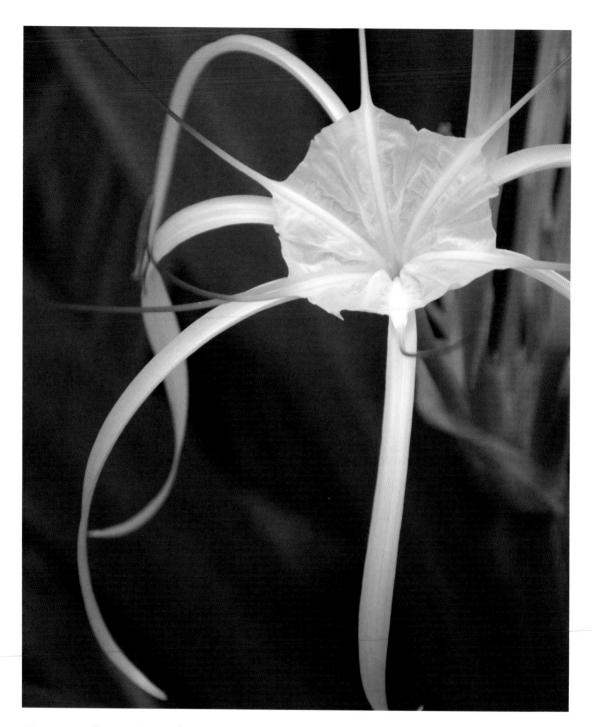

Hymenocallis caribaea (Spider Lily)

This beautiful spider lily represents innocence and openness. You entrance those you meet with your disarming charm and open heart. You have a clear mind and can communicate matters of deep spirituality very clearly. White symbolizes protection, which enables you to remain receptive without being negatively influenced.

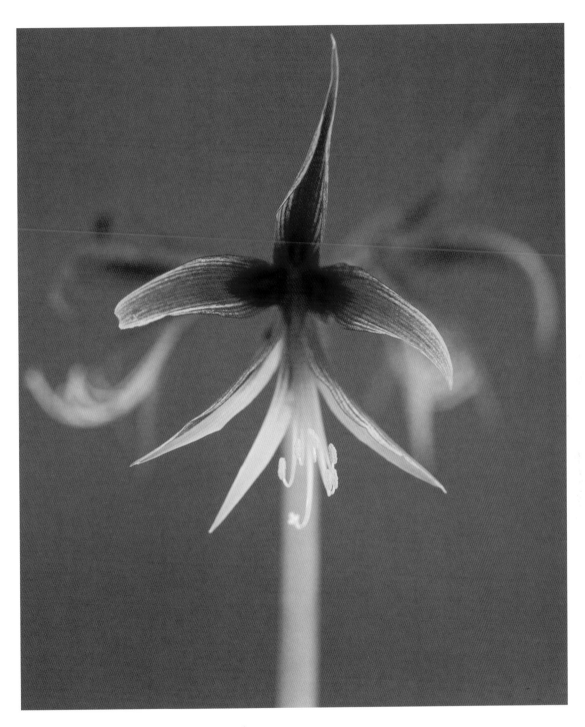

Hippeastrum 'La Paz' (Amaryllis)

Your flamboyant exterior disguises a quiet soul that yearns for peace. Thus you may have to guard against the attentions of others who misinterpret your bold beauty as frivolity. You are a deep thinker and prefer to keep your passionate side in check until others have proven they have your best interests at heart.

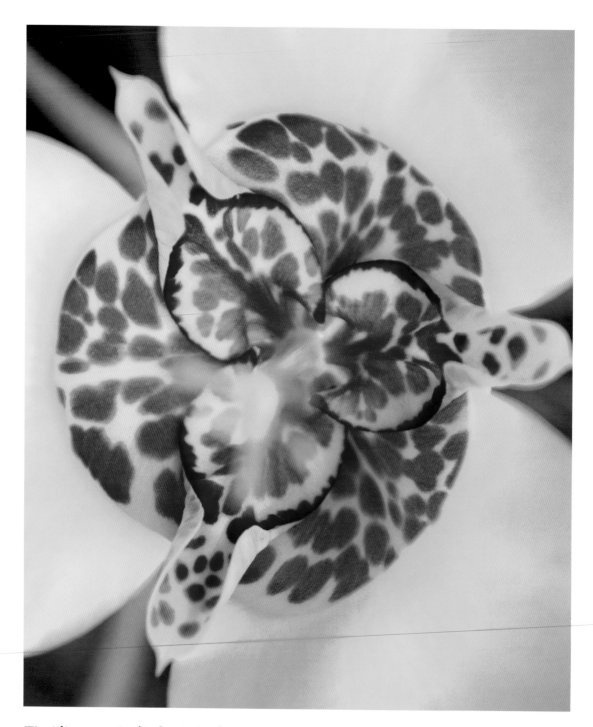

Tigridia pavonia (Jockey's Cap)

Jockey's caps are named for their resemblance to the bright silks worn by horse jockeys. With bold and modern looks you are known for your confidence and strong style. Revealing a fresh face each day, you are eternally youthful with a sunny outlook and a passionate heart that can set others' racing.

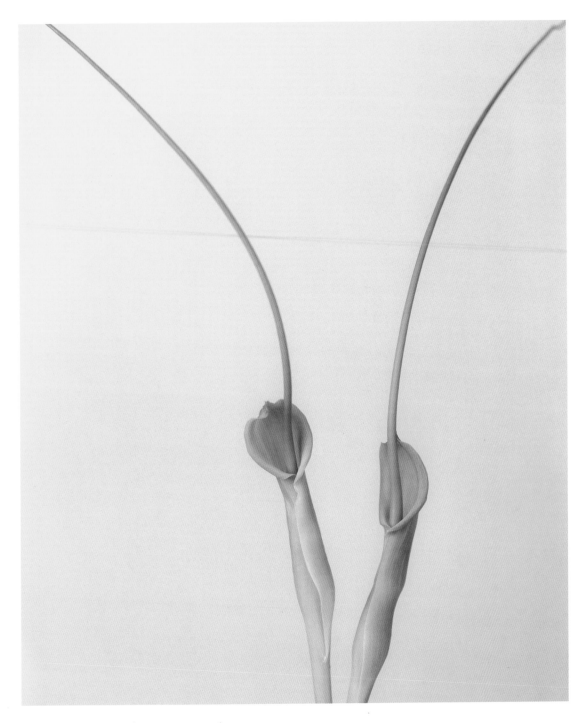

Pinellia ternata (Crow Dipper)

A distinctive flower, the crow dipper symbolizes individuality and independence. You know what you want and how to get it. This forthrightness makes you a force to be reckoned with. You have the ability to thrive in your chosen profession but don't try to branch out, as you perform best with a singular focus.

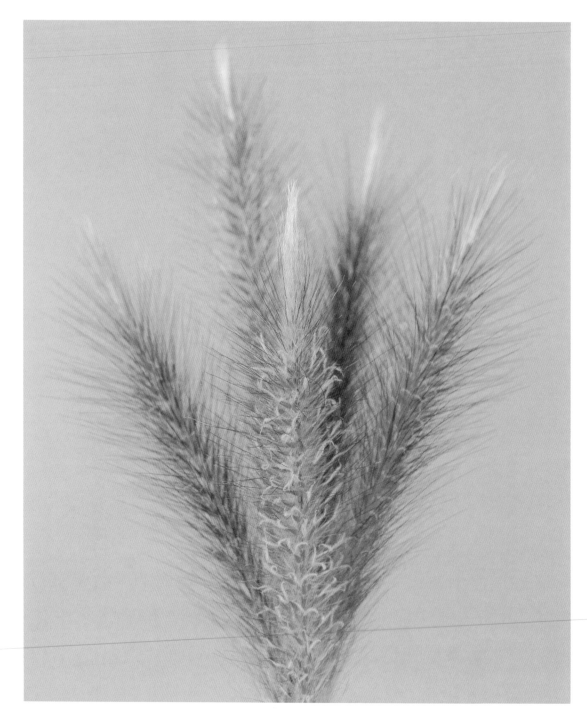

Pennisetum alopecuroides 'Weserbergland' (Fountain Grass)

This tactile and graceful flower represents longevity and advantage. With this combination you find that by exercising patience you will always prevail. Once truly comfortable, your beauty will outlast all others. You seem fresh and contemporary throughout all the phases of your life, allowing you to make vital first impressions.

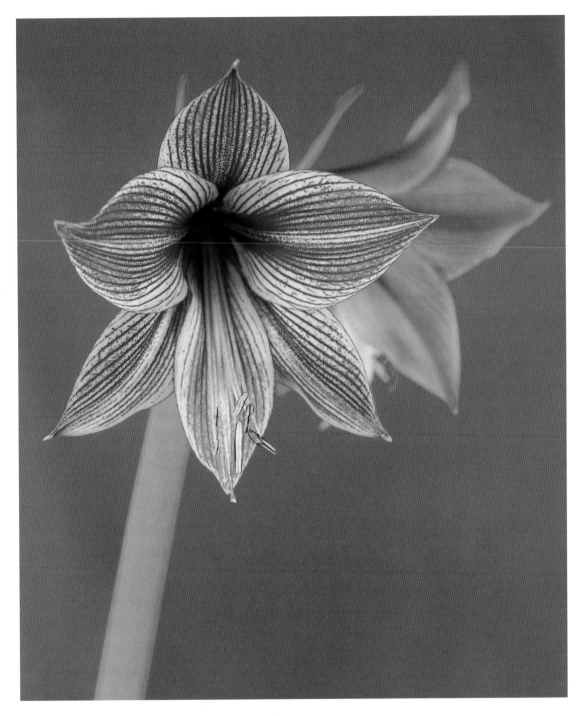

Hippeastrum 'Exotic Star' (Amaryllis)

This confident bloom holds its head high. When this is your flower you are infused with the same strong character and glorious presence. You are popular with people from many walks of life but will find the closest companions among other large personalities—they alone will discern your true acumen.

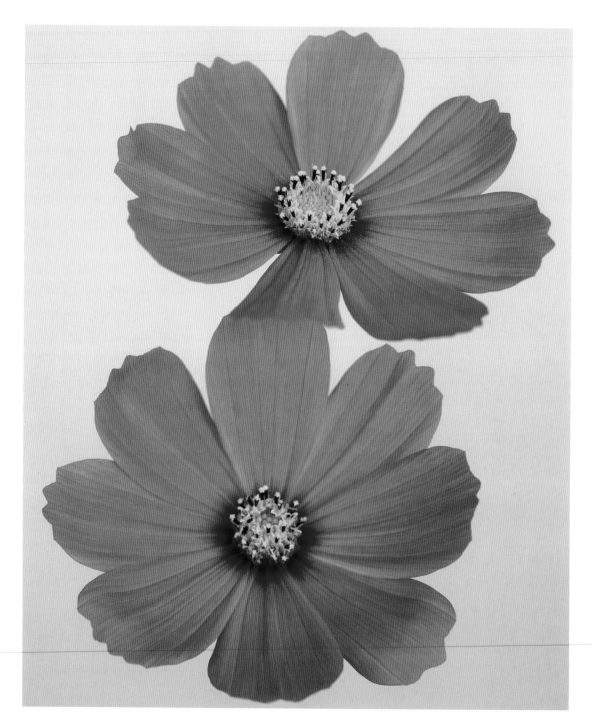

Cosmos bipinnatus 'Gloria' (Mexican Aster)

The Mexican aster is the symbol of daintiness, and confers to you a graceful bearing and delicate beauty. But your greatest gift is unselfish love. You have a nurturing and indulgent nature and can easily alleviate the loneliness and stress of those around you.

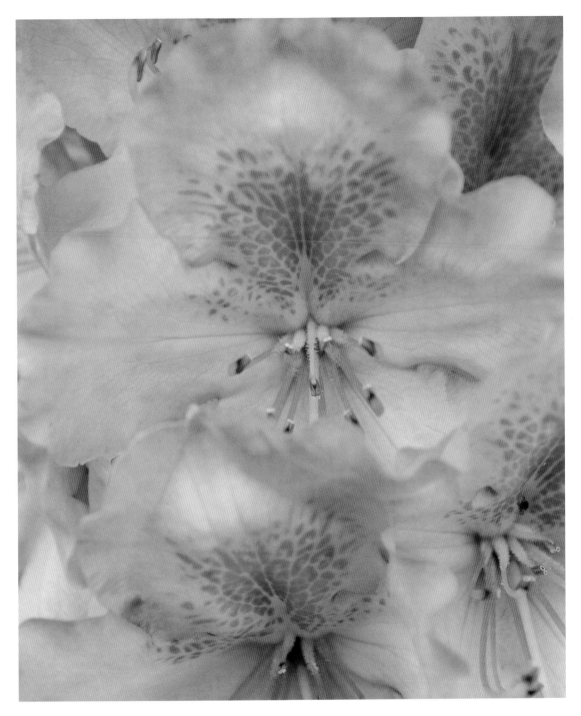

Rhododendron 'Weston's Pink Diamond' (Rose Tree)

'Weston's Pink Diamond' is an invigorating blossom which enlightens hearts. Your have at your core a pure and joyful optimism, which you use to envelope those lucky enough to know you. You ease oversensitivity and vulnerability, offering those around you acceptance and compassion.

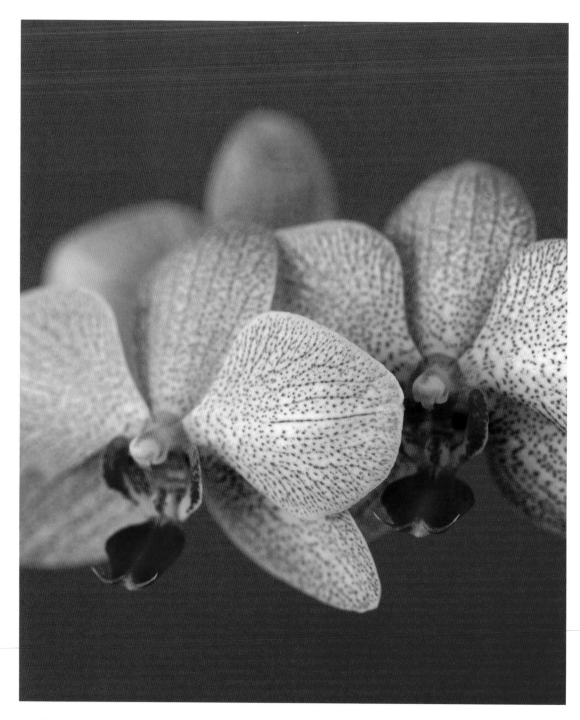

Phalaenopsis 'Baldan's Kaleidoscope' (Moth Orchid)

With its remarkably long flowering period, the moth orchid blesses you with enduring beauty. You bring a sense of calm and decorum to any situation. With a tendency towards things exotic, you may find travel rewarding, but this will need to be balanced with your desire for a large family.

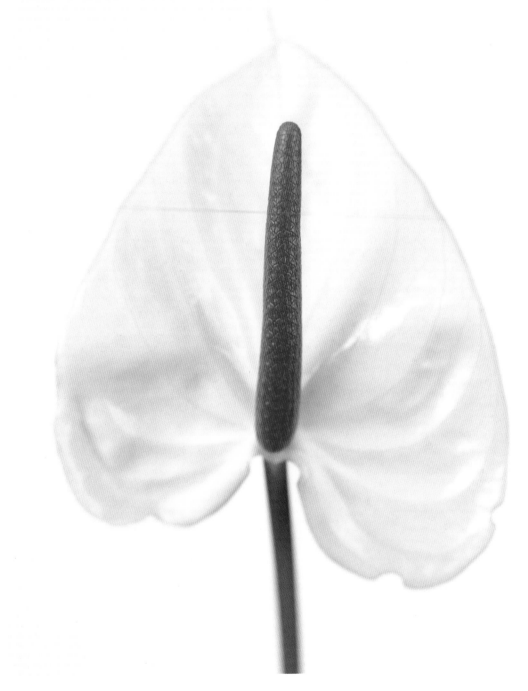

Anthurium 'Cleopatra' (Flamingo Lily)

Your dispassionate exterior belies a core of intense emotion, sometimes to your disadvantage. While you conduct yourself with the serenity of a swan, your feelings are often conflicted; you may find people hard to trust. But you experience profound love when you learn to follow your instincts.

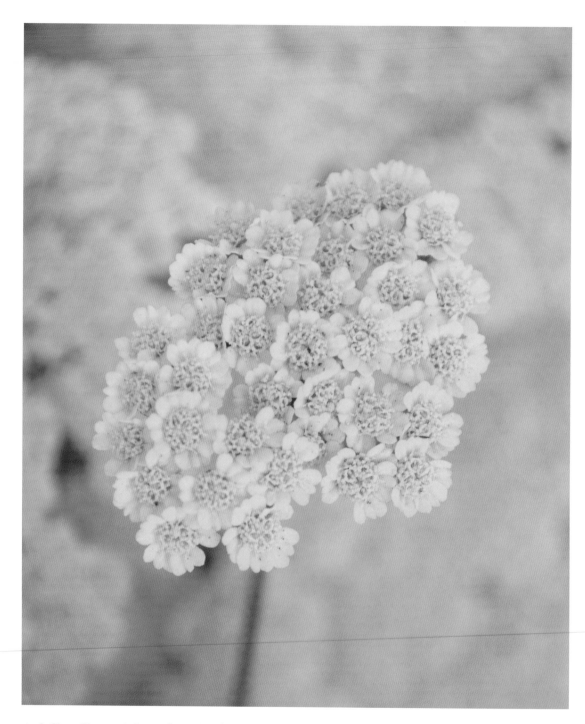

Achillea filipendulina (Fernleaf Yarrow)

Seldom does a flower so freely signal happiness. You share with this joyous bloom a love of people and a real affection for the crowd. Your sunny disposition and bountiful goodwill make you a favorite with animals, and you may meet your soulmate while enjoying the outdoors.

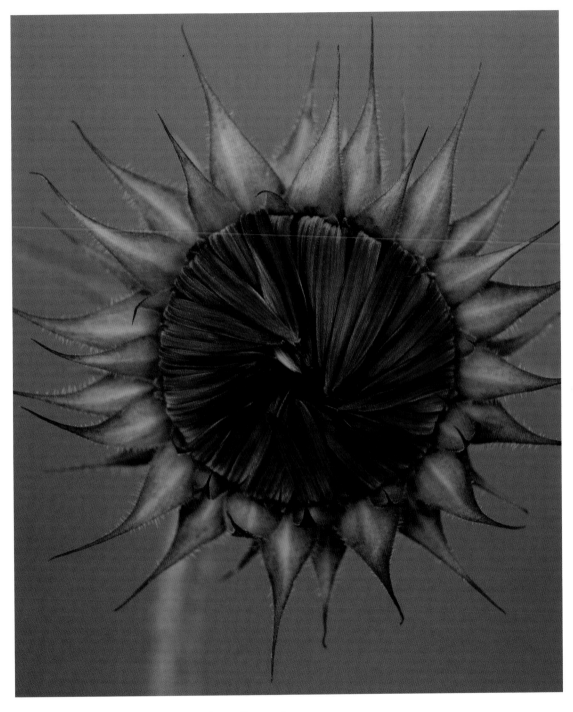

Helianthus annus 'Autumn' (Sunflower)

With its fiery petals the 'Autumn' sunflower gets noticed—and so do you. You are striking, vital and ambitious, but must be wary of extremes of mood. However, you are also kind and down to earth, and your friends admire your intellect and respect your advice.

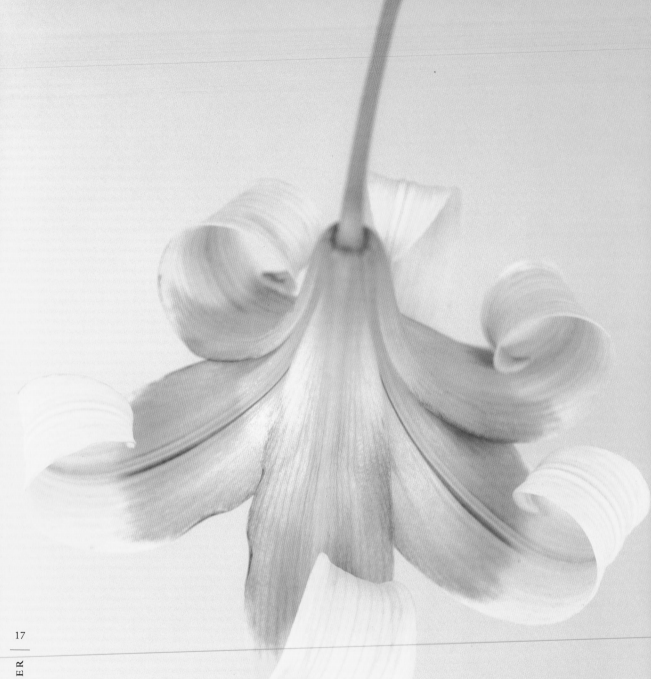

Lilium nepalense (Nepal Lily)

With hints of purple in its coloring, the Nepal lily exudes mystery and pride. A compassionate person, you are capable of great empathy. Whilst sophisticated, you are essentially a relaxed individual. Strangers cannot read you easily but you show your true colors to those you love.

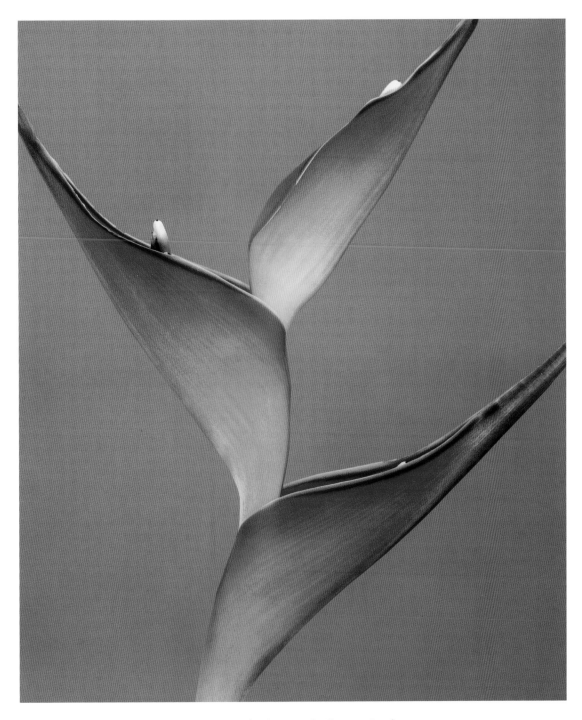

Heliconia stricta 'Iris Bannochie' (False Bird of Paradise)

Providing an important food source for hummingbirds, these statuesque and timeless flowers evoke jungle mystery, adventure and treasures lost and found. You are self-sufficient and proud. Your strong sense of place is founded on your implacable confidence, which sees you stand out in a crowd.

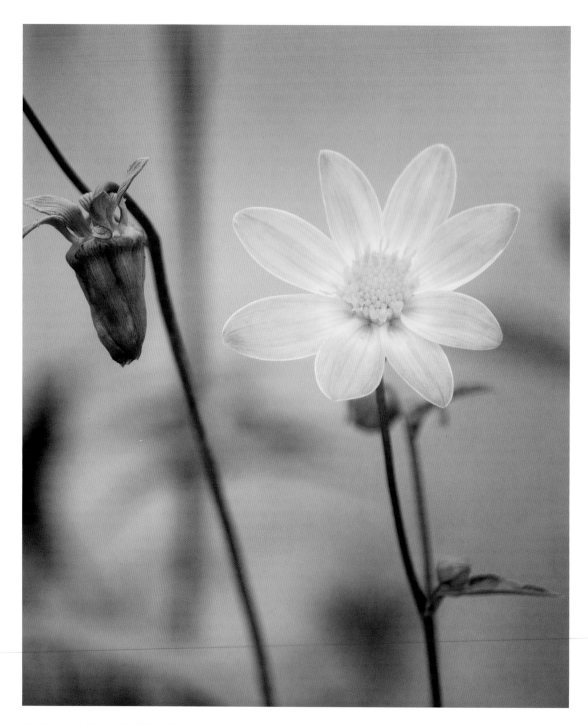

Dahlia 'Minuet' (Dahlia)

The 'Minuet' dahlia is fresh-faced and wears its heart upon its sleeve. You too have an open demeanor and uncomplicated personality. You are cheerful and generous and like nothing more than to be surrounded by friends. With deliberate pragmatism you approach life's problems in carefully measured steps.

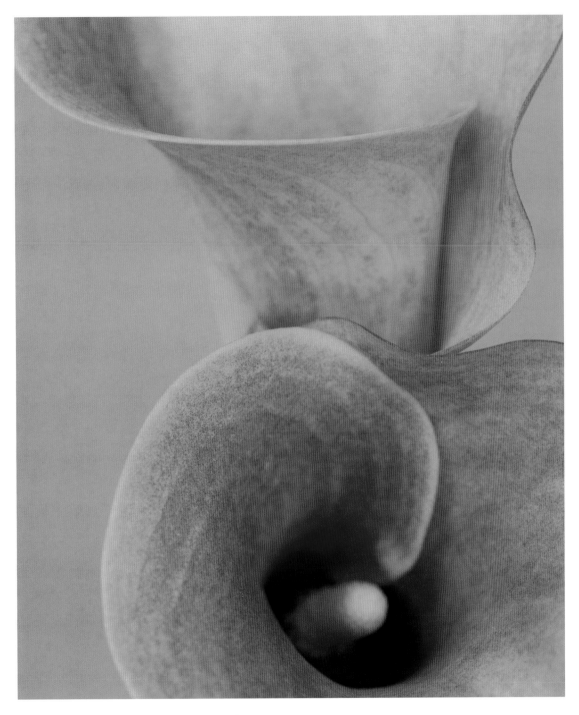

Zantedeschia 'Neroli' (Calla Lily)

This delightful orange calla lily simultaneously evokes a feeling of reassurance and refreshment. Your strong constitution enables you to nurture and advise others, who may describe your presence as 'healing.' You have an innate ability to uncover the source of tension or anxiety affecting people.

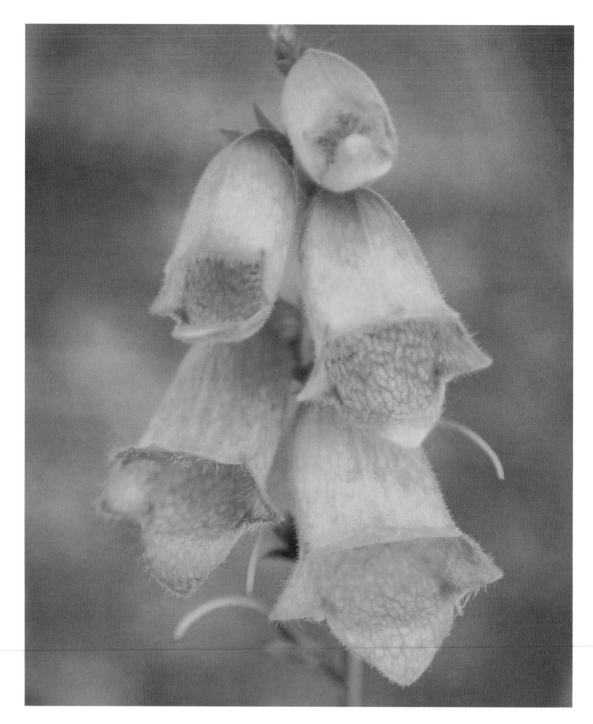

Digitalis 'Honey Trumpet' (Foxglove)

With majestic grace these blooms cascade potential and symbolize truth. You are a magnetic individual with the power to quite literally make hearts beat faster. Your soothing yet regenerating effect on people makes you a popular companion. Something of a tease, you like to reveal yourself slowly to your lovers.

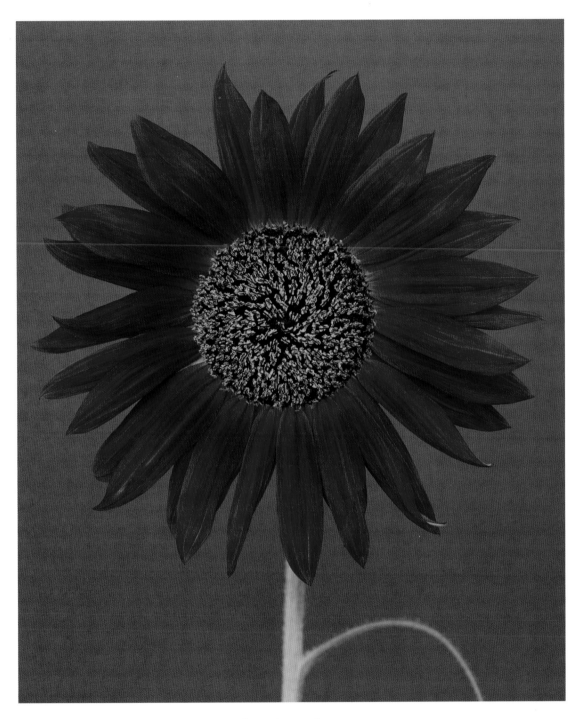

Helianthus annus 'Velvet Queen' (Sunflower)

'Velvet Queen' marries the intensity of love with a complex intellect, giving you an irresistible allure. You are an enigma. Like the sunflower, you wear your heart on your sleeve, yet only those truly in tune with you perceive the depths of your wisdom. You are happiest when you follow your intuition.

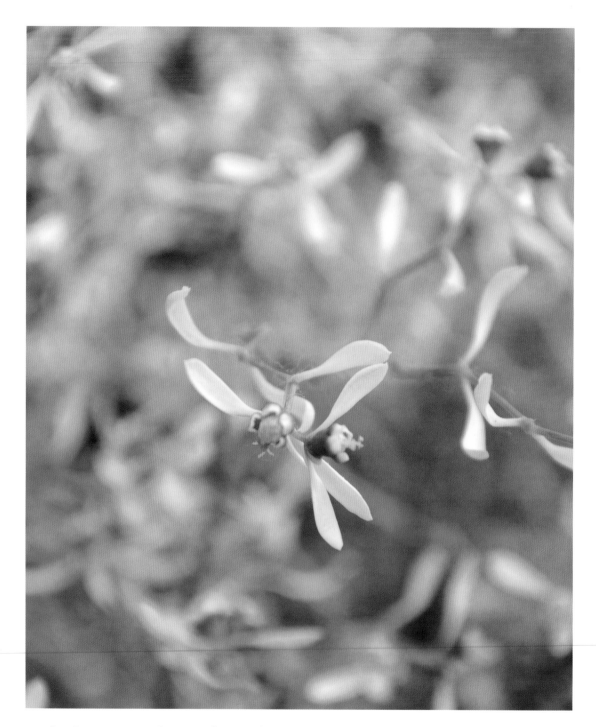

Euphorbia 'Diamond Frost' (Spurge)

Symbolising adaptability and stability, this flower has an architectural appeal. You are known for your generosity and are likely to surprise your loved ones with small but significant treasures. With your indomitable spirit you triumph over adversity, just as these delicate white blossoms persevere throughout the year.

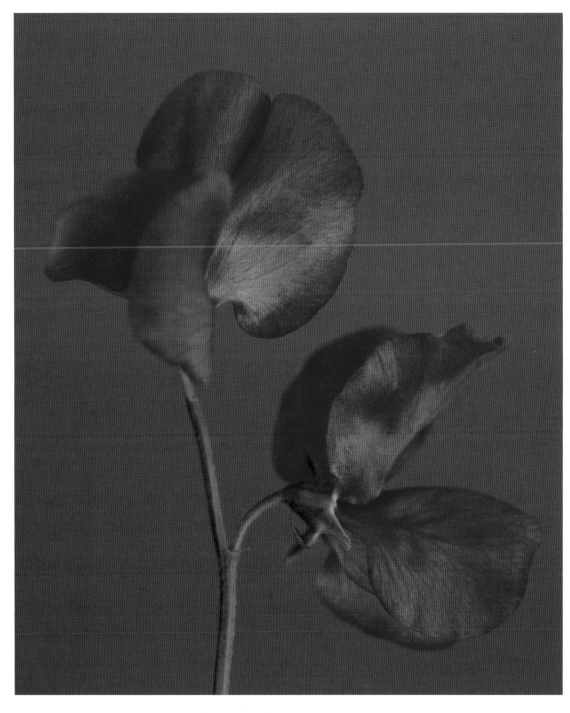

Lathyrus odoratus 'Scarlet' (Sweet Pea)

Like the sweet pea climbing to reach the sun, you like to feel that you are heading in the right direction. People are sometimes overwhelmed by your enthusiasm and often do not see your softer side. Though passionate, you appreciate more subtle expressions of affection.

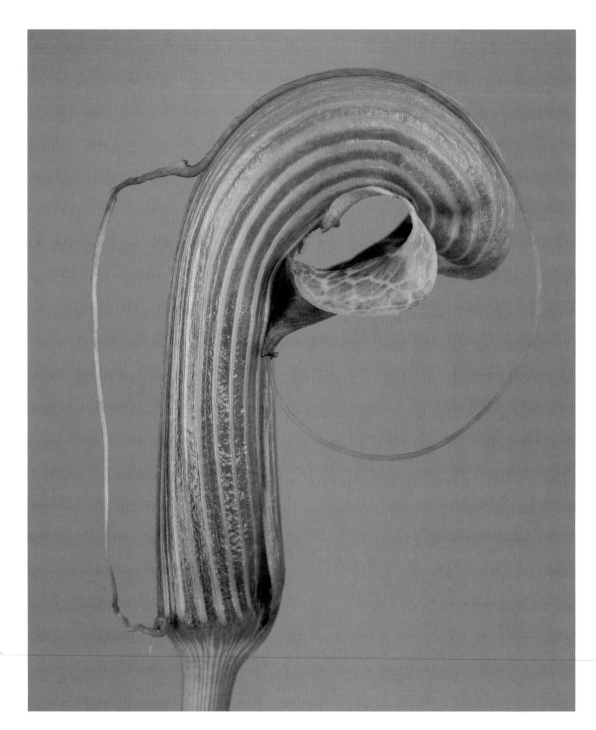

Arisaema galeatum (Helmet Cobra Lily)

Cobra lilies are tender yet strikingly architectural. You are a person of contrasts. Though naturally artistic you also adore structure and balance. Friends say that you have your head in the clouds but your feet on the ground. You will be rewarded when you balance your imagination with your practical conservatism.

Rosa 'Pascali' (Rose)

The purity of 'Pascali' symbolizes peace and eternal love. You have innate grace and strength, and are often described as a 'breath of fresh air'. Your ability to bring calm to stressful situations earns you well-deserved admiration—you are worthy of love and respect.

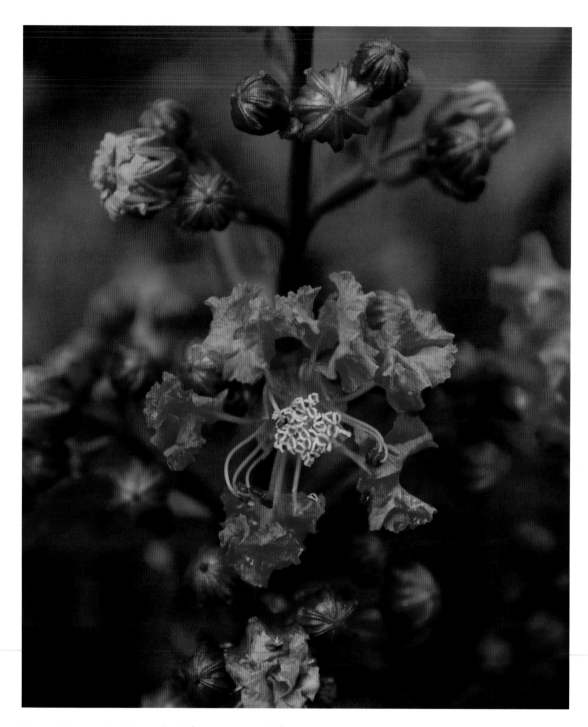

Lagerstroemia 'Arapaho' (Crape Myrtle)

The crape myrtle flowers longer than almost any other plant, greatly rewarding those who care for them. You are fortunate to share this talent, maintaining a glamorous appearance with a minimum of effort. You are passionate and complex, but young and optimistic at heart.

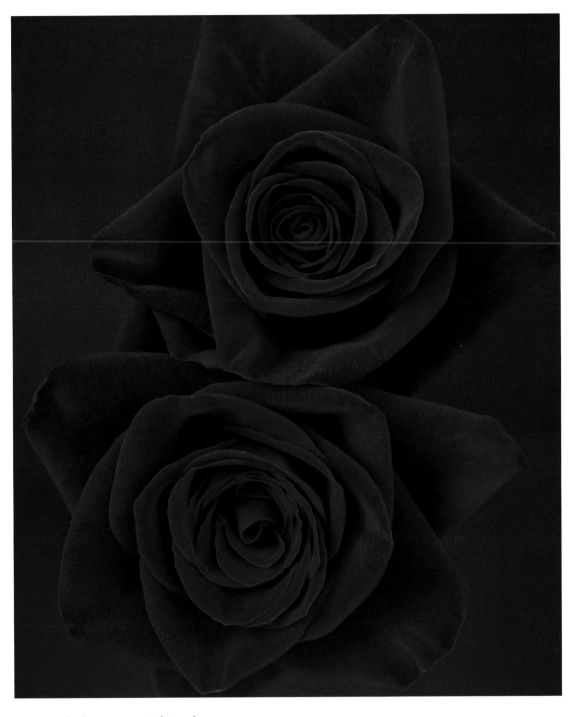

Rosa 'Black Baccara' (Rose)

No flower is as recognizable as the red rose, and there is no red rose as dark as the 'Black Baccara.' With your passionate nature and inherent beauty you stand out from the crowd. Although you have many friends and admirers, you have a sultry and mysterious side that you reveal only to true confidantes.

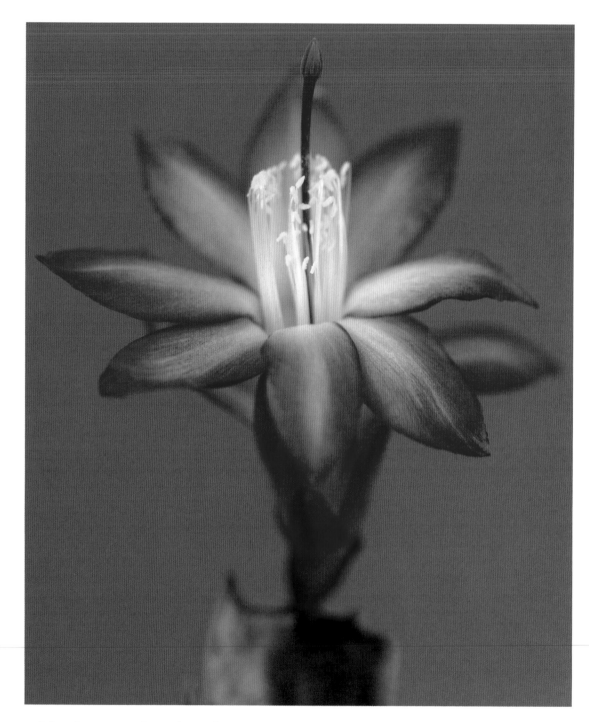

Schlumbergera 'Thor Alise' (Thanksgiving Cactus)

Cactus people are resilience personified, so much so that they can be mistaken for self-sufficient loners. This glorious flower reminds others that you have a soft and loving heart, and much to give. Both tenacious and tender, you are one of nature's most loyal friends.

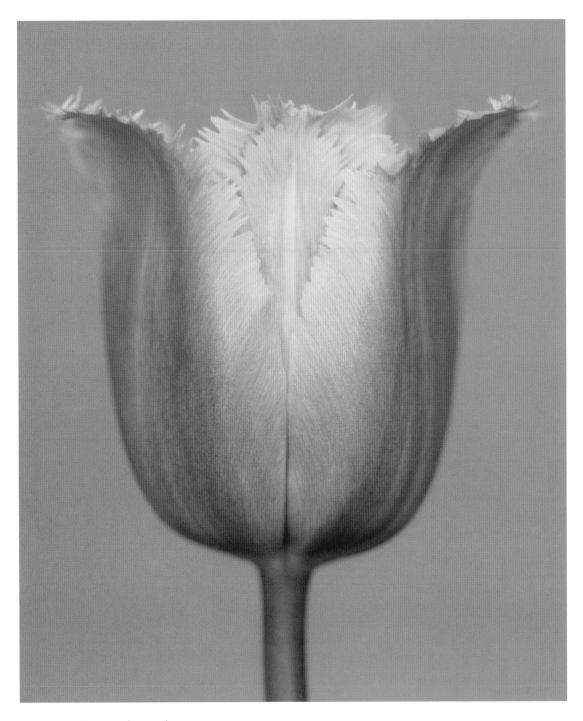

Tulipa 'Aleppo' (Tulip)

A significant tulip with a historical background, 'Aleppo' has many admirers. You embody glamour and mystique. Your charm is so compelling that you are often surrounded by a crowd. Your breadth of knowledge is astounding and reflects your passion for academia and the arts.

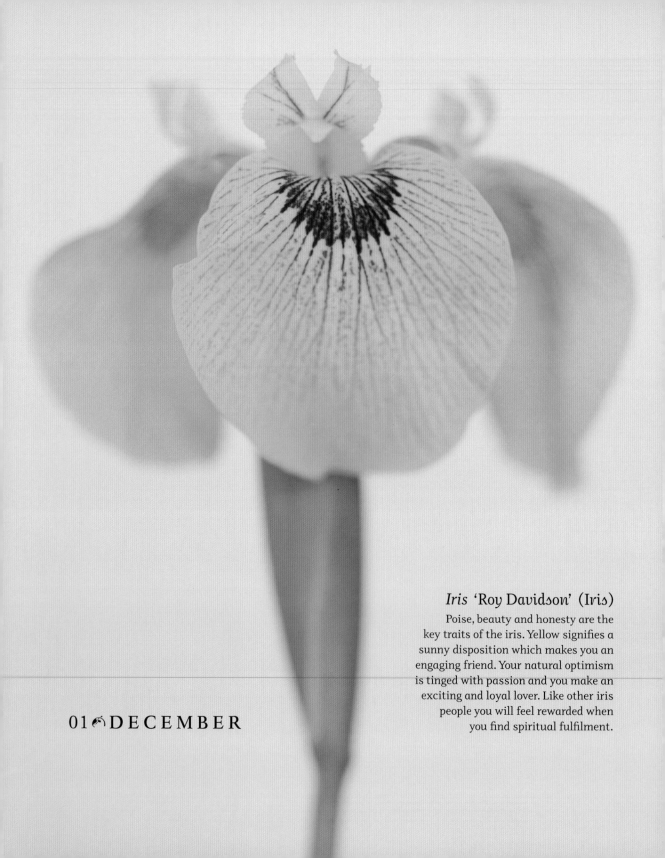

Iris 'Roy Davidson' (Iris)

Poise, beauty and honesty are the key traits of the iris. Yellow signifies a sunny disposition which makes you an engaging friend. Your natural optimism is tinged with passion and you make an exciting and loyal lover. Like other iris people you will feel rewarded when you find spiritual fulfilment.

01 DECEMBER

Tulipa 'Strong Gold' (Tulip)

The bright yellow silky petals of this tulip represent a person of great distinction. You are so overwhelmingly happy and positive that strangers often smile at you without realizing they are doing so. You are generous and kind and are particularly popular with children.

Agapanthus 'Mood Indigo' (Lily of the Nile)

Indigo is associated with intuition and imagination. You are one of nature's dreamers, prone to fantasy and speculation. You may receive the answers to your problems while you sleep, making even your rest time extremely rewarding. Children will be drawn to your gift for storytelling and make-believe.

Tulipa didieri (Didierian Tulip)

The petals of the didierian tulip are flushed with an enticing pink, symbolizing passion and devotion. You are generally a nurturing person but you hold your greatest gifts for your loved one. Like other tulip people you enjoy the finer things in life. With time, you reveal more and more delights.

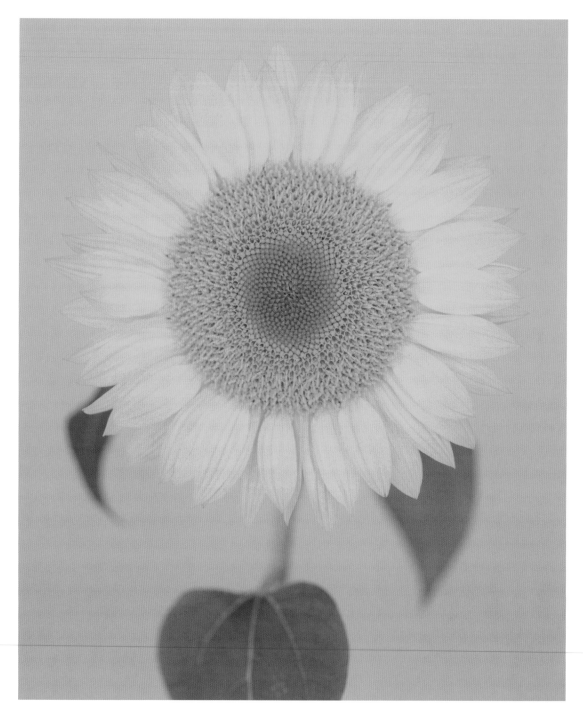

Helianthus annus 'Sunburst' (Sunflower)

There is no flower more cheerful than the sunflower with which you share an abundance of positive energy. You are known for your generosity and warm heart, and friends feel inspired by your optimism. Be prepared to shine—beneath your sunny disposition lies a rare intelligence.

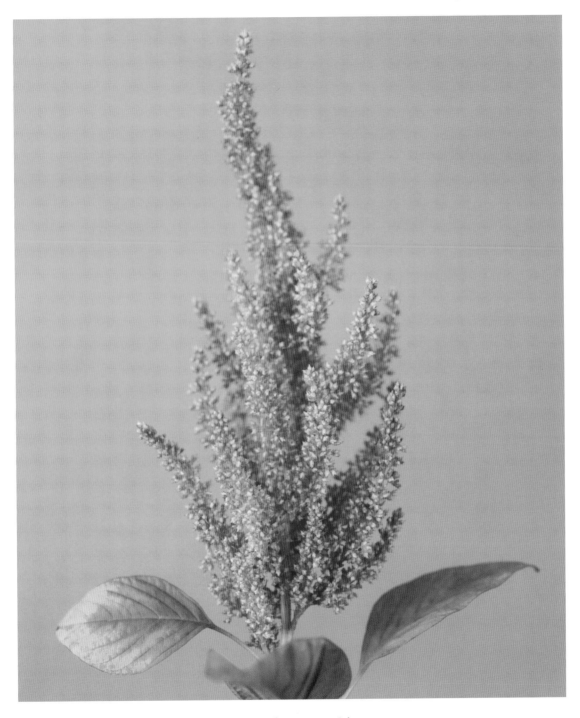

Amaranthus cruentus 'Golden Giant' (Amaranth)

The amaranth is an edible ornamental whose seeds attract flocks of birds. You too may be used to being at the center of an adoring crowd. Your key traits are joy and abundance, making you a magnet for good fortune. Others feed off your energy, so make sure you keep a little for yourself.

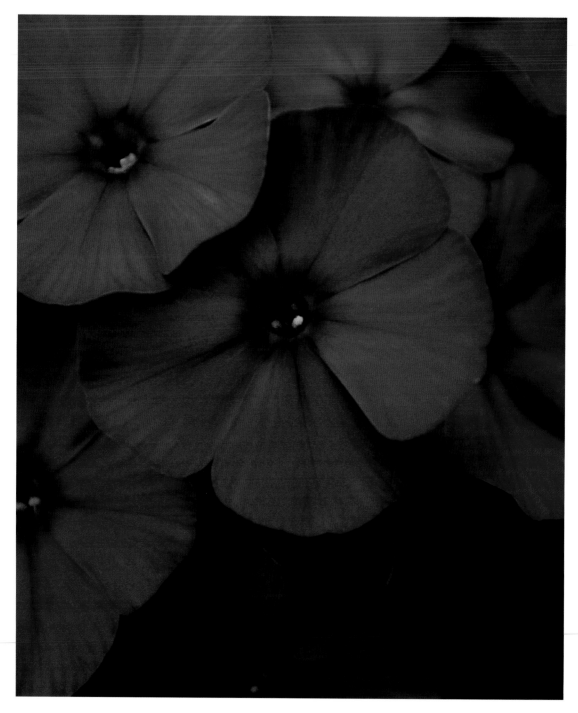

Phlox paniculata (Phlox)

As 'phlox' is Greek for 'flame,' and purple is the color of the priestess, you are a trailblazer, a guardian and an intrepid spirit. You easily attract friends and are admired for your worldly and eclectic knowledge. You have a fascination for the arcane and ancient which leads you into many curious dealerships.

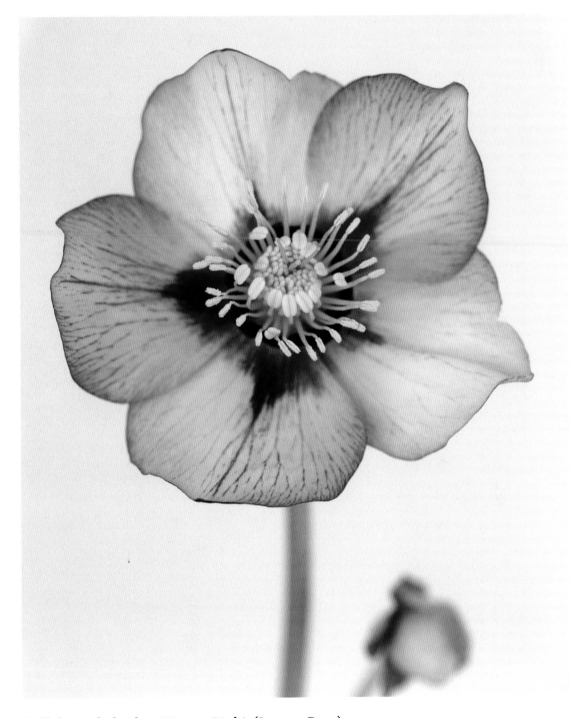

Helleborus hybridus 'Picotee Pink' (Lenten Rose)

'Picotee Pink' is rather more sophisticated than its name suggests. Likewise, the depths of your intellect may be hidden behind some surface distraction. When you show your true abilities to the world you will transcend the constraints of your pretty appearance.

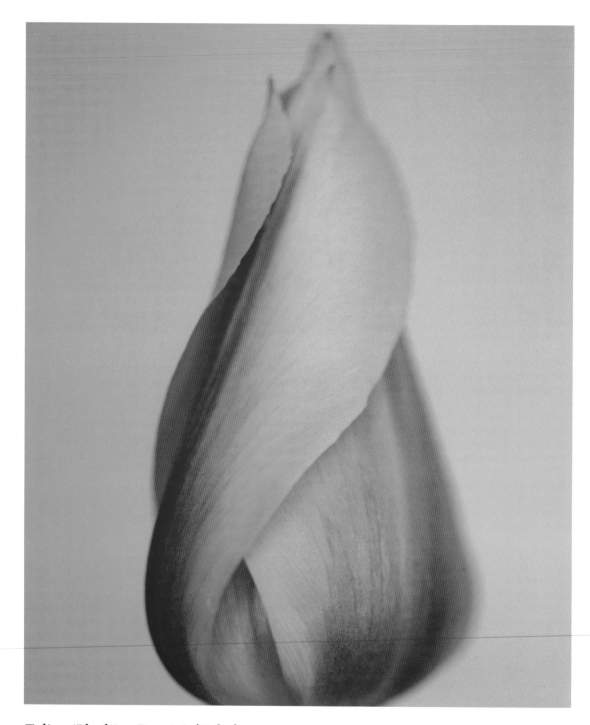

Tulipa 'Blushing Beauty' (Tulip)

The color and shape of this 'Blushing Beauty' help to reinforce the sentiment of its name. You are an outwardly optimistic and cheerful person but, as symbolized by the spiral formation of this particular tulip's petals, you keep a lot of your power in reserve. You will rise to the occasion when truly challenged.

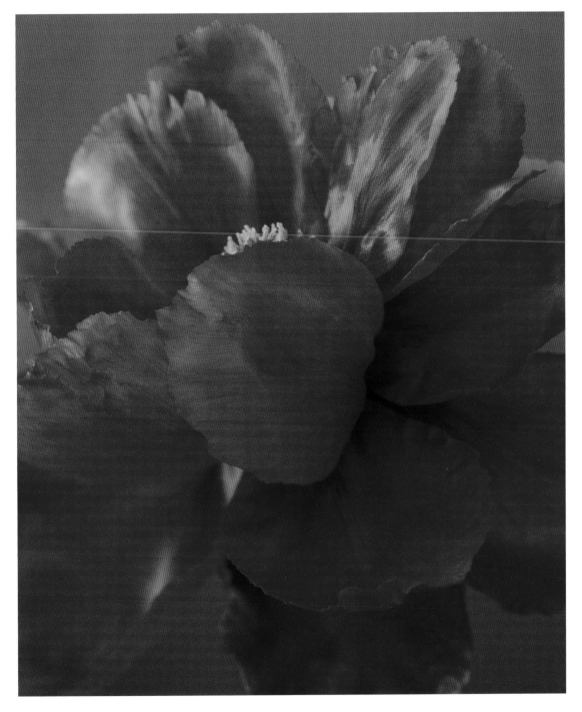

Paeonia suffruticosa (Tree Peony)

The tree peony rewards us when it is left to its own devices. Likewise, if you are uprooted and moved about you tend to forget your purpose and passion. You have an appreciation for antiquity and often find interest in the world of healing.

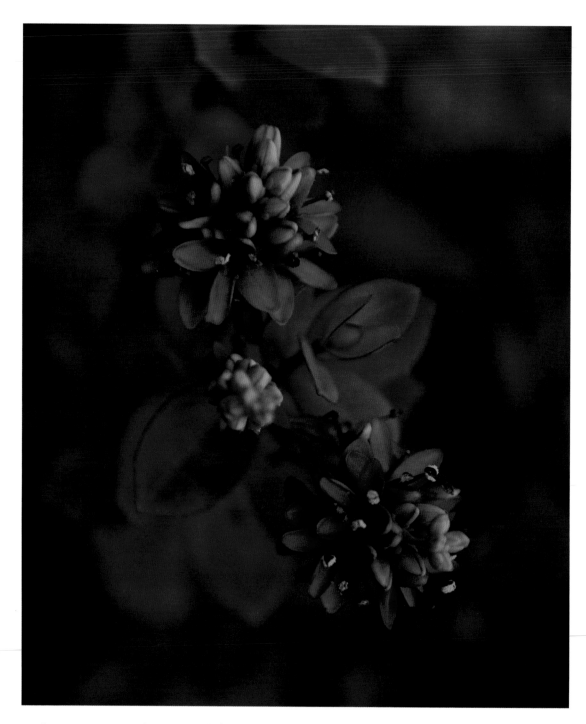

Hebe armstrongii (Aurea Hebe)

Like the Greek goddess for whom it is named, this sprightly bloom perpetually flirts with youth. You have almost legendary powers of regeneration and are often the last to bed and first to rise. Though you may have a boundless source of energy, this is well tempered by your innate wisdom and grace.

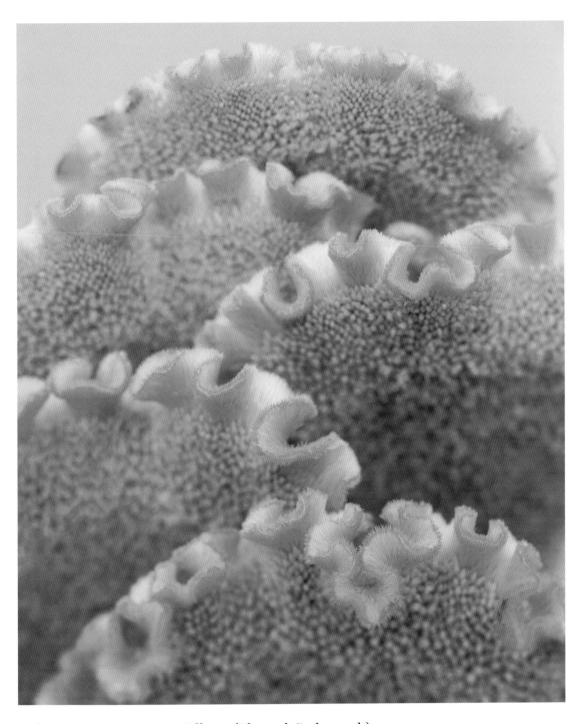

Celosia argentea 'Amigo Yellow' (Plumed Cockscomb)

The undulating lip of this powerful flower denotes an individual adept at the assimilation of new ideas with the ability to see different points of view. You have an enhanced concentration span and, in your eyes, the more convoluted a problem the better. Your cheerful disposition makes you a popular friend and lover.

Euphorbia pulcherrima 'Van Gogh' (Poinsettia)

The delicate variegation in this poinsettia blends fiery red with the peace and clarity of pale green. On the surface you seem soft and subtle but you are a person of extremes. Every facet of your life is driven by your emotions. Fortunately your calm mind keeps your heart in check.

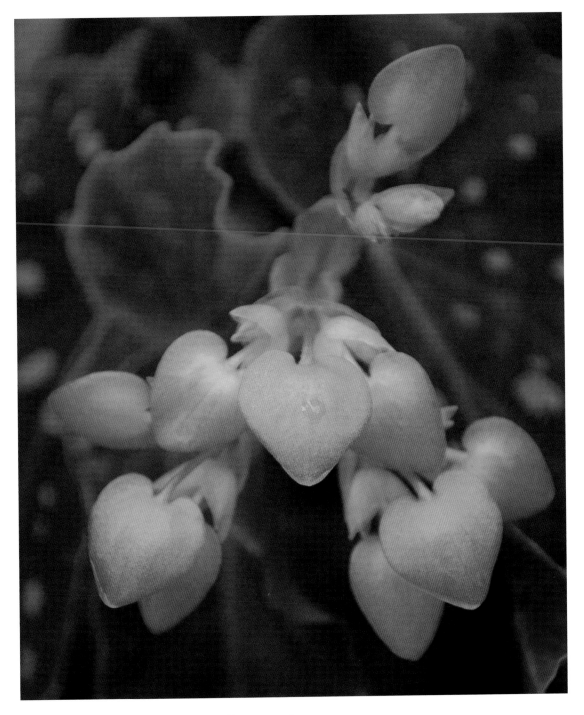

Begonia albo-picta (Lettuce Leaf Begonia)

The tactile blooms of the begonia offer a warning against giving in to dark forces. You have many gifts and charms, including natural good luck, and invariably get what you wish for. With your agile mind and obvious physical attributes you have fabulous potential. You shine your truth for others to see.

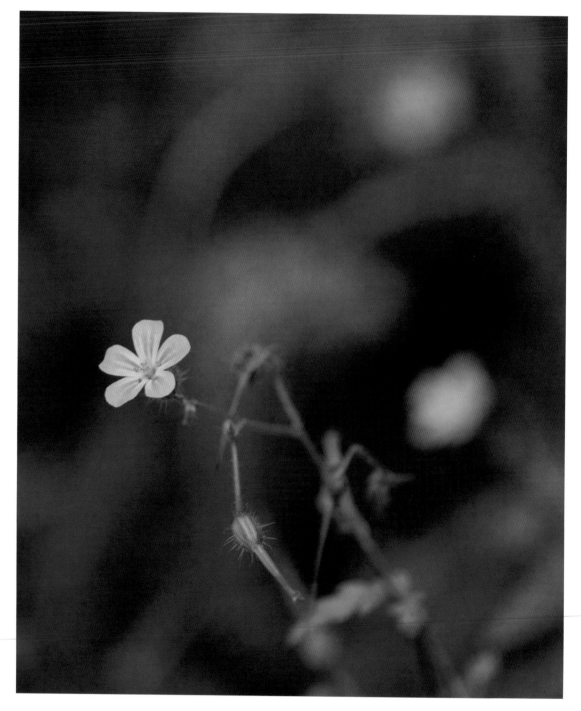

Geranium robertianum (Red Robin)

Protection and fertility are associated with this delicate flower. As a nurturer you are very popular with children and animals, but your adult friends will also seek you out when they need a little care. You have the natural ability to ease the everyday maladies of the physical world with your reserve of emotional calm.

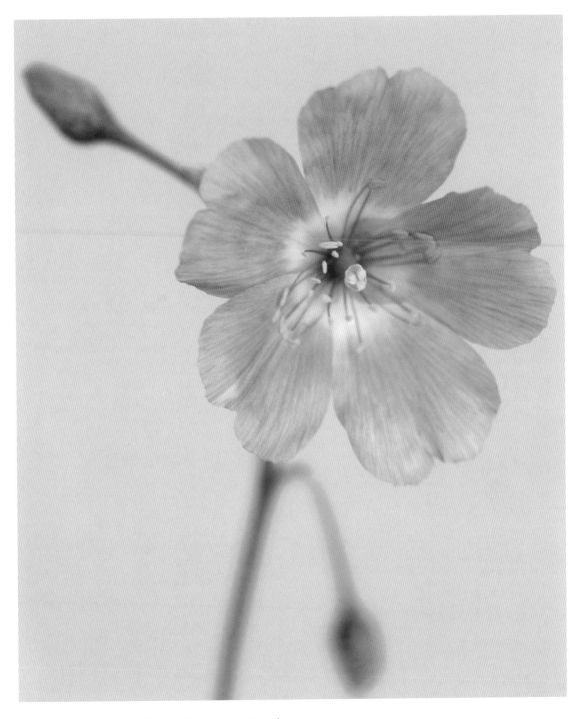

Calandrinia grandiflora (Rock Purslane)

With its optimism and grace, this lovely flower can brighten even the dullest day. You use this ability to express compassion and protection, easing the worries and concerns of those around you. A born leader, you show the way with gentle and elegant tenacity.

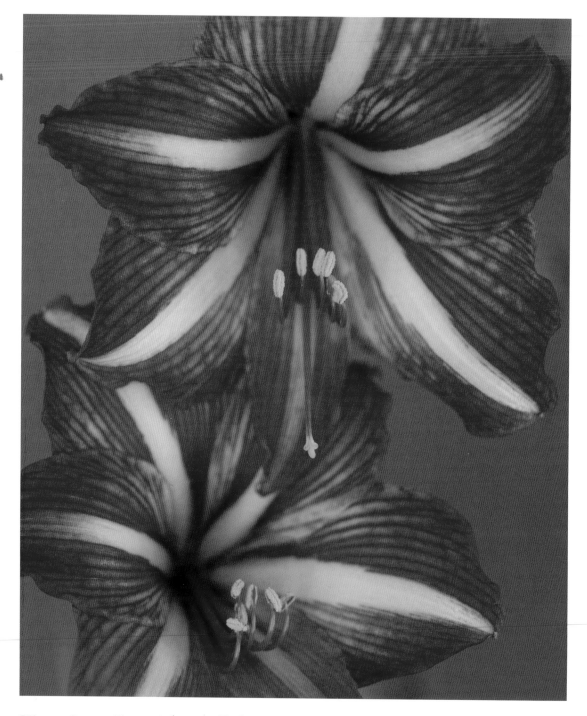

Hippeastrum 'Santos' (Amaryllis)

Despite an exterior of pure passion you have an intelligent and discerning mind. Resourceful and wise, others may describe you as possessing the patience of a saint. But anyone who chooses to push you too far may find themselves exposed to your fiery temper.

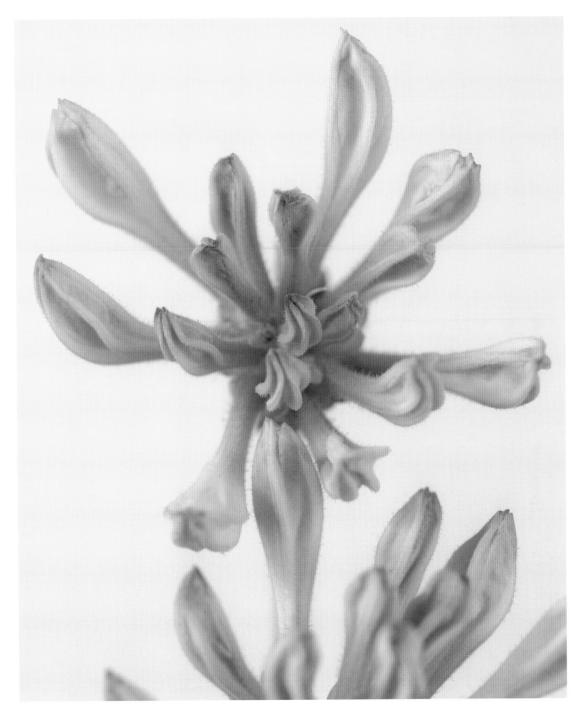

Rhododendron daviesii (Ghent Hybrid Azalea)

Though diminutive in stature, this flower is rich with symbolism. You have a fragile passion which in no way means you are lacking in sensuality. Indeed, with the added allure of intelligence combined with charm, you are subtle yet intoxicating. You are disciplined and creative with a spiritual outlook.

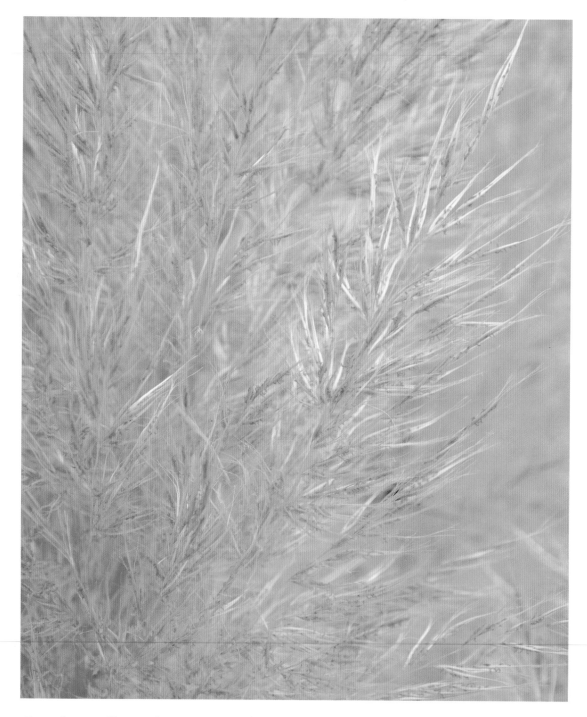

Cortaderia selloana (Pampas Grass)

The delicate swathes of pampas grass bend to the wind, symbolizing an easygoing personality. You move through life with grace and fortitude, and adapt easily to change. With the wisdom to pick your battles carefully, you reserve your precious energy for the things that are truly important.

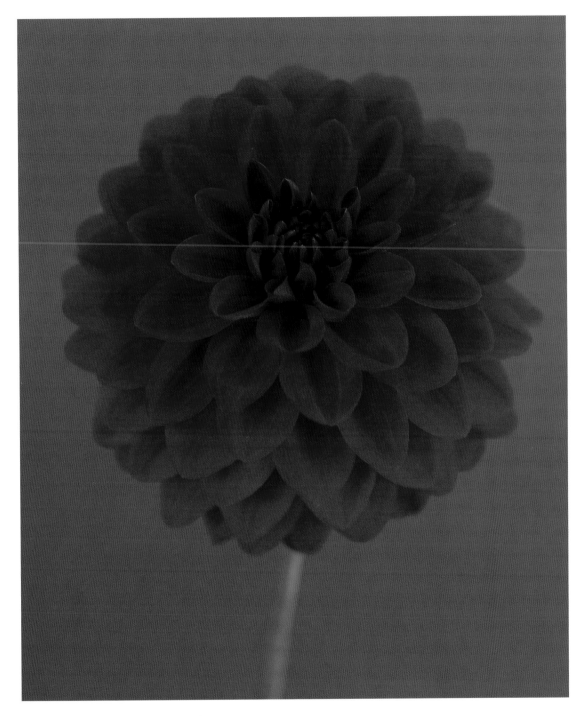

Dahlia 'Marseille' (Dahlia)

The 'Marseille' dahlia is named after the oldest city in France. You share with this outstanding flower an inherent romanticism and long-lasting glamour. You are a bold individual who requires personal space to truly unfold, but when you do you are well-loved for your dynamic beauty and warm heart.

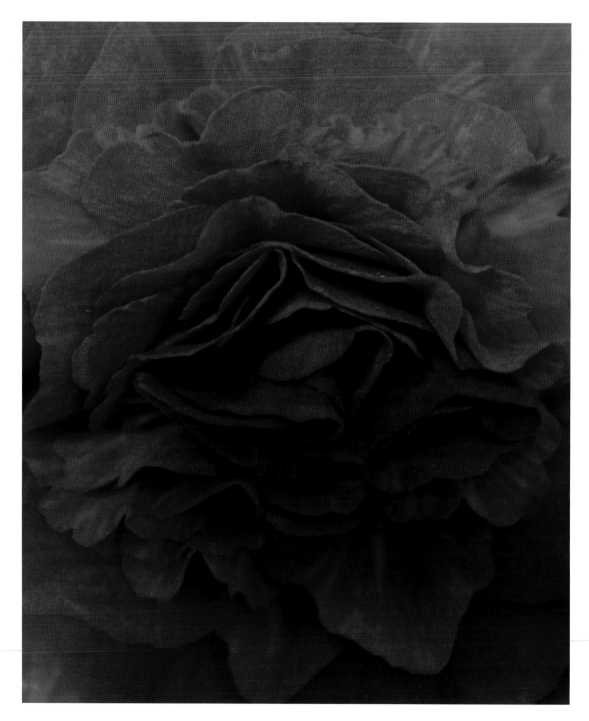

Begonia tuberhybrida 'Ruffled Red' (Tuberous Begonia)

Passion, intrigue and romanticism; this is a bloom of emotional power. This makes you immediately attractive but you must guard against the attentions of needy individuals and focus on rewarding relationships. You have a flair for language and a quick and clever mind, and thrive in environments rich in art and words.

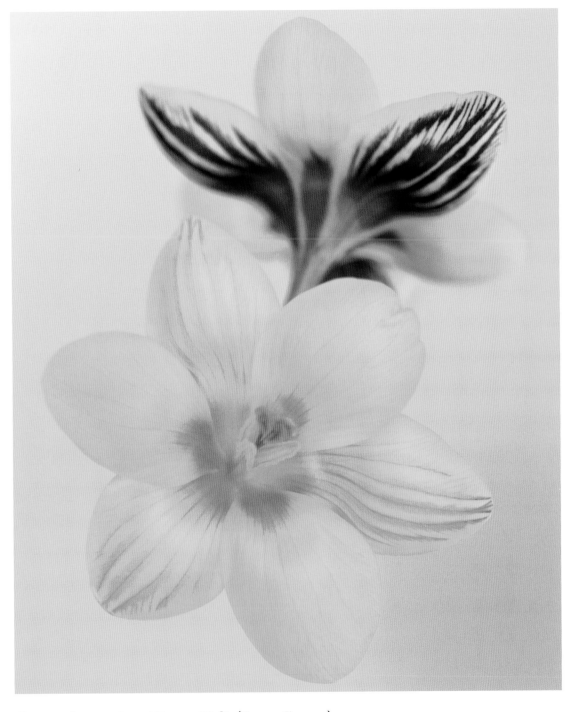

Crocus chrysanthus 'Gypsy Girl' (Snow Crocus)

The crocus is the symbol of happiness and heralds spring. You are a vivacious natural leader with a sunny disposition. You are extremely resilient and find it easy to bounce back after hard times. Your good looks and underlying sophistication could lead you into a career in politics or public speaking.

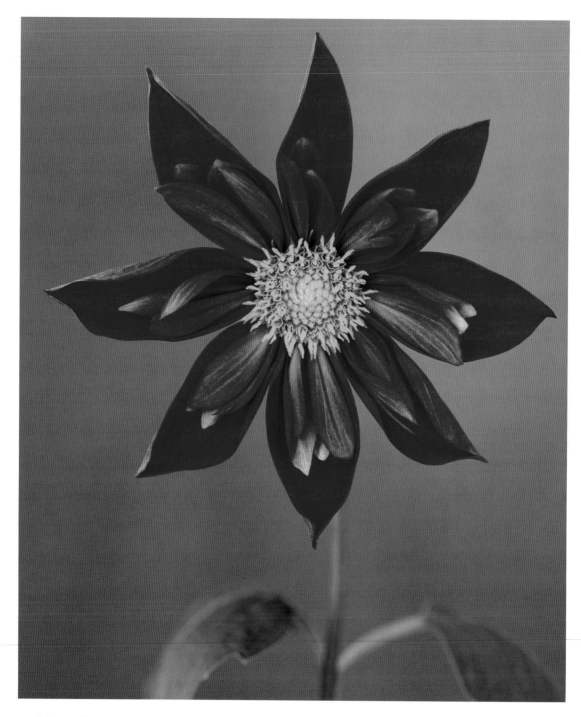

Dahlia collarette 'Mars' (Dahlia)

You are popular and outgoing if a little sensitive. You have an otherworldly wisdom and people may refer to you as an 'old soul.' But beneath your distinguished exterior there beats an ardent heart and emotions that you must learn to control. When you master your passion you will find great joy.

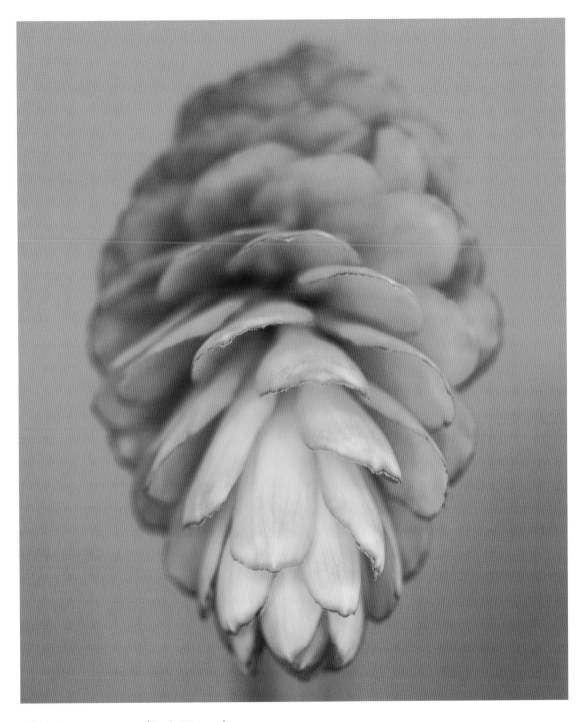

Alpinia purpurata (Red Ginger)

Ginger symbolizes power and success, combined potently in this flower with the vitality and ambition of the color red. You are a force to be reckoned with. Vibrant and outgoing, you enjoy meeting new people and undertaking new challenges.

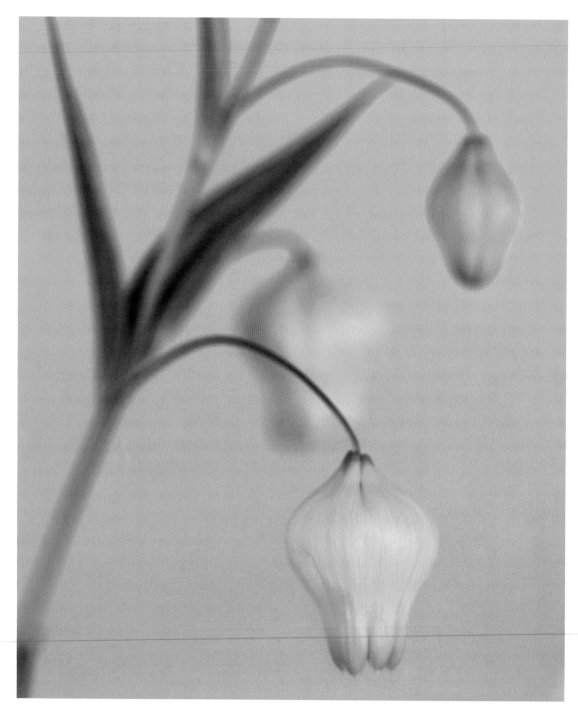

Sandersonia aurantiaca (Christmas Bells)

These elegant flowers symbolize joy and forgiveness. Your capacity to give generously of both your time and spirit has become legendary. You particularly enjoy the delights of a large family and are a gifted homemaker. But you must allow yourself time to unwind and replenish your energy.

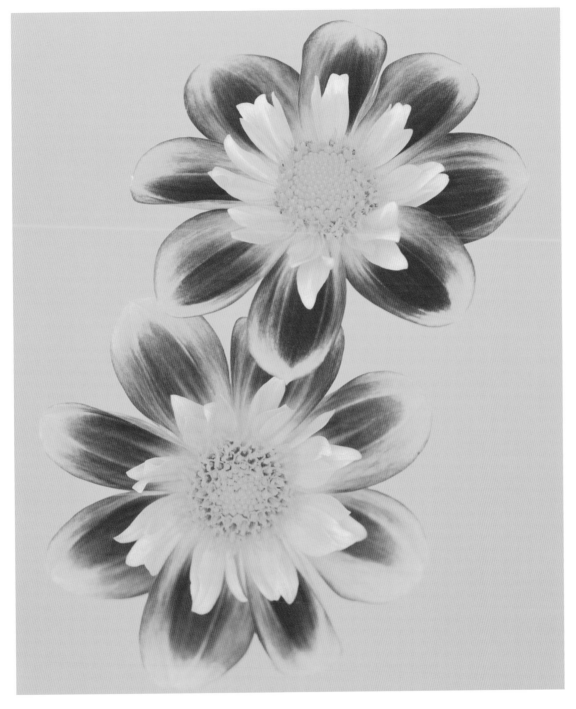

Dahlia collarette 'Pooh' (Dahlia)

At first glance this flower seems sweet and simple, like the famous bear for which it is named, but on closer inspection its complexity becomes evident. You have a sunny disposition and an inviting glow. However, those close to you should not be complacent as you have energy to burn and need to be kept busy.

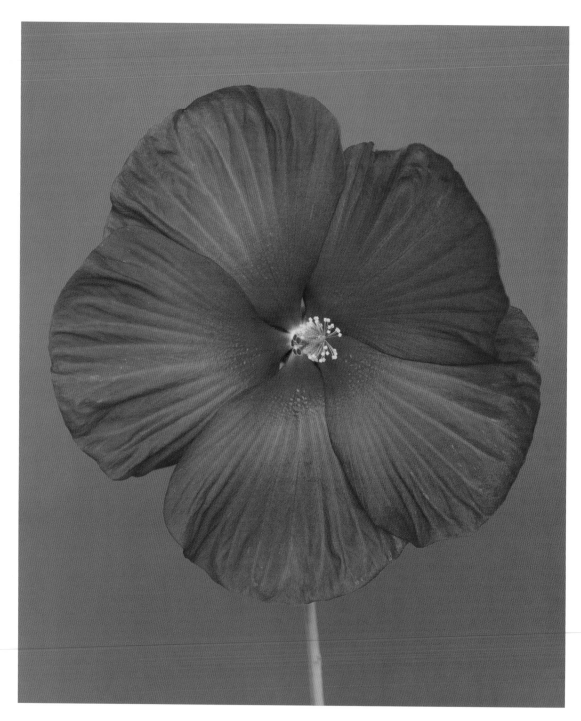

Hibiscus moscheutos (Rose Mallow)

The hibiscus flower is a flamboyant performer during the day, but deeply introverted at night. Like this flower, your bold appearance belies your fragility. You are beautiful and very popular amongst your colleagues, but you prefer the company of close friends and family, and the comforts of home.

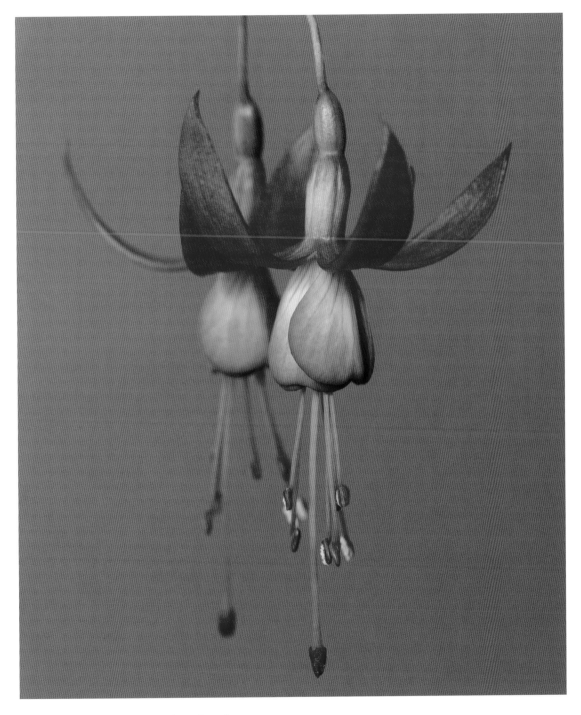

Fuchsia 'David Jason' (Fuchsia)

Though old-fashioned, the fuchsia manages to be a flamboyant flower. It blesses you with classical good taste and exuberant self-expression. You combine these traits with a passionate heart and love of fantasy. When in love, you are both enchanting and enchanted.

Daucus carota (Queen Anne's Lace)

Queen Anne's lace is a symbol of fantasy and lust, a dynamic duo that you embrace. You are fortunate to also have a strong sense of spirituality, which helps to assuage your penchant for getting carried away. You are popular and adaptable, which allows you to fit in and be accepted anywhere.

Rosa 'Fire and Ice' (Rose)

The beauty and romanticism of the rose are undisputed, but every rose has its thorns. The 'Fire and Ice' rose represents duality: hot and cold, good and bad. This makes you an individual of extremes. Though sometimes cool, you are capable of great passion, and you are equally comfortable in moments of stress or serenity.

Hippeastrum 'Royal Velvet' (Amaryllis)

When this glorious bloom is your flower you understand the double-edged sword of beauty. The amaryllis symbolizes timidity, which is ironic considering its upright charm. But you know that it can be hard to shine when you receive unsolicited attention. Luckily you have pride on your side to help you stand tall.

INDEX

LATIN NAME	COMMON NAME	DATE
Dianella tasmanica 'Marsha's Giant'	Variegated Flax Lily	07/29
Dianthus barbatus 'Green Trick'	Sweet William	07/26
Dianthus caryophyllus 'Belle Epoque'	Carnation	02/13
Dianthus caryophyllus 'Picotee'	Carnation	01/01
Dianthus caryophyllus 'Raspberry'	Carnation	01/27
Dichorisandra thyrsiflora	Blue Ginger	09/18
Digitalis 'Honey Trumpet'	Foxglove	11/21
Digitalis purpurea	Foxglove	03/16
Disporum cantoniense 'Night Heron'	Fairy Bells Bamboo	02/06
Echinacea 'Evan Saul'	Coneflower	04/06
Echinacea purpurea 'Green Envy'	Coneflower	03/21
Echinacea purpurea 'White Swan'	White Coneflower	03/02
Echinops ritro	Globe Thistle	08/25
Echinopsis 'Sunflower'	Hedgehog Cactus	07/12
Eichhornia azurea	Anchored Water Hyacinth	05/25
Eryngium amethystinum	Sea Holly	02/05
Eryngium eburneum	Sea Holly	02/28
Eryngium planum 'Jade Frost'	Sea Holly	02/20
Eucharis grandiflora	Amazon Lily	01/31
Eucomis autumnalis	Pineapple Lily	07/20
Eucomis bicolor	Pineapple Lily	10/27
Euphorbia 'Diamond Frost'	Spurge	11/23
Euphorbia 'Limewall'	Spurge	09/24
Euphorbia cyparissias	Spurge	01/30
Euphorbia milii	Crown of Thorns	01/06
Euphorbia pulcherrima 'Early Red'	Poinsettia	04/27
Euphorbia pulcherrima 'Lemon Snow'	Euphorbia	04/10
Euphorbia pulcherrima 'Van Gogh'	Poinsettia	12/13
Eustoma grandiflorum	Lisianthus	07/01
Eustoma grandiflorum 'Jeanette'	Lisianthus	03/10
Farfugium japonicum 'Crispata'	Crested Leopard Plant	05/19
Freesia 'Lavande'	Freesia	10/20
Fritillaria imperialis 'Lutea Maxima'	Imperial Yellow Crown	08/10
Fritillaria meleagris	Checkered Daffodil	07/30
Fritillaria meleagris 'Alba'	Checkered Daffodil	05/01
Fritillaria uva-vulpis	Fox's Grape	08/14
Fuchsia	Fuchsia	03/31
Fuchsia 'David Jason'	Fuchsia	12/28
Fuchsia 'Mrs Popple'	Hardy Fuchsia	10/21
Galanthus nivalis	Snowdrop	09/21
Gazania rigens 'Gazoo'	Treasure Flower	07/24
Gentiana andrewsii	Bottle Gentian	01/08
Geranium 'Rozanne'	Cranesbill Geranium	10/06
Geranium robertianum	Red Robin	12/15
Gerbera 'Kelly N.'	Gerbera Daisy	06/10
Gerbera jamesonii	Transvaal Daisy	03/27
Gladiolus hortulanus	Gladiolus	05/06
Gloriosa superba	Flame Lily	04/23
Godetia grandiflora 'Sybil Sherwood'	Farewell to Spring	03/18
Guzmania 'Limones'	Bromeliad	05/12
Gypsophylla 'Bambino'	Baby's Breath	05/28
Haemanthus albiflos	Paintbrush Plant	06/30
Hebe armstrongii	Aurea Hebe	12/11
Helenium 'Chelsea'	Daisy	01/17
Helianthus annus 'Autumn'	Sunflower	11/16

LATIN NAME	COMMON NAME	DATE
Helianthus annus 'Sunburst'	Sunflower	12/05
Helianthus annus 'Velvet Queen'	Sunflower	11/22
Helianthus annus 'Widow Tillman'	Sunflower	10/29
Heliconia stricta 'Iris Bannochie'	False Bird of Paradise	11/18
Helleborus 'Haiku'	Lenten Rose	10/23
Helleborus hybridus 'Apricot'	Lenten Rose	01/05
Helleborus hybridus 'Picotee Pink'	Lenten Rose	12/08
Helleborus nigercors 'White Beauty'	Lenten Rose	06/26
Helleborus sternii	Lenten Rose	09/17
Hesperaloe funifera	Coral Yucca	02/04
Hibiscus moscheutos	Rose Mallow	12/27
Hibiscus moscheutos 'Luna Blush'	Rose Mallow	02/23
Hippeastrum	Amaryllis	09/07
Hippeastrum 'Amare'	Amaryllis	07/03
Hippeastrum 'Chico'	Amaryllis	10/19
Hippeastrum 'Exotic Star'	Amaryllis	11/10
Hippeastrum 'Exotica'	Amaryllis	07/17
Hippeastrum 'La Paz'	Amaryllis	11/06
Hippeastrum 'Lemon and Lime'	Amaryllis	02/07
Hippeastrum 'Limona'	Amaryllis	04/17
Hippeastrum 'Nebula'	Amaryllis	05/02
Hippeastrum 'Papillo'	Butterfly Amaryllis	08/13
Hippeastrum 'Royal Velvet'	Amaryllis	12/31
Hippeastrum 'Santos'	Amaryllis	12/17
Hosta 'Gold Drop'	Hosta	01/07
Hyacinthus orientalis	Hyacinth	08/19
Hyacinthus orientalis 'Blue Pearl'	Hyacinth	09/13
Hyacinthus orientalis 'Splendid Cornelia'	Hyacinth	04/30
Hyacinthus orientalis 'Woodstock'	Hyacinth	06/16
Hydrangea macrophylla 'Endless Summer'	Lacecap Hydrangea	07/14
Hydrangea macrophylla 'Normalis'	Lacecap Hydrangea	10/10
Hydrangea macrophylla 'Todi'	French Hydrangea	08/22
Hymenocallis caribaea	Spider Lily	11/05
Iochroma cyaneum	Violet Churur	05/26
Ipomoea purpurea 'Midnight Velvet'	Tall Morning Glory	10/04
Ipomoea tricolor 'Blue Star'	Morning Glory	05/14
Ipomoea tricolor 'Karen M.'	Morning Glory	06/29
Iris 'Roy Davidson'	Iris	12/01
Iris douglasiana 'N. Erickson'	Douglas Iris	09/11
Iris germanica 'Bridal Veil'	Iris	03/09
Iris germanica 'Connor'	Iris	08/09
Iris histrioides 'Angel's Tears'	Iris	02/01
Iris hollandica 'Carmen'	Dutch Iris	07/09
Kalanchoe uniflora 'Lovebells'	Trailing Kalanchoe	02/14
Kalmia latifolia	Mountain Laurel	09/22
Kniphofia 'Samuel's Sensation'	Red Hot Poker	02/18
Lagerstroemia 'Arapaho'	Crape Myrtle	11/27
Lantana camara 'Confetti'	Shrub Verbena	03/06
Lapageria rosea 'Yuriko'	Chilean Bellflower	03/20
Lathyrus odoratus 'Black Night'	Sweet Pea	04/15
Lathyrus odoratus 'Scarlet'	Sweet Pea	11/24
Leucospermum cordifolium 'Salmon Bud'	Pincushion Protea	07/18
Lilium 'Albany'	Oriental Trumpet Lily	08/28
Lilium 'Latvia'	Asiatic Lily	06/22

LATIN NAME	COMMON NAME	DATE
Lilium 'Stones'	Asiatic Lily	04/02
Lilium lanceofolium 'Flore Pleno'	Double Tiger Lily	10/11
Lilium landini	Black Asiatic Lily	10/02
Lilium nepalense	Nepal Lily	11/17
Liriodendron tulipifera	American Tulip Tree	06/27
Lobelia tupa	Devil's Tobacco	03/30
Lonicera sempervirens	Coral Honeysuckle	06/24
Ludisia 'Red Velvet'	Jewel Orchid	02/03
Lysichiton americanus	Swamp Lantern	10/07
Magniloa denudata	Yulan Magnolia	06/25
Magnolia 'Heaven Scent'	Tulip Magnolia	09/23
Magnolia grandiflora	Southern Magnolia	06/15
Magnolia liliiflora 'Nigra'	Mulan Magnolia	07/10
Magnolia sieboldii	Siebold's Magnolia	05/10
Malva sylvestris 'Zebrina'	Zebra Mallow	10/05
Meconopsis sheldonii	Blue Poppy	04/25
Medinilla magnifica	Rose Grape	01/24
Muscari 'Blue Spike'	Grape Hyacinth	04/22
Muscari armeniacum	Grape Hyacinth	08/24
Muscari aucheri 'Dark Eyes'	Blue Grape Hyacinth	04/01
Narcissus 'Albus Plenus Odoratus'	Daffodil	01/03
Narcissus 'Dickcissel'	Daffodil	08/27
Narcissus 'Ice Follies'	Daffodil	03/01
Narcissus 'Jamestown'	Daffodil	05/17
Narcissus 'Sinopel'	Daffodil	01/15
Neoregelia carolinae 'Devroe'	Bromeliad	03/07
Nigella damascena 'Persian Jewels'	Love-In-A-Mist	05/20
Nymphaea 'Ishiwata'	Water Lily	10/17
Nymphaea 'Texas Dawn'	Water Lily	06/21
Nyphaea 'Noah G.'	Water Lily	08/16
Oenothera missouriensis	Missouri Primrose	08/02
Origanum rotundifolium 'Kent Beauty'	Oregano	03/19
Osteospermum 'Asti White'	African Daisy	09/28
Paeonia miokosewitschii	Peony	03/14
Paeonia suffruticosa	Tree Peony	12/10
Panicum 'Fountain'	Ornamental Grass	04/24
Papaver nudicaule	Iceland Poppy	09/01
Papaver somniferum 'Black Cloud'	Poppy	08/06
Paphiopedilum 'Citrine'	Lady's Slipper Orchid	11/01
Paphiopedilum 'Pinocchio'	Lady's Slipper Orchid	02/22
Passiflora 'Blue Crown'	Passion Flower	01/10
Passiflora 'Constance Elliott'	Passion Flower	08/07
Pelargonium domesticum 'Carrum Purple'	Martha Washington Geranium	01/04
Pennisetum alopecuroides 'Weserbergland'	Fountain Grass	11/09
Pennisetum glaucum 'Purple Majesty'	Black Leaf Millet	08/12
Penstemon barbatus	Beard Tongue	04/19
Peperomia 'Lilian'	Peperomia	03/26
Petunia 'Lemon Zest'	Petunia	01/14
Petunia hybrida	Petunia	02/11
Phalaenopsis 'Baldan's Kaleidoscope'	Moth Orchid	11/13
Phlox paniculata	Phlox	12/07
Phygelius rectus 'Moonraker'	Cape Fuchsia	07/28
Pinellia pedatisecta	Green Dragon	07/19
Pinellia ternata	Crow Dipper	11/08
Platycodon grandiflorus 'Alba'	Balloon Flower	01/26
Platycodon grandiflorus 'Mariesii'	Balloon Flower	09/16
Plumeria rubra	Frangipani	05/13
Podophyllum difforme 'Kaleidoscope'	Asian Mayapple	07/02
Podophyllum pleianthum	Mayapple	08/23
Primula 'Elizabeth Killelay'	Primrose	06/04
Protea cynaroides	King Protea	06/06
Ranunculus asiaticus	White Persian Buttercup	04/18
Ranunculus asiaticus	Persian Buttercup	04/12
Ranunculus asiaticus 'Bloomingdale'	Persian Buttercup	06/05
Ranunculus asiaticus 'Heloise'	Persian Buttercup	03/13
Ratibida columnifera 'Red Mexican Hat'	Upright Prairie Coneflower	05/07
Rhododendron 'Weston's Pink Diamond'	Rose Tree	11/12
Rhododendron daviesii	Ghent Hybrid Azalea	12/18
Rosa 'Black Baccara'	Rose	11/28
Rosa 'Camille'	Rose	06/09
Rosa 'Cezanne'	Rose	04/29
Rosa 'Doreen'	Rose	02/17
Rosa 'Fibidus'	Rose	11/04
Rosa 'Fire and Ice'	Rose	12/30
Rosa 'Jude the Obscure'	Rose	11/02
Rosa 'Lagowski'	Rose	06/13
Rosa 'Leonidas'	Rose	06/01
Rosa 'Pascali'	Rose	11/26
Rosa 'Pristine'	Rose	09/20
Rosa 'Rubin D.'	Rose	09/08
Rosa 'Stella'	Rose	09/06
Rosa 'Taboo'	Rose	03/05
Rosa 'Vogue'	Rose	08/15
Rosa rugosa	Saltspray Rose	03/11
Rudbeckia hirta 'Prairie Sun'	Black-Eyed Susan	09/02
Rudbeckia laciniata 'Herbstsonne'	Cutleaf Coneflower	06/12
Saintpaulia ionantha	African Violet	02/15
Sandersonia aurantiaca	Christmas Bells	12/25
Sarracenia alata	Sweet Pitcher Plant	01/09
Sarracenia rubra ssp. jonesii	North American Pitcher Plant	06/23
Scabiosa ochroleuca	Pincushion Flower	03/25
Schlumbergera 'Thor Alise'	Thanksgiving Cactus	11/29
Sedum spectabile	Ice Plant	09/19
Sempervivum tectorum	Hens and Chickens Plants	10/09
Seseli gummiferum	Moon Carrot	07/22
Sinningia speciosa	Gloxinia	04/03
Skimmia japonica	Japanese Skimmia	05/23
Solandra maxima	Golden Chalice Vine	10/24
Solenostemon scutellarioides	Coleus	10/22
Sprekelia formosissima	Aztec Lily	07/25
Syngonanthus chrysanthus 'Mikado'	Mikado	09/29
Thunbergia alata	Black-Eyed Susan Vine	05/15
Thunbergia alata 'African Sunset'	Black-Eyed Susan Vine	07/05

LATIN NAME	COMMON NAME	DATE
Thunbergia grandiflora	Sky Flower	10/26
Tibouchina urvilleana	Princess Flower	08/03
Tigridia pavonia	Jockey's Cap	11/07
Tillandsia cyanea	Pink Quill	01/21
Tithonia rotundifolia 'Torch'	Mexican Sunflower	05/08
Tulipa 'Absalon'	Tulip	09/05
Tulipa 'Aleppo'	Tulip	11/30
Tulipa 'Blushing Beauty'	Tulip	12/09
Tulipa 'Bonsoir'	Tulip	04/11
Tulipa 'Christo'	Tulip	01/02
Tulipa 'Fire Queen'	Tulip	10/18
Tulipa 'Flame'	Tulip	08/08
Tulipa 'Flaming Parrot'	Tulip	09/15
Tulipa 'Fringed Elegance'	Tulip	02/24
Tulipa 'Helmar'	Tulip	10/31
Tulipa 'Ice Cream'	Tulip	05/22
Tulipa 'Insulinde'	Tulip	06/08
Tulipa 'Maureen'	Tulip	06/03
Tulipa 'Maytime'	Tulip	05/16
Tulipa 'Picture'	Tulip	07/13
Tulipa 'Pink Parrot'	Tulip	06/17
Tulipa 'Prince de Lignac'	Tulip	08/05
Tulipa 'Prinses Irene'	Tulip	05/29
Tulipa 'Queen of the Night'	Tulip	10/12
Tulipa 'Rococo'	Tulip	02/27
Tulipa 'Rogue'	Tulip	01/25
Tulipa 'Sancerre'	Tulip	03/12
Tulipa 'Segwun'	Tulip	02/16
Tulipa 'Strong Gold'	Tulip	12/02
Tulipa acuminata	Tulip	08/31
Tulipa didieri	Didierian Tulip	12/04
Tulipa humilis 'Persian Pearl'	Tulip	07/04
Tulipa turkestanica	Tulip	01/11
Viola 'Clear Crystal Yellow'	Pansy	08/26
Viola 'Crown Azure'	Pansy	03/17
Viola 'Crown Rose'	Pansy	04/04
Vriesea 'Carly'	Bromeliad	02/26
Xerochrysum bracteatum 'Sundaze'	Golden Everlasting	08/11
Zantedeschia variegata 'Mint'	Arum Lily	09/25
Zantedeschia 'Bolero'	Calla Lily	07/31
Zantedeschia 'Neroli'	Calla Lily	11/20
Zantedeschia aethiopica	Arum Lily	08/20
Zantedeschia aethiopica 'Amelie'	Calla Lily	01/13
Zantedeschia aethiopica 'Green Goddess'	Arum Lily	07/23
Zantedeschia rehmannii	Calla Lily	01/23
Zinnia elegans	Zinnia	05/11